Framing Film:
Cinema and the Visual Arts

Framing Film:
Cinema and the Visual Arts

Edited by Steven Allen and Laura Hubner

intellect Bristol, UK / Chicago, USA

First published in the UK in 2012 by
Intellect, The Mill, Parnall Road, Fishponds, Bristol, BS16 3JG, UK

First published in the USA in 2012 by
Intellect, The University of Chicago Press, 1427 E. 60th Street,
Chicago, IL 60637, USA

A catalogue record for this book is available from the
British Library.

Cover designer: Holly Rose
Copy-editor: MPS, India
Typesetting: John Teehan
Production Manager: Melanie Marshall

ISBN 978-1-84150-507-7

Printed and bound by Hobbs the Printers Ltd, UK.

Contents

ACKNOWLEDGEMENTS

This edited collection stems from an international conference 'Framing Film – Cinema and the Visual Arts' held at the University of Winchester in 2009. The conference and book were made possible by support from the Faculty of Arts, University of Winchester. We would like to thank everyone who helped with the administration of this conference, in particular Lisa Simpkin and Jess Redway, and all the delegates who attended, and enabled it to be the success that it was. Special thanks go to the two Keynote Speakers, Professor John Pett and Professor Ian Christie (who is also a contributor to this volume).

We warmly thank the contributors to this collection for their valuable intelligence, energy and enthusiasm throughout the process of compiling and editing the chapters. We also thank all copyright holders who allowed us to use their images in the book and so illustrate the wealth of visual arts under discussion. We are very grateful to the team at Intellect, in particular Melanie Marshall for her kind and generous assistance over the course of editing this book, and we would also like to thank Wendy Toole who compiled the index, and Inga Bryden at the University of Winchester for her guidance. Above all else, we greatly enjoyed working with you, and together, on this project, so our thanks go to you all, and our families, for making it possible.

Introduction

Steven Allen and Laura Hubner

Films have always been inspired by the visual arts[1] and have in turn played a pivotal role in developing and framing directions in art, design and visual culture. Cinema's reliance on art and graphic design – for promotion, subject matter and aesthetics – is central to our understanding and appreciation of the medium. This book charts the intricate and diverse intersections between cinema and the visual arts and considers the cinematic experience as a discourse with adjacent art forms and graphic designs.

Since its inception, film's place among the visual arts has been debated at great length.[2] Less documented, at least until quite recently, is the interchange between film and the other visual arts, and it is the nature of this cross-pollination, not the validity of film as art, that this edited collection intends to frame. Recent scholarship has recognised the need to probe this interchange. For instance, Dudley Andrew et al., in the edited collection *The Image in Dispute: Art and Cinema in the Age of Photography* (Andrew 1997), have explored the change in status of images during the nineteenth and twentieth centuries, when visual culture incorporated photography, cinema and video. In her study entitled *Cinema and Painting: How Art Is Used in Film* (1996), Angela Dalle Vacche has looked at how film-makers have appropriated and positioned themselves in relation to pictorial sources, helpfully concluding that cinema is a dialogic medium. More recently, Susan Felleman, in *Art in the Cinematic Imagination* (2006), has contributed to the field by bringing a distinctively art historical angle to her study of artworks and artists within films. Other writers have focused on the exhibition space of the moving image, such as Catherine Fowler's (2004) insightful examination of gallery films to explore issues of time and framing and Maeve Connolly's (2009) thorough analysis of site and space in artists' film and video, providing a valuable enquiry into shifting exhibition structures.

To some extent drawing on this significant interdisciplinary trend, this book explores cinema in the context of traditional fine arts, such as painting and photography, but at the same time proposes a definition of the arts that permeates beyond this framework to include a variety of art and design forms. The central premise of this collection lies in bringing together texts from popular culture and high art, examining a broad range of visual arts and design as equally valuable codes of representation. Such an approach, based on a parity of cultural forms, has become a key aspect of film studies, influenced by other related disciplines such as media studies and cultural studies. A vital aim is to explore the formal and historical relationships between cinema and visual culture, taking an interdisciplinary approach based on close readings of how specific films use

the visual arts as well as analytical and interpretative discussions of commodified and industrialised design in respect of the cinema.

As the title *Framing Film* indicates, *film* is the initial impulse for this collection and the guiding medium for this interdisciplinary study. Chapters feature an international range of films, from early cinema through to contemporary media formats, and afford a synthesis of the textual, intertextual and extratextual. The book encompasses perspectives from academics working in film studies, art history and philosophy, plus creative media practitioners, making the study a dynamic exploration of the relationship between cinema and the visual arts which draws on a diverse set of theoretical and conceptual frameworks.

Framing within film involves the selection of both what to display and to mask, and concomitantly what to imagine. Framing can also imply the capturing, most often to enable scrutiny, of a specific representation, and in the context of the moving image, affords a reflection on choices of stasis and movement. In addition, a number of chapters in this volume consider the re-framing of images, or the appropriation of the cinematic, to use the visual elements in distinct cultural contexts, where meanings are revised or reinforced.

The connections identified in relation to the film texts, although diverse, gravitate towards certain themes that structure the book. Within these groupings, a variety of topics, films and contexts form the basis for exploring the convergences and distinctions between films and a range of visual arts, including posters, paintings, production design, the photo-novel, comic books and photography. These art forms range from commercial products to anthropological studies and so define a scope, if not the absolute boundaries, of connections that are made. Inevitably, it is not an all-inclusive list but involves analogue and digital media, oscillations between what might still be regarded as 'high' and 'low' arts, and contacts between the pictorial and the literary. In combination the chapters chart the complex mutual dependency of cinema and the other visual arts, and individually they establish artistically, culturally and historically specific interconnections.

The book is divided into four main parts: 'Intertextual Relays of Art and Design', 'Movement and Stasis', 'Paintings, Artists and Film' and 'Evocative Frames'. This clustering of topics helps to highlight the synergies across diverse texts and also serves to make these synergies more directly accessible. Part I begins the collection by taking a broad perspective on the interplay of the visual arts and cinema. Entitled 'Intertextual Relays of Art and Design', it considers the role of the visual arts in shaping cinematic design and narratives, as well as the various visual texts and products that are subsequently produced, both to service the economic and commercial needs of the film (promotional posters) and those that exceed these demands (when a film image becomes 'iconic', generating new associations and meanings beyond the film). The first two chapters set out ways cinema uses, and in some cases depends on, existing visual practices to function. Ian Christie charts the history of production design as he attempts to redress the neglect this important component of film-making has faced. While directors, writers, cinematographers and editors have frequently been celebrated for defining or authoring the look of a film, the production designer is more usually regarded as an appendage,

supporting the vision of others. Christie argues that, beyond its vague appellation, there is a largely uncharted lineage that stretches back beyond when production design became 'visible' via German cinema after World War I and reaches up to computer-generated imagery (CGI)-enhanced designs such as James Cameron's *Avatar* (2009). Collectively, we might understand these as acts of artistic 'worldmaking', which along with cinematography, sound and so forth enable film to not merely record but to be regarded as a visual art.

Ian Hague focuses on adaptations of comic books to explore cinema's relationship to the other arts. Interrogating Zack Snyder's film *Watchmen* (2009), a transposition to the screen of the DC Comics series written by Alan Moore and pencilled by Dave Gibbons, he sets out the complexities of converting the work. Applying Pascal Lefèvre's (2007) arguments regarding the 'Incompatible Visual Ontologies' of the two mediums, he asserts that both the 'silence' of comics and the layout design, which affords linear and non-linear engagement, are at odds with the cinematic. Hague concludes that the film, in spite of cinema's ability to capture the look of the graphic art form, is unable to replicate effectively *Watchmen*'s application of split narratives and the tension it generates between the whole page and the individual panels or single images within it.

The latter two chapters of Part I focus on (re)interpretations of the films in relation to other visual arts. Dorota Ostrowska traces the interplay between cinema and poster graphic design. Considering the political and cultural context of Poland after World War II, Ostrowska pinpoints a flourishing of the visual arts, with both cinema and posters given the status of art as a result of the cultural politics of the socialist state. Of particular concern is the representation of French films at this time, which were imported in large numbers and became the popular cinema for many Polish cinema-goers. Ostrowska argues that the posters that complemented these films, and others, became part of a gallery of the streets in a country that recognised the educational and political value of visual culture; they thereby did not conform to capitalist demands centred on consumption but placed an emphasis on graphic display. Looking at how the posters reject the purely representational, she shows how they interpret the mood of the films, so that even when the female star is deployed, the design fragments or distorts the image to the will of a graphic imperative.

Rounding off Part I, Laura Hubner considers a range of intertextual relationships between one film, *The Shining* (Stanley Kubrick 1980), and the visual arts. Hubner's focus on what has become a virtual synecdoche for the film, Jack Nicholson's face thrust between the shards of a shattering door, leads her to trace its function and position in the film in relation to its deployment in instances elsewhere, which range from promotional graphic designs (posters and DVD covers), through reinterpretation as ephemera (lighters and hot water bottle covers), to the personally artistic (paintings and tattoos). The re-framing of this iconic image, which takes the form of homage as well as parody, is possible, Hubner argues, because the source, the stilled instant in the film, embodies an uncanny fusion of the comedic and the horrific.

Part II, 'Movement and Stasis', examines cinema's long-held affiliation with the 'static' arts and photography, looking at how cinema incorporates and references photography and how the use of photography in turn reflects and transforms conceptions of cinema, adding a further dimension to debates about still-movement relationships. Steven Allen explores the interplay between stasis and movement by examining how Donald Thomson's ethnographic photographs are used, re-enacted and invigorated by cinematic context in *Ten Canoes* (Rolf de Heer and Peter Djigirr 2006), an Australian fiction film inspired by the photographs. Allen reflects on stasis within this context in relation to and as distinct from the photographic form, suggesting that the specific utilisation of the image in *Ten Canoes* functions to revise cultural perceptions of history and to narrativise pastness. Allen argues that the film's layers of uncertainty challenge the assuredness (of knowing and seeing history) that is often at the heart of traditional anthropological and ethnographic film-making.

Stillness and movement are also central concerns for Tina Kendall, who focuses on the DVD format of *Ratcatcher* (Lynne Ramsay 1999), with specific reference to the stills gallery feature included on the Pathé disc in the United Kingdom and the Criterion disc in the United States. Kendall argues that the film's insistence on the intermedial relays between images helps reframe perceptions of the relationship between 'old' and 'new' media. The DVD format provides a fresh and unique form of visibility to the film's wider narrative and aesthetic interest in the still-movement relationship, insisting on an experience of the uncanny that is given renewed significance in an era of digital spectatorship. On a more general level, Kendall suggests that ontologically DVD's temporality and materiality are fundamental in rethinking the ways that stillness and movement have been understood in film theory.

Matilde Nardelli draws attention to the elaborate and mutually dependent relationships that have emerged between print and cinema, focusing on the ascendance in popularity of print media alongside cinema, looking at examples including post-war photo-novel magazines and 1960s artists' books. Nardelli asserts that while the print publications – which might be conceived of as a composite of photography and 'book' – can to some degree be seen to represent cinema or even as a type of cinema, they can also transcend and transform the cinema's technological apparatus, by turning the notion of cinema into something tangible and portable. Indeed, she suggests that cinema is *re*-materialised via the illustrated bound page (which clearly lacks the movement so distinctive of cinema) to involve the reader/viewer in unique processes of physical movement and narrative engagement.

Part III, 'Paintings, Artists and Film', takes as its central concern one of the most frequently commented on relationships between cinema and the other visual arts. The chapters are knowingly positioned within these debates and recognise the familiarity of cinema's textual and narrative concerns for painterly works of art and their creators. An overlapping acknowledgement in the three chapters is how the film-makers who are the focus of attention in the respective studies (Carl Theodor Dreyer, Steve McQueen

and Martin Scorsese) can, because of their formal preoccupations, be concomitantly associated with an artistic sensibility that emboldens them to the status of auteur. While Leighton Grist's chapter is the only one that takes the correlation as a primary line of investigation, a tone of the artist as legitimating figure for the film director inflects them all. Nonetheless, they each propose quite distinct lines of investigation, whilst sharing an impulse to rethink simplistic or familiar formulations of their director's work and its relationship to paintings and other works of art.

David Heinemann explores the function of both the artist and the artist's work in his chapter on two films by director Carl Theodor Dreyer which, despite being made four decades apart, share significant formal and thematic preoccupations. Examining *Michael* (1924) and *Gertrud* (1964), Heinemann sets out the decorative and narrative functions of paintings and *objets d'art* in the films, proposing that art and artistic creation serve to channel feelings of love. Analysis of Dreyer's tableau style and the posing of characters in relation to works of art reveal a thematic concern for the conflict between object and subject, predetermination and free will, which are seen as embodying the dislocations of the human soul. The relationship between the economic or cultural value of art and its ability to act as an emotional and revelatory conduit subsequently comes to the fore, with the films themselves offering a similar tension between emotional engagement and recognition of their artifice.

In her chapter on Steve McQueen's *Hunger* (2008) – a film centred on the hunger strikes in the Maze prison in Northern Ireland in 1981 – Toni Ross is not concerned with a diegetic artist but the artistic pull that shapes the film. Noting that McQueen's film was informed by, and has been interpreted through, the painterly influences of Velázquez and Goya, Ross moves away from these artists to advocate a profitable link to nineteenth-century realist art. Considering the nature of this realism via art criticism, Ross suggests it functions as a democratic aesthetic whilst the artistic power of the film should not be limited to its visual component but should be perceived via its multi-sensory function or haptic realism. Through detailed analysis of the use of close-ups, framings and the interplay between sound and image of everyday events, parallels to the textuality of the paintings of German artist Adolph Menzel are produced; ultimately, according to Ross, the political significance of the film arises from a visceral experience of Bobby Sands's death, which relies on the phenomenal immediacy of visual art.

In Leighton Grist's chapter we return to the depiction of artists. Exploring the role of such figures (and the visual arts more generally) in Martin Scorsese's films, Grist rejects a biographical interpretation to assert a resolutely materialist view of the auteur. Initially centred on the 'Life Lessons' segment of *New York Stories* (1989), it is argued that a narrative privileging of modernism (against postmodernist practices) works to validate Scorsese's own film-making, a process traceable in his other films as his mode of film-making became marginalised as Hollywood embraced high-concept cinema.

Part IV, 'Evocative Frames', the final section of this book, focuses on the emotional and aesthetic frames evoked by the parallels and relationships between cinema and

visual art. With detailed reference to the work of North American artist Edward Hopper (1882–1967) and a range of applicable films, David Morrison traces the similar methods employed in painting and cinema to convey the emotion of loneliness. Strategies for evoking loneliness include more general qualities of blankness, stillness and emptiness alongside more specific tropes, from the downward gaze and the gaze from the window through to the isolation of figures within the setting and frame. Applying Torben Grodal's (2009) 'bioculturalist' approach Morrison explores the recognisable ways of communicating loneliness across different cultures and film-making traditions. While Morrison's focus here is on the particular emotion of loneliness, it opens up the broader possibility for ascertaining a much wider aesthetics of feeling.

The framing devices of cinema as an art form to evoke the horror and loss of war form the focus for Dennis Rothermel's study of *Hiroshima, mon amour* (Alain Resnais 1959), *Waltz with Bashir* (Ari Folman 2008) and *Alexandra* (Alexander Sokurov 2007). Rothermel applies Judith Butler's (2009) exposition of grievability and precariousness to look at how violence can be brought back home to be seen for what it is, without carrying the frame of war that conceals and complicates its meaning. Rothermel demonstrates the way that impressions of personhood, worth and honourable sacrifice, driven by the frame of war that a nation adopts, can be reframed by the poetry of filmic images to generate new meanings and understandings of the (universal) human experiences at the heart of war. Rothermel puts the spotlight on the critical concept of 'framing', which is central to this volume's concerns. In addition, through close analysis of these films, the chapter explores and carefully unveils the material and aesthetic qualities of the images themselves, together with their specific exposition, from photographic and documentary imagery through to the drawings that are used to 'animate' the soldiers' voices in *Waltz with Bashir*.

Bringing Part IV to a close, and the collection as a whole, Judith Buchanan examines the associations between early cinema (1895–1913) and fine art, investigating the ways that early screen frames employed decorative devices to reference, emulate and aspire to be (aligned with) fine art. Buchanan suggests that by courting the look and feel of painting, by claiming artists, studios and paintings as its own and by referencing identifiable paintings, early cinema articulated its glorious impurity. The study explores early cinema's attitude to conventional artists, arguing that the illusory animations from the still to the moving image depicted in numerous films reflected self-consciously on the processes of cinema itself. We see in Buchanan's account of the emerging film industry a lively display of intermedial collaboration and playful competition with fine art, which is evocative of a rich and dynamic relationship between cinema and the visual arts more broadly.

What follows then is a collective attempt to comprehend the diverse interplay between cinema and the visual arts through traditional and new appreciations of film and our contact with its imagery. Through the various frames that exist around film, we explore the effects of, and influences on, the fields of painting, production design, photography, graphic art and the wider milieu that constitute our rich, cinematically informed, visual culture.

Bibliography

Andrew, D. (ed.) (1997), *The Image in Dispute: Art and Cinema in the Age of Photography*, Austin: University of Texas Press.

Arnheim, R. (2006), *Film as Art: 50th Anniversary Printing* (1957), Berkeley: University of California Press.

Butler, J. (2009), *Frames of War: When Is Life Grievable?* London: Verso.

Connolly, M. (2009), *The Place of Artists' Cinema: Space, Site and Screen*, Bristol: Intellect.

Felleman, S. (2006), *Art in the Cinematic Imagination*, Austin: University of Texas Press.

Fowler, C. (2004), 'Room for Experiment: Gallery Films and Vertical Time from Maya Deren to Eija Liisa Ahtila', *Screen*, 45:4, pp. 324–43.

Grodal, T. (2009), *Embodied Visions: Evolution, Emotion, Culture, and Film*, New York: Oxford University Press.

Lefèvre, P. (2007), 'Incompatible Visual Ontologies: The Problematic Adaptation of Drawn Images', in I. Gordon, M. Jancovich and M. McAllister (eds), *Film and Comic Books*, Jackson: University Press of Mississippi, pp. 1–12.

Perkins, V.F. (1990), *Film as Film: Understanding and Judging Movies* (1972), Harmondsworth: Penguin.

Vacche, A.D. (1996), *Cinema and Painting: How Art Is Used in Film*, London: Athlone.

Notes

1. For instance, the Lumière films made use of the rules of perspective that had dominated Western painting since the sixteenth century.
2. Although these are well-rehearsed debates, familiar to film scholars, it is worth recalling that key contestations included cinema's mechanical properties and ('lowly') cultural standing, which in turn, V.F. Perkins (1990: 10) indicates, led to an 'obsession with status' by cinema's partisans via their quest to define it as art. In the 1930s, Rudolf Arnheim's formalist approach, whilst recognising the links to photography, sought a specificity for cinema that exceeded 'the feeble mechanical reproduction of real life' and from which could be derived 'the principles of film art' (2006: 34).

Part I

Intertextual Relays of Art and Design

Chapter 1

Crafting Worlds: The Changing Role of the Production Designer

Ian Christie

It is not generally recognised by the public that the most genuinely creative member of a film unit, if the author of the original story and screenplay is excluded, is the art director.

– Michael Powell (1986: 343)[1]

My aim is to re-write a script in visual terms; to reflect dramatic structure through the design elements at my disposal – architectural space, line, colour, pattern, repetition, contrast.

– Richard Sylbert (interviewed in Ettedgui 1999: 40)

P roduction designers do not share the celebrity status that can extend from directors to writers, cinematographers and composers, within the family of professions and crafts that combine to create films. Few film-goers or critics are likely to be able to name leading designers, or recall their main credits, as Michael Powell noted in his autobiography. Richard Sylbert, quoted above, who designed films for Elia Kazan, Roman Polanski, Warren Beatty and Brian De Palma, described 'production designer' as 'a title searching for a definition'. Unlike cinematographers and even costume designers, Sylbert argued, where the title reflects some identifiable responsibility, a production designer's contribution can range from 'renting chateaux or stately homes' – which he considered undeserving of the title – to taking responsibility for almost every aspect of what appears on screen, other than the actors (Ettedgui 1999: 39).

Sylbert might have added that many of the other department heads within film-making have the advantage of appearing on set, like cinematographers beside their camera, or editors, seated in what is obviously their technical domain. But by necessity, production designers are rarely on set at the time of shooting, since they are invariably working on the *next* set, leaving their art directors, set decorators and property masters to deal with the detail in front of the camera. If the production designer has a traditional professional image, it is standing by the drawing board, preparing the plans that will finally translate a film's script into visual terms. But even this tradition is changing, as film design is increasingly created on-screen with the new digital tools of three-dimensional visualisation and compositing. And with changing technology, as in so many branches of film-making, there is a further level of automation implicit in the term

'CGI' (computer-generated imagery), often invoked as if it were merely a service.[2] But even if this is *produced* with computer software, it also requires – and invites – a degree of design that is as autographic as painting. At a time when a film's 'world', however fantastic, can be unified as never before, we surely need to have a better grasp of what production design means.

The central irony (or perhaps paradox) of film as a visual art lies in the persistent belief that film essentially records the visible world, when it is also regarded as dreamlike or unreal. Early in the career of 'animated photographs', there was a widespread belief that film could never be 'art' because it mechanically reproduced what was already visible.[3] Later, between the 1930s and 1950s, influential writers on the aesthetics of cinema would subtly reinforce a belief in the intrinsic 'realism' of film. Both Rudolf Arnheim (1958) and André Bazin (1967) based their defence of cinema's artistic potential on the ability of the photographic medium to reproduce reality. For Bazin (1967: 14–15), photography is above all able to 'lay bare the realities', providing the 'natural image of a world we neither know nor can know'; and, in one of his most famous phrases, 'cinema is objectivity in time'. Now there is certainly much more to Bazin's (and Arnheim's) aesthetics than a naive realism. But I would argue that the cumulative effect of such canonical writings, especially because of their linkage with Italian Neorealism and with the location-based films of the *nouvelle vague*, has been to privilege a view of cinema as optimally realist – a recording of whichever portions of the visible world have been selected to appear on screen, ignoring what may have been created solely to register as an image of 'reality'.

Another unfortunate, but persistent, extrapolation from Bazinian aesthetics has been the distinction between a cinema of documentary realism and of studio-based 'fantasy' – Lumière versus Méliès. Despite Godard's deft reversal of this dichotomy in *La Chinoise* (1967) – where a character argues that the Lumières offered a fantasy of the real, while Méliès's films deconstructed any sense of reality – the idea of a fundamental distinction running through cinema history has persisted (see Sarris 1968: 108). Yet every spectator, and surely every critic or historian, knows that cinema is built on visual artifice and not only when it is at its most obviously fantastic. Dante Ferretti, who worked initially with Pasolini and Fellini, before becoming closely linked to Scorsese, recalled an early 'invaluable lesson about how to handle realism' from Fellini. Having designed a set that included a sink, and added visible pipes, he was told to 'lose the pipes'. For Fellini, it was important that such details would not 'take you out of the dream and return you to reality':

> Everything on our sets was exaggerated or distorted – not just in the set design, but also in the furnishing and props: a chair was never a normal chair, but always a little too big. (Ferretti in Ettedgui 1999: 51)

This is, of course, a lesson that could be drawn from the history of caricature or illustration. And rather than accept a genealogy of film design confined solely to the era of moving pictures, I want to argue that it is essential to take a much broader view, based on seeing

cinema as merely a phase in what Laurent Mannoni (2004: 41–52) has shown to be a long history of 'the art of illusion'. In Europe, that history began with the magic lantern, peep shows and shadow theatre, and continued with the profusion of new optical devices and entertainments of the nineteenth century – while the earlier traditions also continued, as they do today.

Film-making has drawn on many traditions of visual display since its earliest days, borrowing from stage design, painting and photography, according to the needs of the story and the storyteller. One of the earliest accounts based on this long view is Sergei Eisenstein's remarkable essay 'On Stereoscopic Cinema', written in 1947–48, although not published in English until 1970, and then only in abbreviated form.[4] Here, prompted by the appearance of the first Soviet stereoscopic film, Eisenstein pointed to the prevailing tendency towards enhancing 'depth' in recent films – very

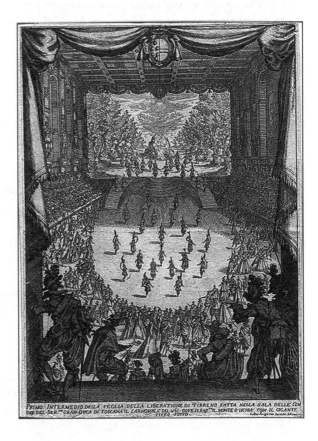

Figure 1. Engraving of an Interlude staged at the Medici court in Florence, 1616, by Jacques Callot; cited by Sergei Eisenstein in his discussion of baroque theatre as the forerunner of 'staging in depth'.

much as Bazin would in his essays of the early 1950s – before reaching back into the history of theatre and spectacle in order to demonstrate a long-standing urge to break down the barrier between performer and audience and include the latter in the performance. Drawing his evidence from such diverse sources as the sixteenth-century court masque, the baroque theatre, the Japanese Kabuki theatre and the early Soviet revolutionary theatre in which he had participated, Eisenstein argues that there has been a constant search for ways to immerse the spectator, which cinema took up and intensified during its first 50 years. In this perspective, stereoscopic cinema appeared an entirely logical next step, already anticipated in the 'depth' staging of Wyler, Welles and Hitchcock in the 1940s.

Leaving aside the relevance of Eisenstein's prehistory of stereoscopy for the renewed popularity of 3D, his argument reminds us that cinema has long made use of 'good old theatrical traditions' to bridge the gulf between spectator and spectacle. This provides a useful corrective to the widely held view in the 1930s that early film-making had been little more than 'the photography of bits of dramatic action ... without the technique of cinematography ever being handled by an artist' (Carrick 1938: 9). This statement appears in what was probably the first book on film design, written in 1938–39 by Edward Carrick, a practising art director who had also started a film school and was understandably concerned to establish the professional status of his craft. From what little was known of early film at this time, Carrick's disdain is understandable. But after the rediscovery of early cinema that began in the 1980s, we should be able to begin a long-overdue reassessment of the first decades, before there was a designated 'art director' or designer – or indeed any of the modern distinctions of role.

<p style="text-align:center">* * *</p>

Early moving picture entertainment in the mid-1890s offered much less of a break with previous forms of representation than has often been implied by film historians. Many of its conventions and subjects were in fact carried over from the variety stage and from other contemporary practices such as the posing of 'life models' for the dramatic tableaux of stereoscope pictures, lantern slides and eventually postcards.[5] During the later nineteenth century the magic lantern created a vast repertoire of literary, theatrical and even opera slide-sets, anticipating, by some five decades, the range of subjects that cinema would tackle. We should therefore not be surprised that early producers were quick to see the potential of representing already popular subjects. The issue was not whether the new medium of film was 'adequate' to portraying, say, a full-scale novel or opera – which films lasting only a minute or two plainly could not do – but rather that the new device could demonstrate its novel powers by re-presenting acknowledged cultural icons. This process has been persuasively theorised by Jay Bolter and Richard Grusin (1999) as 'remediation' in their study of digital media.

Diffusing prestigious contemporary works to far-flung audiences was also a mission for the new medium. In 1899, British Biograph filmed scenes from Beerbohm Tree's London production of Shakespeare's *King John* under the promotional title 'A Scene – King John – Now Playing at Her Majesty's Theatre', billing this exclusive as 'taken with all the scenery and effects of the original production', which indicates that these theatrical features were considered an attraction (Brown and Anthony 1999: 272). Similarly, Edison would go to great expense to film scenes from a 'runaway' Metropolitan Opera production of Wagner's *Parsifal* in 1904, using the original stage sets.[6]

When Robert Paul undertook a Dickens adaptation in 1901, *Scrooge, or Marley's Ghost*, this groundbreaking six-minute condensation of *A Christmas Carol* in thirteen scenes closely followed a stage adaptation that had long been popular. Like all Dickens's work, the original story had appeared with illustrations, establishing a visual tradition from the outset, which the filmed 'remediation' would extend, with the added benefit of photographic supernatural effects as the ghostly apparitions of his past appear to Scrooge.[7] The catalogue illustrations that survive from earlier Paul films (now lost), such as *The Last Days of Pompeii* (1900) and *The Hair's Breadth Escape of Jack Shepard* (1900), show that this pioneer studio was already experimenting with the kind of dramatic effect created on stage in 'sensation melodrama', using painted cycloramas with built foreground structures to create such popular subjects as Pompeii's destruction and scenes from the life of a notorious outlaw.

Figure 2. Early set design, influenced by stage and il-lustration tradition: *Scrooge, or Marley's Ghost* (1901).

Better known than these British films, Georges Méliès's exuberant trick-work and pantomime fantasy have tended to distract from the sheer variety of his scenography. While this undoubtedly started from the conventions of the intimate 'magic theatre', such as his own Théâtre Robert-Houdin, and the more elaborate musical comedy of the Folies Bergère, it also quickly developed to include the range of pictorial effects required by his expanding production repertoire. We can trace a rapid evolution from the stage setting of *The Vanishing Lady* (1896) and other early conjuring subjects to the 'arch' feature that frames many of his more elaborate 'transformation' films of 1901–02,[8] to the later multi-scene works such as *A Trip to the Moon* (1902) and *The Impossible Journey* (1904). And amid these, Méliès also pioneered the creation of 'documentary' settings, for such films as his *Dreyfus Affair* (1899) and the notorious *Coronation of Edward VII* (1902), a carefully faked account of the Westminster Abbey ceremony commissioned by Charles Urban and filmed in Paris.[9]

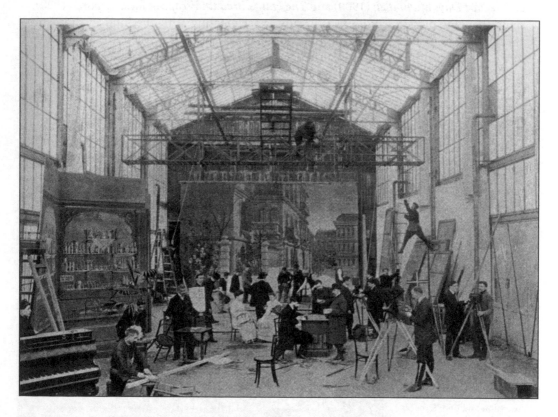

Figure 3. The Pathé studio at Vincennes c. 1910, showing partial sets for interior scenes.

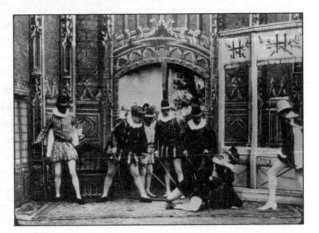

Figure 4. The *film d'art* movement, launched with *The Assassination of the Duc de Guise* (1908), emphasised authentic settings and costumes.

Méliès was not the only French producer paying close attention to scenic design during the early 1900s. Both Pathé and Gaumont developed studios with standing sets, which were skilfully re-dressed for the interiors of their comedy series and interspersed with use of the surrounding Parisian suburban streets. There may not have been an 'artist' or designer involved, but no viewer today could doubt that these films were efficiently organised to portray the typical domestic settings required for popular comedies that would make Pathé and Gaumont internationally successful during the years before 1910.

These routine building blocks for early cinema programmes did not aim to draw attention to 'design': their appeal lay in performances and stories, for which only adequately plausible settings were necessary. However, developments that began around 1908 would introduce – or perhaps reintroduce – the idea of historical decor and costume as an attraction in its own right. In France, the Societé Film d'Art produced *The Assassination of the Duc de Guise*, based on a famous incident in French sixteenth-century history, with actors from leading theatres and a music score by the prestigious composer Camille Saint-Saens. Much discussed in the histories of cinema that began to appear in the 1930s, the *Duc de Guise* has often been presented as a 'wrong turning' in cinema's early development, emphasising 'theatrical' trappings at the expense of the purely filmic (see Bardèche and Brasillach 1938; Rotha 1930). But while there would certainly be many excessively ornamental and over-costumed 'literary adaptations' in the years to come, it can equally be argued that the *film d'art* movement marked a vital stage in cinema's creation of believable historical worlds and so opening up a wider range of fictional subjects and appealing to a vastly increased audience.

Inspired by early examples of the *film d'art*, which were widely circulated by Pathé, film-makers outside France began to experiment with literary classics and historical settings that reached back to classical antiquity. Italian producers, in particular, saw an opportunity to capitalise on their cultural tradition. Films of popular operas, such as *La Traviata* and *Rigoletto* (both 1908), were soon followed by the great Greek and Roman stories that already had universal appeal: *Nero* (1909), *The Fall of Troy* (1911), *The Last Days of Pompeii* (1912), *Quo Vadis?* (1913) and finally *Cabiria* (1914).[10] Crowning five years during which Italian epics became the most prestigious and commercially successful films being shown in many countries, Giovanni Pastrone's *Cabiria* set a new standard for spectacle, with its elaborate architecture and sculpture, especially for the Temple of Moloch, and massed crowds of extras, enhanced by dramatic chiaroscuro lighting and a moving camera. Among those who recorded their impressions was the future playwright Eugene O'Neill, still a student at Harvard, who described *Cabiria* as 'simply stupendous', before listing its most spectacular scenes:

> Hannibal's army crossing the Alps, the destruction of the Roman fleet at Syracuse by the reflecting mirrors of Archimedes, the Temple of Moloch at Carthage, the desert expedition of the King of Cirta, the siege of Carthage by Scipio – all of these are done with the grimmest realism and are blood-stirring in their gripping action. (Letter from O'Neill to Beatrice Ashe, 7 October 1914, in Hayes 2001)

Such responses make clear that it was the scenic scale and variety of *Cabiria*, combining studio-built sets with location filming, which made such an impression – its ability to articulate the 'adventure world' of epic that Mikhail Bakhtin (1981: 84–129) would later identify in his account of the development of fictional forms. But despite this achievement, none of *Cabiria*'s designers are known by name!

The preceding decade had been one of great achievement in stage design, with Adolphe Appia, Gordon Craig and Max Reinhardt producing a powerful body of theory and practice that pointed towards the combination of visual and plastic elements into, in Craig's 1907 phrase, 'a unified stage picture' (2008: 1–26). The first signs of a cross-fertilisation between vanguard theatre and film were also appearing. Reinhardt ventured into film-making as early as 1910, although without the success he enjoyed in theatre, and another of the period's great producers, Vsevolod Meyerhold, directed two films before 1917.[11] Yet the absence of any known names associated with the art or construction departments of cinema during this period seems to have led many to assume that there *was* no 'art direction', which is manifestly absurd.

In many cases, we can guess that the director would effectively have been the designer, and in a few this can be confirmed. We can assume that the Russian Yevgeny Bauer designed at least his early melodramas for Khanzhonkov between 1913 and 1917, having trained as an artist and photographer, and entered cinema by designing a lavish historical pageant in 1912.[12] The controlled intensity of his *After Death* and *Daydreams* (both 1915),

with their elaborately furnished *art nouveau* interiors punctuated by dramatic tableau effects, clearly points to a single organising vision. And we know that Enrico Guazzoni scripted, directed and edited as well as designed his impressive *Quo Vadis?* (1913), which was the immediate precursor of *Cabiria*. Guazzoni was described by Leon Barsacq (1976: 15) as 'a painter and stage designer, who grew up in the Italian pictorial tradition' and is credited with being the first Italian director to build his sets in a studio, rather than shooting on location among the 'remains of antiquity'.[13] Although Barsacq could shed no further light on how Guazzoni and his colleagues made the transition from purely pictorial representations of the ancient world – familiar from painters such as Jean-Leon Gérôme and Lawrence Alma-Tadema – to the three-dimensional worlds that Italian film-makers created around 1912–14, he maintains that this 'can be explained only by the contribution of architects, who replaced stage designers and scene painters, and by the large-scale use of decorative sculpture … [a speciality] of talented Italian craftsmen' (Barsacq 1976: 18). Architectural training, combined with a knowledge of decorative techniques, would henceforth become the basis of art direction.

According to legend, and probably also history, it was the example of *Cabiria* that inspired D.W. Griffith to offer competition with his massive Babylon set for *Intolerance* (1916); and for this we have what is probably the earliest first-hand account of a designer and art department at work, provided by Karl Brown, who was a young camera assistant on that film. 'Somebody had to design the show', Brown (1976: 150) wrote, before identifying Griffith's choice for the role, Walter L. Hall, who meticulously planned the vast structure that took shape in Hollywood for the Babylonian episode of *Intolerance*. Brown explained in awestruck detail how Hall's faultless drawings were squared up to be executed by the construction workers. Griffith's film has survived, and the Babylonian spectacle still impresses us. But similar ambition was at work in film-making elsewhere. Very few British features from the 1910s are extant, and one of those lost is Cecil Hepworth's version of Dickens's *Barnaby Rudge*, set during the Gordon riots of the 1780s. A British trade paper wrote admiringly of the Old London set, in terms that suggest the writer visited it during filming:

It is a wonderful piece of stage architecture, complete in every detail, and the illusion of solid realism, when viewed from the proper aspect, is quite perfect. The paved sidewalks, the cobbled roadway, the doors with their link-holders and extinguishers, the glazed windows with their neat white curtains – every tiny point has been remembered … Behind the streets, moreover, there is a magnificent reconstruction of Newgate Prison – an immensely lofty structure, grey, drab, and forbidding, with a sinister gallows before its outer wall. (*The Bioscope*, 24 September 1914, p. 1160, in Low 1948: 54–55)

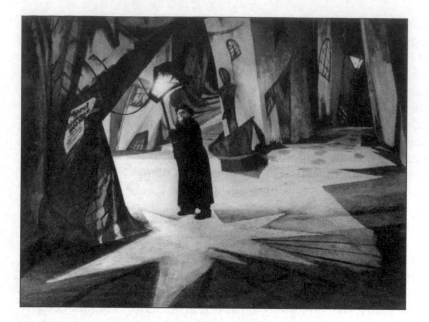

Figure 5. Jagged 'expressionist' settings for *The Cabinet of Dr Caligari*
(1919), designed by Hermann Warm, with the painters Walter Reimann
and Walter Röhrig, made film design 'visible'.

The sets were credited to Warwick Buckland, who is known today only as a long-serving director, but would seem to have been also one of Britain's earliest film designers – suggesting this role was recognised, at least within the film business.[14]

What made film design 'visible', and controversial, was German cinema after World War I and in particular one film: *The Cabinet of Dr Caligari* (1919). To represent what is eventually revealed as a story told by a madman, the film's designers created a series of jagged screen-pictures, using angled planes and painted geometric shadows. The effect was hailed as 'expressionist', referring to the then current avant-garde movement among German poets and painters; and as a number of later German films further developed and refined this intense stylisation, 'Caligarism' became a hotly debated aesthetic issue. German 'expressionist' cinema had created a powerful, often overbearing, sense of fantastic or highly subjective 'worlds'. *Stimmung* (mood) was made all but palpable through its use of chiaroscuro lighting and boldly geometric sets.[15] Stylisation of a

different kind was also a feature of avant-garde French cinema in the 1920s, leading to the films of Jean Epstein, Germaine Dulac and others being labelled 'impressionist', as if to counterbalance Germany's 'expressionism', while there are also visible traces of Cubist and art deco influences.

For some, the association of cinema with contemporary culture heralded its coming of age, and the mid-1920s successors to *Caligari*, films such as Friedrich Murnau's *Faust* (1926) and Fritz Lang's *Metropolis* (1926), made use of a much wider range of stylisation, reflecting their directors' backgrounds in visual art and architecture. For other critics, however, such attempts to 'pre-stylise' the film image through design amounted to 'dodging the problem' of how to 'manipulate and shoot unstylised reality in such a way that the result has style' (Panofsky [1934] 1974: 169).[16] This verdict was by the distinguished art historian Erwin Panofsky, who declared in his influential essay on cinema that 'the medium of the movies is physical reality as such … material things and persons' ([1934] 1974: 169). Panofsky compared the cooperative work of film-making with the building of the medieval cathedrals, casting the director as 'architect in chief', but strangely omitting from his list of film technician roles any mention of the art department. The logic of this somewhat conservative position would seem to be that art direction should confine itself to providing more or less realistic settings, against which the other artists and craftsmen will create what Panofsky believed was 'not often good art, but besides architecture, cartooning and "commercial design", the only visual art entirely alive' ([1934] 1974: 152).

<div align="center">* * *</div>

The main thrust of Panofsky's message in 1934 was that cinema had already developed greatly since its 'jerky beginnings' and would no doubt continue to add new technical resources, while still remaining essentially a form of visual storytelling.[17] Synchronised sound and colour might seem disruptive of an earlier equilibrium, but they would be assimilated. In fact, the 1930s saw the consolidation of the studio system, with its specialist departments and highly organised workflow ensuring the regular delivery of films that met at least a minimum standard. The art department was in many ways central to this process, since without the required sets, shooting schedules could not proceed smoothly and stars' popularity would be compromised. Hollywood studios' art departments employed vast numbers of specialised staff, organised hierarchically under a chief designer who could maintain the distinctive 'studio style'. One such department head, Cedric Gibbons, was chief art director at MGM for 32 years, between 1924 and 1956, overseeing some 1500 films and no doubt helping to shape certain norms of design and decoration. We might therefore think of the MGM or Warner 'look' as a 'world' maintained across films of similar genre from the same studio.

An equivalent process of delegated control was in force in smaller studios and also within the production of complex films. At Alexander Korda's new Denham Studios

Figure 6. Vincent Korda's futuristic decor for *Things to Come* (1936).

in England, his brother Vincent Korda reigned as chief art director, not only creating authentic period decor for historical films such as *The Private Life of Henry VIII* (1933), *Rembrandt* (1936) and *Fire Over England* (1937) but also coordinating the work of many others on elaborate projects like the futuristic *Things to Come* (1936) and the fantastic *Thief of Bagdad* (1940). Similarly, Alfred Junge, who had served his apprenticeship on German 'expressionist' films, would head the art departments at a succession of British studios, while also acting as production designer on a number of key films, notably for Michael Powell and Emeric Pressburger. The title 'production designer' is itself a product of the 1930s, and is generally believed to have been created by David Selznick for William Cameron Menzies, in recognition of his contribution to overseeing *Gone with*

the Wind (1939), which had at least four directors. During the 1940s, it gradually became the standard title for the head of a film's art department, with 'art director' reserved for those working under the production designer, often supervising construction and being on set during shooting.

If the location-based naturalism that attracted wide attention in the 1940s and 1950s seemed to renounce 'design', there was also a very different production trend during the same period that could be characterised as 'total cinema' – in American musicals, from *Hellzapoppin'* (1941) to *The Bandwagon* (1953), the British films of Powell and Pressburger, from *Black Narcissus* (1946) to *The Tales of Hoffmann* (1951) and the two-part *Ivan the Terrible* of Eisenstein (1944–46). These stylised, highly artificial worlds, usually created entirely within the studio, were the successors of the spectacular settings of the 1920s and the 'big white sets' that established the dominance of the Hollywood musical in the 1930s. They were also often 'reflexive', encapsulating other forms of spectacle (stage shows, ballet, liturgical drama and court entertainment in *Ivan*, film-making itself in *Sunset Boulevard*, 1950, and *Singin' in the Rain*, 1952). Charles and Mirella Affron (1995: 157) identify these as the climax of a category of film design they term 'set as artifice', in which the setting creates a wholly fabricated world geared to the 'self-reflexive realities of performance'.[18] We might indeed find an equivalent to these heavily coded artificial worlds outside the history of film in the Jacobean court masque, as developed by Ben Jonson and the architect-designer Inigo Jones, with its elaborate stage machinery and emphasis on audience participation.[19] We might also note that recent spectacular cinema has returned to this theme, making use of enhanced CGI in such films as Terry Gilliam's *The Imaginarium of Doctor Parnassus* (2009) and James Cameron's *Avatar* (2009) in order to create immersive spectacle, partly as a vehicle for reflecting on the seductive power of illusion.[20]

<p style="text-align:center">* * *</p>

During the 1960s, many kinds of film-making began to move out of the studio, shooting on location for a variety of reasons. The directors of the New Waves that paralleled France's *nouvelle vague* were generally impelled by a search for greater authenticity – whether in the streets of Paris (Godard, Chabrol, Truffaut, Rivette), Nottingham and Salford (Richardson), Parma (Bertolucci) or New York (Coppola, Scorsese).[21] Cheapness was also a concern, as was a lack of familiarity with studio practice among many of these novice directors. Other film-makers, long steeped in the studio tradition, were keen to break away from this and inject a new sense of the exotic into their films. Sergio Leone, for instance, had worked extensively on ancient world 'peplum' films, based at Cinecittà studio in Rome, before embarking on the 'spaghetti westerns' starring Clint Eastwood that would create his reputation. These were in fact largely filmed on Spanish locations that could represent the Mexico-Texas border country. Another refugee from the studios

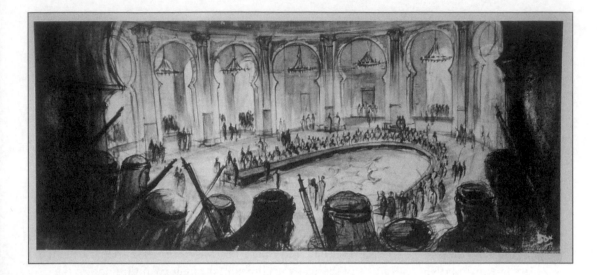

Figure 7. One of John Box's designs for the Arab council of war in
Lawrence of Arabia (1962), filmed in Seville. Courtesy of the John Box
collection in BFI Special Collections with the permission of the Box
family and BFI.

was David Lean, most of whose films had been studio-based, with some location shooting,
until he made *The Bridge on the River Kwai* entirely in Sri Lanka in 1957.

Having discovered what filming on location could bring to a film, Lean subsequently
tried to work as fully as possible in the field. For *Lawrence of Arabia* (1962), he based
himself in the Jordanian desert for months and was only persuaded, with difficulty, by
the film's production designer, John Box, to move to Spain in order to find settings for the
non-desert scenes. The script included sequences set in Cairo, Jerusalem, Damascus and
Aqaba, none of which could be filmed in these locations in their modern state. Box found
a solution in Seville, especially in the group of buildings erected for the 1929 Spanish-
American exposition, which were 'Moorish' in style and could be dressed to represent
various Middle Eastern cities. Although not 'authentic', these provided an architectural

framework for Lean to counterpoint the desert landscapes that he identified as central to the film. But even when in the desert and close to actual places that Lawrence described, this 'eyeball stretching' terrain also needed careful preparation for filming (John Box in Christie 2009: 54). While planning a crucial scene where Lawrence meets the Bedouin who will become his closest comrade in arms, Box was worried about the lack of 'concentration' in the featureless expanse of the desert. By adding barely visible patches of differently coloured sand and a line of camel tracks, he was able, almost subliminally, to create enough focus for the actors and for the final image of a camel and rider slowly approaching an oasis.

Lawrence of Arabia undoubtedly conveys an almost physical sense of the Jordanian desert and what it meant to the historical Lawrence, in contrast to his often bruising encounters with British officers and diplomats. But it does so through wholesale *in*authenticity: nowhere that is seen in the film, apart from St Paul's Cathedral and some wide shots of the Wadi Rum, is actually what it purports to be – any more than the Spanish landscapes of Leone's 'Dollars' trilogy are New Mexico, or for that matter is Ireland, where much of *Braveheart* was shot, the Scotland that it celebrates. Obviously, such substitutions have long been routine in film-making. But the difference in much post-1960s location-based cinema is the importance attached by the film-makers to the *experience* of working on location and how this influences the film and ultimately the audience.

While filming on location was a distinct trend of the 1960s, an older tradition also enjoyed a revival. The full-scale architectural recreation of the past that was central to *Cabiria*, *Barnaby Rudge* and *Intolerance* – and had continued into the 1920s with the spectacular sets for DeMille's *The Ten Commandments* (1923), Worsley's *The Hunchback of Notre-Dame* (1923) and MGM's *Ben-Hur* (1925) – was revived, starting with a monumental remake of *Ben-Hur* by MGM in 1959, based in Italy. The box-office success of this major investment led to more films involving massive sets. *Cleopatra* (1963) was relocated from England to Rome, where its opulence incurred legendary expenditure. Meanwhile, the development of Spanish locations and studios continued with Lean's and Box's next film after *Lawrence*, *Doctor Zhivago* (1965), which involved building a large composite set representing Moscow on the outskirts of Madrid. Three years later, John Box would create Charles Dickens's London on an equally large scale at Shepperton studio for *Oliver!* (1968). Actors in both these films recalled the feeling that these were almost 'real' environments, solidly constructed with great attention to detail, helping them to enter into the period of the narratives.[22]

More recently this comprehensive approach to creating a film's 'world' has been followed with Dante Ferretti's massive set for Martin Scorsese's *Gangs of New York* (2002), representing the Five Points district of New York in the mid-1800s, built at Cinecittà almost as solidly as Box's Moscow and Dickensian London.[23] Elsewhere, the Polish designer Allan Starski has created impressive 'environmental' sets for two Roman Polanski films: *The Pianist* (2002), shot at Studio Babelsburg in Berlin (where the same 'Central European' street was subsequently used for other films, including *The Reader*

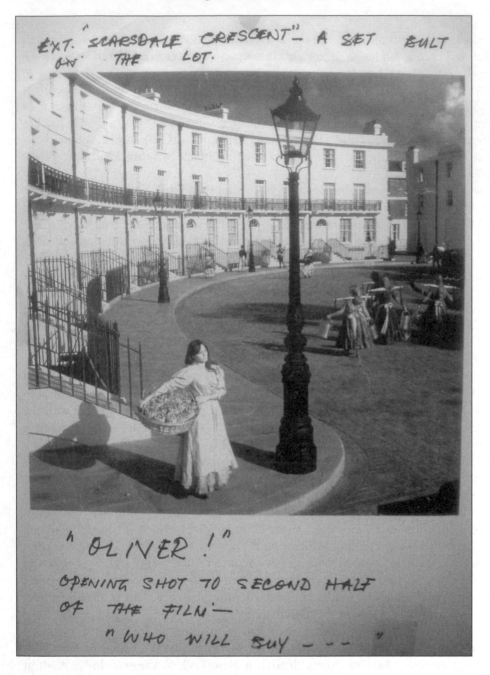

Figure 8. Design for 'Scarsdale Crescent' by John Box, built at Shepperton
for *Oliver!* (1968). Courtesy of the John Box collection in BFI Special
Collections with the permission of the Box family and BFI.

in 2008), and *Oliver Twist* (2005), at the Barrandov Studio in Prague. The advantages of creating an ensemble of buildings and streets are obvious for other members of the creative team. As Starski explains,

> I try to design it so that the crew won't run out of ideas for coverage after three days. I create opportunities for interesting camera angles and movement, and I populate the set with possibilities for visual anecdotes. (Ettedgui 1999: 107)

In such cases where a film's script and budget point towards the construction of a substantial composite set, the director, actors and camera crew are able to inhabit a make-believe world for the duration of filming. What the designer has done, ideally, is pre-visualise the fictive 'world' of the film, and both Box and Starski have spoken about the crucial moment when they first show a completed set to their director – waiting to see if it will fulfil the director's own vision, which has been imaginative rather than concrete up to this point.[24] Indeed, it may do more, by crystallising what had not been a clear or coherent vision on the part of the director until the moment of encountering what the designer has produced.

It is an article of faith among almost all production designers that they do not seek to impose their vision but aim to serve the director's – assuming the director has one. Richard Sylbert, quoted at the beginning of this chapter, was unusually candid in his 1999 interview in stating that some of the major directors he had worked with had little or no visual sense and so relied on him to realise the script in visual terms. Elia Kazan was one of these – fully focused on the actors and their performance, yet the films that Sylbert designed for him, such as *A Face in the Crowd* (1957) or *Splendour in the Grass* (1962), do not reveal any division of creative responsibility. Unless we have the testimony of designers, and directors, and evidence of their preparatory work in the form of drawings, sketches and models, we are unlikely to penetrate the seamless fictive world that most films present.

Does this mean that understanding production design is condemned to guessing 'who did what' in terms of a film's authorship and to remaining at a rudimentary level of stylistic analysis? Not necessarily. It could embrace a concept of the 'film world', as proposed by Daniel Frampton (2006) and recently developed by Daniel Yacavone (2008). Drawing on the philosopher Nelson Goodman's theory of artistic 'worldmaking', Yacavone (2008: 86) outlines a useful distinction between film worlds as 'perceptual and symbolic objects', which transform the elements that they draw on in the process of representation, and the 'subjective experience' of these worlds, as we encounter them. The director and designer, however they work together, are jointly engaged in 'making a world' in every film, and this world inevitably draws on other represented worlds, often in fragmentary or hybrid form, while seeking to convince the viewer of its ontological status and narrative logic.

Adopting such an approach would respect most film-makers' belief that design – like cinematography, editing, sound etc. – should not be seen in isolation but as part

of a durational whole, which is the film – constructed to be experienced. It could also help direct attention away from spectacular sets and 'effects' towards the full range of perceptual crafting that production design involves. Sylbert gives an excellent example of such subtle crafting in his work on Polanski's *Chinatown* (1974), where 'certain sets are designed to echo others, for example the Water and Power Department and the police morgue are deliberately reminiscent of each other in terms of colour and geography' (Ettedgui 1999: 43). Such a symmetry, if it is noticed at all, is likely to be ascribed to the 'director's vision'; yet that vision is almost certainly one shared between director, production designer and very likely the cinematographer and editor. Despite Sylbert's scorn for those who 'rent buildings', selecting precisely what is to be filmed – or drawing lines in the real desert, as in the case of *Lawrence of Arabia* – can make as great a contribution to a film's aesthetic impact as building a complete facsimile of a city or creating an imaginary landscape with digital tools. What finally matters is that all these can become 'more real' for the spectator than the literal reality that film invokes and transforms through representation.[25]

Bibliography

Affron, C. and M.J. Affron (1995), *Sets in Motion: Art Direction and Film Narrative*, New Brunswick, NJ: Rutgers University Press.

Albera, F. and N. Kleiman (eds) (1986), *Eisenstein: le movement de l'art*, Paris: Cerf, pp. 97–158.

Arnheim, R. (1958), *Film as Art*, London: Faber.

Bakhtin, M.M. (1981), 'Forms of Time and of the Chronotope in the Novel', in M. Holquist (ed.), *The Dialogic Imagination*, Austin: University of Texas Press, pp. 84–129.

Bardèche, M. and R. Brasillach (1938), *History of the Film*, I. Barry (trans.), London: Allen and Unwin.

Barsacq, L. (1976), *Caligari's Cabinet and Other Grand Illusions: A History of Film Design*, E. Stein (trans. and rev.), New York: New American Library.

Bazin, A. (1967), *What Is Cinema?* Vol. 1, H. Gray (ed. and trans.), Berkeley: University of California Press.

Bordewich, F.M. (2002), 'Manhattan Mayhem', *Smithsonian Magazine* (December 2002), available at http://www.fergusbordewich.com/PAGESjournalism/FBgangs.shtml. Accessed 10 December 2010.

Bolter, J. and R. Grusin (1999), *Remediation: Understanding New Media*, Boston: MIT Press.

Brown, K. (1976), *Adventures with D. W. Griffith*, K. Brownlow (ed.), New York: Da Capo.

Brown, R. and B. Anthony (1999), *A Victorian Film Enterprise: The History of the British Mutoscope and Biograph Company, 1897–1915*, Trowbridge: Flicks Books.

Carrick, E. (1938), *Designing for Moving Pictures*, London: Studio Publications.

Christie, I. (2000), *A Matter of Life and Death*, London: BFI Publishing.

—— (2009), *The Art of Film: John Box and Production Design*, London: Wallflower Publishing.

—— (2012), 'Ancient Rome in London: Classical Subjects in the Forefront of Cinema's Expansion after 1910', in P. Michelakis and M. Wyke (eds), *The Ancient World in Silent Cinema*, Cambridge: Cambridge University Press.

Craig, E.G. (2008), 'The Artists of the Theatre of the Future' (1907), re-published in E.G. Craig and F. Chamberlain, *On the Art of the Theatre* (1911), London: Taylor and Francis, pp. 1–26.

Eisenstein, S. (1970), 'Stereoscopic Films', in R. Griffith (ed.), *Notes of a Film Director*, New York: Dover, pp. 129–37.

Eisner, L. (1969), *The Haunted Screen*, London: Thames and Hudson.

Ettedgui, P. (1999), *Production Design and Art Direction*, Crans-Près-Céligny, Switzerland: RotoVision.

Frampton, D. (2006), *Filmosophy*, London: Wallflower Press.

Hayes, R. (2001), '"The Scope of the Movies": Three Films and Their Influence on Eugene O'Neill', *The Eugene O'Neill Review*, 25:1 & 2, available at http://www.eoneill.com/library/review/25-1.2/25-1.2e.htm. Accessed 7 December 2010.

Leapman, M. (2003), *Inigo: The Troubled Life of Inigo Jones, Architect of the English Renaissance*, London: Headline Books.

Low, R. (1948), *The History of the British Film 1914–1918*, Vol. 3, London: Allen & Unwin.

Mannoni, L. (2004), 'The Art of Illusion', in L. Mannoni, W. Nekes and M. Warner (eds), *Eyes, Lies and Illusions*, London: Hayward Gallery, pp. 41–52.

Panofsky, E. (1974), 'Style and Medium in the Motion Picture' (1934), in G. Mast and M. Cohen (eds), *Film Theory and Criticism: Introductory Readings*, New York: Oxford University Press, pp. 151–69.

Powell, M. (1986), *A Life in Movies*, London: Heinemann.

Rotha, P. (1930), *The Film Till Now*, London: Cape.

Sarris, A. (1968), 'The Illusion of Naturalism', *The Drama Review* [TDR], 13:2, pp. 108–12.

Talbot, D. (ed.) (1966), *Film: An Anthology*, Berkeley: University of California Press.

Winter, O. (1982), 'The Cinematograph', *The New Review* (February 1896), reprinted and introduced by S. Bottomore, 'Ain't It Lifelike!', *Sight and Sound*, 51:4, pp. 294–96.

Yacavone, D. (2008), 'Towards a Theory of Film Worlds', *Film-Philosophy*, 12:2, pp. 83–108.

Notes

1. Here Powell was referring to Alfred Junge, his main art director/production designer for a decade.
2. CGI can, of course, be a remedial service ('we'll fix that with digital'), but it is also how an increasing proportion of a film's visual substance is created, replacing the capture of 'indexical' photographic imagery.
3. One of the earliest writers on moving pictures, an otherwise unidentified critic named O. Winter, wrote of the cinematograph as an indiscriminate recording machine that showed 'the complete despair of modern realism' (Winter cited in Bottomore 1982: 296).
4. 'Stereoscopic Films' appeared in *Notes of a Film Director* edited by Richard Griffith, 1970, but its eight pages represent only a fraction of the nearly 60-page original, which appeared in

French translation in François Albera and Naum Kleiman (eds), *Eisenstein: le movement de l'art*, 1986.

5. In some cases, one company could span this range of media, as did Bamforth and Co., based in Holmforth, Yorkshire. For examples of their output, see http://www.bamforth.0catch.com/ (accessed 10 December 2010).

6. Filming scenes from the Metropolitan opera's production of *Parsifal* was an unusually expensive project for Edison, who nonetheless regarded opera as a natural subject for film when combined with phonographic recording. Gaumont in France and Messter in Germany also filmed opera in this period.

7. *A Christmas Carol in Prose, Being a Ghost Story of Christmas* (usually known as *A Christmas Carol*) was first published in December 1843, with illustrations by John Leech.

8. For example, *The Dwarf and the Giant* (1901), *The Dancing Midget* (1902) and *The Man with the Rubber Head* (1901), all of which can be viewed on the Georges Méliès site at http:// filmjournal.net/melies/ (accessed 6 December 2010).

9. Méliès apparently visited the Abbey as part of his research before staging the coronation in his Paris studio, but the fact that the film appeared before Edward's delayed coronation dissipated any pretence that this was a record of the actual ceremony.

10. Dates for these early spectacle films can vary because of the multiple versions that were released (and re-released) in different territories. See my chapter 'Ancient Rome in London: Classical Subjects in the Forefront of Cinema's Expansion after 1910' (Christie, forthcoming 2012).

11. Max Reinhardt directed four films between 1910 and 1914: two based on his major stage successes, *Sumurun* and *The Miracle*. Vsevolod Meyerhold made *The Portrait of Dorian Gray* (1915) and *The Strong Man* (1917).

12. By the end of Bauer's career (cut short by a fatal accident in 1917), he was working with an art director (the future director Lev Kuleshov) – on his last film, *For Happiness* (1917).

13. Léon Barsacq's *Le Décor de film* (1970) was the first historical account of set design, later published in English under the title *Caligari's Cabinet and Other Grand Illusions: A History of Film Design* (1976).

14. Warwick Buckland (1863–1945) appears to have been unconnected with Wilfred Buckland, Cecil B. DeMille's art director from 1914–20, and to have served as an all-round member of Hepworth's studio staff.

15. The term *Stimmung* is used extensively in Lottie Eisner's influential book on expressionism in German cinema, *The Haunted Screen* (1969).

16. Erwin Panofsky's 'Style and Medium in the Motion Picture' was first printed in 1934, revised in 1947, and is included in Mast and Cohen's edited collection *Film Theory and Criticism* (1974).

17. The essay was first given as a talk to promote the new film library of the Museum of Modern Art in New York, considered 'a rather queer project by most people at the time', as Daniel Talbot remarked when introducing the essay in his 1966 anthology (Talbot 1966: 16) – which may explain its conservative tone.

18. The Affrons' useful theorisation of screen design proposes five levels of 'intensity', from 'denotation' and 'punctuation' to 'set as narrative'.

19. Elsewhere (see Christie 2000) I have referred to the masque in relation to Powell and Pressburger's *A Matter of Life and Death* (1946) and *The Life and Death of Colonel Blimp* (1943). On Jones and the masque, see Leapman (2003: 240–45, 295–305).

20. Both *The Imaginarium of Dr Parnassus* and *Avatar* have as their theme, in different ways, the potential of immersive illusion to create empathy and change beliefs – when 'Tony' (Heath Ledger) enters the Imaginarium and its deconstructive fantasies, and when the paraplegic marine Jake (Sam Worthington) 'becomes' a member of the Na'vi through virtual reality techniques (which the audience experiences in 3D).

21. Paris in *A bout de souffle* (Godard 1959), *Les Cousins* (Chabrol 1959), *Les Quatre-cent coups* (Truffaut 1959), *Paris nous appartient* (Rivette 1961); Nottingham in *Saturday Night and Sunday Morning* (Richardson 1960); Salford in *A Taste of Honey* (Richardson 1961); Parma in *Prima della rivoluzione* (Bertolucci 1964); New York in *You're a Big Boy Now* (Coppola 1966), *Who's That Knocking at My Door* (Scorsese 1967).

22. Among the actors who commented on the detailed authenticity of the *Zhivago* and *Oliver!* sets were Omar Sharif, in an unpublished interview with the author in Paris (2003), and Harry Secombe (in Christie 2009: 91–92).

23. The *Oliver!* set lasted for many years and was re-dressed for subsequent films. On *Gangs of New York*, see Bordewich (2002).

24. Box (in Christie 2009: 31–32) described waiting nervously for Carol Reed's reaction to his interiors for *Our Man in Havana* (1959). Starski describes taking the director onto the completed set as 'the most important moment' (Ettedgui 1999: 107).

25. The production designer Ken Adam, most famous for his work for Kubrick and on the James Bond films, summed up his aim as follows: 'to create a stylised reality for the audience that in the context of a particular dramatic moment or character is more "real" than a literal interpretation of reality' (Ettedgui 1999: 26).

Chapter 2

Adapting *Watchmen*

Ian Hague

Written by Alan Moore, pencilled by Dave Gibbons, coloured by John Higgins, and published by DC Comics from 1986 to 1987, *Watchmen* is the story of a dystopian USA where superheroes are real, but often neither super nor heroic. More than that though, *Watchmen* is a comic book about comic books. Its subjects are not simply the history of American comics or the social contexts of their production (though each of these themes is present in *Watchmen*), but the form of comics and the nature of the medium as a unique mode of storytelling. This uniqueness is extremely important to Alan Moore in particular, who has said of *Watchmen*:

> The plot was more or less incidental. All of its elements were properly considered, but it's not the fact that *Watchmen* told a dark story about a few superheroes that makes it a book that is still read and remembered today. It's the fact that it was ingeniously told and made ingenious use of the comic strip medium. (Musson and O'Neill 2009: 29)

While such comments are inescapably value laden and self-promoting, they do mark up some important issues for adaptation studies as it comes to consider the translation of works from comics to film, emphasising the difficulties of shifting from one mode of storytelling to another. In this chapter, I would like to discuss some of these difficulties, taking *Watchmen* as a case study in order to explore the complexities of converting works from the comics page to the cinema screen. *Watchmen* presents a particularly effective means for doing this because as we will see, the formal characteristics of the comics page are critical to understanding the *Watchmen* series. Indeed, Alan Moore has gone so far as to assert that his comics 'were written to be impossible to reproduce in terms of cinema' (*The Culture Show* 2006) and it is therefore unsurprising that these elements are the areas that are arguably the most problematic in Zack Snyder's film adaptation of *Watchmen*, which was released in cinemas in 2009.

In order to structure my discussion, I will draw upon an essay by Pascal Lefèvre (2007) entitled 'Incompatible Visual Ontologies: The Problematic Adaptation of Drawn Images', in which the author identifies four problems inherent in adapting comics for the screen.[1] They are:

> The deletion/addition process that occurs with rewriting primary comics texts for film.
> The unique characteristics of page layout and film screen.

The dilemma of translating drawings to photography.

The importance of sound in film compared to the 'silence' of comics. (Lefèvre 2007: 3–4)

Lefèvre is keenly aware that form and format fundamentally affect the stories it is possible to tell and the meanings that can be conveyed in comics, and his model is a useful one because it does not overstate the importance of the story, instead contextualising it within the formal characteristics of the comics page. In this sense, Lefèvre's model provides us with a means for assessing the *adaptation* of *Watchmen* from a comic book series to a film, rather than narrowing our focus to the differing expressions of a particular narrative in two forms and assuming that this narrative can somehow be detached from its presentation. This type of understanding is essential if we are to consider a series that makes 'ingenious use of the comic strip medium' (Musson and O'Neill 2009: 29), because it allows us to consider the success of the adaptation by determining whether the original's meanings have been (or indeed can be) expressed effectively on screen. We are not limited to discussing the story of *Watchmen* at the expense of the formal elements of this complex work. Let us now begin our discussion in earnest by moving on to focus on the first of Lefèvre's four points.

The deletion/addition process that occurs with rewriting primary comics texts for film

Of all of Lefèvre's points, the process of deletion/addition is perhaps the one that skews closest to a focus on story. He outlines this problem in the following way:

The dilemma is [. . .] that a film that too 'faithfully' follows a comic will seldom be a good film. Since it is another medium with other characteristics and rules, the director has to modify the original work. (Lefèvre 2007: 5)

This position is an interesting one, given that many adaptation theorists have treated fidelity to the source material as the norm (Leitch 2007: 127). Lefèvre's own discussion of this point is fairly generic, focusing upon the notions of relevance and detail, and arguing that modifications to original works are often necessary, even if they are resisted (particularly by fans). He notes that in some instances (for example Enki Bilal's *Immortel (ad vitam)* (2004) the act is not so much one of adaptation but of rewriting, i.e. producing something that is substantively different from the supposed original (Lefèvre 2007: 4). This acknowledgement of the importance of modification points to some of the more specific problems posed by comics when they are approached by the film-maker. Although all forms of adaptation from one medium to another involve choices being made about the inclusion or exclusion of material, there are factors that are unique to (or at least common in) the field of comics that are not found elsewhere. One of the most significant, I would suggest, is the publishing schedule, and this is something that can play a major role in determining the complexity of adapting a comic for the screen.

The genre of superhero comics often follows a publishing model based upon the monthly, serialised adventures of a recurring character or characters. When a character has been in existence for a long time, as is the case with Superman, who first appeared in *Action Comics* #1 in 1938 and has been in publication in various forms ever since, it is easy for a vast quantity of source material to build up. In the first two years of Superman's existence, the character appeared in no fewer than 29 comics; he has now featured in literally thousands. In addition to presenting the comic book writer with the difficulty of plotting stories that appear to move forward but do not 'consume' the character (Eco 1972), this also poses problems for the film-maker.[2] With such a large amount of material to choose from it is unsurprising that the preferred method of production for many superhero films is rewriting rather than adaptation: cherry picking elements from numerous comics and using them to construct an original narrative. In Richard Donner's 1978 *Superman: The Movie*, Superman battles Lex Luthor but the basis for this conflict lies in their generic protagonist/antagonist relationship, not in the storyline from any single comic book. Some elements will be familiar to comic book readers, for example Superman's origin story, which is expanded from a one-page sequence in *Action Comics* #1 (Siegel and Shuster 2006: 4) to a forty-eight minute long sequence in the film, but this expansion could not truly be said to violate an existing corpus because this type of change has been made in comics too.[3] In *Superman* #1, which was published a year after the character's first appearance, Superman's origin doubled in length (Siegel and Shuster 2006: 195–96), and this was only the first of many updates, rewrites and expansions. For this reason, it can be argued that Donner's film is not being unfaithful to the source material; it is simply presenting one alternate version that sits among many others.

Not all works are published serially, however, and not all tell expansive continuing narratives or metanarratives. *A History of Violence* (Wagner and Locke 1997) is one such work, which tells a story that is completed within a single volume (and, like the Superman comics and *Watchmen*, has been adapted into a film (David Cronenberg 2005)). The completion of the narrative marks off the work as a discrete unit and thereby invites direct comparisons between that work and any filmic adaptation/rewrite of it. It is only in this type of work that fidelity to the source can truly be considered a desirable or even plausible goal. Unlike the serial, which is always open to reinvention and reinterpretation, the finished piece *is* the object, and this object can (in theory at least) be adapted into another form. The serialised comic is not a finished form itself, so only parts of it can be re-presented in an alternative medium; these adaptations/rewrites then fold back into the unfinished mass and complicate its constitution still further because they too are subject to reinterpretation and rewriting in later instalments. In taking on completed works, fidelity to the original narrative becomes more of a pressing concern because if the film-maker diverges too far from the source material it becomes questionable whether they have actually produced an adaptation or an original (or perhaps plagiaristic) narrative of their own (which could also be termed a rewrite).

Watchmen lies somewhere between the extremes of ongoing serialised comics and completed narratives. Although it was published serially by DC Comics, the series was always intended to be finite. The narrative has a definite beginning, middle and end, and does not lend itself well to the idea of continuation after its conclusion, which perhaps positions it closer to *A History of Violence* than to Superman. Unlike Superman, *Watchmen* has never been a heavily merchandised or franchised property (though this has begun to change since the release of the film) and the characters and their universe were remarkably contained until recently, when DC Comics announced it would begin printing a series of prequel comics in 2012 (Hyde 2012). Thus, for a long time the series was not subject to the continual process of rewriting and reinvigoration that Superman was. Following the publication of the original twelve issue series (which has never been reprinted in its entirety), DC Comics released a collected edition. Though it has been through numerous reprintings, this version remained relatively untouched until the twentieth anniversary of the original series prompted DC to publish a slipcased hardcover edition as part of their 'Absolute' editions line, which featured re-coloured artwork and a selection of pre-publication documents. This new printing formed the basis for subsequent editions of the trade paperback. Prior to the prequels, only a very small amount of material set within the *Watchmen* universe had been created outside the main narrative sequence (specifically two modules and a sourcebook for a *Watchmen* role-playing game, which provided players with background information on the characters from the series). This relative dearth of additional materials meant that the 'canonical' nature of the main series had been retained, although the prequels (forthcoming at the time of this writing) will change that. While it cannot truly be said that *Watchmen* has proven inviolate since the completion of the series' original publication in 1986-7, the changes that have been made to the main series are more reasonably viewed as minor amendments than major rewrites.

This being the case, the act of adaptation is, in theory, made easier. To be successful in this area, the adaptation need only incorporate the story of a twelve-issue comic book series. Though complex, the graphic novel's storyline is not unfilmable, as the adaptation evidences in its retention of the majority of the narrative. The characters, events and much of the dialogue have been retained from the comic book series, with only one major alteration being made to the ending, which director Zack Snyder argued makes for a more 'elegant' (Franklin 2008) conclusion to the film. In fact, it was this very fidelity that proved problematic for some reviewers, with *New York* magazine labelling the film 'Hopelessly Devoted' (Edelstein 2009) to the book and *Vanity Fair* asking 'Did Zack Snyder Love "Watchmen" Too Much?' (Sancton 2009). Nevertheless, it could be argued that if fidelity is a desirable goal for an adaptation, each of these reviews actually serves to emphasise the success of Snyder's *Watchmen* and goes some way towards refuting the notion that Alan Moore's comics *are* 'impossible to reproduce in terms of cinema'. It is important to remember, however, that Moore does not class *Watchmen*'s storyline as its primary area of interest, asserting that the work's importance lies in:

the storytelling techniques, and the way that me and Dave [Gibbons] were altering the range of what it was possible to do in comics; this new way that we'd stumbled upon of telling a comic book story. (Musson and O'Neill 2009: 29)

While it is somewhat dangerous to follow the argument of the author solely because he *is* the author, *Watchmen* is a formally complex work, and it therefore behoves us to be cautious in asserting that it is possible to adapt it for cinema solely on the basis that its storyline can make the jump from page to screen. Let us now move on to consider some of the other ways in which *Watchmen* expresses meaning in order to develop a more holistic understanding of the problems for its adaptation.

The unique characteristics of page layout and film screen

In his book *Alternative Comics: An Emerging Literature*, Charles Hatfield identifies comics as 'an art of tensions' (Hatfield 2005: 32). He goes on to describe four specific types of tension evident within the medium, one of which is 'sequence vs. surface' (Hatfield 2005: 48). 'The page', he argues, 'functions both as sequence and object, to be seen and read in both linear and nonlinear, holistic fashion' (Hatfield 2005: 48). The sequence is comprised of the individual panels understood as single images apprehended in their reading order. The surface is the page in its entirety; it is not what we read but what we see. In *Watchmen*, the tension between the two is employed to create a meaning that is arguably unique to the comics form, and this is one of the reasons that the work is such a useful case study when we are considering the possibilities for adapting comics for the cinema screen in a more general sense.

On the first page of *Watchmen* #4 (Figure 1), the character of Dr. Manhattan sits on the surface of Mars and reflects on his life. Curiously, Manhattan, who gained various superpowers from an accident with an 'intrinsic field chamber', perceives all time simultaneously; what we would class as past, present and future are concurrent for him. In order to convey this to the reader, Moore and Gibbons use fairly basic devices such as Dr. Manhattan's narration, which runs throughout the page. At the same time, they manipulate the tension between sequence and surface to give the reader the same power over the page that Manhattan has over time itself. In Panel 2, Manhattan comments, 'In twelve seconds time, I drop the photograph to the sand at my feet, walking away. It's already lying there, twelve seconds into the future' (Moore, Gibbons and Higgins 1986–87 (*Watchmen* #4): 1). The artwork in the panel depicts what Manhattan describes, namely the photograph lying in the sand. A tension between word and image is employed here; the words are twelve seconds behind the image. More subtly than this though, the sequence/surface tension is invoked because the image of the photograph is also visible in Panel 9, which is in the future from the reader's perspective. Similarly, once the reader has moved past Panel 2 the image of the photograph persists as an element of the surface

Figure 1. Doctor Manhattan contemplates his past, present and future.
© DC Comics. Used with Permission.

rather than fading as it would if it was a memory, that is, something we are only aware of through recall. As Dave Gibbons's plan for the issue evidences, the complexity of the multiple repetition patterns that run throughout the issue required detailed consideration well in advance of the drawing stage (Gibbons, Kidd and Essl 2008: 133).

In film, the representation of this idea becomes extremely problematic because the persistence of the image that is required for the effect is not possible. In his adaptation, Zack Snyder chooses to present this section of the story as a montage of shots, and indeed it may appear that montage, which Eisenstein has described as 'the means of *unrolling* an idea through single shots' (Eisenstein 1998: 95), is analogous to page layout. Certainly, Francis Lacassin unproblematically employed the term in his description of the language of comics in a 1972 issue of *Film Quarterly*, arguing, '[i]n both [comics and film], the language is composed of a succession of "shots," (that is to say, images with variable framing) in a syntactical arrangement or montage' (Lacassin 1972: 11). This description, however, like Eisenstein's, serves to suggest the inaccuracy of the term 'montage' when applied to the comic book page because it does not account for the tension between sequence and surface. Although we can observe a sequence of images on the page, it is the distinction between this sequence and the page as a whole that gives it additional, arguably unique, meaning. As Thierry Groensteen has remarked, 'the linkage of shots in a film, which is properly the work of editing, carries itself on a single linear dimension: that of time, while the panels of a comic are articulated at once in time and in space' (Groensteen 2007: 101). Where the film viewer extrapolates the broader ideas from a series of images that move forward linearly at a fixed speed, the comic book reader must work with both the series and the whole to ascertain the meaning because they are confronted by that whole at the same time as the parts.

It could be argued that other types of presentation, such as split screen, and alternative forms of viewing technology, such as DVD, could help to bridge the gap between the two media. The former, it would seem, does provide a type of surface that could be read in the same way as the comic book's page, while the latter allows the viewer to negate the mono-directionality of film by moving backwards and forwards using the rewind and fast-forward buttons. While I am reluctant to discount these options altogether, they are not wholly effective in expressing the same meaning as the pages in *Watchmen*. Because the split-screen presentation would (presumably) be beholden to the forward motion of the film, its ability to convey the surface would be rather limited because that surface would only be part of a larger sequence (a reversal of the relationship described above, in which the sequentially deployed elements form the constituent parts of the surface). As Scott McCloud has observed, '*Space* does for *comics* what *time* does for *film*' (McCloud 1993: 7, emphasis in original). The viewer would be pulled through the sequence at the speed of the film; they could not linger over the surface as the comic's reader can, making it very unlikely that the numerous repetition sequences in *Watchmen* #4 could be expressed in a comprehensible way. DVD or similar technology may allow the viewer to overcome these barriers but would itself present problems because it would require

a considerable amount of effort on the part of the viewer; it would be impossible to employ in a cinema, and it would retain an emphasis on the sequence rather than the surface (even if the viewer could move backwards and forwards through that sequence at will). While it is possible that a combination of the two approaches could be used to express the relevant sections of *Watchmen*'s narrative in some form, the conventions of viewing films suggest that such an approach would not be feasible outside an avant-garde context.

None of these points should be taken to mean that one or other of the two media is somehow superior to the other, but only that they are more different than they may superficially appear. Comics and film may both be examples of sequential art ('A train of images deployed in sequence' (Eisner 1996: 6)), but the positions in which those images stand relative to each other, and the ways in which they are experienced by the viewer, are very different. The panels in *Watchmen* may be images within a frame, but this does not mean that they are the equivalent of the images that make up a film storyboard because of the different ways in which they are juxtaposed. In Zack Snyder's storyboards for *Watchmen*, the page layout has been eliminated completely, as Snyder extracts panels and sets them up as the basis for his shots (see Snyder 2008a, 2008b). Though the images he uses cohabit pages in his workbook, the screens they depict are presented sequentially, not concurrently.

It is not only page layout, however, that causes problems for the transfer of the comic book image to the cinema screen, and here we come to the third of the difficulties identified by Pascal Lefèvre.

The dilemma of translating drawings to photography

The visual aspects of Alan Moore's comics have rarely translated well from the page to the screen, and they serve to indicate some of the more general problems with this type of conversion. In *From Hell* (Albert Hughes and Allen Hughes 2001), Eddie Campbell's scratchy, intricate and at times even abstract line work was replaced with the clear, realistic photography of film. Though there is a certain stylisation to the film, it does not challenge the viewer in the same way as the book does, and it does concede to certain visual tropes. Campbell's lumpy-faced Inspector Abberline, one of the book's lead characters, was portrayed by the far more youthful and vital Johnny Depp in the film, bringing him into line with a more typical Hollywood leading man's appearance of the type seen in other films of the same year, such as *Ocean's Eleven* (Steven Soderbergh 2001) and *Pearl Harbor* (Michael Bay 2001). Similarly, the taut pencilling of Kevin O'Neill in *The League of Extraordinary Gentlemen* was converted into a fairly standard action film aesthetic for the screen in the film of the same name directed by Stephen Norrington (2003). Again, this serves to make the film more comparable to action films like *X-Men 2* (Bryan Singer 2003) than to the comic book series itself. A similar critique could be levelled at

James McTeigue's 2006 adaptation of *V for Vendetta*, which transforms the soft, almost crayon-like artwork of the comic book series into a *Matrix*-esque visual presentation (hardly surprising given that the Wachowski brothers were among the film's executive producers).

By comparison with these more stylised works, *Watchmen* initially appears to present less of a challenge to the film-maker. Dave Gibbons's art, though highly detailed, is relatively naturalistic: characters have realistic proportions, and they exist in a believable world. It is perhaps worth noting the use of very flat colour on the page, which suggests the European *ligne claire* style that will be familiar to readers of the Tintin books, rather than evoking the more dynamic and ostensibly realistic American superhero comics of the period (e.g. Marvel's *Avengers* #271 (September 1986), which features relatively complex shading to evoke depth in its artwork). Nevertheless, the nature of the photographic image does prove somewhat problematic for Snyder's interpretation. Although the film-makers did take pains to replicate the chromatic scheme of the comic, the nature of light somewhat defeated their efforts as objects shine and sparkle in ways that they do not in the comics. The projected image, composed solely of light, is unable to replicate the dullness of the light as it is represented on the page. Furthermore, liberties have been taken in areas such as costuming; one particularly obvious example being that of the outfit worn by the character Nite Owl, which has been modified to avoid the intentionally ridiculous appearance of a somewhat podgy man dressing up in a cape and heading off to fight crime (though as I have indicated above, such alterations are not unique to *Watchmen*). Nevertheless, in terms of its general visual aesthetic, *Watchmen* is remarkably close to the comic book, and it is probably the most satisfactory adaptation of one of Alan Moore's comics in this regard. As we have seen, however, this does not mean that it is capable of the visual complexity of the comic book's pages, and like the question of fidelity to the story, the similarities between the two versions of *Watchmen* are largely subjective. If one feels that visual similarity between original and adaptation is desirable, then Snyder's *Watchmen* is likely to be acceptable.

There is, however, one area where it would appear that film almost certainly has the upper hand on comics in terms of presentational devices, namely sound, and this brings us to the fourth and final difficulty addressed by Pascal Lefèvre.

The importance of sound in film compared to the 'silence' of comics

To consider the complexities of sound I would like to turn to one of the aspects of *Watchmen* that Alan Moore considers to be unfilmable, namely 'split-level narratives with a little kid reading a comic book, a news vendor going into a right-wing rant next to him and something else going on in the background in captions, all at the same time and interrelated' (Musson and O'Neill 2009: 29). The subplot to which Moore is referring first appears on the opening page of Issue 3 (Figure 2).

Figure 2. The newsvendor and child are introduced, along with the narration boxes from *Tales of the Black Freighter*. © DC Comics. Used with Permission.

As Moore asserts, on this page we can see two monologues running in parallel to each other, beginning as early as the first panel and running throughout the page. The first monologue comprises a series of narration boxes that are part of the comic being read by the child sat on the floor in the bottom panel. The second is found in the speech bubbles originating from the newsvendor sat next to him. Taking the first panel as an example, we can see that the two tracks are both commenting on the same imagery, albeit in different ways. The panel depicts a small section of a nuclear fallout shelter sign. The comic book narration reads as follows:

Delirious, I saw that hell-bound ship's black sails against the yellow sky, and knew again the stench of powder, and men's brains, and war. (Moore, Gibbons and Higgins 1986–87 (*Watchmen #3*): 1)

Meanwhile the newsvendor remarks:

We oughtta *nuke Russia* and let *God* sort it out. (Moore, Gibbons and Higgins 1986–87 (*Watchmen #3*): 1, emphasis in original)

The comic book's narration is more abstract and metaphorical, drawing the reader's attention to the broader ideas and deeper meanings of words such as war, while the newsvendor's speech is blunt and to the point, relating directly to contemporaneous events, though as subsequent examples demonstrate, he may not always be as aware of what is going on as his polemic suggests.

This situation is complicated still further on the next page (Figure 3), where another doubling occurs. Here we are witness not only to a multiplicity of monologues but also to a multiplicity of diegetic levels or environments. We see the street on which the newsvendor's stand is located, but we also move in on the comic being read by the child until the panels within that comic are clearly visible. In this way the two-way commentary that began on Page 1 is completed by a reversal. The relevance of the comics' commentary to the real world is reflected in the relevance of the newsvendor's commentary to the comic. The two environments, and the two monologues, serve to comment on each other with equal validity in the comic book medium. This equality, and the inviolability of the two tracks, is essential because it allows for the two commentaries to interact without being actively affected by each other: a form of ironic juxtaposition that would be impossible if the two tracks were synthesised. It is precisely because they are two distinct voices *at different ontological levels* that they are able to employ these forms of indirect commentary on each other.

It is telling that this is one of the most significant excisions made by Zack Snyder in his adaptation. The newsvendor and child appear only very briefly in the film, while the narrative from *Tales of the Black Freighter* was cut altogether, exiled to a DVD, *Watchmen: Tales of the Black Freighter* (Daniel Delpurgatorio and Mike Smith 2009), released just after the film's theatrical debut, but later incorporated into the main narrative sequence on the

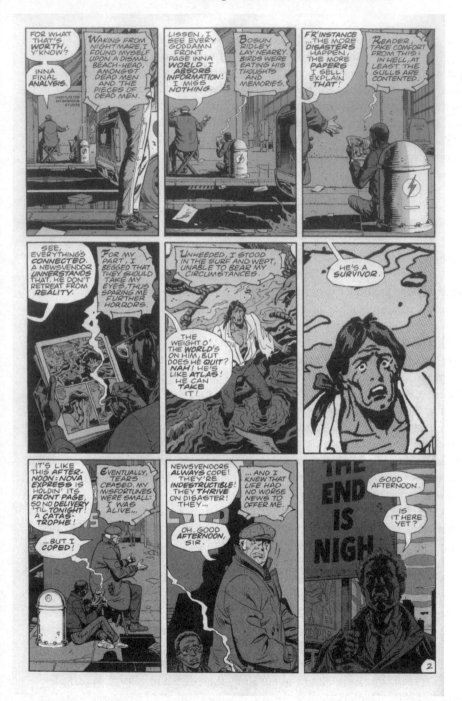

Figure 3. Images from *Tales of the Black Freighter* propagate a complex set of commentaries running back and forth between the "real world" and the comic book. © DC Comics. Used with Permission.

Watchmen: The Ultimate Cut DVD. Given that this material sits quite comfortably within the comics, the decision to exclude it from the film of *Watchmen* suggests a fundamental difference between the two media. The sequences I discussed earlier play with the idea of tensions between words and images, but they also emphasise the possibility for tensions within these fields. There is, for example, a tension between the narration boxes from the *Tales of the Black Freighter* and the newsvendor's speech bubbles. This is easy to represent in comics through visual difference. The reader will not confuse the two commentary tracks because they are visually distinctive. In film, where most narration and speech is represented aurally, this is more difficult to imply because the *ontological* distinction between the two cannot be easily indicated to the listener. As Jonathan Rée has noted,

> There is [no] special word for visual sensations in general, or for directly visible qualities – no word which covers everything that can be seen, in the way that 'sound' serves for the entire range of what can be heard. (*Sights, visions, views, light* and *appearances* come quite close, but none of them has the simple aptness or neutral generality of the word *sounds*.) (Rée 1999: 44, emphasis in original)

Converting the visible monologues into an audible commentary would serve to negate the complexity that is possible in visual representation because although it would be feasible to use two distinctive voices, one for each aspect of the commentary in *Watchmen*, they would ultimately be reduced to a single ontological level, that of the soundtrack, which would stand apart from the visual element of the film, rather than being integrated into it as speech bubbles and caption boxes are in the comic.

One way in which this problem might be overcome is through the use of visual insertions into the film itself. Rather than having the narration from the comic *spoken* by a narrator as it is in the animated version of *Tales of the Black Freighter*, the captions could be represented visually on the cinema screen, while the newsvendor's speech could be spoken aloud. This would have the benefit of identifying the ontological levels at which each commentary track sits and therefore would allow for the type of distinction that is evident in the comic. It is important to note, however, that such a mode of representation would not be identical to the comics' mode. The transient nature of sound affords spoken words no permanence: they pass from nonexistence into fleeting solidity and then disappear; the words on the page, by contrast, persist and coexist continuously, forcing the reader to remain aware of the tension between them and again emphasising the productive interplay between sequence and surface. This is something that is inevitably lost if the words are converted into sounds.

Conclusion

If we return to Lefèvre's four difficulties we can see that the nature of comics as an 'art of tensions' (Hatfield 2005: 32) is perhaps the most problematic area for adapting

comics into films. Where a tension is not being challenged, as is the case in 'the deletion/ addition process that occurs with rewriting primary comics texts for film' and 'the dilemma of translating drawings to photography', the adaptation's success or failure is almost wholly subjective. Certainly, we can see elements of the plot that have been omitted or alterations to the visual ethos that jar with the original work, but these are the areas where unique meaning is rare. 'The unique characteristics of page layout and film screen' and 'the importance of sound in film compared to the "silence" of comics', by contrast, are those areas where the more specific qualities of the comic book medium lie. It is here that Snyder's adaptation inevitably falters; in neither case is he able to develop a working alternative for the cinema screen. While this is not necessarily a significant problem for adaptations that draw on formally basic comics, *Watchmen* cannot be said to fall into this category. Here we are confronted with a work that was created to tell a story in a way that is only possible in its source medium, and thus, no matter how close an adaptation comes to the plot or visual look of the comic, it is bound to fail when it comes to accessing and translating the unique elements that are so crucial to the text. Although Snyder's film is in many ways very successful as an adaptation (which I am here consciously distinguishing from a rewrite along the lines described above), it is ultimately a dilution of the original work that is incapable of expressing the full range of meanings that are found in the comic book series and adds little, if anything, that is new. Thus, while the film version of *Watchmen* does not completely validate Alan Moore's assertion that his works are 'impossible to reproduce in terms of cinema', it also does little to suggest that they can be adapted effectively and gestures towards some of the more significant problems that affect comic book adaptations in general.

Acknowledgements

I would like to thank Dr. Hugo Frey, Dr. Will Brooker and Dr. Julia Round for their comments on an early draft of this chapter.

Bibliography

The Culture Show, 'The World of Alan Moore', BBC2, tx. 9 March 2006.

Eco, U. (1972), 'The Myth of Superman', N. Chilton (trans.), *Diacritics*, 2:1, pp. 14–22.

Edelstein, D. (2009), 'Hopelessly Devoted: Zack Snyder's *Watchmen* Is as Faithful an Adaptation as a Fanboy Could Want', available at http://nymag.com/movies/ reviews/55005/. Accessed 13 February 2011.

Eisenstein, S. (1998), 'The Dramaturgy of Film Form (The Dialectical Approach to Film Form)', R. Taylor and W. Powell (trans.), in R. Taylor (ed.), *The Eisenstein Reader*, London: British Film Institute, pp. 93–110.

Eisner, W. (1996), *Graphic Storytelling and Visual Narrative*, Paramus, NJ: Poorhouse Press.

Franklin, G. (2008), 'Special Feature: Zack Snyder on Watchmen', available at http://www.darkhorizons.com/news/12491/special-feature-zack-snyder-on-watchmen. Accessed 29 November 2010.

Gibbons, D. et al. (2008), *Watching the Watchmen*, London: Titan Books.

Groensteen, T. (2007), *The System of Comics*, B. Beaty and N. Nguyen (trans.), Jackson: University Press of Mississippi.

Hatfield, C. (2005), *Alternative Comics: An Emerging Literature*, Jackson: University Press of Mississippi.

Hyde, D. (2012), 'DC Entertainment Officially Announces "Before Watchmen"', available at http://www.dccomics.com/blog/2012/02/01/dc-entertainment-officially-announces-%25e2%2580%259cbefore-watchmen%25e2%2580%259d. Accessed 2 April 2012.

Lacassin, F. (1972), 'The Comic Strip and Film Language', *Film Quarterly*, 21:1, pp. 11–23.

Lefèvre, P. (2000), 'The Importance of Being "Published". A Comparative Study of Different Comics Formats', in A. Magnussen and H. Christiansen (eds), *Comics and Culture: Theoretical Approaches to Reading Comics*. Copenhagen: Museum Tusculanum Press, University of Copenhagen, pp. 91–105.

—— (2007), 'Incompatible Visual Ontologies: The Problematic Adaptation of Drawn Images', in I. Gordon, M. Jancovich and M. McAllister (eds), *Film and Comic Books*. Jackson: University Press of Mississippi, pp. 1–12.

Leitch, T. (2007), *Film Adaptation and Its Discontents: From Gone With the Wind to The Passion of the Christ*, Baltimore: Johns Hopkins University Press.

McCloud, S. (1993), *Understanding Comics: The Invisible Art*, New York: HarperPerennial.

Moore, A. and D. Lloyd (1990), *V for Vendetta*, New York: DC Comics.

Moore, A. and E. Campbell (2000), *From Hell: Being a Melodrama in Sixteen Parts*, London: Knockabout Comics.

Moore, A. and K. O'Neill (2003), *The League of Extraordinary Gentlemen: Volume Two*, La Jolla, CA: America's Best Comics.

—— (2007), *The League of Extraordinary Gentlemen: The Black Dossier*, La Jolla, CA: WildStorm Productions.

—— (2007), *The League of Extraordinary Gentlemen Century #1 '1910'*, Marietta, GA & London: Top Shelf Productions & Knockabout Comics.

Moore, A., D. Gibbons and J. Higgins (1986), *Watchmen*, L. Wein and B. Randall (eds), 12 vols, New York: DC Comics.

—— (1987), *Watchmen* (original TPB version), New York: DC Comics.

—— (2005), *Absolute Watchmen*, New York: DC Comics.

—— *Watchmen* (2007 British TPB version), London: Titan Books.

Moore, A., K. O'Neill, B. Dimagmaliw and B. Oakley (1999), *The League of Extraordinary Gentlemen: Volume One*, La Jolla, CA: America's Best Comics.

Musson, A. and A. O'Neill (2009), 'The Mustard Interview: Alan Moore', *Mustard*, 4, pp. 14–21, 28–34.

Rée, J. (1999), *I See a Voice: Language, Deafness, and the Senses*, London: Harper Collins.

Sancton, J. (2009), 'Did Zack Snyder Love *Watchmen* Too Much?', available at http://www.vanityfair.com/online/daily/2009/03/did-zach-snyder-love-watchmen-too-much.html. Accessed 13 February 2011.

Siegel, J. and J. Shuster (2006), *The Superman Chronicles: Volume One*, New York: DC Comics.

Snyder, Z. (2008), 'Storyboards', available at http://rss.warnerbros.com/watchmen/2008/01/storyboards.html. Accessed 29 November 2010.

—— (2008), 'That's a Wrap!', available at http://rss.warnerbros.com/watchmen/ 2008/02/ thats_a_wrap.html. Accessed 29 November 2010.

Wagner, J. and V. Locke (1997), *A History of Violence*, New York: Vertigo.

White, M.D. (ed.) (2009), *Watchmen and Philosophy: A Rorschach Test*, Hoboken, NJ: John Wiley & Sons, Inc.

Young, Á. (2011), '*From Hell*: Examining the Transition from Page to Screen', *Studies in Comics*, 2:1, pp. 207–21.

Notes

1. For an application of the same model to another of Alan Moore's works, *From Hell*, see Young (2011). That Young and I have both arrived at this model as a useful means for the examination of Moore's works is perhaps indicative of the broader validity and applicability of Lefèvre's approach to adaptations from comics to film, and it will be interesting to see if it is taken up in examinations of other adaptations in future.
2. Eco argues that Superman must paradoxically remain both 'consumable' and 'inconsumable' since '[h]e possesses the characteristics of timeless myth, but is accepted only because his activities take place in our human and everyday world of time' (Eco 1972: 16). On the one hand, the natures of serialised publication and the undefeatable character mean that Superman is effectively immortal (or inconsumable), while on the other, the character must be able to move forward in time (by acting, aging, moving towards death, etc.) and is therefore consumable. This, Eco suggests, is the contradiction that the writers of Superman comics must resolve.
3. The sequence from the beginning of the film (including credits, which do serve a minor narrative purpose) to the point at which Superman first takes flight (comparable in meaning to the panel showing Superman towering over the city at the end of his one-page origin sequence in *Action Comics* #1) is 48 minutes and fifteen seconds; however, this figure is taken from the special edition DVD (2001), which contains eight minutes of footage that did not feature in the original theatrical release. It is therefore reasonable to assume that the origin sequence in the theatrical release would have been shorter but by no more than eight minutes.

Chapter 3

Poster Graphic Design and French Films in Poland after World War II

Dorota Ostrowska

Poster as a graphic form has a long and rich history bound up with the history of advertisement and reaching back to the nineteenth century and the work of French graphic artists, such as Henri Toulouse-Lautrec and Jules Chéret in particular. The history of poster as an art form, on the other hand, is considerably shorter and associated with quite a different set of historical and economic circumstances which emerged in the Soviet Russia after the Revolution and in other socialist countries throughout the period of the Cold War. In the place of a poster as a vehicle for commercial advertisement, poster art developed a form closer to a public announcement and whose role 'was not primarily to sell but to interpret a complex artistic production; and interpretation was itself a specifically artistic and thus personal activity' (Rotzler 1961: 100). Unlike mass advertisement thus conceived poster was directed at 'a culturally wide-awake stratum of the society' who could appreciate its innovative and original format (Rotzler 1961: 103).

Among the socialist countries Poland found itself in a unique position in regard to the poster art. In 1948, young Polish artist Henryk Tomaszewski won five medals for his poster designs at the Vienna International Poster Exhibition (Crowley 1993: 26). By 1956 two large exhibitions of Polish posters were organised in Paris, Brussels and other European cities where over two hundred posters designed by 25 different Polish graphic designers were exhibited, including those by Tadeusz Trepkowski, Eryk Lipiński, Henryk Tomaszewski, Wojciech Zamecznik and Józef Mroszczak (Rohonyi 1956: 68). This international success meant that in Poland poster designers were regarded as artists in their own right and shortly were to be given an opportunity to display their works in a purpose-built poster museum established in 1968. But it was the close relationship of the Polish poster art with cinema which was most often commented on by the early critics of the poster art attending the international exhibition.[1] They remarked on the posters 'standing in a direct relationship with the unique nature of the theatre or film production, which is itself something quite different from a commodity, a product among many other similar products' (Rotzler 1961: 103). Poster and film were two forms of cultural production which were elevated to the status of the art form by the cultural politics of the socialist state and endorsed critically at home and abroad.

What were the characteristics of this new poster art? Susan Sontag, one of the most perceptive observers of its emergence in the socialist cultural sphere, described in 1970 this new step in the poster evolution from advertisement to art, and from graphic design to artistic graphic design, in the following way drawing on the example of post-revolutionary Cuba:

The Cubans make posters to advertise culture in a society that seeks *not* to treat culture as an ensemble of commodities – events and objects designed, whether consciously or not, for commercial exploitation. Then the very project of cultural advertising becomes somewhat paradoxical, if not gratuitous. (Sontag 1999: 206)

Sontag was right in pointing out that the function of poster had changed dramatically in the socialist countries. Yet the poster seemed 'gratuitous' and 'paradoxical' only when compared to the commercial function fulfilled by the poster in capitalist economies. If considered in the context of the socialist state's investment in the practice of the poster art, the poster design emerges as having a distinctly different function. In the words of Jan Lenica, a leading Polish poster designer and a spokesman for the new art form:

The creation of such a poster was made possible only by the nationalisation of the film industry and publicity which did not seek to impose their demands upon the artist but rather put emphasis on the education role of the poster in forming the public taste. (Lenica 1956)

The poster art was about developing in the viewers an aesthetic sensibility towards not just the arts which were advertised on the posters but also towards visual culture as such, of which the poster was an integral part by its nature of being displayed in the streets and in public spaces. In this way the poster was producing 'an intellectual challenge to "the man on the street"' and thus fulfilling its 'educational' role while being a tool of political persuasion (Crowley 1993: 28). The aesthetic element of the poster was seen as part and parcel of the poster's communicative function, not different to the myth-making function of a 'mask' in pre-modern societies, and closely linked to the broader political objectives of visual culture under socialism (Lazar 1965).[2]

It was only natural to expect that poster design and politics would be joined at the hip; arguably that goal was even reflected in the title given to one of the pioneering figures in the Polish poster design, Henryk Tomaszewski, 'Professor of Propaganda Graphic Design'. Tomaszewski is known to have argued during the debates organised by the socialist party about the role of the poster as propaganda that the poster has to be first and foremost 'of high artistic value, pulsating with life, far from schematism and not hampered by doctrinal tenets' (Schubert 2008: 36). But what happened to the political and ideological aspect of the poster? Was it at all possible to forget this role of the poster in the centralised cultural apparatus where artistic activity was controlled and closely supervised?

The ideological role of the poster was still present even in the posters which were recognised for their formal experimentation, thus allowing the posters to achieve their ideological goal and question capitalist morality and aesthetics. Sontag comments on this engagement with capitalism in a very succinct manner in her discussion of Cuban poster art, which also applies to the Polish case:

Cuban posters reflect the revolutionary communist ethics of Cuba in one obvious respect, of course. Every revolutionary society seeks to limit the type, if not the content, of public signs ... – a limitation that follows logically on the rejection of the consumer society with its phony free choice among goods clamouring to be bought and entertainments to be sampled. (Sontag 1999: 210)

Lenica provided the most exact definition of the 'limits' Sontag was referring to in relation to the posters designed for films. For him, the film poster design reflected 'a definite effort on the part of our artists to attain a compact synthesis, to hit upon the shortest possible artistic way of expressing the contents and mood of a given film' (Lenica 1956). Synthesis is about something essential, perhaps emotional or intellectual, to which the whole cultural event could be reduced and through which it could be communicated, while synopsis, associated with western poster design, implies primarily the engagement with the narrative. Furthermore, visual brevity and synthesis proposed by Lenica is an effort to somehow impose a limit on the visual, sensual or technological fullness and the visceral quality of film, which is played up in capitalist forms of advertisement in order to sell it. The socialist poster art thus presented a convincing alternative to sexy postures and a cocked revolver. But this is not all. The socialist poster art not only reduced these consumerist tropes but also reinvented those elements of films, which would make up a traditional film poster, and transformed them into a new set of visual tropes. It is in this process of analysis, exchange, remaking and reinventing that the political function of the poster design was realised.

Poster art was an experiment where the elements of the western graphic design of film posters were questioned and reassembled after being filtered through the lens of contemporary art. Western critics of Polish poster art who

had faith in the 'democratic' potential of modernism believed that they had found [in the Polish poster art] a field of design in which the complexities and values of modern art were given popular expression, more accessible that the museum and, at the same time, more purposeful than 'commercial art'. (Crowley 1993: 28)

Posters offered an innovative combination of visual tropes, a new visual mosaic, which was affecting the urban space and thus educating the public into a new set of values and ideas. The fact that numerous posters were designed for French films shows how this new art was forged in response to the cultural production, which at the time was regarded as ideologically opposed to that of Poland. The meeting between French films and Polish poster design was really a clash of ideologies, which was resolved and renegotiated on the level of the poster design and through a specific set of rhetorical tools.

With Poland being in the avant-garde of the poster revolution after the World War II, it is useful to understand the terms in which this type of cultural production was actually debated in Poland. The remainder of the chapter will do so and is split into

three main areas. The first part will focus on the critical discussion of the visual culture in Poland, of which posters and films were integral parts. Freeing poster design from any associations with advertisement and linking it instead to visual education and developing the poster into an art form were possible only in the context of the socialist cultural policy where all arts management and funding were centralised and channelled to serve the ideological objectives of the socialist state. The second part will examine the ways in which film culture was organised in Poland and how the poster designers and their work featured in it. Finally, in the third part, by analysing a sample of posters designed for French films, we will explore some key formal characteristics of the poster art in Poland and see how the French films were reinterpreted for the Polish audiences by the means of visually innovative poster design, thus bringing these films in line with the socialist ideology.

Visual culture under socialism

In a dictionary of fine arts from 1969 we read that a poster is 'an artistic genre of the graphic design (applied graphics) which is used for information, advertisement, propaganda and political agitation' (Kozakiewicz 1969: 283). Poster is marked by 'the economic use of the visual means of expression, a tendency towards implicit understanding, the use of metaphors, and of the intensive colour palette' (Kozakiewicz 1969: 283). Importantly, the definition draws a distinction between the artistic graphic design and graphic design *tout court*. What made artistic graphic design distinct was the fact that 'the whole artistic process was concentrated in the hands of an individual artist – beginning from the draft of the idea, through the choice of the most appropriate technical means, creating a negative, and aimed at making copies' (Kozakiewicz 1969: 128). The dictionary thus characterised a new art form and emphasised the supremacy of a poster artist. Around the time when this definition of the poster art was coined the first ever purpose-built Museum of Poster Art was opened in Warsaw. The Museum and the related activity of displaying posters in the street on special installations was an important step in developing a new type of visual pedagogy and visual culture in which both films and posters played a pivotal role.

The importance of the visual culture and its educational and political value was debated in Poland in the context of research and teaching in the area of plastic arts ('plastyka'), which were understood very broadly to encompass elements of visual design found in the man-made objects and in nature. 'Visual values' were the basis of plastic arts and included 'everything that is perceived visually, for instance all kinds of lines, dots, patches, plains, textures, colours, lights, three-dimensional forms, and the elements which are of the secondary or derivative nature, for instance contrast, rhythm, space, movement, etc.' (Marciniak 1975: 233). These 'visual values' meant that 'plastyka' was not a separate area of artistic activity; instead it was connected to all different spheres of

human life and thus more appropriately translated as 'visual culture' (Marciniak 1975: 233). The importance of education in the area of visual culture was seen as crucial for two reasons. First, the viewers were able to engage with the visual message only if they 'had the ability to understand references, allusions, metaphors, suggestions, symbols and moods' conveyed visually (Marciniak 1975: 234). Second, the viewers had to learn how to develop their visual sensibility because the products of visual culture, such as posters, films and later on TV, 'not only appealed to the viewers' attitudes but they also wanted to form them' (Marciniak 1975: 235). People's sensibilities and political opinions could thus be shifted quite radically as a result of the visual education of which posters and films were an integral part. This education in the area of the visual encouraged formal exploration and experimentation on the part of the visual artists, in particular poster designers.

The view of public art such as posters and films as broadly educational in the realm of the visual culture, and the valorisation of this type of education, gave posters a new purpose which was functional but in a different way from advertisement; for in this new set of cultural hierarchies the poster was not just allowed to experiment with its own form, but it was required to do so. The overlap between the objectives of the visual education and that of the poster artists is explicit in the terms used to describe both projects. As artists, poster designers were seeking to use a metaphorical language, which was ambiguous, symbolic and open to interpretation. As pedagogues they were aiming for their posters to provide an interface between human subjects and their environment, thus helping them 'to look and to see, to experience and to think, to analyse and to draw conclusions, to live more fully and to develop one's personality [because] this is what the plastic education was all about' (Marciniak 1975: 238). The use of metaphors and symbols in the poster design was helping develop a new kind of sensibility in the human subjects, not just an aesthetic but also a political one, dependent upon sophisticated visual signs and messages.

The poster's role in the visual pedagogy, and thus its evolution into an art, was directly linked to the cultural product it was engaging with and the way in which that was done. It is not without reason that the main characteristic of the posters in the socialist countries was that they were posters of cultural events – theatre, opera, concerts and most importantly cinema. A great many of the Polish film poster designs were for French films, which suggests that French films were particularly visible in Poland at that time. This is striking given that we are examining here the visual culture of a socialist country at the time of the Cold War. It is thus the history of the relationship between French cinema and poster design in Poland which will be most useful to trace in order to understand the dynamics of the evolution of the poster into a poster art, its relationship with the art of cinema and the ideological function both of these art forms were to fulfil in order to create the socialist visual culture.

Foreign films on Polish screens

After 1945, film culture in Poland underwent a complete overhaul, which was due to the change of the political and economic system, the shift of the country's border and the war devastation, which included the pulverisation of most of the pre-war cinematic infrastructure. It took about fifteen years for Poland to come around and slowly rebuild its film-making capacity. Significantly, in this period of reconstruction, Poland did have a buoyant and vibrant film culture constituted mostly by imported films from USSR, France, United Kingdom, United States, Italy and some socialist countries, such as East Germany and Czechoslovakia, which were shown in the growing number of cinemas

Table 1: Imports of foreign films to Poland, 1945–68

Year	USSR	France	United States	United Kingdom
1945	34			2
1946	40	3	3	10
1947	34	12	23	6
1948	30	15	31	16
1949	33	11	1	3
1950	40	5	–	–
1951	23	2	–	1
1952	14	4	–	–
1953	16	4	–	–
1954	38	4	1	1
1955	33	13	2	2
1956	33	17	–	9
1957	19	36	7	6
1958	26	39	4	6
1959	32	34	18	18
1960	45	34	23	16
1961	56	17	32	16
1962	44	17	31	14
1963	38	16	20	23
1964	30	27	17	17
1965	35	23	23	10
1966	28	22	22	8
1967	37	26	26	10
1968	27	25	25	11

Source: Kołodyński (1969: 135–50).

(Table 1).[3] At the same time the domestic production remained on a very low level. For instance, between 1946 and 1955 only twelve feature films were made, which was not enough to fill the growing number of city and countryside cinemas.[4] This low level of domestic production also explains why until the mid-1950s the bulk of the posters were designed for foreign films.

The fluctuations in the numbers, kinds and origins of the imported films corresponded to the changes in the political climate, which at its most extreme saw the period of Stalinisation which brought with it the doctrine of socialist realism in the arts, and then relaxation and relative liberalisation of cultural life after Stalin's death. The high number of films imported from France in some years surpassed that of the Soviet films. French films also enjoyed a great success with the Polish audiences. In 1956 the most popular French film in Poland, and the most popular film *tout court*, was *Fanfan la Tulipe/Fanfan Tulipan/ Fan-fan the Tulip* (Christian-Jaque 1952) with attendance figures of 8,000,000 entries. The most popular Soviet film in the same year was *Knyazhna Meri/Księżniczka Mary/Princess Mary* (I. Annensky 1955) with only 1,115,000 entries, which was only slightly above the least popular French film, *Crin blanc/Biała grzywa/White Mane* (A. Lamorisse 1953) with 950,000 entries (Anon. 1956: 28–29). Given low numbers of Polish productions, the imported films, in particular from France, became the popular cinema for a large number of the Polish cinema-going public for a long time after the end of the World War II.

Among the films imported from France there was a high number of genre films, thrillers, melodramas, costume historical dramas and psychological dramas, featuring such French stars of the day as Fernandel, Jean Gabin, Gérard Philipe and Brigitte Bardot. Some of the imported films were box-office hits in France, while others won awards at the international film festivals in Cannes and Venice. The commercial and artistic success of the films thus certainly served as a motivation for showing them on the Polish screens, but it was not the only or the most important reason. A quick glance at the titles shows that the imported films overall chimed with the ideological objectives of the socialist Poland. Among the films classified as dramas many focussed on the miscarriage of justice in the capitalist France, for example, *L'Affaire de Maurizius/Sprawa Mauriziusa/ On Trial* (J. Duvivier 1954). Some films dealt with the problems of working classes, in particular the films of Marcel Carné such as *L'Air de Paris/Zdarzyło się w Paryżu/Air of Paris* (1954), or, like *La Meilleure Part/Decyzja/The Best Part* (Y. Allegret 1956), focussed on moral struggles of professionals such as engineers, which was an important group in the socialist Poland, both courted and supported by the state. The films of left-wing or left-leaning film-makers were particularly welcome, that of André Cayatte and Jean-Paul le Chanois being well represented. The comedies and satires populated by middle classes and petit bourgeoisie were interpreted as a critique of capitalist society and so frequently programmed. A number of films, for example, *Hiroshima, mon amour/Hiroshima, moja miłość/Hiroshima, My Love* (A. Resnais 1959), focussed on questions of war and peace, an important theme in post-war Eastern Europe, which just like the West feared the escalation of the nuclear threat.

Centrala Wynajmu Filmów (Film Distribution Centre) was an institution responsible for film imports, for programming cinemas across Poland, and also for commissioning film posters. A special artistic committee was established within the Centrala Wynajmu Filmów to oversee the film poster design. The committee included graphic designers themselves educated in the pre-war Poland but whose careers in some cases were cut short because of the war (Eryk Lipiński) and those who had enjoyed some professional success in the area of poster design before the war (Henryk Tomaszewski) as well as the new talent such as Jan Lenica, Józef Mroszczak and Wojciech Fangor.[5] They were interested in the innovative and creative aspects of the design, which contributed to the climate of experimentation and discovery (Szemberg 1957: 399).[6] The reason why graphic designers found film poster design attractive was that while nobody was certain what it was supposed to be almost everybody was clear what it was not to be. As cartoonist Eryk Lipiński explained, graphic designers received quite an open brief which stipulated that they should not design 'typical posters featuring large faces and figures of the actors but graphic compositions inspired by the content of the film' (Schubert 2008: 31).

The decision to teach graphic design at the Academy of Fine Arts played an important role in encouraging innovation in the poster design in Poland. Although the Department of Graphic Art existed next to those of Painting, Sculpture and Interior Design, students were not allowed to enrol in the individual departments before the third year because all had to go through a two-year introductory course in the Department of Painting. It is for this reason that the inspiration from painting and the painterly effect were so pronounced in the posters from that early period and served as a visual interface between the poster and the film, and in line with the ambition of developing new visual values in the cinema-going audience. The use of the human figure 'treated as though it was a painting, represented in full or fragmentary form, acting as a prop for the metaphorical interpretation of the film content' was an important feature of posters, as illustrated by the poster for *Donnez-moi la chance/Chcę być gwiazdą/Give Me My Chance* (L. Moguy 1957) (Figure 1) demonstrates (Schubert 2008: 59). After the post-Stalinist thaw Polish poster designers gained better access to modern and contemporary art and were drawing on it freely. For example, the poster for *Oeil pour oeil/Oko za oko/An Eye for an Eye* (A. Cayatte 1957) (Figure 2) by Jan Lenica (1958) has an overwhelming and original painterly quality to it, reminiscent of Rothko.

Another reason for the presence of the painterly style in the posters for foreign films is that their audience was mostly urban. This related to the patterns of film distribution for foreign, particularly western, films in the post-war Poland, which were almost exclusively screened in cities rather than in the countryside. The graphic artists were able to create more ambitious forms of poster art because they could count on a certain level of sophistication from their mostly urban public and on the fact that this audience would be receptive towards certain degrees of formal experimentation.

Placed in special exhibition spaces arranged directly in the streets, the posters served as conduits for visual knowledge which had educational, intellectual, aesthetic and,

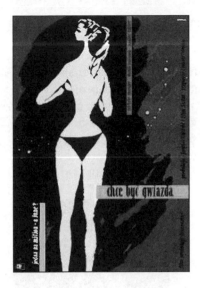

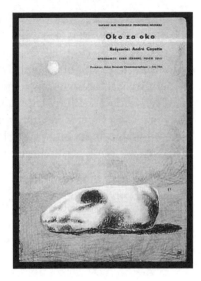

Figure 1. Liliana Baczewska, 1958 (Source: Classic Polish Film Posters http://www.cinemaposter.com).

Figure 2. Jan Lenica, 1958 (Source: Classic Polish Film Posters http://www.cinemaposter.com).

importantly, political value. The idea of 'street gallery' gained real momentum when Poland was in the midst of the post-war reconstruction effort happening under the tutelage of the socialist state. The idea of the poster street gallery belonged to an effort to reorganise the visual cityscape in line with the ideology of the socialist project to become an expression of a new socialist reality – where not only recognisable art historical tropes but also the elements of the western poster design were being actively transformed into a new art form – that of the socialist film poster.

New poster art and French films

The graphic artists reinvented in their designs the elements used by film advertisers in the capitalist system, such as film stars, new technologies, violence, sex and nudity, in particular female nudity. The treatment of the female body is a particularly telling example of this process in which visual tropes are 'recycled'. Often the new poster iconography of

the female body was inspired by painting. The female figure was highly stylised, alluring, erotic and mysterious, her sexuality present but subdued and signalled by the size of the hips as is the case in *Elena et les hommes/Helena i mężczyźni/Elena and Her Men* (J. Renoir 1956) (Figure 3) and *Donnez-moi la chance* (Figure 1). The latter shows just a single stylised anonymous female figure, with her back to us, who is projected onto the black and dark-blue backdrop. The overall effect is rather melancholic and forlorn. The poster of *Helena et les hommes* presents a female figure next to a chessboard which connotes subjectivity and psychology at the expense of female sexuality, which suggests that film viewing is an intellectual rather than libidinal activity.

Figure 3. Liliana Baczewska, 1958 (Source: Classic Polish Film Posters http://www.cinemaposter. com).

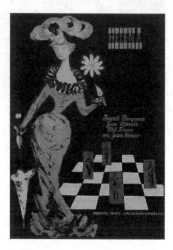

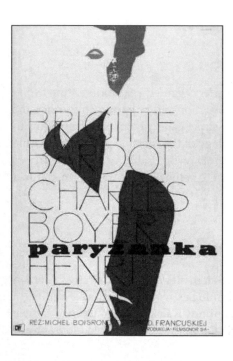

Figure 4. Waldemar Swierzy, 1958 (Source: Classic Polish Film Posters http://www.cinemaposter.com).

The Polish poster for the film *Une parisienne/Paryżanka/La Parisienne* (M. Boisrond 1957) (Figure 4) is different in its treatment of the female figure and female sexuality. The female figure in this poster appears as a sublimation of a highly sexualised female figure – a vamp – consisting of only selected and exaggerated parts of her body, breasts, hips, hair and lips. However, there is no way of telling that the figure we see is in fact Brigitte Bardot. Significantly, the font in which her name is written is very light and quite subtle, making it difficult to see from a distance, which would matter given the street context in which this poster was likely to be displayed.

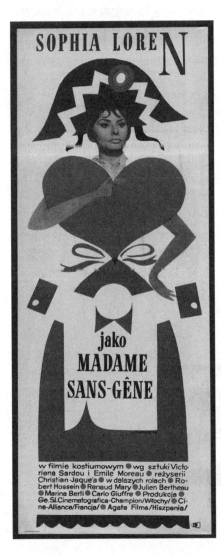

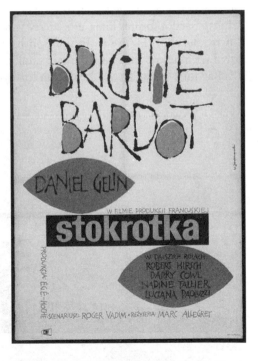

Figure 5. Jerzy Treutler, 1964 (Source: Classic Polish Film Posters http://www.cinemaposter.com).

Figure 6. Władysław Janiszewski, 1962 (Source: Classic Polish Film Posters http://www.cinemaposter.com).

The poster contains the explicit message about the sexual and erotic content of the film. But while the poster advertises sex as such, with a curvaceous woman in a tight red dress, as a vehicle for sexual pleasure, the identity of the person to whom this sex appeal belongs is not made explicit. Sexuality is made universal rather than specific and linked to the figure of BB. Importantly, the representation of her body is fragmented, exaggerated and thus distorted, with the text blocking the image but also holding it together like a fishnet. Both the body fragmentation in the poster of *Madame Sans-Gêne/ Madame/Madame Sans-Gêne* (Christian-Jaque 1961) (Figure 5) featuring Sophia Loren and the creative use of typography were an important characteristic of the Polish poster design in particular in relation to the films which featured stars. Sometimes the oversized typography of the name of the star was the 'star' of the poster, as in the poster for *En Effeuillant la marguerite/Stokrotka/Please Mr Balzac* (Marc Allegret 1956) (Figure 6) with Brigitte Bardot. The textual and the discursive were as important elements of the poster design as its painterly quality.

Polish poster design for the films with major stars had to reflect the progressive aspect of the socialist society, which stripped the most privileged of their advantageous position. In cinema it meant stripping film stars of their royal status. Graphically, this was achieved by granting equal place to all the elements of the poster, including the figure of the star or the female lead. The powerful example of this process is a poster of Brigitte Bardot for her film *Cette sacrée gamine/Nieznośna dziewczyna/Naughty Girl* (M. Boisrond 1956) (Figure 7). In the Polish poster the figure of Bardot is literally toppled down with her picture turned horizontally. As in the case of the poster for *La Parisienne* it is Bardot's sexuality which is being foregrounded.

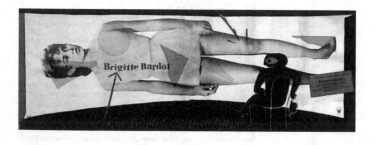

Figure 7, Waldemar Zamecznik, 1957 (Source: Classic Polish Film Posters http://www.cinemaposter.com).

The toppled Bardot is, on the one hand, just a visual object, which can be manipulated in a variety of ways by graphic artists; on the other hand, it shows that she is just another signifier of the film, an element in the chain of signification of the poster, no different from any other. In fact, in the composition of this poster, the photographic body of Bardot has the same status as the triangular and circular shapes in light yellow, pink and aquamarine, which are imposed on her silhouette suggesting yet another graphic rendition of the female body. At a closer inspection the geometric shapes emerge as the scattered elements of a graphic sign, which could be a female form, including the head, the trunk of the body, hips, neck and legs. The coloured shards evoke the kaleidoscopic nature of the cinematic experience, with her slightly parted legs connoting a projector's beam. This combined with the unusual horizontal format of the poster, itself a humorous commentary on CinemaScope, the format in which *Cette sacrée gamine* was shot, and the presence of a rather ominous black figure of the male spectator, whose head is positioned between Bardot's legs, makes the poster a commentary on the apparatus of cinema and its scopophilic pleasures. The poster provides a visual critique of the apparatus of western cinema driven by stars, technology and male desire. Paradoxically, the assault mounted at the apparatus of western cinema was also an assault on the female body *tout court*, which was pervasive irrespective of the state's ideologies. In spite of its progressive goals gender relations in the East were marked by the same deep-seated misogyny that was found in the West.

Conclusion

The formal experimentation in the area of poster design was motivated by the desire to impact a spectator-citizen in the public space. The poster had to be 'concise, instantly legible, and aggressive' because 'it has to be readable in a particular space (that of the street) which is different from the contemplation in the four walls (of a museum or a gallery)' (Olkiewicz 1957: 11). The emphasis on the 'readable' is important because it draws attention to the critical and discursive aspects of the poster. It also echoes that of El Lissitzky, a poster designer himself, who, speaking about the visual culture of the post-revolutionary Russia, claimed that the contemporary poster art was transforming the traditional book culture into the visual library located in the streets. He saw the practice of graphic design in the avant-garde of this optical revolution and highlighted the difference between the socialist and capitalist forms of poster design and practices of spectatorship:

The Revolution in our country [Russia] accomplished an enormous educational and propagandistic task. The traditional book was torn into separate pages, enlarged, coloured for greater intensity, and brought into the street as a poster. By contrast with the American poster, created for people who will catch a momentary glimpse whilst speeding past in their automobiles, ours was meant for people who would stand quite close and read it over and make sense out of it. (Lissitzky 1999: 29–30)

Posters as pages of a gigantic book scattered across the city, and meant to be read and understood, gesture towards poster graphic design as a coherent set of (visual) signs, which are as much part of visual as literary culture. The poster could be thus both – a special kind of a book page with an imprint of a film created in the process of the poster design. Arguably it is this process of imprinting by extracting and synthesising the key aspects of the film which is fundamental to understanding the implications which the poster's link to the film and literary culture has. In the process of the poster design in Poland in the 1950s, French popular cinema became the object of the same kind of critical analysis which the French New Wave film-makers were going to conduct in the early 1960s using not just the French popular cinema but, in particular, the classical Hollywood films. The poster designers reassembled the key elements of the films, in the process of *mise en page*, in the same way in which the New Wave film-makers created a new *mise-en-scène* in their films drawing on the elements of popular and genre cinema. This affinity of aesthetic aims explains at least in part why Wojciech Zamecznik's treatment of the female figure and the star of Brigitte Bardot is not different from that of his French counterparts; it is enough to mention the objectification of the female body in Jean-Luc Godard's *Le Mépris/Contempt* (1963) or its fragmentation in *Une femme mariée/A Married Woman* (1964).

The visual artists on both sides of the Iron Curtain were inscribing their works into the unfolding discourse of modernity while engaging with the vestiges of the consumerist culture. What the poster designers in Poland demonstrated was that they shared the mode of engagement with their western counterparts, especially with those of the French New Wave, who aimed at shattering and reassembling anew what was classical cinema. Considered together the outcome of their practices contribute to a more complete picture of the visual culture in Europe in the period when it was believed to be most divided and disconnected from each other.

Bibliography

Anon. (1956), 'Frekwencja na filmach wyświetlanych w 1956 roku', *Filmowy Serwis Prasowy*, 23–38, pp. 28–29.

Boczar, D. (1984), 'The Polish Poster', *Art Journal*, 1, pp. 16–27.

Crowley, D. (1993), '"An Art of Independence and Wit": The Reception of the Polish Poster School in Western Europe', in Dydo, K. and A. Szpor-Węglarska (eds), *100 lat polskiej sztuki plakatu/100th anniversary of Polish poster art. Exhibition catalogue*, Kraków: Biuro Wystaw Artystycznych, pp. 23–29.

Kołodyński, J. (1969), 'Handel zagraniczny (Eksport i Import Filmów)', in J. Wittek, W. Swieżyński, W. Wertenstein and J. Trafisz (eds), *Kinematografia polska w XXV-leciu PRL*, Warszawa: Wydanie Specjalne Serwisu Prasowego, pp. 135–50.

Kowalska, G. (ed.) (1966), *20 Lat Kultury Polski Ludowej*, Warszawa: Główny Urząd Statystyczny.

Kozakiewicz, S. (1969), *Słownik terminologiczny sztuk pięknych*, Warszawa: Państwowe Wydawnictwo Naukowe (PWN).

Lazar, J. (1965), 'Wstęp', in J. Dalek (ed.), *I Ogólnopolskie Biennale Plakatu*, Katowice: Wydawnictwo Artystyczno-Graficzne, n.pag.

Lenica, J. (1956), 'Polish Film Poster' in J. Lenica (ed.), *L'Affiche Polonaise du cinéma. Polish film posters. Exhibition*, Poland, n.pag.

Lissitzky, E. (1999), 'Our Book' (1926), in M. Bierut, J. Helfand, S. Heller and R. Poynor (eds), *Looking Closer 3: Classical Writings on Graphic Design*, New York: Allworth Press, pp. 27–31.

Marciniak, T. (1975), 'Koncepcja kultury plastycznej', in I. Wojnar (ed.), *Integracja wychowania estetetycznego w teorii i praktyce*, Wrocław: Zaklad Narodoway Im. Ossolinskich/Wydawnictwo PAN, pp. 231–38.

Olkiewicz, J. (1957), 'Myślenie plastyczne', *Projekt*, 4, pp. 11–25.

Rohonyi, C. (1956), 'Polish Film and Theatre Posters', *Graphis*, 63, pp. 68–78.

Rosner, C. (1960), 'Lenica', *Graphis*, 87, pp. 20–31.

Rotzler, W. (1961), 'Advertising for Film and Theatre', *Graphis*, 94, pp. 100–18.

Schubert, Z. (1972), in M. Matusińska and B. Mitschein (eds), *IV Międzynarodowe Biennale Plakatu*, Warszawa, n.pag.

—— (ed.) (2008), *Mistrzowie plakatu i ich uczniowie/Poster Masters and Pupils*, J. Holzman (trans.), Warszawa: Przedsiębiorstwo Wydawnicze Rzeczpospolita SA.

Sontag, S. (1999), 'Posters: Advertisements, Art, Political Artefact, Commodity' (1970), in M. Bierut, J. Helfand, S. Heller and R. Poynor (eds), *Looking Closer 3: Classical Writings on Graphic Design*, New York: Allworth Press, pp. 196–218.

Szemberg, H. (1957), 'Polish Posters 1957', *Graphis*, 73, pp. 398–407 and 462.

Wherever it was possible the author did her utmost to obtain permission from the artists to reproduce their artwork in this chapter.

Notes

1. The reception of Polish poster art abroad is discussed by David Crowley (1993: 25–29).
2. It is interesting to note that in the 1970s the artistic success of the poster created a debate as to whether its sophisticated design actually continued to fulfil the poster's 'communicative' or 'mythmaking' function or whether the poster design turned into an art, became an 'art for art's sake' (Schubert 1972). All Polish translations are mine.
3. Data about the growth of cinema screens in Poland can be found in Kowalska (1966: XVI).
4. In 1960 and 1965 the film production increased, reaching 20 and 24 films, respectively (Kowalska 1966: 29).
5. Wydawnictwo Artystyczno-Graficzne (Art and Graphics Publishing House) was a state-owned art publishing firm which was involved in commissioning poster designers (Szemberg 1957: 399, 465). However, Centrala Wynajmu Filmów was unique in that it commissioned only film posters while Wydawnictwo Artystyczno-Graficzne published posters for all different kinds of cultural events.
6. The international success of the film posters with the critics and galleries also focussed the attention of those involved on the creative side of the poster design (Crowley 1993: 27).

Chapter 4

Here's Johnny! Re-Framing *The Shining*

Laura Hubner

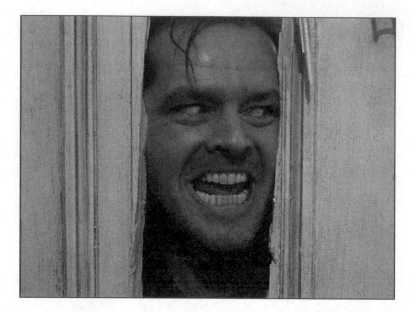

Figure 1. 'Here's Johnny!', *The Shining*.

Film endures as a medium made of moments: the brief, temporary and transitory combining to create the whole.

– (Brown and Walters 2010: xi)

Despite the cinema's illusion of movement, and the forward drive of each frame towards a film's completion, certain moments and individual images from films rise to prominence, creating an indelible impression; the 'brief, temporary and transitory' can shift in different contexts to attain longevity. A single image can become emblematic of a film as a whole, fixing its values and associations in condensed form, or an image can assume new significance beyond the film's imaginings, animating new associations and meanings, even as it returns to the film as referent.

This chapter examines Stanley Kubrick's film *The Shining* (1980) and the diversity of art and design works triggered by it. As a film that is itself partly influenced by the framing devices and aesthetic properties of (still) photography,[1] *The Shining* bears a rich relationship with the other visual arts and has increasingly inspired painters, photographers and caricaturists. Conscious of this dynamic and expanding relationship, this chapter focuses on a single image from the film, as a way of examining specific values, meanings and associations that carry across works of art, in an attempt to shed light on the intricate and complex relationships that can emerge between cinema and the other visual arts, and between movement and stasis, when an image is framed as *iconic*.

When an image has an immense symbolic meaning for a broad section of society during a specific historical period, it has attained 'iconic' status. When an image within a film is seen as iconic, values and meanings injected by the narrative context – fuelled by the tone and meanings invested in the *moment* – elicit emotional reactions that can motivate audiences, artists and designers to create and consume (new artworks), in turn intensifying and reshaping its iconicity.

This chapter explores the close-up image of Jack Nicholson's grimacing face bursting through the door, precisely because of the image's iconic status. Nicholson is playing Jack Torrance, the 'caretaker' of the isolated Overlook Hotel in the Rocky Mountains of Colorado. It is the moment he has slashed a hole with an axe through the bathroom door at the far end of their family apartment nestled within the labyrinthine entrails of the

hotel. Driven to distraction, Torrance is on the rampage to kill his wife Wendy (Shelley Duvall) and son Danny (Danny Lloyd) – his face thrusts through the hole he has made, his cheeks framed either side by the shattered edges of the door. While it can be said that the entire film is rich with carefully framed shots and this is certainly not the only image that has been used to allude to the film, *The Shining*'s (increased) association with this singular image suggests that it contains elements of central worth to the film as a whole.

Since *The Shining*'s inception, this image of Jack's face has stimulated and inspired a plethora of reproductions, new artworks and commercial ephemera, such as paintings, sketches, posters, tattoos, graffiti and merchandise. The reproduction of the image serves promotional and corporate functions; it not only adorns the film's poster and DVD cover[2] but also lighters, badges, canvas prints, hooded tops, key rings and hot water bottle covers. While mass-produced items suggest infinite uses and meanings for diverse consumers and customers they are likely to attract, a singular artwork, such as an individual painting that emulates, or is inspired by, this image tends to signal an artistic interpretation – crucially linked with the artist who has created it.

An Internet search for artworks inspired by *The Shining* leads to a YouTube page where there are a number of 'Speed Painting' videos made by and of artists drawing or painting 'Jack Nicholson'.[3] The image they have chosen to 'copy' is this moment from *The Shining*. Creating 'Jack Nicholson' involves the necessary return to a specific moment, positioning the image of the star in the past, fixed forever within the historical locus of the film. Watching the face speedily take form, and attempting to guess which part of the face, strand of hair or eyebrow the artist will choose to draw in which order, there is both the fascination with the handiwork of the artist (and the material used to conjure the portrait) and the pleasure of knowing what the final image will be like. The experience drives backwards to a known beginning that is fixed and lifeless, to an image that for some precedes the film but is always connected to it. Watching a number of these speed painting portraits of the same image becomes a hypnotic experience, with the near complete picture resonating in and out of focus at various stages through the videos. The final resolution – if these short films can be said to contain a narrative – is the image that we are already familiar with, and yet each impression is strangely new and autonomous.

This chapter revisits *The Shining*, initially sketching out a brief analysis of its visual style, as a way of moving in to examine the framing of this image of Jack's face close up. It explores the image's intrinsic aesthetic qualities, together with its uncanny fusion of the comedic and the horrific, looking at how meaning and tone are framed by the moment it occurs within the film. Moving out from this, I will examine how this iconic image has been reproduced, re-imagined and reframed within a range of artworks and commercial ephemera, generating new meanings external to the film's pace and tone, whilst simultaneously remaining tied to *The Shining* as film and Nicholson as star.

Stylistically, *The Shining* offers certain meanings explicitly. When Jack first enters the Overlook Hotel it is bustling with life and daily sounds; out of season the hotel is pivotal in creating the horrors that occur within. It is inanimate and animate – a large carcass for

events and spectral visions or a pulsating body seeping with the blood that gushes from its elevator doors. Wendy's discovery of Jack's literary output produced through the duration of their stay – amounting to nothing but the repeated words 'All work and no play makes Jack a dull boy' – is projected in purely cinematic terms.[4] Alternating high- and low-angled shots of Wendy and the multiple pages of differently formatted varieties of the same citation convey Wendy's terrified realisation of Jack's mental breakdown and extreme writer's block. As Walter Metz argues, '*The Shining* offers a liminal narrational system caught between the horror film and the family melodrama' (1997: 40). However, I would suggest that in this short scene there is a temporary synthesis of these two genres. It visualises the key themes that underpin the film as melodrama: 'the disintegration of this nuclear family, coincident with the plummet of Jack into the throes of madness' (Metz 1997: 49). But it also registers a vital turning point in the film as horror movie, for in Wendy's look of terror we realise the threat of her husband and the need to escape.

The film is riddled with dualities that in their visual incarnation bring to mind Kubrick's skills as a photographer.[5] We might think of the mirrored reflection of REDRUM or the shots of the two Grady girls, the murdered daughters who haunt Danny, and their uncanny register of Diane Arbus's photograph of twins taken in 1967. There is also the final double portrait of Jack – first dead, frozen in the snow, second, framed within the black-and-white photograph of the 4th July Ball at the Overlook Hotel in 1921, suggesting perhaps that he was the previous caretaker.

When *The Shining* was first shown in 1980 critics were united in perplexity, struggling with the film's sphinx-like façade. P.L. Titterington's overview (1981: 117) of contemporaneous reviews suggests that, while varying in the nature of their interpretations and focus for discussion, there was the general consensus (driven often by an overtly authorial stance) that Kubrick's indulgence in the visual meant the neglect of story, character and suspense. Clearly, suspense is an essential ingredient for what was popularly perceived to be a horror movie. Critics and audiences simply stumbled on the 'loose ends' (see accounts in Leibowitz and Jeffress 1981: 51; Titterington 1981: 117). Titterington suggests,

A possibly typical first reaction is one of bafflement and disappointment; but within hours of the screening, it can happen that the sequences and the experiences begin to rearrange themselves and a completely different way of looking at the film starts to emerge. (1981: 117)

More recently, Jason Sperb (2006: 10) avowed that it was Nicholson's 'empty face, the feeling of that appearance' that initially 'compelled' him to write about Kubrick's films:

In *The Shining*, it is not so much the mind we see as it is the face. We see very little of the world beyond the surface of projections and perceptions. There are of course many violent moments of mental images in the film, but they produce nothing constructive

in the world of the story and constitute mere slivers of time within long periods of narrative uncertainty and ambiguity. (Sperb 2006: 4)

For Sperb, the empty shell of Jack's face slowly emerging through the course of *The Shining* embodies the film's arctic vacuity and lack of meaning: 'The power of the Kubrick facade is not in what it means but in what it creates outside itself' (2006: 12).

Thus, some academics and critics have found the surfaces of *The Shining* impenetrable, seeing the film as reflexively generous but internally lacking. On one level, as a study of the multiple reproductions and new forms of artwork that have emerged since the film, this chapter is interested in looking at what *The Shining* creates 'outside itself'. However, since it is for some a film that refuses admission, I also want to explore how far it is possible to drill down into this single image, to examine the internal quality of the moment. The image of Jack's face – thrusting between the splintered frames of the bathroom door – has attained a significant value that resonates both within and outside the film's parameters. The image is clearly meaningful to the point of being iconic, but iconic of what exactly?

The moment when Jack's face first appears through the space in the door occurs towards the end of the film, with around sixteen minutes to go until the final credits on the standard DVD version of one hour and 53 minutes.[6] It takes Jack approximately two seconds to cite the catchphrase 'Here's Johnny!' While the take is relatively short, it can be argued that the close-up of the face itself gives the moment heightened significance. As Laura Mulvey expounds,

> The close-up has always provided a mechanism of delay, slowing cinema down into contemplation of the human face, allowing for a moment of possession in which the image is extracted, whatever the narrative rationalization may be, from the flow of the story. (2006: 163–64)

This suggests that while film or the moving image has a measurable duration, the speed of our engagement might vary according to specific filmic devices employed. In this instance, the particular framing of this close-up and the exaggerated contortions of the face make this a moment that shouts for attention.

While the iconic status of this image emerged before the advent of digital technology, the DVD now allows us to pause on the exact moment to look at it more closely. Mulvey has written on the capacity that new technologies (and electronic and digital viewing) bring to the moving image, allowing moments and scenes to be re-viewed, so that 'the spectator is able to hold on to, to possess, the previously elusive image' (2006: 161). The DVD pause function allows this sense of possession. Digital software also allows the 'frame' to be 'grabbed' or 'captured' so that the 'elusive image' can be arrested, extracted perfectly intact from its temporal context, and analysed as a still image. Together, these functions help us to analyse this moment from the film as (if it were, in itself) a still image.

The vertical rupture through the cream-coloured bathroom door slices the frame from top to bottom. We see splintered edges from the axe's cuts. Jack's face appears through these, his cheeks slightly squashed by the edges, but the hole is large enough to see his complete face, his reddened hairy neck half in shadow from his chin, his top row of teeth shadowing his tongue as it moves into the second part of the word 'Johnny'. His mouth is open in its sneer, with lips taut to the gums to reveal both rows of teeth as the words are delivered. Long, rugged stubble frames the mouth and his cheeks pull up tight around the eyes. The whites fill most of the eyes; the pupils are over to the far right, just a small fraction of them in sight. Jack's look is cold as a wolf's – hungry and predatory.

At the bottom of the frame we see part of his dark-blue and red checked shirt, absent or scarcely visible in the reproductions of this image, which tend to be cropped at the chin with much less of the door frame visible either side, making Jack's face more central to the composition. Light shines on his temples, across the top of his right cheek and at the point of his nose, brought almost to a sweat after the repeated swings with the axe. The illumination seems to come from slightly higher than his face, suggesting it emanates from the glare of the bright bathroom light. The spot of illumination on his right temple rests beside the loose strands of hair falling in waves stuck together with sweat, kinking across his forehead and eye. Their shape mirrors the curvature of the splintered frame slashed from the door.

It is worth noting that within the context of the film Jack's sideways peer to the far corner works in a similar way to an eyeline match, but here it links *back* to the previous shot of Wendy screaming in the far corner of the bathroom. The poster used to promote the film contains a split frame. The first (left-hand) frame contains the image of Jack's face through the door. The remaining two-thirds of the poster convey the previous shot of Wendy screaming in the corner, her head back against the wall, eyes and mouth wide open in trepidation, her limp left hand clutching the wall, wedding ring in sight, and her right hand holding the large kitchen knife. In the left foreground of this image and slightly out of focus, the axe penetrates the door, filling more than half of this side of the split frame. Wendy's bulging eyes are fixed on the enormous axe. Thus in this early promotional poster Jack's grimacing face is given supporting context, as it is followed by the axe and screaming wife. Reversing the chronology works to narrativise his actions for audiences who at this stage were unlikely to be familiar with the film. Subsequent reproductions drop the axe and screaming female, suggesting that Jack's face alone is enough to connote the moment and the context; his crazed sideways look alone is enough to connote his actions and his sought for prey. It also suggests the sustained iconic status of Nicholson as star.

Moreover, it is clear that there is a resounding sound in the image. The coming together of the timbre and tone of Nicholson's voice citing the catchphrase 'Heeere's Johnny!' has the effect of extending the moment and making it stand out. It is on the final sound, or more precisely the transitional sound – as the 'n' jumps to the 'ee' of 'Johnny' – that we catch a fleeting glimpse of the moment that has generated a multiplicity of still-image reproductions and emulations. We hear the catchphrase in the arch of the tongue, the

shape of the mouth, the raised cheeks and eyebrows, the slight sneer and flash of teeth; the words are synonymous with the image. Much of the merchandise capitalises on this relationship. For example, the 'Here's Johnny' range, including an antique silver lighter, embroidered iron on badge, 'hoody' and PVC key ring, all feature the caption underneath the image. These are all reworked from an independent design[7] using block monochrome, in which black shades capture the important features – the hair strands, pupils, facial hair, neck, mouth and fine crease beneath the eyes. Block shades of black across the left-hand eye and to the far right side of the other pupil, together with the waved arch of the eyebrows, form an arrow that points to the right-hand side (to where Wendy would be positioned). These have become the key features of the iconic grimace, reducing the detail of the face to the important signatures that denote both catchphrase and context.

The synonymous relationship is so ingrained that designers play around with it. For example, on the hot water bottle cover, the caption is replaced by 'Sleep Tight' in gothic Chiller-style font, ridiculing and emulating both the intense horror and the ironic tone of *The Shining*. Indeed, getting the catchphrase wrong has become part of the game. A recent example of this appeared on the cover of British current affairs magazine *The Week* (11 September 2010) with the caricatured drawing of Tony Blair's broad-grinning face smashing its way through door splinters to the caption 'He's back!' The silly misquote, overly arched eyebrows and wonky teeth combined with the more sinister subheading – 'Is Blair Damaging His Party?' – capture something of the mixed tones and meanings embedded within the original scene of *The Shining* but also bring a satirical twist specific to the new context.

However, identifying the meaning and tone of the original scene is not easy. It was voted Number 1 in the British television 'Best Of' countdown show, *The 100 Greatest Scary Moments* (Channel 4, Saturday 25 October 2003). Why is this moment perceived to be so 'scary'? At its base level, the idea of a father attempting to murder his wife and son is a horror of mythological proportions. The threat of murder within the family was a terror seen as important by writer Diane Johnson who worked with Kubrick in adapting Stephen King's novel to screen. When asked what she felt had been essential to keep in the screenplay, she replied,

> The horror, of course – the whole atmosphere of growing fear within the domestic circle was the core, I think. The thing that was more interesting to us, though, was *why* this situation was horrifying, if it is horrifying. There was something very basic here with the father trying to kill the son and the son trying to kill the father. That and the feeling of powerlessness. (McCaffery and Johnson 1981: 78)

Significantly, Johnson then refers to this as the 'archetypal situation' (McCaffery and Johnson 1981: 78). Earlier in the interview, McCaffery comments on the way Johnson's recent books, *The Shadow Knows* and *Lying Low*, as well as her work on *The Shining*, 'seem to increasingly concern themselves with what a character in [her] work calls "the

terror of the real beneath the form'" (McCaffery and Johnson 1981: 76). Since *The Shining* has sometimes been considered a film where surface style and form reflexively mask the sense of 'terror of the real beneath', Johnson's conception of the horrific helps to suggest why this scene with Jack slashing through the door is so pivotal to the film. This is the moment when the realisation of this 'archetypal situation' is at its most intense.

Just prior to striking the first blow to the bathroom door, Jack cites words taken from the children's fairy tale the *Three Little Pigs*: 'Little pigs, little pigs, let me come in.' With a smile increasingly wide and exaggerated, eyes racing and eyebrows raised excessively, he speaks for the 'little pigs', asking, 'Not by the hair of your chinny chin chin?' He delivers these lines like a father telling the tale in the guise of the cartoon wolf.[8] As if in jest, with puffed up jowls and eyebrows awry, he steps back shakily and says rather stumblingly: 'Then I'll huff and I'll puff and I'll blow your house in.' He takes a big swing with the axe, and we hear Wendy scream from the other side of the door.

As Geoffrey Cocks asserts, 'the wolf is literally at the door' (2004: 33), and this is an expression of an archetypal fear that is deep-seated within fairy-tale horror. It is a double horror – the wolf as outsider (and hungry predator) has become the wolf within the family, an expression of patriarchal violence at its most extreme. The sexual threat posed by the aggressive violation of his axe as it triggers Wendy's screams also recalls the wolf of *Little Red Riding Hood*. Furthermore, the wolf analogy alludes to the film's broader concerns with gothic horror dualities and notions of the split self. The boundaries between animal and what it is to be human crumble as Torrance is possessed by uncontrollable urges.[9]

While the moment can be seen as truly terrifying, Nicholson's overblown performance also makes him a comical and slightly pathetic figure. It takes him a significant amount of time and effort to break through the two doors with his axe – about seventeen hacks through the first door to their quarters and then approximately fourteen through the bathroom door, plus a deal of back-hacking and breaking bits off as he tugs the axe back through to take the next swing. Unbeknown to him, Danny manages to escape just before he recites the words from the *Three Little Pigs*. Wendy will subsequently slice the back of Jack's hand with the knife, and he will cower like a pet with a wounded paw as it draws blood. He will not get through the door to his victims, and by the end of the film Danny will outwit him in the maze.

However, the tone is far from light and there is something uncanny in the scene leading up to the moment, and the combination of terror, irony and (to borrow Johnson's term) 'powerlessness'. As Jack staggers through their living quarters, there is a sense of *déjà vu*, to the first visit to the 'staff wing' earlier in the film, when Ullman first showed Jack and Wendy where they would be staying, 'There are your quarters – living room, bedroom, bathroom.' This swift announcement drew attention to the clear contrast between their modest quarters and the enormous Colorado lounge in the previous sequence, which had ignited such excitement from Wendy, 'Beautiful … Oh God … This place is fantastic isn't it!' We recall Jack's camp nicety at that earlier point in the film and his empty smile ('Perfect … for a child') in response to seeing the small basic room where Danny would

sleep with its z-bed, brown mattress and drab folded blankets. Thus, Jack's entry into these family quarters at this later point in the film, in his transformed and degenerate state, represents the return of the repressed, but within a setting that is homely and familiarly mundane.[10]

The Shining's dual worlds of everyday familiarity and another darker sphere are characteristic of gothic horror. As Charlene Bunnell articulates, '[t]he Gothic, acutely aware of the universal dichotomies in life, is concerned with two worlds, coexisting in the genre's portrayal of reality: a diurnal world and a nocturnal one' (1996: 81). Jack's chirpy citation of the dutiful husband's call through the apartment's outer door, 'Wendy, I'm home!', as he peeps through the peach surrounds of the shattered door frame to the peach floral wallpaper of the apartment hallway, has a comical and performative function that in this changed context subverts essentialist domestic discourses associated with American commercials and TV shows.

For Sigmund Freud 'the uncanny is that species of the frightening that goes back to what was once well known and had long been familiar' (2003: 124). Freud's long investigation into the German root of 'uncanny' directs him to the meaning in which *heimlich* merges with *unheimlich* – 'the one relating to what is familiar and comfortable, the other to what is concealed and kept hidden' (2003: 132). This leads to the helpful deduction 'that the term "uncanny" (*unheimlich*) applies to everything that was intended to remain secret, hidden away, and has come into the open' (2003: 132). It is Jack's jovial tone, his eye-rolling madness and ironic references to popular culture as he lunges through the mundane clutter and pink furnishings of their apartment, past comic books and games to the bathroom, the most private room of these remote quarters, that make this scene uncannily disturbing.

And this is not the first bathroom encounter in the film. Jack's meeting with the beautiful naked woman in Room 237 who decays when he embraces her and Danny's first conversation with his visionary finger character 'Tony' both occur within a bathroom setting. The location also recalls the shower scene in *Psycho* (Alfred Hitchcock 1960). As Cocks argues, the connection is particularly strong because of the setting: '*Psycho* marked a turning point in horror cinema by bringing horror in from its origins far away and long ago into the contemporary domestic scene' (2004: 185). Like *Psycho*'s 'brightly lit' motel, this scene from *The Shining* hosts a similarly 'modest façade of comfort and security' (Cocks 2004: 185).

But it is Nicholson's performance in combination with the setting that establishes the tone of the moment. Sharon Marie Carnicke analyses Nicholson's 'exaggerated performance' (2006: 22) during another sequence in *The Shining*, examining its Brechtian capacity as distinct from Duvall's more naturalistic style: 'In the face of Duvall's reactive terror, Nicholson does not react so much as over react' (Carnicke 2006: 28). And I would argue that although Torrance plummets into madness through the course of the film, there is clearly an unnerving quality to Nicholson's delivery from the start of the film that presses against any sense of linear descent. His raised eyebrow during the 'interview'

scene serves as an early example of this duality.[11] The tensions between character and star give substance to the meanings of the 'Here's Johnny!' image.

Most accounts of this sequence are quick to point out that 'Here's Johnny!' was ad-libbed during the moment of filming. Within the context of the film, it offers a self-reflexive moment conjured by the charismatic star displaying a unique humour, associated with Nicholson's persona. In many of the reproductions of the image, such as the mounted photographic stills that fans have on their walls, the mythic qualities surrounding spontaneity give the sense of returning to the historical moment of Nicholson's performance. Writing about the specific quality of stillness found in an image electronically stilled or paused from a moving image or film, Mulvey argues that '[w]hile the flow of the image at 24 frames a second tends to assert a "now-ness" to the picture, stillness allows access to the time of the film's registration, its "then-ness"' (2006: 102). In this instance, there is the double sense of capturing the 'then-ness' of Nicholson's performance (at the time of the film's 'registration') at the same time as being aware of it as a specific moment from *The Shining* as film. We see through the face of Jack Torrance to that of the star Jack Nicholson, and vice versa, and the doubling is reinforced by the simultaneous recognition of the shared name 'Jack'.

In *Story of the Scene*, which provides 'the inside scoop on 80 famous moments in film' and significantly displays the image of Jack's face on its cover,[12] Roger Clarke's description bears testament to the importance of the stars' personae:

> Kubrick's frequent verbal assaults on Shelley Duvall are said to be responsible for her nervous, harried look. That poster image of Duvall's face and Nicholson's demonic grimace always evokes Nicholson's ad-libbed line, 'Here's Johnny!' (Clarke 2009: 120)

This highlights the importance for audiences of the stars' and director's presence – at the point of filming. Clark's piece ends by reminding us of the source of the catchphrase reference: 'the classic introduction used by Ed McMahon when he ushered Johnny Carson onto the *Tonight Show*' (2009: 121). Within the violent context of this horror, the familiar line 'Here's Johnny!' gently mocks and pays homage to a slice of contemporaneous American popular culture, while at the same time acting as a lightly subversive and acerbic chuckle at the inanity of *The Tonight Show* and the type of consumer who vacuously laughs at such catchphrases and shows.[13]

Concentrating solely on the visual aspects of the image from *The Shining*, we see that Jack's teeth-bearing grimace is exaggerated to the point of caricature. While it can be argued that on one level the baseline horrors of the moment are defused by the humour of Nicholson's performance, there is also something extremely disturbing about the image, *because* of the humour, both as it appears within the film and in many of its reproductions and interpretations. Seeing the image recast as a tattoo on a person's arm, for instance, where Nicholson's sneering face seems to break through the surfaces of the skin, recalls Victorian art historian John Ruskin's description of one of the many

'grotesque' heads that 'disgrace the latest buildings' of Venice: 'huge, inhuman, and monstrous, – leering in bestial degradation' (Ruskin 1979: 206).

James Naremore explores 'the aesthetics of the grotesque' in relation to Kubrick's work, drawing on the influential definitions given by Ruskin: 'It seems to me that the grotesque is, in almost all cases, composed of two elements, one ludicrous, the other fearful' (Ruskin 1853, cited in Naremore 2006: 6). Although Naremore does not analyse this actual moment from *The Shining*, his point that the grotesque is a fusion of 'laughter, fear and disgust' in unsettled tension is crucial in unpacking the tone of this image and many of its reproductions:

> In all its visual and verbal manifestations … the grotesque is structured by a dual implication and therefore has something in common with such rhetorical figures as ambiguity, irony and paradox … In effect, it fuses laughter and screaming impulses, leaving the viewer or reader balanced between conflicting feelings, slightly unsure how to react. (Naremore 2006: 6)

Naremore's definition is helpful when thinking about the humorous and grotesque values at stake in some of the body art interpretations of this image. The tattoos tap into the dualities underlying Nicholson's performance and role, but the re-framing of the image on the human body also adds a dimension that is freshly uncanny, bringing with it new associations and meanings.

In addition, tattoos have a specific cultural value, independent of other arts. As Enid Schildkrout asserts, the recent 'renaissance' for tattoos in western culture comes as a result of

> a shift in many aspects of Western tattooing (the nature of the people who created tattoos, involving a shift from tattooists to tattoo artists); a change in clientele (from sailors, bikers, and gang members to the middle and upper classes). (Schildkrout 2004: 335)

On a par with the values attributed to Nicholson and *The Shining* are the subcultural values associated with the tattoo artist and venue (where the tattoo was inked). On the website 'Rate My Ink', for example, a photograph of a man's arm bearing a tattoo of the image of Jack's face through the door is captioned with the identity of the artist, plus the name and date of the convention ('Pastor' from Deep Six Laboratory in Philadelphia, at the Hell City Tattoo Festival in Columbus, Ohio, May 2008).[14] Comments from the guests on the site praise the high quality of the shading as much as the film the image is taken from, drawing attention to the handiwork involved in the creation of the new work of art.

This brings us back to where we began at the start of this chapter, to the YouTube celebrity 'Speed Painting' videos made of artists' interpretations of Nicholson. Like the

tattoo sites, comments focus largely on the artist's skill in interpreting and bringing life to the image.[15] For example, one of the paintings stimulates praise of the specific materials used at each stage, such as the soft graphite colouring pencil and the watercolour paints.[16] Similar kinds of self-reflexivity are evident in the online responses to the street art that pays tribute to *The Shining*. And one of the most transparent examples of self-reflexivity within the artwork itself is the graffiti that adorns the doors of a shop called Videodrom in Berlin, where the graffiti image of Jack holds out a spray can in his left hand.[17]

Tom Gunning's reflections on the significance of movie moments help to draw this chapter towards its conclusion:

> Movies are made up of moments, which both accumulate to an end and, in a sense, scatter across our memories. If we think of a movie as something which moves continuously, following the actions of characters and the trajectory of a story, then moments might seem to mark the points along the way. But if we dwell on the sense of a *moment* in its singularity, it seems less to evoke momentum of a plot than something that falls outside the story and its pace. (Gunning 2010: 5)

Meaning and tone vary within different contexts. The growing range of tributes to this image of Jack's face through the door has been incited – and made all the more internationally accessible – by recent developments in online digital exhibition, which allow new frameworks for relating to the film and a space for renewed expressions of homage, parody and fan value. Alongside this, close analysis of the image within the context of *The Shining* establishes a sense of the competing tones and meanings of this moment. The specific qualities of humour, horror, gothic duality and the 'grotesque' are captured, reproduced and reinterpreted within the multiple artworks and commercial ephemera that have been stimulated by this single image.

Bibliography

Brown, T. and J. Walters (2010), 'Preface', in T. Brown and J. Walters (eds), *Film Moments,* London: BFI Palgrave Macmillan, pp. xi–xii.

Bunnell, C. (1996), 'The Gothic: A Literary Genre's Transition to Film' (1984), in B. K. Grant (ed.), *Planks of Reason: Essays on the Horror Film,* Lanham, Maryland and London: Scarecrow Press, pp. 79–100.

Carnicke, S.M. (2006), 'The Material Poetry of Acting: "Objects of Attention," Performance Style, and Gender in *The Shining* and *Eyes Wide Shut*', *Journal of Film and Video*, 58:1/2, pp. 21–30.

Clarke, R. (2009), *Story of the Scene: The Inside Scoop on Famous Moments in Film*, London: Methuen Drama.

Cocks, G. (2004), *The Wolf at the Door: Stanley Kubrick, History, and the Holocaust*, New York: Peter Lang.

Freud, S. (2003), 'The Uncanny' (1919), in *The Uncanny*, D. McLintock (trans.), London: Penguin Classics, pp. 123–162.

Gunning, T. (2010), 'Shadow Play and Dripping Teat: *The Night of the Hunter* (1995)', in T. Brown and J. Walters (eds), *Film Moments*, London: BFI Palgrave Macmillan, pp. 5–7.

Leibowitz, F. and L. Jeffress (1980), '*The Shining*', *Film Quarterly*, 34, pp. 45–51.

McCaffery, L. and D. Johnson (1981), 'Talking about *The Shining* with Diane Johnson', *Chicago Review*, 33:1, pp. 75–79.

Metz, W. (1997), 'Towards a Post-structural Influence in Film Genre Study: Intertextuality and *The Shining*', *Film Criticism*, 22:1, pp. 38–61.

Mulvey, L. (2006), *Death 24x a Second: Stillness and the Moving Image*, London: Reaktion Books.

Naremore, J. (2006), 'Stanley Kubrick and the Aesthetics of the Grotesque', *Film Quarterly*, 60:1, pp. 4–14.

Ruskin, J. (1979), 'Grotesque Renaissance' (1853), in J.D. Rosenberg (ed.), *The Genius of John Ruskin: Selections from His Writings*, Boston, London and Henley: Routledge & Kegan Paul, pp. 204–17.

Schildkrout, E. (2004), 'Inscribing the Body', *Annual Review of Anthropology*, 33, pp. 319–44.

Sperb, J. (2006), *The Kubrick Facade: Faces and Voices in the Films of Stanley Kubrick*, Lanham, Maryland, Toronto, Oxford: Scarecrow Press, Inc.

Titterington, P.L. (1981), 'Kubrick and *The Shining*', *Sight and Sound*, 50:2, pp. 117–21.

The Week, 11 September 2010, Issue 783.

Notes

1. This area is touched on later in this chapter. For a more detailed account of Kubrick's connections with photography, see James Naremore (2006: 7–8).
2. Region 2: 2001, 2007 Two-Disc Special Edition (Warner Home Video); Region 1: 2007, 2010 (Warner Home Video).
3. http://www.youtube.com/watch?v=yL0j3nkVVzY (28 April 2011).
4. There is no culminating moment like this in Stephen King's book, *The Shining*, first published in 1977.
5. During his early career, Kubrick worked as a photographer for *Look* magazine and was also associated with the cutting-edge photographic artists of the period from the 'New York School'.
6. On the standard-length DVD Jack's face first appears through the door at 1:36:38; the specific image that is analysed is at 1:36:40 (entire film duration: 1:52:31). On the director's cut version, the timings are 2:04:14 for this image, and the whole film duration is 2:23:37.
7. For example, 'The Shining Hoody' has the following disclaimer: 'Independent design featuring licensed photos and artworks from independent sources. They are not officially endorsed or connected with any of those people and companies depicted within or anybody affiliated with them. All names for identification only', http://www.kapowgifts.co.uk/acatalog/The_ Shining_merchandise.html (28 April 2011).
8. Geoffrey Cocks notes that the lines Jack quotes are from the 1933 Walt Disney version, *Three Little Pigs* (Burt Gillett), rather than 'The Story of the Little Pigs' first published in England in J.Q. Halliwell's *Nursery Rhymes and Nursery Tales* (1843), and suggests that this highlights the importance of the movies in the Torrances' lives (2004: 38).
9. There is the added dimension of viewing this retrospectively, since Nicholson's role in *Wolf* (Mike Nichols 1994).
10. Even the camerawork is chaotic at times, allowing objects to blur out of focus, in sharp contrast to the Steadicam smoothness of other sequences in the film.
11. In addition, Nicholson's star persona was to some extent shaped by his roles in films made prior to *The Shining*, such as *One Flew Over the Cuckoo's Nest* (Milos Forman 1975).
12. The version reproduced on the book cover is 'closer' to the face and decentred, in the sense that the face fills the frame with no door showing on the left, and just a slice of the door in sight on the right.
13. This aspect of American popular culture is further parodied in US animated television show *The Simpsons*. In its spoof of the film, comically re-titled *The Shinning*, it is the lack of television and beer that drives Homer Simpson to the point of murderous insanity, scrawling the words 'NO TV AND NO BEER MAKE HOMER GO CRAZY' across the walls, ceiling, floor and stairway. 'The Simpsons Halloween Special V', 'Treehouse of Horror V', *The Simpsons* DVD, Season 6, Disc 1 (20th Century Fox Home Entertainment).
14. http://www.ratemyink.com/?action=ssp&pid=57534&cat=1 (28 April 2011).
15. Sometimes the website overtly advertises the artwork's commercial value. For example, one of the paintings displays a caption above the film stating that it is available for purchase on eBay, and there is also a reminder of this at the end of the film.
16. http://www.youtube.com/watch?v=yL0j3nkVVzY (28 April 2011).
17. http://www.slashfilm.com/the-shining-street-art/ (28 April 2011).

Part II

Movement and Stasis

Chapter 5

Narrativising Pastness: The Photographs of Donald Thomson and *Ten Canoes*

Steven Allen

A photograph arrests the flow of time in which the event photographed once existed. All photographs are of the past, yet in them an instant of the past is arrested so that, unlike a lived past, it can never lead to the present.

(Berger and Mohr 1989: 86)

John Berger and Jean Mohr's claim points to a distinction between a lived experience and the insurmountable distance that exists between a photographically captured past and the now of viewing the picture. However, a central aim of this chapter is to propose that the still image, when invigorated by both a cinematic context and a culturally specific validity, can function to construct a credible, embodied status that the photograph inherently denies. To do so, I will examine *Ten Canoes* (Rolf de Heer and Peter Djigirr 2006), a film that is not only inspired by but also recreates a series of existing still images, thereby making it a most productive object of study when analysing the relationship cinema has with photographic visual art. The exploration is part of a dual focus that also seeks to suggest how dramatisation might augment the documentation propensity of the photographic. In so doing, I will discuss how *Ten Canoes* relies on, and paradoxically critiques, visual anthropology's ability to neatly authenticate the past. I therefore wish to propose that the film's connections with other visual arts allow it to draw strength from the imitative display of hermetic temporal remoteness but concurrently renew contact with it by speculatively narrating its pastness.

Ten Canoes is a fiction film made as a collaborative project between the Yolngu people of the Ramingining community in Arnhem Land, part of the Northern Territory of Australia, and white immigrant director Rolf de Heer. The film is comprised of two stories, set in different time periods. The film cuts back and forth between the two, offering comparable importance, but with the second story emanating from the first as a narrated fable. In the former, filmed in black and white, Minygululu leads ten men on a goose-egg hunt in the Arafura swamp in Northern Australia. Minygululu discovers that his younger brother, Dayindi, desires his third wife. To teach Dayindi to adhere to social codes, he tells him a meandering morality tale. This second story is set in mythical times and is filmed in colour. It features Ridjimiraril, his three wives and his brother, Yeeralparil, who covets Ridjimiraril's youngest wife, Munandjarra. After a stranger has visited, Nowalingu, one of Ridjimiraril's other wives, disappears; the outsider is blamed

resulting in tribal conflict. Dayindi's story is set much more recently than the temporally distant mythical times of the morality tale, but nonetheless it illustrates a time of no influence by white people, with the press kit stating it is 'a thousand years ago' (Palace Films 2006: 4).

Ostensibly, the question of pastness is therefore not based on the effects of colonisation, and yet, Dayindi's tale is visually informed, as is the film as a whole, by the photographs taken in the 1930s by white anthropologist Donald Thomson.[1] Between 1935 and 1937, Donald Thomson was sponsored by the Australian government to go to the region to help find a peaceful solution to conflict, both internal and with the outside world. The latter was particularly sensitive at that time, after the Yolngu had killed five Japanese fishermen, and three white men, including a policeman. Heightened public attention fuelled fears the Indigenous people might mass together to attack the local white settlers (notably a Mission Station on Groote Eylandt Island), so a 'punitive expedition' was proposed, which would have undoubtedly led to a massacre. Thomson records that he did not recognise the depiction of the Indigenous people as mindless murders, describing them as 'warm, kindly and friendly people' (Thomson 2005: 26), and he felt compelled to intercede.[2] A key part of the legacy of Thomson's stay with the Yolngu is a set of photographic imagery (approximately 4000 black-and-white glass plates) that depicts a mode of living largely untouched by the influence of white people. And although colour film exists of Thomson's time in the desert region of Australia, in respect of Arnhem Land, the 20,000 feet of film that he shot was destroyed in a warehouse fire in 1946 (Bell 2007: 35); such historical happenchance no doubt contributes to the cultural significance for the Yolngu of the existing monochrome still imagery.

The film's tie to Thomson's photographs of the 1930s, a recognisable time period, is important because a continuity is established between it and the film's depicted epochs that predate that time. What I will therefore explore in this chapter is the particular formulation of pastness in the film, one that relies on approaches to visual anthropology to assert an indeterminacy more usually regarded as being at odds with the photograph's apparent ability to capture events.

Photography

The Thomson photographs were the direct inspiration for the film, with Indigenous actor David Gulpilil showing them to de Heer when the director visited him in Ramingining, near the Arafura swamp, during the planning stages. Of specific resonance was one that informed the title of the film (Figure 1).[3] Taken by a white outsider to document the Yolngu, Thomson's photographs had already become part of a process of self-definition for the community, as the pictures had found a route back to Ramingining (via Museum Victoria) many years after they were shot, with the early 1990s seeing 'some folders of images [being placed] in the office at Bula'bula Art Centre with the one of the ten canoes

Figure 1. Goose hunters, Arafura Swamp, Northeastern Arnhem Land, 1937.
Photograph by D.F. Thomson. Courtesy of the Thomson family and
Museum Victoria (TPH 1090).

on the wall' (Hamby 2007: 135). The men in the photograph of the ten canoes, which de Heer regards as 'profoundly cinematic' (Palace Films 2006: 8), have been identified, and ancestral relationships provided the basis on which the people were chosen to play the roles in the film. *Ten Canoes* enabled the photographs to be re-appropriated by the Yolngu to tell their story, not that the originals were seen negatively, with Thomson being a champion of the rights of Indigenous people. Moreover, the people of the Ramingining community remember positively what is called 'Thomson Times' as a period when their kin, recognisable in the photographs, were still living according to traditional cultural ways. In this respect, the images never totally lacked the 'lived past' that Berger and Mohr (1989: 86) define photography through.

But the film offered the opportunity to narrate a history in relation to the still images. Whilst the colour sequences of the film employ an almost constantly moving camera, the black-and-white sections are predominantly still compositions, with a locked off camera, which frequently include a recreation of a recognisable Thomson photograph. These moments re-enact the stilled image, filling the cinematic frame with a historically recognisable composition. Rather than being 'profoundly cinematic', which I take de Heer to mean as visually and narratively dynamic, these lulls in action appear governed by the contemplative mode possible with still photographs. Thus, at these instances the cinematic properties of the image are recast as dormant, held in check whilst charged with a latent capacity (especially for movement). The shots act as a prelude to entering the world of the still image, a transitional process the film-makers saw as 'the essence of real cinema' (Palace Films 2006: 8).

So what is contemplated during these moments of stasis? Roland Barthes has described how 'the Photograph always carries its referent with itself' (Barthes 2000: 5). Consequently, he argues that the effect of the photograph is 'to attest that what I see has indeed existed' (Barthes 2000: 82). But in *Ten Canoes*, the referent for the stilled image is another still image, the photograph taken by Thomson. Through the comparative framing, composition and subject matter, what the film's stilled image directly attests to is the archive rather than the event, which remains referenced but one stage removed. As I will explore below, it is therefore the historical record that is borne out by the stasis rather than the pro-filmic; ultimately it is the former that is questioned.

The publicity for the film ensured audiences were aware of the original photographs: the Press Kit devotes a page to discussing them and another to telling how David Gulpilil first showed them to Rolf de Heer (Palace Films 2006: 8–9); the director converses about them in most interviews (see Bell 2007; Walsh 2006); they are referenced in reviews (see Gray 2007; Kuipers 2006), and alongside the film's premiere at the Adelaide Arts Festival, there was an exhibition including other photographs by Donald Thomson. Therefore the images that stall the action are read as a re-presentation of imagery and image-making, thereby foregrounding the mediation process. The strategy forms part of a re-authoring of the presentation of Indigenous people. The objectification, and arguably fetishisation, of anthropological imagery, however well intentioned and culturally significant to those

depicted (as Thomson's work evidently was and is), is brought to consciousness by deliberately posing the image and then breaking the stasis with movement. We become aware we are observing what has become the historical record and that it is impossible for it to contain the past, which we witness spilling over into the narrative. Stylistically, the film signals the incompleteness of the historical record whilst honouring the power that the images have within the cultural memory. Analysis of a sequence where Yeeralparil pursues Ridjimiraril's wife, Munandjarra, will illustrate this.

Beginning with a montage of very short scenes of Yeeralparil being thwarted by Banalandju as he attempts to meet with Munandjarra, the sequence then cuts to the other primary time period of the film, namely that centred on Dayindi's goose-egg gathering. In the first of the former scenes, the camera tracks from behind a purposefully walking Yeeralparil; the shot then cuts to in front of him whilst continuing to track his movement, before the camera pans to show Munandjarra being escorted away by Banalandju. In the next, the camera pans with the two women before continuing along the same alignment, but with greater haste, in response to Yeeralparil's whistle to attract his object of desire; from the point-of-audition shot that results, the camera pans back as the women turn tail and retreat In the final attempt to communicate, we witness a rapid track back from a close-up of Yeeralparil hiding behind a leafy branch, with the camera's speed of movement emphasised by the change of shot scale of the diminishing foliage; Banalandju then shoos him away. These three short scenes, shot in colour, are followed by a cut to a monochrome long shot of the swamp, where the mid-ground displays the empty, still water for six seconds before Dayindi's canoe slowly enters the frame from the right. The shot, of 34-second duration, records the leisurely movement, as the canoe appears, proceeds across and then exits the frame on the left-hand side (Figures 2, 3 and 4). At approximately the midpoint, the composition recreates a Thomson photograph of a man in a canoe (Figure 5). After pausing once again on the empty frame to balance the beginning of the shot, we cut to Dayindi on dry land, peeling bark from a tree, which looks likely to be used in building tree platforms.

The contrast between the colour sequences and the black-and-white ones draws our attention to time, both shot duration and epochs. The moving camera, frequent edits and varying shot lengths of the colour sections are accentuated in the above example by the stasis of the subsequent long shot of the black-and-white swamp. Rather than the action continuing to happen, we are forced to anticipate an event, to await the canoe. It draws our attention to the passage of time, of the event unfolding. Similarly, although giving us time to appreciate the landscape – in a Bazinian sense the spectator can make links between the objects in the deep-focus shot (Bazin 1967: 35) – I would argue it is not the space we are drawn to, but time, in this case through the figure passing through the shot. The flow of images, which constitutes a progression of time, is paradoxically not what conveys the time. Instead, it is when the associated movement or change, which we anticipate in cinema, is stalled that we notice time passing. Of course, there is some movement, ripples, the effect of wind and so forth, as the image is not frozen, but the essence is the

Figure 2. Movement and stasis: awaiting Dayindi's canoe, *Ten Canoes*.

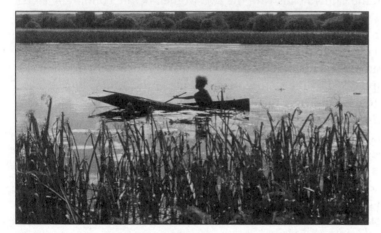

Figure 3. Movement and stasis: Dayindi's canoe in *Ten Canoes*, framed to replicate a photograph by Donald Thomson.

Figure 4. Movement and stasis: after Dayindi's canoe has exited the frame in *Ten Canoes*.

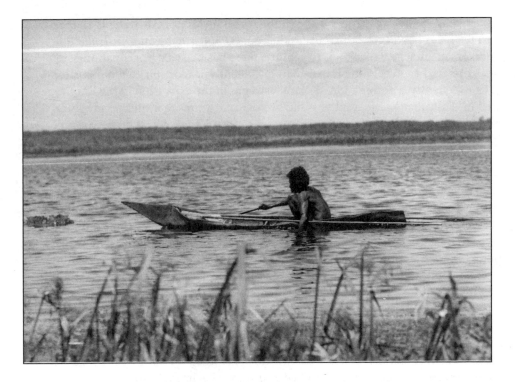

Figure 5. Goose hunter in bark canoe, Arafura Swamp, Northeastern Arnhem Land, 1937. Photograph by D.F. Thomson. Courtesy of the Thomson family and Museum Victoria (TPH 1096).

stillness. That there is some motion, but that it is negligible, is what heightens the effect of stasis, for as Deleuze notes, 'water is the most perfect environment in which movement can be extracted from the thing moved, or mobility from movement itself' (1992: 77); so we observe the minuteness of the change. We might also note that Barthes suggests the constant flux of the moving image prevents an insistence on a former existence of the referent (Barthes 2000: 89), so it cannot point to the archive in the manner the static shot does. The key aspect then is that the allusion to photographs, both a historical record, and a retarding of the flow, reinscribes the past. What has elapsed, and the capturing or fixing of it, are what frame how we are to approach what we are shown.

That time comes to the fore has added resonance when one considers that the nation's penal colony foundations were underpinned by spatial concerns that eclipsed the past. Australia's colonial history is based on a denial of time, a rejection of Indigenous culture

before the arrival of white westerners. Indeed, the visual history of Australia is framed within such terms. Helen Ennis has argued in her book *Photography and Australia* that with no markers of ancient civilisations to capture, there has been a preoccupation 'with the physical, material aspects of life rather than its metaphysical or spiritual dimension' (2007: 9). Consequently, a domination of space, via signs of the expansion of the Empire, proliferated in Australian photography, as did geological features marking geographical space. The terrain was illustrated via physical presence. *Ten Canoes* offers no perspective on the land being dominated; in fact, I believe it unsettles the familiar and repeated assertion of what the Australian landscape is (namely being a red desert), something I will discuss shortly, but for the moment, I wish to suggest that the juxtaposition of aesthetics in the film points to a landscape of time rather than space.

The emphasis on time passing contrasts the ontological status of a photograph. Susan Sontag (1997: 17) designates photographs as embodying 'a neat slice of time', and the film disturbs that neatness. The combination of stasis then movement in the film breaks the temporal boundaries of the photograph, suggesting events beyond those the picture contains. The temporal register of cinema has not gone unnoticed by others, as André Bazin observes:

> The cinema is objectivity in time. The film is no longer content to preserve the object, enshrouded as it were in an instant, as the bodies of insects are preserved intact, out of the distant past, in amber. … Now, for the first time, the image of things is likewise the image of their duration, change mummified as it were. (Bazin 1967: 14–15)

Bazin's point is that cinema can objectively convey spatiotemporal relationships, a flow, rather than a singular juncture. However, *Ten Canoes* complicates the configuration. Its static images correspond, in spite of being recreations, to specific events captured by the photographic objectivity of Thomson's lens. The film's scenes of movement that emerge from these moments of stasis refer to both the time and space of the original photographs as well as the pro-filmic that the movie records. Through the comparative placing of these two modes of representation, cinema's temporal dimension is not afforded the same objectivity as the still image; it is instead rendered suppositional, located in the fictional film rather than the archive. Going outside the fixed temporality of photographs, *Ten Canoes* proposes a subjunctive history of events surrounding the slice of time recorded by Thomson; this is not the mummified change to which Bazin refers, or at least what it preserves is not the same as that documented in the static shot. The certainty of the still photograph, the containment of a moment, is replaced by a speculative 'what if'.[4] In doing so, it reveals the inadequacies of the photograph's (and by association, the archive's) ability to convey sufficient information, whilst celebrating the image's symbolic status.

The tonal qualities of the imagery are significant too. The movie was contracted to be made in colour, but the Press Kit states that because the Thomson photographs were in monochrome 'the cultural history of the [Yolngu] people was in black and white' (Palace

Films 2006: 11). It was through the Thomson photographs that they framed their culture prior to the influence of white people: a pre contact history. Louise Hamby has therefore argued that 'in both their [the Yolngu people's] production and reception of Dayindi's story, it takes place not 1000 years ago but in "Thomson Times"' (2007: 127). Converting the still images into moving ones became a means for the Yolngu people to narrate their own relationship with the past. When discussing the decision to use black-and-white images in *Time* magazine, Paul Grainge has argued they 'evoke time in a culture of space' (Grainge 1999: 384). Reading *Ten Canoes* in such a way, the monochrome elements complement an emphasis on temporality in relation to the land and its people, rather than the familiar focus on the landscape. Grainge goes further suggesting black and white, as a chosen aesthetic, supports a specific engagement with what is depicted, stating '[i]f colour reports, monochrome chronicles' (Grainge 1999: 385). With the storytelling in *Ten Canoes* situated within the black-and-white section of the film, it signals the narrativising of the past as not only coming from within the Yolngu community but also being the voice of the archive, that which is chronicled. The monochrome, stilled aesthetic therefore does more than tie the film to the anthropological collection of Thomson's photographs. The neat slices of time these encapsulate are breached, both visually by movement and narratively by constructing the stories the stilled images spill over into. We witness this in the scene mentioned above with Dayindi both exiting the frame and then being shown in the subsequent event where he peels the bark from the tree. The frozen certainty of the photographic past is replaced by a self-consciously demonstrative and speculative uncertainty.

The Yolngu's understanding of the past, their pastness, might be determined through Thomson's images, but the film suggests the importance of the photograph is not the recording of the referent but the stories and histories constructed around them. Myth and memory become indistinguishable when the photographic past is put to such usage. That the past cannot be neatly confined is made clear by paralleling the two epochs depicted in the film. Overlapping themes in the stories, the same actors appearing in both narratives and the depiction of similar locations contradict the photograph's status as a captured idiosyncratic moment. Indeed, the rejection is specifically illustrated by including almost identical shots of the eponymous canoe photograph in both stories. Used in different contexts, one a goose-egg hunt (Figure 6), the other a war party (Figure 7), the still image is revealed to have different meanings dependent on the accompanying story. Although depicting the past, a specific event, a neat slice of time, the original photograph is shown to convey more than that; it offers a pastness, an impression of what has gone before, detached from a specific history. Through its re-enactment, it offers an understanding of the past that is more fluid, one that can be negotiated, and that is comprehended and valued through 'a citational act', that refers back to social action (Edwards 2001: 157). The envisaging of the social meaning therefore takes precedence over the historical record of the photograph. This may appear to diminish its anthropological value, but I wish to suggest otherwise.

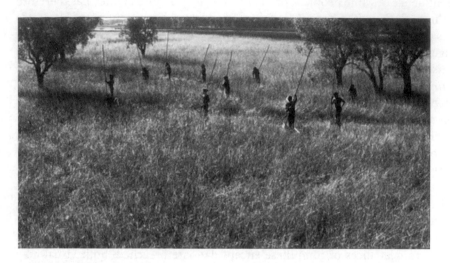

Figure 6. Pastness: recreating Donald Thomson's photograph to depict goose egg hunting 'a thousand years ago' in Dayindi's story, *Ten Canoes*.

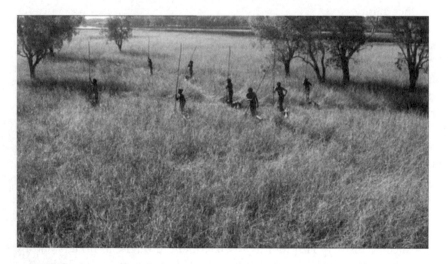

Figure 7. Pastness: recreating Donald Thomson's photograph to depict a war party from mythical times in Ridjimiraril's story, *Ten Canoes* [original in colour].

Revisioning visual anthropology

Louise Hamby (2007: 136, 143–45) notes that de Heer's rather loose interpretation of a precise moment, the historical truth of 'Thomson Times', which is transposed from the 1930s to 1000 years ago, resulted in confusion and criticism.[5] The temporal slippage is compounded by some of the images produced for the planned complementary book, *Fourteen Canoes* (and contained in the DVD extras),[6] deliberately not recreating Thomson's photographs exactly. For instance, Hamby demonstrates that one composition of a tree platform does not include Thomson's billycan and filming equipment seen in the original and in so doing erases white contact and the concomitant history of conflict (2007: 136). Ultimately, Hamby contests, '[f]or Ramingining people "Thomson Times" is a historical truth, which the film, in one way of looking at it, sadly elides' (2007: 145).[7]

Hamby makes a valid point, but the re-enactment strategies are not without precedence, as I will discuss below, and offer a powerfully speculative chronicling, a form of history in the subjunctive mode. *Ten Canoes* is positioned as such. The beginning of the film sets the tone for unpacking the historical record of Indigenous people and their land. The opening four and a half minutes, comprised of eight shots, goes from a tracking helicopter perspective of a rich green landscape to the confines of a waterhole. The longest shot, of just over one and a quarter minutes, is another aerial view as we glide along the course of a river into the spectacularly lush Arafura Swamp. The shot is accompanied by post-synchronised sounds of nature that privilege the cries of geese and deny the presence of the helicopter.[8] This wide-angle shot ascribes a curvature to the earth, and the movement of the helicopter offers Dutch tilts as we follow the meandering water. Combined, we witness (visually and aurally) a bountiful land of blues and greens that is associated with the perspective of a bird, some of which we see below the camera, flying as we apparently are.

On a cinematic level, the extract defamiliarises, creating a space to question accepted representations. Foremost it contests the photographic mainstay of non-urban Australia: the dead, red centre. The vibrant colours of the verdant, aquatic landscape contrast the unearthly dryness that normally represents Australia beyond its cities and coast. Indeed, the swamp is defined as the source of life via the voice-over of the narrator, who locates the land not in space but time:

> This land began in the beginning. Yurlunggur, that Great Water Goanna, he travel [sic] here. Yurlunggur made all this land then. He made this water, and he made this swamp, that stretches long and gives us life. [Pause] I come from a waterhole in this land Yurlunggur made.

The statement is powerful in a number of ways. It establishes a vast, historically imprecise ('in the beginning') pastness for the Indigenous people. Further, it substantiates the revisioning, contradicting the uninhabitable space inherent in the colonialist claims that Indigenous people had no recognisable relationship with the land, that it was *terra nullius*.

And finally, it foregrounds the interplay of the mythic and the cultural. In totality, the geographical and historical landscapes are fused.

Over the extensive tracking shot of the river, the narrator's voice-over had earlier confirmed the film will offer a new perspective, one founded on the visual record:

> Once upon a time, in a land far, far away [laughs]. No, not like that; I'm only joking. But I am going to tell you a story. It's not your story, it's my story – a story like you've never *seen* before. But you want a proper story, huh? Then I must tell you something of my people and my land. Then you can *see* this story and know it. (My emphasis).

Ten Canoes is, as the narrator suggests, 'a story like you've never seen before', with the sequence re-presenting, within a realist framework, the visualisation of the landscape and its people, challenging ingrained expectations of the terrain and acknowledging the centrality of myth in its storytelling (and western cinema via the allusion to *Star Wars* (Lucas 1977)). The emphasis is on a new way of seeing. And yet in many ways the film is conventional and familiar, using existing codes of representation. However, these principles belong more to those films identified as ethnographic than as fictional, and so the assuredness of the historical record is brought into question by the explicit narrativisation of the text. In effect, by using self-reflexive strategies of storytelling in relation to Thomson's photographs, the tools of anthropology are turned back on themselves.

Somewhat surprisingly, in spite of the positivist claims often made in respect of anthropology, staging events has been a regular part of its visual strategies. Some interventions became naturalised early on in its history, for example, moving branches or trees for composition, paying for activities such as sacred dances to be performed or even relocating spatially specific acts outside for daylight filming. Furthermore, in early photography in Australia, Indigenous people tended to be depicted in traditional dress rather than the European cast-offs which were more typical of the time (Ennis 2007: 21). Nonetheless, the camera's ability to capture an event, and effectively authenticate it through the photograph's indexical relationship to the object depicted, has aligned it with a scientific veracity. The tension generated when an image is revealed to have not been extracted from a real-time, fieldwork study brings the anthropological validity into question. It is deemed, as Elizabeth Edwards notes, 'epistemologically flawed in terms of the scientific morality of the discipline' if one intervenes and constructs rather than neutrally records (Edwards 2001: 157).

A number of key texts within visual anthropology have prompted much debate because of such a tension. A particular example is Robert Gardner's *Dead Birds* (1963), which was made among the Dani of New Guinea and 'documented' their practice of ritual warfare. Central criticisms aimed at the film are that events were greatly compressed and reordered, and that Gardner interprets events and actions, even narrating the thoughts of characters (see Mishler 1985). An additional problem was the post-synchronised sound, including the main character, Weyak, being voiced in the studio (Ruby 1991: 7).

Consequently, whilst some anthropologists have rejected the film for lacking the positivist impulse, 'Gardner's stock has been high among consumers of "the visual arts" (Loizos 1993: 139).[9] Therefore, although positioned much closer to (and more transparently as) anthropological film-making, and through its setting of the New Guinea Highlands being demarcated as culturally specific, *Dead Birds* can be profitably compared with *Ten Canoes* because Gardner 'continually distanced himself from realism' (Loizos 1993: 140), relying on metaphors, symbols and repetitions to locate the Dani within their physical and cultural landscape.

It is enlightening to explore the opening sequence of Gardner's film as it affords specific overlaps with *Ten Canoes*.[10] We have a long take linked, ostensibly, to a bird in both instances and which reveals the landscape from above. Unfamiliar animal or animalistic sounds are shared by the two soundtracks. And there is an omniscient narrator in both, who tells a metaphorical tale that is used to set the location and cultural beliefs. The narration in *Dead Birds* begins by stating,

> There is a fable told by a mountain people living in the ancient highlands of New Guinea about a race between a snake and a bird. It tells of a contest which decided if men would be like birds and die or be like snakes, which shed their skins and have eternal life. The bird won, and from that time, all men, like birds, must die.

The impersonal tone of the opening voice-over is cold, especially when followed by the second shot in the credits that shows a dead man; it certainly lacks the disarming humour of *Ten Canoes*. And yet the gravity of the depicted mourning is recast by the choice of phrasing that establishes the narrative alongside a mythical story. In the commentary to the DVD release,[11] Gardner, responding to Ross McElwee's suggestion that the mythic tale contrasts with the spectator being shown 'utter actuality', contends that '[i]t's also nice to hear it phrased in terms of a fable because it sets you up in a way … to knowing that you're going to be taken back to the time where fables began'. This simultaneity of verity and creative fiction is also of prime concern to *Ten Canoes*' construction of pastness.

Commonalities additionally lie in the function of the specifically geographic opening sequences. Like Gardner's detailing of the Dani mortality myth being accompanied by the bird's movement taking us across the landscape to the next shot, that of a funeral, *Ten Canoes*' opening vistas are completed by arriving at a spiritual site of death and rebirth. The narrator tells of the waterhole being his place of birth, before declaring, 'When I die, I will go back to my waterhole. I'll be waiting there like a little fish; waiting to be born again.' Both then construct an eternal cycle of mortality, although *Ten Canoes* places its emphasis on renewal, with Ridjimiraril's death in the film being bookended by an aerial journey back to a waterhole, complete with splosh, to close his narrative.

The detached, observational stance of *Dead Birds*, rather than the embedded, inclusive perspective of *Ten Canoes*, betrays the ethos of the discipline and the attitudes of its age. Where *Dead Birds* relies solely on the external narrator for exposition, including the

thoughts of characters, *Ten Canoes* employs subtitles for all characters,[12] thereby granting Indigenous people a voice in their tales. And, although using the voice-over convention of earlier ethnography to provide cultural information, *Ten Canoes* recasts it by explicitly (and literally) giving the narrative voice to an Aboriginal actor, who immediately signals an unexpected perspective, from within the culture: 'my people'. Furthermore, the authority of staid knowledge is replaced by humorous familiarity ('I'm only joking'). Just as the photographs are reconstructed and extended by the speculative stories that emanate from them, so the narrator establishes a subjunctive mode. The 'once upon a time' statement frames the story, removing the assuredness of the positivist attitude towards visual anthropology. Doubt is also incorporated into the structure. The film concludes with the narrator declaring, 'And they all lived happily ever after', before he laughs, and then continues, 'Nah, I don't know what happened after that.' The comment rejects the omniscient conviction of anthropological films, even those such as *Dead Birds* that are character centred and informed by dramaturgical principles, for they nonetheless depend on generating a dependable exegetic status.[13] Rather than attempting to disguise the narrativising amidst the ethnographic observation (or at least not acknowledge it, as is the case in *Dead Birds*), *Ten Canoes* employs its speculative disposition, a hesitancy if you will, as a feature alongside anthropological film-making techniques. Through this, it details a suppositional and contingent understanding of the past.

Dead Birds does not attempt to renew contact with the past. Unlike *Ten Canoes*, which cannot, and does not wish to, escape its ties to the historical record, *Dead Birds* is not indebted to a photographic referent that encodes a cultural memory in a black-and-white still image. However, in a moment of serendipity for a researcher, Gardner has announced he produced a black-and-white print of his film, which he states on the DVD commentary to the extract of the film's beginning, he much prefers. His rationale is pertinent:

[F]or me, that bird is much more a bird in black and white than it was in colour… that flight was much more flight. To see it in some more lifelike way in colour did not enliven the bird; it burdened the bird with data that was irrelevant to its birdness.

Gardner's view might be summed up as a contradiction: the mimesis of colour obscures the materiality. Lucien Taylor responds on the commentary by stating the black-and-white imagery 'returns us to a realism that isn't there … or isn't of the same order in colour, and yet it also, paradoxically, takes us out of that sensation of realism'. The recreations of Thomson's photographs can be similarly described. The realisation of a past comes via the symbolism of the image, without the extraneous detail. The essence of the bird, its 'birdness', is comparable to the essence of the past, the pastness of the later film. The arrested images achieve an historical gravitas through the film's modes of representation. And rather than merely illustrating a sensibility via Gardner's afterthought, de Heer and Djigirr embed the comparative viewing process in the film's structure. At once artificial

and legitimate history, the black-and-white imagery provides continuities with the coloured sequences of the fable and the monochrome of Thomson's photographs, and together they remake and revision the historical record, foregrounding the process of reconstruction, to propose a past that exceeds a specific instance and the properties of the referent.

'Seeing' and 'knowing'

Elizabeth Edwards has argued that ethnographic photography could learn from other photographic practices and thereby recognise '"expressive" and "realist" as two not incompatible rhetorics' (1997: 75), with there being space for doubt. As demonstrated, *Ten Canoes* blends the two modes (framed as ethnographic films and narrative cinema) to relocate the photographic testament amidst evocative speculation. On such a basis we might argue that, in spite of its re-enactments, it is evidentially valid because it is a 'historically and culturally grounded perception of authenticity as a social process' (Edwards 2001: 160). In effect, the Yolngu deem it culturally meaningful. Thus, in spite of its centring of storytelling, *Ten Canoes* can, for a western audience, be read as an ethnographic film. For the Yolngu people, it reconnects a past that stretched beyond the time when Thomson took his photographs to form a wider sense of pastness. Rather than being historically faithful to events and slices of time, it instead embodies an essence that superimposes the speculative Indigenous voice on ethnographic certainty.

It should not come as a surprise that we can find connections between the visual anthropology of Thomson and Gardner and *Ten Canoes*' manifestations of the wishes of the Yolngu people to reconnect with their ancestors. These ethnographers were sensitive to the role the visual arts might play within their discipline. And the film fits into other recent art projects that have raided the archives to reinscribe the subjects. Artists working in the visual arts, including film-makers, have re-appropriated anthropological materials. Peter Loizos praises photographer and director Tracy Moffatt, an Indigenous Australian, whom he sees 'stretches the conventional meaning of the term "ethnographic" to the limits' (1997: 98) in her film *Nice Coloured Girls* (1987). Her use of narrated moments of 'first contact' between native Australians and white travellers alongside non-realist depictions of contemporary meetings establishes a history (and repetition) of sexual encounters. Furthermore, Moffatt usurps the authority of the white male anthropologist by subtitling the female Aboriginal voice throughout, thereby 'elevating it to the status of the written accounts' (Haslem 1999: 322). Like earlier re-enactments undertaken by anthropologists, which Edwards (2001: 157) regards as 'transform[ing] an unseen or unseeable cultural past into a visual representation for "seeing" and "knowing"', so too does Moffatt, but she also inserts the Indigenous voice within the ethnography. As with *Ten Canoes*, the text leaves authenticity as contestable. The historic past is decentred to form a pastness.

Michael Dawu, a relative of one of the original canoeists and who plays the stranger in the film, describes the remaking this way: 'you can make this one film and bring that memory back! Rolf, you bring us memory. We got culture because we got memory ... what a story, brother' (in Palace Films 2006: 23). Dawu's equating of story, a constructed truth, with culture, the values, beliefs and social networks that visual anthropology endeavours to capture, summarises how Thomson's photographs are used in the film. Unlike in traditional anthropological films it is not a criticism to be seen to do so; rather, it is a way of narrativising pastness. Edwards has articulated the importance of comparable reformulated texts, stating '[t]he generalising frames of anthropology are demolished in these works to be reconstituted as localised histories or contested histories and a re-articulation of that experience' (Edwards 1997: 70). In such interventions in visual anthropology, the image is narrativised, or as the narrator in *Ten Canoes* describes it, 'you can see the story and know it'.

Bibliography

Allen, S. (2010), 'Counterfictional Suffering: Authenticity and Artistry in *The Passion of the Christ*', in E. Christianson and C. Partridge (eds), *Holy Terror: Understanding Religion and Violence in Popular Culture*, London: Equinox, pp. 82–92.

Barbash, I. (2007), 'Out of Words: A Conversation with Robert Gardner', in I. Barbash and L. Taylor (eds), *The Cinema of Robert Gardner*, Oxford: Berg, pp. 93–118.

Barthes, R. (2000), *Camera Lucida – Reflections on Photography* (1981), R. Howard (trans.), London: Vintage.

Bazin, A. (1967), *What Is Cinema?* Vol. 1, H. Gray (ed. and trans.), Berkeley: University of California Press.

Bell, J. (2007), 'The Way It Was', *Sight and Sound*, 17:6, pp. 34–37.

Berger, J. and J. Mohr (1989), *Another Way of Telling*, Cambridge: Granta Books.

Deleuze, G. (1992), *Cinema 1: the Movement-Image*, H. Tomlinson and B. Habberjam (trans.), London: Athlone Press.

Edwards, E. (1997), 'Beyond the Boundary: A Consideration of the Expressive in Photography and Anthropology', in M. Banks and H. Morphy (eds), *Rethinking Visual Anthropology*, New Haven, London: Yale University Press, pp. 53–80.

—— (2001), *Raw Histories: Photographs, Anthropology and Museums*, Oxford: Berg.

Ennis, H. (2007), *Photography and Australia,* London: Reaktion Books.

Grainge, P. (1999), '*TIME*'s Past in the Present: Nostalgia and the Black and White Image', *Journal of American Studies,* 33:3, pp. 383–92.

Gray, S. (2007), 'Imagining Australia's Past', *American Cinematographer,* 88:3, pp. 80–81.

Hamby, L. (2007), 'Thomson Times and *Ten Canoes* (de Heer and Djigirr, 2006)', *Studies in Australasian Cinema,* 1:2, pp. 127–46.

Haslem, W. (1999), 'Moffatt, Tracey', in B. McFarlane, G. Mayer and I. Bertrand (eds), *The Oxford Companion to Australian Film,* South Melbourne, Oxford: Oxford University Press, p. 322.

Kuipers, R. (2006), 'Film Reviews: Adelaide: *Ten Canoes*', *Variety,* 402:7, p. 70.

Loizos, P. (1993), *Innovation in Ethnographic Film: From Innocence to Self-consciousness, 1955–1985,* Manchester: Manchester University Press.

—— (1997), 'First Exits from Observational Realism: Narrative Experiments in Recent Ethnographic Films', in M. Banks and H. Morphy (eds), *Rethinking Visual Anthropology,* New Haven, London: Yale University Press, pp. 81–104.

MacDougall, D. (1998), 'The Subjective Voice in Ethnographic Film', in L. Taylor (ed.), *Transcultural Cinema,* Princeton, NJ: Princeton University Press, pp. 93–122.

Mishler, C. (1985), 'Narrativity and Metaphor in Ethnographic Film: A Critique of Robert Gardner's *Dead Birds*', *American Anthropologist,* 87:3, pp. 668–72.

Palace Films (2006), *Ten Canoes: Press Kit,* Sydney: Palace Films.

Ruby, J. (1991), 'An Anthropological Critique of the Films of Robert Gardner', *Journal of Film and Video,* 43:4, pp. 3–17.

Sontag, S. (1997), *On Photography* (1977), New York: Farrar, Straus and Giroux.

Thomson, D. (2005), *Donald Thomson in Arnhem Land,* comp. and intro. N. Peterson, rev. edn, Carlton, Victoria: Miegunyah Press.

Walsh, M. (2006), '*Ten Canoes*', *Metro Magazine,* 149, pp. 10–17.

Notes

1. Donald Thomson's comprehensive studies of Indigenous culture include photographic, filmic and sound recordings as well as cultural artefacts. The Thomson Collection, held in the Museum Victoria, contains approximately 11,000 photographic images.

2. Thomson states the Indigenous people had attacked the fishermen after two Japanese luggers had trespassed into Yolngu waters to fish illegally and the crews had stolen 'their women'. It was said that the policeman had raped the wife of Dhaakiyarr, the man accused of his murder (Thomson 2005: 22–32).

3. I would like to thank Heather Gaunt of Museum Victoria for her help in obtaining permission to include the Thomson photographs in this chapter and for identifying the second photograph (Figure 5).

4. I have argued elsewhere (Allen 2010) that *The Passion of the Christ* (Gibson 2004) depends on comparative artifice to convey a sense of authenticity, but here the purely speculative is heavily indebted to the certainty embodied in the photograph.

5. Hamby argues that 'some people, including Gulpilil, still talk about the film as if it records a real past time, perhaps even the time of Donald Thomson' (2007: 129).

6. The reference relates to the 2007 Australian double DVD release by Madman.

7. Hamby does, however, recognise that accuracy may not have been the vital element for the Yolngu of Ramingining, and that instead the film enabled them to reconnect with their ancestors and their way of life.

8. The whole sequence also intercuts close-ups of plants and insects, where the sound could be diegetic, although noises of thunder and water are heightened.

9. Gardner's affinity with the visual arts is not surprising when we note that in addition to his ethnographic works, he has completed films on painters Sean Scully and Mark Tobey, artist Alexander Calder and film-maker Miklós Jancsó (Gardner cited in Barbash 2007: 113).

10. Thematically the two films are also linked. *Dead Bird*'s application of tribal rivalry as its narrative drive aligns the film with Ridjimiraril's story of intergroup conflict and formalised vengeance.

11. The reference relates to the 2004 double DVD release by the Film Study Center at Harvard University.

12. This refers to the theatrical version, which also has the English-language storytelling by the narrator. Other versions provide the whole film, including the narration, in Aboriginal language.

13. That key developments in Gardner's film (such as the killing of a boy, Weyakhé, who acts as a surrogate for one of the main characters) take place beyond the gaze of the camera demonstrates the limits of the fictional framework. As David MacDougall (1998: 109) notes, 'in fiction the author would have been there'. Concordantly, Ridjimiraril's death is witnessed in full in *Ten Canoes*.

Chapter 6

The Still Life: DVD Stills Galleries and the Digital Uncanny

Tina Kendall

C ritical discussions of *Ratcatcher* (Lynne Ramsay 1999) have frequently noted the film's painterly and/or photographic aesthetic.[1] Director Ramsay's background in photography is often evoked as having an important influence on the film's visual design and its approach to charting the traumatic aftermath of the death of a young boy. Such discussions have highlighted the film's tendency to suspend narrative movement in moments of *tableau vivant*, and its frequent *mise en abyme* framings, both of which self-consciously mimic the look of paintings and photographs. Such techniques confirm film's profound affinities with the so-called static media of painting and photography but also foreground what Laura Mulvey calls the 'fundamental, and irreconcilable, opposition between stillness and movement' that defines filmic materiality and distinguishes it from other visual arts (2006: 67).

Rather than reifying divisions between cinema and the static arts, *Ratcatcher* calls attention to the complex ways in which stillness and movement are remediated across the spectrum of visual arts. Elsewhere I have argued that *Ratcatcher*'s complex play with the relation of stillness and movement works to create an interstitial space between film's moving images and the still life of painting and photography (Kendall 2010). In this chapter, I want to think about some of these questions in relation to *Ratcatcher*'s DVD format, to look in particular at the stills gallery feature, which is included on both the Pathé disc in the United Kingdom and the Criterion disc in the United States. The DVD format brings another form of visibility to the film's wider narrative and aesthetic interest in stillness as the still-moving binary inherent in celluloid is displaced onto, and remediated by, the electronic screen.[2] I will argue that the stills gallery further deconstructs the ontological grounds on which stillness and movement have traditionally been understood in film theory. Drawing from debates about intermediality and digital spectatorship, this chapter will consider how the stills gallery participates in *Ratcatcher*'s questioning of aesthetic polarities, challenging divisions between 'old' and 'new' media. By foregrounding and embracing the material hybridity and intermedial potential of both still and moving images, *Ratcatcher* points towards the emergence of what Laura Mulvey, D.N. Rodowick (2007) and other scholars have identified as a new ontology in which, to quote Mulvey, 'ambivalence, impurity and uncertainty displace ... traditional oppositions' (2006: 12).

In *Death 24x a Second*, Mulvey privileges stillness as an increasingly important part of the new horizons of spectatorship created by technologies such as the video and DVD. She notes that these technologies allow for a spectator who is much more actively

involved in the still-moving relation in that he or she can pause, slow down or speed up the image at will. For Mulvey, these technologies can foster an expansion of both the affective and analytical relationship of spectator and screen. She writes, '[i]n the stilled image, moments of beauty or meaning can be found, and then, as the image is reactivated, continue to affect the image once returned to movement' (Mulvey 2006: 28). Such an expansion of experience is premised, for Mulvey, on a 'pensive' spectator who is able to move past a utilitarian relationship to the image to allow himself or herself to be affected emotionally or intellectually. Countering Roland Barthes's claim that cinema leaves no time for the *punctum* to develop, Mulvey suggests that the ability to pause the moving image as a still frame opens up the possibility of finding and being 'pricked' or 'wounded' by a film. The frozen frame, she notes, 'restores to the moving image the heavy presence of passing time and of the mortality that Bazin and Barthes associate with the still photograph' (Mulvey 2006: 66). For Mulvey, then, the possibility of pausing a DVD to reveal the still frame gives cinema an intensive power that Barthes located only with respect to photography – a power that is given renewed possibilities in our age of digital remediation.

While Mulvey's argument offers insight into the ways in which new home playback technologies such as the VCR and DVD player have reframed the horizons of spectatorship, it is less attentive to the question of how these same technologies reframe the very nature of cinema and moving image culture. Her argument has been critiqued for offering an over-celebratory account of spectatorship, which does not attend to the more radical cultural shifts and aesthetic implications taking shape in the current economy of DVD production, dissemination and consumption. In her review of *Death 24x a Second*, for instance, Mary Ann Doane notes that such technologies do not simply offer spectators unfettered access to more films than ever before; they also constitute 'a new (or possibly simply an intensified) regime of images – one that is not as utopian as we would perhaps like' (Doane 2007: 117). Significantly, Mulvey's account rarely moves past a consideration of the *narrative* films that she discusses, to reflect in substantial detail on how the transcoding of film for the DVD format – with its interactive menus and proliferation of extra or bonus materials – might also call into question the textuality and ontology of cinema.

Recent scholarship on DVD has sought to engage with these sorts of questions through a consideration of the 'particular textuality of DVD itself' and with 'the kinds of activity DVD textuality seems to presuppose' (Bennett and Brown 2008: 6). I want to consider the stills gallery, then, both as this feature relates to, and remediates, *Ratcatcher*'s aesthetic and narrative interest in the relationship between stillness and movement *and* in light of the particular textuality of the DVD. How might the stills gallery feature contribute to the film's questioning of aesthetic affinities and polarities between cinema and the visual arts? How might the distinctive textual properties and features of DVD – such as interactivity, electronic displays, stills galleries, commentaries, 'making of' featurettes, short films and so forth – be said to transform the experience of spectatorship and its

spatial and temporal framing? In the case of *Ratcatcher*, what are the textual and temporal implications of the transformation of the image, as it mutates from photographic still, to moving cinematic image and finally as it is transcoded as a digital file for an electronic, interactive display?

Still-moving: Photography, film and the in-between of images

Ratcatcher begins with the accidental death by drowning of a twelve-year-old boy, Ryan Quinn, and the subsequent narrative is seen through the perspective of his friend James Gillespie, who was present at the time of Ryan's death and who feels emotionally responsible for it. Much of the film charts the emotional consequences that spring from the scene of this trauma. Set during the rubbish workers' strike in Glasgow during the 1970s, the film captures James's increasingly urgent desire to leave behind the squalor of the Glasgow tenement and to start a new life with his family in a housing development that is undergoing construction on the city's outskirts. Narratively, the film presents James's predicament as lodged intolerably between the need to move on and the states of physical and emotional paralysis, which appear to foreclose any possibility of progression or change.

The relationship between stillness and movement is thus both a narrative and a formal concern in *Ratcatcher*. On a formal level, Ramsay maps these emotional meanings of stasis and movement onto the complex play that she establishes between different media of representation, including photography, painting and moments of *tableau vivant*. Emma Wilson notes that the film's 'slowness, stillness and numbness' derive from its 'concern to chart and respect the tempo and disruption of traumatic experience' and from 'Ramsay's background in photography and her palpable experiments with the boundaries between still photography and narrative cinema' (Wilson 2003: 110). The look of *Ratcatcher* is informed by Ramsay's research into the period of the dustmen's strike, which consisted of looking at paintings and photographs from the time. These photographic records, along with Ramsay's memories as a young girl growing up in Glasgow, form the film's starting point; yet what is surprising is the extent to which Ramsay rejects context and history in favour of the visual and symbolic richness offered by the strike setting. Ramsay's interest in photographic source material does not appear to have been animated by a concern with historical authenticity derived from photography's indexical relationship with reality. Rather, *Ratcatcher* foregrounds photography's emphasis on the frame and the range of affective responses that it can be said to produce. She has noted thus in interviews: 'I was a photographer before, so I sometimes look at stills more than films. At times I think stills are more intense and I wonder what's going on outside the frame. The mystery in stills I find very different from filmmaking' (Ramsay in Bailey 2000). As Ramsay notes here, photographs present a static world-view that is visible on the basis of a space beyond the frame that is by

definition inaccessible and unknowable, contributing an air of mystery and uncertainty to what is presented. *Ratcatcher*'s frequent tableaux framings, which explicitly mimic the look of photographs, tap into this potential of photography to convey and solicit intense affective moods and responses. This affective response is conditioned both by photography's spatiality and its distinctive temporality. As D.N. Rodowick notes, the particular affective tenor of the photograph has to do with the 'curious sentiment that things absent in time can be present in space' such that '[w]hat we feel in photographs is equally *our* absence from the view presented, that this view is screened for us, and from us, in time' (2007: 64–65). *Ratcatcher* frequently taps into this intensity of photography's distinctive temporal and spatial properties by staging moments of photographic stillness within the forward thrust of narrative movement and by calling attention to the frame. Such techniques create a series of affective resonances that are derived from tensions that the film establishes between movement and stillness, presence and absence, preservation and deterioration, life and death. However, rather than setting these still-moving relationships into neat opposition, *Ratcatcher* creates, through their remediation, a space between film's moving images and the still life of photography.

DVD stills galleries and the digital uncanny

I would now like to turn to a consideration of what happens to this intermedial dialogue and its emphasis on the in-between in the case of the DVD stills gallery. What happens to our experience of this still-movement relationship as it is remediated by the DVD format? In particular, I am interested in exploring how *Ratcatcher*'s stills gallery participates in, and is conditioned by, the film's wider questioning of aesthetic polarities. As I will argue, by insisting on the intermedial relays between images, *Ratcatcher* helps to reframe our understanding of the relationships between 'old' and 'new' media. In foregrounding and embracing cinema's material hybridity in an age of digital spectatorship, the film insists on the power of ambivalence and uncertainty to displace such oppositions. In so doing, I argue, it insists on an experience of the uncanny that is given renewed importance in an era of digital spectatorship. In adopting the term 'digital uncanny', I refer both to Freud's original definition of the uncanny, 'that class of the frightening which leads back to what is known of old and long familiar' (Freud 1997: 195), and to the range of scholarly approaches that have foregrounded the uncanny affects that are produced more specifically through encounters between digital and analogue media.[3]

The stills gallery feature on the *Ratcatcher* DVD consists of 76 colour photographs taken on set during the production process by second-unit director of photography Thomas Vincent-Townend. It is one of several special features that appear on both the Pathé disc in Europe and the Criterion disc in the United States.[4] These sorts of features are clearly part of the expanded experience that has become a staple part of DVD spectatorship. Such features offer a behind-the-scenes look at the research and planning, production and

post-production phases of film-making, documenting and offering for inspection the very processes that are normally excluded from the feature film. As a format that increasingly encompasses both the film text 'itself' and various extra- or para-textual materials, the DVD implies a new kind of hybridity that calls for an updated understanding of cinematic textuality. Indeed, as scholars such as Catherine Grant (2008) and D.N. Rodowick (2007) have argued, the DVD format establishes a complex play between the fictional and the factual, and between the image 'as information' and 'as art' (Rodowick 2007: 143). The textual hybridity of the DVD also has important implications for thinking about temporality. Shuttling between the feature film on the DVD and its various supplementary materials, the spectator is involved in what Adam Lowenstein describes as 'a radiation outward toward multiple textualities and temporalities' (Lowenstein 2007: 68). Unlike a narrative feature film, in which, according to Mulvey, 'different levels of time are fused together', the DVD would appear to sort out and assign different functions to 'the time of the index' (in 'making of' featurettes, for example, which bring the temporality of production and of the pro-filmic into the frame) and 'the time of the fiction' (the feature film) (Mulvey 2006: 183). Such tensions are crucial for thinking about how *Ratcatcher*'s DVD incarnation further mediates and complicates the still-moving relationship that the narrative film takes as its thematic and aesthetic premise. In contrast to the moments of stillness in the film, these images embody stillness in a different way and engage the spectator differently in a contemplation of the relationship between stillness and movement.

Taken as they were during production, the images in the stills gallery may appear to offer a series of supplementary, behind-the-scenes insights into the making of the film. The images may be said to act as photographic documents in this way, preserving the unique presence of humans and things, and inscribing them within the 'time of the index' (Mulvey 2006: 183). Like many DVD menus, the main menu screen offers a choice between the feature film and extra features, notionally demarcating the 'factual' space of the stills gallery from the 'fictional' space of the film, and the 'time of the index' from the 'time of the fiction' (Mulvey 2006: 183). However, as D.N. Rodowick argues, the notion of 'interactivity' implied by digital screens also suggests a subtle shift in the way we approach such distinctions. According to Rodowick, photography's affective potential springs partially from the sense that photographs allow us to 'preserve an image against the flow of time', providing us with a heightened 'experience of duration' (Rodowick 2007: 175). By contrast, digital formats such as DVD emphasize interactivity and communication in present time, leading Rodowick to conclude that through such digital expressions, we no longer seek to preserve time so much as 'to manage time in relation to information and as information' (Rodowick 2007: 175). As Rodowick suggests, the affective resonances derived from cinema's relationships with photographic technology are arguably undercut or transformed, as a photographic image is transcoded as digital information for interactive electronic screens. However, I would argue that it is not always easy to disentangle those two textual registers in the case of *Ratcatcher*'s stills gallery. This fusing and confusing of temporal and textual modes results not only from

the design of the DVD but also – and more significantly – as an extension of the feature film's interest in exploring the in-between of images. In other words, the emphasis on the in-between and the contemplative mode that is promoted by the *Ratcatcher* feature film radiates outward to implicate and complicate the temporality of the stills in the DVD gallery and to enable a different kind of affective response than the one Rodowick attributes here to digital formats.

Ratcatcher's stills gallery is accessible via the DVD's main menu, which is illustrated by a still image of James framed against the canal, its mirrored surface reflecting the sky and the surrounding landscape. The composition of this still is noteworthy for its contemplative tone and its emphasis on meditative looking. In this image, James is framed with his torso facing the spectator, but with his head and shoulders turned away, looking out into the distance. This image figures him as both the object and subject of the look, inviting the viewer to look at him, but also past him, at the canal that is the focus of his subjective gaze. The spectator who has seen the film already will find this framing familiar – James is frequently depicted looking into blank landscapes such as these, and these moments, in which we watch James watching, function as privileged moments of introspection and intensified affect, both for James and for the spectator. Indeed, much of the film consists of sequence-shots that depict James looking out onto the canal, as a means of coming to terms with Ryan's death and with his sense of responsibility for it. The tableaux framings expressly mimic the look of still photographs and derive their intensity by foregrounding the site of conjuncture where cinema's moving images meet the mystery and intensity of still photographs. The inclusion of such an image as the illustration for the main menu confirms the importance of such moments and may also sanction just such an introspective, contemplative approach as a model for the spectator's encounter with the film's emotionally charged subject matter.

Here, however, that affective tenor is arguably undercut by the accompanying menu text, which lays out options for the DVD user as follows: 'play film', 'scene selection', 'theatrical trailer', 'short films' and 'stills gallery'. These commands ask for the interactivity of the DVD user: by toggling through the arrows on a DVD remote or using the up/down command keys or mouse functions on a computer, the user/viewer can manipulate a square icon to enter into the next window and gain access to the desired feature. By choosing the stills gallery option, the user encounters another menu, again illustrated with an image of James by the canal, though this time he is framed in a long shot and is shown skipping rocks on its surface. Beneath the title caption, this menu divides the stills gallery into a further four options: 'James', 'The Family', 'World of Children' and 'The Canal'. Each one of these options provides access to stills galleries comprising individual photographs, which the user can scroll through individually. Although the spectator may choose which galleries to view, and in what particular order, the stills can only be accessed in a successive, linear fashion. However, the user does control the duration of each image, so may either pause at length to take in the sorts of details that she might miss when viewing the narrative film or may scroll through more quickly.

In general, then, I would argue that the design of this particular DVD works to promote the values of contemplation, aesthetic looking and introspection that are in keeping with a tradition of images as art as opposed to information. It does this in ways that arguably cut against the grain of many of the textual properties of DVD and their affinity with the logic of information, interactivity, efficiency and so forth. The inclusion of a stills gallery and Ramsay's short films as special features arguably shore up the film's affiliation with art and authorship more than they do with entertainment or information, and the particular image selected to illustrate both the main and stills gallery menu would also appear to reinforce such values.[5] What is more, the layout of the stills gallery is designed to play up visual associations with photography, as each image is masked by a black border on four sides, delimited internally from the dimensions of the screen and thereby made to resemble a photograph as closely as possible. The thematic grouping of the stills gallery also works to extend the aesthetic and diegetic world of the fictional film, by referring to characters, settings and thematic groupings rather than to film-makers, actors or other aspects of the film's production history. In fact, it is remarkable that of the 76 still photographs on display in the stills gallery, none contain any indication of, or reference to, the filming paraphernalia that is commonly made visible in 'making of' and stills gallery features, such as images of the director and crew, booms, mics, cameras and other equipment. Rather, these images seem to point us doggedly back to the diegetic and affective space of the film, and engage us in a different yet complementary type of contemplation of the still-moving relationship that the feature film takes as its main premise.

Many of the images chosen for inclusion in the stills gallery seem to have been selected primarily for their aesthetic qualities, such as the first image in the gallery devoted to the canal. This image consists of a sepia-toned, closely cropped, water-level view of the canal, which pictures a bundle of sticks and debris knotted together that float on the canal's smooth and mirrored surface. Nothing in this image refers us to the process of production, and it certainly does not ask to be read in terms of information. Rather, it offers a supplementary view of the tactile physical world of the film and invites the sort of contemplative, multi-sensory look that parallels James's gaze within the diegesis. The emphasis here again is on contemplation and the kind of arresting and arrested image that might fuel such a meditative looking. Consequently, to insist on the function of these images as transmitters of information is to neglect their place within a more complex intermedial dialogue that takes shape across both the main and extra features on the DVD. By foregrounding the in-between of images, *Ratcatcher*'s stills gallery offers an expansion of the affective, intensive qualities of stillness affirmed by the narrative film and contributes a subtle re-framing of aesthetic experience from the film text 'itself' to the hybrid, intermediated textuality of the DVD. While DVD stills gallery features would seem particularly well suited to exposing this 'in-between' of images, more often than not they work to reify divisions between cinema and the visual arts, and between 'old' and 'new' media formats. As I have noted, they do this chiefly through their clear delineation between the 'main' and 'extra' features – the former positioned as being 'for'

aesthetic experience and the latter as being 'for' informational expansion. In the case of *Ratcatcher*, however, both the design features of the DVD and the self-conscious play with stillness and movement in the feature film work to call those divisions into question and to bring cinema's essential hybridity into focus.

A closer look at some of the individual photographs in the stills gallery offers further insight into this space and time between images and on the uncanny effects that they may be said to produce. What is most striking about these images is the way that they extend the visual world of the film and hence are always-already infused by narrative meanings. If the feature film plays on the way that photographic stillness can haunt the flow of cinematic movement, the still images in the galleries may be said to perform precisely the reverse operation: infused by narrative meanings, the stillness here is animated with a sense of virtual movement, duration and change that is derived from cinema's expression of time passing. Encountering these images as fragments of a more protracted narrative text, the viewer/user of the gallery is able to add her own movement, change and becoming to these images. As a result, I would argue, these images are able to play on and distort time in uncanny ways.

For instance, in the 'World of Children' gallery, Image 10 pictures Ryan in his family's flat, sitting on the brown floral-patterned sofa. He is shown in the lower left-hand quadrant of the frame, and the portrait on the wall behind him this time seems much bigger than it did in the corresponding scene from the film, and it is hanging directly over his head. Furthermore, whereas the narrative film keeps Ryan squarely in focus, in this still, it is the image on the wall that is the focal point, leaving Ryan's face slightly out of focus. Although this painting is not given any special emphasis in the film's narrative, there is something about its inclusion in the stills gallery that gives it an additional layer of meaning for me. The painting bears little more than a passing resemblance to Ryan – they both have the same hair colour and are framed in a similar fashion, from the torso up. But in this still, there is something about the enhanced importance that is conferred by the framing, and the *mise-en-abyme* composition, which gives this painting the uncanny air of a portrait or even a double. Of course, the function of portraiture – to preserve the image of a loved one against the decay of time – stands in stark contrast to the scene of Ryan's death that will follow this sequence in the narrative film. Both the 'portrait' and the still frame – in which both Ryan and his 'double' are suspended, as if embalmed in time – work in a kind of productive tension with the film's emphasis on images of decay, on time passing, and ultimately, on death. While Mulvey associates the 'awareness of death' with the spectator's encounter with the 'time of the index', here such an awareness is also closely associated with the 'time of the fiction', infused with narrative meanings, to the extent that the narrative film, too, is concerned with death and its aftermath (Mulvey 2006: 183). This particular still constructs an intermediated, liminal space infused with narrative meanings, suspended somewhere between momentum and stasis, between a life preserved in time and a death already foretold, and confusing levels of time that are frequently demarcated in extra features such as these. This heightened experience of

the uncanny is clearly only possible when viewing the still image through the affective rubric created by the feature film, such that the awareness of narrative movement infuses the still image with an added layer of uncertainty and ambivalence. The uncanny effect of this particular still is thus derived from the complex relays that are staged between the textualities and temporalities of film, and both the 'old' media of painting and photography, and 'new' media formats such as DVD.

Many other images in the stills gallery create an effect of uncertainty by seeming to present us with images from the film but introducing subtle differences that make us question the relationship of text and paratext. Images 6 and 7 in the 'canal' gallery, for instance, picture Da, submerged from the waist down in the canal, his bare chest clutching a lank, dark figure that looks to be the body of a young boy or, more plausibly, a dummy stand-in. This image corresponds narratively to Da's moment of heroism in the film, when he is called on to save Kenny from drowning in the canal. However, in the feature film, a parallel editing pattern is used, which cuts between Da, the canal and Margaret-Ann in the bath, such that the precise moment pictured in these stills is elided in the feature. What is more, the view we are presented with here is taken from a completely different angle in comparison with the narrative film, seeming to introduce a new point of view altogether. Such alterations, although subtle, introduce curious distortions in the film text, causing the spectator to pause to take stock of the relationship of these images to the feature. The viewer of this image is struck with a series of irresolvable questions about where, exactly, this image 'belongs': if it is to the process of production, where are the visual signs that let the viewer in on the apparatus of film-making, which should be disclosed through such features? If it refers, rather, to the diegetic world of the film, how are we to account for the differences in presentation noted above? At stake in this distinction is not only an attempt to assign a clear 'place' to the image but also to know precisely how to approach it, to know how we should respond affectively and intellectually: following Rodowick, should this image be approached as 'information' or contemplated as 'art'? I believe that it is precisely the sense of indecision and uncertainty produced here that allows these images to convey more than just a desire to manage time as information.

In his essay 'The Third Meaning', Roland Barthes considers the effect of uncertainty that is generated from film publicity stills: the still, he notes, is 'the fragment of a second text *whose existence never exceeds the fragment*; film and still meet in a palimpsest relation, without our being able to say that one is *on top of* the other or that one is *extracted* from the other' (1977: 67). For Barthes, the effect of such indecision is crucial in that it demands that the spectator detach the image from its place in the narrative, giving free reign to the imagination and access to what is most ambiguous and ineffable in film. Like the publicity stills discussed by Barthes, the images in *Ratcatcher*'s DVD stills gallery confuse the relationship of text and paratext, and involve a reworking of the relationship of stillness and movement. These stills cannot be considered as extracts from the film but offer supplementary or even alternate views on it; they refer to and break from the

film's narrative flow, breaking up its cohesion in ways that photograms or screen grabs may not.

However, as Rodowick notes, these images also embody a more fundamental kind of 'ontological strangeness', confounding our sense, more radically, of what an image *is* in our age of digital remediation (Rodowick 2007: 98, 131). The presence of what we might call a 'digital uncanny' springs from the ways in which digital technologies are modelled on, and able to mimic the look of, analogue media. In the *Ratcatcher* stills gallery, the stills may have originated as photographs, and have been made to resemble them as closely as possible, but once they are transcoded for the DVD format, they cannot be considered as photographs at all in a traditional sense. As we have already seen, their material support is different, they perform different functions and they would appear to solicit different responses from viewers. But beyond this, digital images such as these embody a powerful paradox for Rodowick. Whereas cinema derives its illusion of movement from the film projector's animation of still frames, when presented on electronic displays, 'the image *is* movement', even if it pictures stillness, as is the case here. As Rodowick notes,

> [E]ven a 'photograph' displayed on an electric screen is not a still image. It may appear so, but its ontological structure is of a constantly shifting or self-refreshing display. Electronic images are in constant movement or states of dynamic change, even when they appear to be static. (Rodowick 2007: 138)

This capacity of digital images to simulate stillness is, for Rodowick, a powerful if as yet unacknowledged source of the uncanny. Whether we are consciously aware of it or not, the material properties of DVD also challenge our understanding of what an image is and, hence, what cinema's essence might be as it transitions into its digital future. In the case of the *Ratcatcher* DVD, the stills gallery may be said to embody the kind of uncertain ontology that scholars such as Mulvey and Rodowick attribute to the context of moving image culture today. These images are neither photograms (extracted from celluloid) nor photographs in their original material state but transcoded digital images made to simulate photographs, which in turn refer us to the space of the film even though they do not bear any strict relationship to the film itself. They set up a complex relay in which different media of representation constantly refer to one another, borrow from, stage and displace one another both aesthetically and ontologically.

By highlighting the relationship of stillness and movement, *Ratcatcher* creates an interstitial space in which ambiguity and uncertainty work to reframe the act of spectatorship. As I have argued, the temporality and materiality of DVD call for an updated understanding of the ontological grounds on which the relationship of stillness and movement has been understood in film theory. However, as I have suggested, the distinctive temporality and textuality of DVD need not always imply a desire to 'manage time in relation to information and as information' but, staged as a series of intermedial relays between images, can also create a more uncertain, ambivalent response to the image

(Rodowick 2007: 175). As I have argued, such DVD features can exist more complexly as sites of reflection and contemplation, and as conduits of affect that tap into the distinctive hybridity of cinema in a digital age. To affirm these possibilities is to confirm cinema's continued reliance on, and kinship with, the visual arts and to insist on the renewed potential of digital technologies to share in – and to complicate – the in-between of images and the intermediated, liminal space between cinema and the visual arts.

Bibliography

Bailey, A. (2000), 'Gutter Jewel, Lynne Ramsay Finds Beauty in *Ratcatcher*', *IndieWire*, available at http://www.indiewire.com/article/interview_gutter_jewel_lynne_ramsay_finds_beauty_in_ratcatcher/. Accessed 3 December 2010.

Barthes, R. (1977), 'The Third Meaning', in S. Heath (ed. and trans.), *Image/Music/Text*, New York: Hill and Wang, pp. 52–68.

Beckman, K. and J. Ma (eds) (2008), *Still Moving: Between Cinema and Photography*, Durham: Duke University Press.

Bennett, J. and T. Brown (eds) (2008), *Film and Television after DVD*, London: Routledge.

Cubitt, S. (2004), *The Cinema Effect*, Cambridge, MA: MIT Press.

Doane, M.A. (2007), 'Laura Mulvey, *Death 24x a Second: Stillness and the Moving Image*', *Screen*, 48:1, pp. 113–18.

Freud, S. (1997), 'The "Uncanny"' (1919), in *Writings on Art and Literature*, Stanford: Stanford University Press, pp. 193-233.

Grant, C. (2008), 'Auteur Machines? Auteurism and the DVD', in J. Bennett and T. Brown (eds), *Film and Television after DVD*, London: Routledge, pp. 101–15.

Kendall, T. (2010), 'The In-Between of Things: Intermediality in *Ratcatcher*', *New Review of Film and Television Studies*, 8:2, pp. 179–97.

Kuhn, A. (2008), *Ratcatcher*, London: BFI.

Lowenstein, A. (2007), 'The Surrealism of the Photographic Image: Bazin, Barthes, and the Digital Sweet Hereafter', *Cinema Journal*, 46:3, pp. 54–82.

McDonald, P. (2007), *Video and DVD Industries*, London: BFI.

Mulvey, L. (2006), *Death 24x a Second: Stillness and the Moving Image*, London: Reaktion.

Rodowick, D.N. (2007), *The Virtual Life of Film*, Cambridge, MA, and London: Harvard University Press.

Shaviro, S. (2007), 'Emotion Capture: Affect in Digital Film', *Projections*, 1:2, pp. 63–82.

Wilson, E. (2003), 'Still Time: *Ratcatcher*', in *Cinema's Missing Children*, London: Wallflower.

Notes

1. See Bailey (2000), Wilson (2003), and Kuhn (2008) in particular.
2. On the 'still-moving' paradox, see Beckman and Ma's 'Introduction' to *Still Moving: Between Cinema and Photography* (2008: 1–19).
3. See, in particular, Mulvey (2006), Rodowick (2007), Shaviro (2007), and Cubitt (2004).
4. For the purposes of this chapter, I will focus on the Pathé disc rather than the Criterion disc. Although the discs are very similar, there are minor differences to the layout, and the Criterion disc also includes an interview with director Lynne Ramsay, which is not available on the Pathé version.
5. Of course, such design features are part of the discourses used to market art-house films to target audiences. As Paul McDonald (2007) has argued, such features work to confer the 'aura of quality' onto the DVD as an aesthetic object, which adds to their appeal for certain spectators.

Chapter 7

Leafing Through Cinema

Matilde Nardelli

In *Loving Lie* (*L'amorosa menzogna* 1949), an early documentary by the Italian director Michelangelo Antonioni on the then popular phenomenon of the *fotoromanzo* (or photo-novel), the narrator introduces the genre as a 'pocket cinema'. *Fotoromanzi* – essentially fictional photo-stories in cheap magazines, in a characteristic comic-strip layout – were certainly profoundly informed by cinema. In Italy and proximate countries, particularly France and Spain, their heyday, between the late 1940s and the early 1960s, coincided with the heyday of cinema itself, and a variation of the genre, the cine-novel, was specifically dedicated to the representation of released films – generally, but not exclusively, successful Hollywood hits. Though the actual format of magazines dedicated to *fotoromanzi* was generally larger than pocket size, the expression 'pocket cinema' succinctly points to the way in which these publications manifested – if not, more strongly, embodied – cinema yet also transformed it. If these publications *were* cinema, or if cinema was *in* these publications, then cinema had also been turned into something tangible and portable: a composite unit of photographs, text, page and pagination.

In this respect, the *fotoromanzo* magazine is an example of what Pavle Levi has recently described as 'cinema by other means': 'the practice of positing cinema as a system of relations directly inspired by the workings of the film apparatus, but evoked through the material and technological properties of the originally non-filmic media' (Levi 2010: 53).[1] In the case of the photo-novel, these non-filmic media can essentially be described as photography and 'the book', intended here broadly as a form made of printed, bound pages (glued, stapled, stitched or simply folded). In what follows, I will discuss some of the ways in which the composite of photography and the book functions as a representation – and, even, as a *kind* – of cinema in forms such as the photo-novel and subsequent, more or less overt, re-elaborations of the genre, particularly the artists' photo-books that flourished from the mid-1960s. If these printed forms' '*re*-materializations' of cinema made the medium somewhat *more material* than in its original incarnation – fixing its evanescence on the page and within front and back covers – then one of the questions to consider will be how such re-materializations may obviate for the movement so distinctive of cinema, which they ostensibly lack.[2]

<p style="text-align:center">*　　　*　　　*</p>

In a recent exhibition catalogue on the use of photography in artists' books, one of the essays bears the catching and, perhaps, somewhat disorientating title: 'The Book Is the Medium of Photography' (Honnef 2002). As critical reflections on photography tend to note, encounters with a single photographic image and, more broadly, with the medium of photography in isolation, have overall been rare occurrences in the history of photography itself (see, for example, Burgin 1980; Campany 2008; Sontag 1977; Stimson 2006). Reflecting on the medium in his posthumously published collection of Bauhaus teaching notes, *Vision in Motion* (1947), the artist László Moholy-Nagy noted how the series seemed both a natural and a logical form of photography and cited 'photographic comics, pamphlets, books' as examples (Moholy-Nagy 1947: 208).[3] Two crucial, and crucially interrelated, aspects of photography's development are highlighted in this assessment, for it points both to the fact that photography largely developed as a plural form – a medium of series and sequences – and that print media played a fundamental role in fostering such modality.

In part, confirmation of this assessment could have been found even as far back as one of photography's very points of origin. William Henry Fox Talbot announced his discovery of the calotype process with a publication – the famous *The Pencil of Nature* (1844–46) – which included a series of 24 photographs and suggested possible uses for the medium which, as David Campany has recently noted, 'implied assemblies rather than single images' (Campany 2008: 60). Talbot's publication included original plates rather than 'typographical' reproductions, for which methods had not yet been developed. Yet it prefigured not only the plural form that photography would by and large assume but also the part that print media would come to play in promoting such plural form as well as photography's diffusion and growth – another way in which the medium is 'plural' – more broadly.[4] Newspapers, magazines, books and advertising became the primary modes of circulation of photographic imagery in the twentieth century. As Patrick Maynard has argued, the elaboration of printing processes enabling the reproduction of photographs in ink – processes themselves largely photographic in nature – was 'perhaps photography's greatest reinvention, thanks to ink's permanence, its combination with letterpress technology, and its powers of cheap and wide distribution' (Maynard 1997: 55). By the 1940s, when Moholy-Nagy wrote the assessment cited above, the consolidation and industrial application of printing methods such as gravure was making the ink reproduction of photographs increasingly cheaper and faster, boosting the illustrated press and publishing market.[5] As we have seen, it is from this source – this *kind* – of photography that Moholy-Nagy, listing 'photographic comics, pamphlets, books', drew to declare the 'naturalness' of the series to the medium. The important connection between innovative printing methods and the promotion of photography's reproduction and circulation is succinctly encapsulated in the Italian name for the kind of photographically illustrated magazines that emerged in the interwar period and boomed in the post-war years: these came to be called *rotocalchi*, from the industrial, rotary-press-based application of photogravure methods. Magazines especially dedicated to *fotoromanzi* were indeed a particularly heavily illustrated type of *rotocalco* that started

to be produced after the war, as photographic reproduction and printing methods were consolidated and made increasingly cost and time effective (Forgacs and Gundle 2007: 35–42, 95–123).

An important corollary of photography's circulation and consumption through print media, and book forms in particular, is its 'incarnation' on – and even *as* – a page, its embedment in it as an element (sometimes the only element) of typography. Moholy-Nagy had enthusiastically described this new composite as 'typophoto' – or 'phototext', if no other elements besides photography were present on the page – in his Bauhaus book *Painting, Photography, Film* (Moholy-Nagy 1967 [1927]: 38–40). The experimental layout of his 'Dynamic of the Metropolis: Sketch of a Manuscript for a Film' (1921–22), included in *Painting, Photography, Film* (124–37), signalled Moholy-Nagy's excitement for the possibilities which photography brought to typography – possibilities which he and artists such as Alvin Tolmer saluted as a new era of printing (Moholy-Nagy 1967: 39; Tolmer 1931). But this investment in a new typographical art, through which the physical and aesthetic boundaries of both the page and the photographs within it would be made conspicuous and tested, did not exclude a conviction that the page and sequences of pages were set to be one of photography's 'natural' sites. In other words, as the title of the essay I cited earlier boldly puts it, the book was emerging as 'the medium of photography' as well as a form whose own material and formal attributes were becoming complexly, and even indiscernibly, interwoven with those of photography itself (Maynard 1997; North 2005).

But this union of photography and the book amounts to more than the sum of its parts. For not only is the development of this composite profoundly related to, and informed by, cinema but it can also itself be seen as a *kind* of cinema. Photography and the book can here be seen as the 'sum' of two media whose 'result' begets a third medium: cinema – evoked, if not even *re*-materialized, through the alternative, non-filmic means of photography in print.

The technological development and consolidation of ink photography, and the concomitant rise of photographically illustrated print culture from the late 1920s onwards – which saw the launch of mass-consumption magazines such as *Life* (begun 1936) or the Italian *rotocalchi* as well as the emergence of the novel format of the photo-book as such, as with Moholy-Nagy's aforementioned *Painting, Photography, Film* or Walker Evans's *American Photographs* (1938) – is fundamentally related to the contemporaneous ascendance of cinema as a popular medium. When Moholy-Nagy welcomed the introduction of photography on and as the page, stressing what he saw as its novelty through neologisms such as 'typophoto' and 'phototext', he also explained that such post-Gutenbergian forms were the product of the 'age … of the film' and film's distinctive 'kinetic process' (Moholy-Nagy 1967 [1927]: 39, 40). Similarly, in his later praise of the photographic series of 'photographic comics, pamphlets, books', the form is understood in cinematic terms, not only because it promotes a 'vision in motion' but also because, like cinema, 'the single picture loses its identity and becomes part of the assembly' (Moholy-Nagy 1947: 208). The influence of cinema on photography and the

page, and on the synthesis of the two, can be traced in a variety of examples, from the diffusion of the 'close-up' angle which, as Beaumont Newhall noted in 1937, was 'most uncommon before the moving picture', to the success of non-fictional, current affairs photo-stories in magazines such as *Life* (Newhall 1937 in Campany 2008: 64; Edey 1978). Arguably, however, nowhere is such influence more exemplarily encapsulated than in the *fotoromanzo* magazine.

Figure 1a (previous page) and 1b. Front cover and internal pages of Italian cine-novel
of *Seventh Heaven* (Italian title: *Settimo Cielo* [Henry King, USA, 1937])
(Published in *I grandi cine-romanzi illustrati* no. 235, 7 November 1937).

Fotoromanzi magazines, such as *Grand Hotel* (begun 1946) and *Bolero Film* (begun 1947), as I mentioned above, emerged in the post-war period and peaked in the mid-1960s when, as the role of cinema itself as a source of mass-entertainment had partly been replaced by television, their popularity begun to wane. In countries such as France and Spain, as well as Italy, where photo-novels boosted especially dedicated publications and became particularly popular, the genre's heyday, then, coincided with that of cinema (Anelli et al. 1979; De Berti 2000). Yet the genre's diffusion – not unlike the cultural

pervasiveness and resilience of cinema itself – was overall a more widespread and enduring phenomenon as, among others, Clive Scott's exploration of photo-stories in 1980s teenage magazines in Britain (Scott 1999: 184–214), the continuing publication of *Grand Hotel* and even, now, the emergence of web-based photo-novels, such as Anthony van Winkle's *Night Zero* (begun 2008), contribute to show.[6]

Cinema informs – and, as I shall argue, takes form in – the *fotoromanzo* magazine in numerous ways. To start, the photo-novel's genealogy can be traced back to cinema via the cognate form of the cine-novel, from which the genre in fact derived. Cine-novels begun to be published in dedicated magazines, such as *Al Cinemà* (begun 1922) or *I Grandi Cine-Romanzi Illustrati* (begun 1935) in the 1920s and 1930s (Alovisio 2007; De Berti 2000). Unlike *fotoromanzi*, which were usually based on original stories, cine-novels were illustrated narrations of released films.[7] Early cine-novels, however, were scarcely illustrated: the Italian example shown in Figure 1 (a and b), dedicated to *Seventh Heaven* (Henry King 1937, starring James Stewart and Simone Simon), boasts only two pictures over 28 pages of text. Yet, like the photo-novel which it historically precedes by a couple of decades, the cine-novel, too, evolved into the characteristic picture-frame sequencing of the *fotoromanzo* in the wake of the printing developments of the 1940s. In adopting this format, the cine-novel thus came to use – and, indeed, *literally*, to re-materialize – cinema in more than one way, not only in its stories, 're-presentations' of existing films (which thus functioned as collectible souvenirs and tangible aides-mémoire in a pre-video era), but also in its materials, as cine-novels' pictures would mostly consists of frames reproduced from the actual film or stills shot on set.

Directly inspired by the cine-novel, the *fotoromanzo* and its publications also developed as forms deeply related to cinema – though the relationship to cinema bears here in enticingly *less literal* ways. The first issue of *Grand Hotel* (in July 1946) made evident its cinematic aspirations by featuring on its front cover an image of a couple about to enter a cinema bearing the very name of the magazine (De Berti 2000: 114). Leafing through any issue of magazines of *fotoromanzi*, the presence of the world of cinema is instantly apparent: from full-page autographed portraits of famous actors, and feature articles on their private and professional life, to adverts for talent contests, cinema-extras or beauty products promising their users the look of a star (one of the taglines for a leading brand of face powder, for instance, was 'Hollywood Velvet').

At the level of the *fotoromanzi* themselves, production and consumption replicated cinematic conventions and protocols, as Antonioni so effectively outlined in *Loving Lie*, the semi-documentary that was also to provide the core idea for his story for Federico Fellini's *The White Sheik* (*Lo sceicco bianco* 1952). Both films (and with evident parodic intent in *The White Sheik*) draw attention to the ways in which the making of photo-novels 'mimed' the universe of cinematic production – from the existence of a circuit of dedicated facilities, technical staff and actors to the deployment of procedures such as storyboarding. In the case of photo-novels, however, all of this was on a much humbler scale and, crucially, had as its end the production of still images. So, as *Loving Lie* shows,

the shooting studio might be a modest basement, actors and photographers might have another day job and props such as champagne flutes might be quite likely to be drawn in by hand in post-production – a cheaper solution than buying actual ones to use during shooting. While *Loving Lie* is more restrained in stressing the 'poverty' of the *fotoromanzo vis-à-vis* cinema, one of the enduring gags of *The White Sheik* consists in dwelling on the irony of showing a rather conceited *fotoromanzo* 'director' preside over what looks like a grand cinema set, only to shout 'be still!' rather than 'action!' once shooting begins: rather than acting, the *fotoromanzo* actors have to freeze for the camera (Campany 2008: 13–14). The photo-novel's stillness, *The White Sheik* seems to surmise, may be a crucial reason for the genre's cultural subalternity: its intrinsic lack of movement condemns it to remain a 'poor', if not an inferior, form with respect to cinema. As well as dwelling on the cinematic aspirations of the *fotoromanzo*'s production, Antonioni and Fellini's films also outline the ways in which photo-novels generated patterns of consumption that, if in the shadow of cinema in many respects, were nevertheless crucially cognate with it. Such patterns ranged from the demand for new 'releases' (or, in fact, further instalments, as single stories often continued over twenty or more episodes in consecutive issues) to a system of stardom and fandom largely articulated and supported via the magazines themselves, whose gossip and agony columns were dedicated to *fotoromanzo* as well as cinema actors.

If, as *Loving Lie* and *The White Sheik*'s 'behind the curtain' exploration of the *fotoromanzo* discloses, its modes of production and consumption invoked the institutional and cultural apparatus of cinema, its look on the page invoked cinema's technological apparatus and the aesthetic forms the apparatus begets or encourages. So, as the conversation represented in Figure 2 shows, *fotoromanzi* adopted – and *adapted* – cinematic devices such as the close-up (which, as noted above, was rare in photography before cinema) and the shot/reverse-angle shot or, as can be seen on the right-hand page in Figure 3, parallel editing. In fact, if text – the non-diegetic commentary 'A Bruxelles … (In Brussels)' appearing in the top-left corner of one of the images – ultimately explains the simultaneity between the primary event and the secondary event introduced in the two bottom-right frames of the page, the photographs' layout does much to suggest the coexistence and hierarchy between them. In a variation on the typical layout of six frames per page (distributed in three rows of two pictures) (see Figure 2), the main event is here presented via two larger pictures frames (each double the size of a standard one), whose L shape somehow encloses the sub-event introduced towards the bottom right of the page. In fact, while adaptations of cinematic devices such as those just mentioned do appear in photo-novels, they are sparingly used. For, overall, the tendency is both to favour shots of greater distance from the actors than the close-up, such as head and torso shots or knee-length shots, and to maintain these shots across picture frames, as in Figure 4. Cuts are generally used to signal the start of a new scene or, as with the example of the telephone conversation above, where the images alternate between the two (in fact, here, three) interlocutors, when diegetically justified by the story itself (Scott 1999:

199–200). Though the adoption of a fixed-distance shot and the avoidance of frequent, drastic changes of content from frame to frame may seem anti-cinematic, the very logic by which photographs tend to be sequenced so as to create a sense of visual continuity derives from procedures common to narrative cinema. For what Scott calls the 'inertia' within, and between, vignettes of the photo-novel is ultimately the way in which the form applies cinema's so-called continuity rules, whereby editing is generally made to work for, rather than against, story development and comprehension. In fact, the overall visual uniformity of the photo-novel may even at some level be reminiscent of the look of the (typically) incremental differences between frames on a piece of footage.

Figure 2. Double-page spread from *Grand Hotel, no.* 958, 31 October 1964 (story: 'Il podere dei mandorli' ['The Almond-Orchard Estate']).

Figure 3. Double-page spread from *Grand Hotel* no. 958, 31 October 1964
(story: 'Un destino per Isabella' ['A Destiny for Isabella']).

If this display of cinematic *traits* on paper (or, indeed, the appropriation of these traits for the paper) is interesting, what is perhaps most compelling about the *fotoromanzo*'s relationship to cinema is the way in which, as a material object, it may, more holistically, come to function as *a kind of cinema*. In addition to sharing some of cinema's attributes, the typographical incarnation of photography on the bound page – the composite of photography and 'the book' – that makes the *fotoromanzo* may also generate an alternative cinematic apparatus.

Above all, this is a matter of sequencing. In a general though crucial sense, *any* book – any form of bound page – even without illustrations, entails sequentiality. Indeed, arguably, 'sequence' is one of the 'fundamental structural elements' of a book

Figure 4. Double-page spread from *Tipo* no. 19, 15 March 1953
(story: 'Lettere Nascoste' ['Hidden Letters']).

(Drucker 2004: 257). This fundamental structure was brilliantly pinned down by artist and writer Ulises Carrión's aphoristic essay 'The New Art of Making Books' (1975), one of the products of the sustained exploration of 'the book' in 1960s and 1970s art and certainly one whose enthused yet critical stance resonates strongly with the experimental enthusiasm of Moholy-Nagy and Tolmer in the previous generation. 'A book', Carrión writes, 'is a sequence of spaces', and as '[e]ach of these spaces is perceived at a different moment – a book is also a sequence of moments' (Carrión 1985: 31). Of course, this definition of the book as 'a time-space sequence', as Carrión further glosses it (Carrión 1985: 32), can also double as a definition of cinema or, certainly, film-based cinema, whose spatial sequencing – its succession of one frame next to the other – is 'activated'

as a temporal sequence by the projector, where frames proceed one after the other. If, as in the case of the photo-novel, 'the book' is actually made of illustrated pages, the way in which the composite of photography and the book form can invoke, if not even re-materialize, cinema 'by other means' begins to come into fuller focus. At a key level, both cinema and the photo-novel – and even, more generally, the photo-book – rely on a sequentiality of pictures: an ensemble whose images are distinct, yet fundamentally related and even inseparable, where meaning emerges precisely from the *relationship between images*. As Moholy-Nagy noted in his appreciation of 'photographic comics, pamphlets and books', 'the single picture loses its separate identity and becomes part of the assembly; it becomes a structural element of the related whole which is the thing itself' (Moholy-Nagy 1947: 208; Stimson 2006: 27–30). In this respect, the composite of photography and the bound page functions as a kind of cinema because, like cinema, it works through a *structural* interdependence and interrelatedness of images. It is *montage* on the page and across pages: a composite whose 'total' transcends the constitutive parts, adds up to more than the sum of individual elements.

As in cinema, furthermore, the way in which sequentiality is 'activated' relies on movement. For, as (again) Moholy-Nagy had intuited in his enthusiasm for the possibilities of photography on the page, the point is not so much that the book incarnation of photography is intrinsically still, as that the movement of cinema is repositioned elsewhere. For, if cinema is an apparatus that puts *images in motion*, then the composite of photography and the book is an apparatus that puts '*vision in motion*' – a mechanism whereby movement is entrusted to the user (Moholy-Nagy 1947: 208, my emphasis). The apparatus of cinema – in itself a composite one, distributed across a number of heterogeneous parts (e.g. filmstrip, camera, projector and screen) – is re-materialized via the illustrated bound page in a distributed form that includes the reader/viewer as one of its parts. Or, we could say, the reader/viewer needs to play the part of the projector – to turn a 'sequence of spaces' into a 'sequence of moments'. Where cinema is a moving sequence of images, in an illustrated publication such as the *fotoromanzo* the sequencing of images is organised so as to facilitate, guide and even, I would argue, emphasise the reader's function as the source of movement. Considering the *fotoromanzo* in this way as a kind of cinematic apparatus also helps to illuminate why cinematic devices such as cuts, close-ups and so on are used sparingly within it. Paradoxically, it is precisely the avoidance of these cinematic traits that helps the form function *as* a cinema. Eschewing frequent, brusque, radical changes from one picture frame to the other favours the movement that the reader needs to bring to the form to 'activate' its cinema. But if the relative visual uniformity of picture frames, as Scott has noted, 'facilitates the movement of the eye from vignette to vignette' (Scott 1999: 200), such facilitation does not mean that the reader/viewer's contribution of this physical movement is underplayed or made unobtrusive.

On the contrary, particularly in magazines such as *Grand Hotel, Tipo* and *Bolero Film*, the readers' contribution of movement – *their* part in this alternative apparatus – is, I believe, foregrounded. To an extent, this is precisely so as to make this cultural subaltern

of the 'real' cinema 'real' in its own terms, if not, even, palpably more material than the ephemeral real cinema: a paper cinema one can be very close to and, indeed, touch with the hand, caress with the eye and 'motor' at will. With a publication format about 1.5 times an A4-size page (a size normally doubled 'in use', when the publication is held open, with facing pages in view at the same time), and individual picture frames generally measuring 12 x 10cm (up to twice as much when, as we have seen, larger frames are used), the very action of reading/viewing becomes something of which users might become aware. Both the movement of the hands required to turn or hold open the pages and the movement of the eyes necessary to proceed through the space of the page are accentuated. In fact, to negotiate the pictures and their sequencing it is not only the eyes that need to move but also, perceptibly, the head and face, as they accompany the eyes' re-framing from vignette to vignette in an action of proximate, intimate looking and reading which is mixed with touch – if not even, itself, a kind of touching. Furthermore, similarly to cinema, where the concrete movement of the projector is the basis of the more intangible movement such mechanics produce or make appear 'within' the images themselves, the physical movement of hands and eyes across the *fotoromanzo*'s pages is also the basis of a more abstract movement provided by the reader/viewer. For, to engage with the *fotoromanzo*'s narration – to turn the sequencing of picture frames into narrative moments, space into time – the reader also applies movement mentally. Indeed, in order to reconstruct the dynamics of the story out of the genre's synthetic textual and visual information, readers supply *imagined* movement; they need to imagine movement within – and even between – its images, its selective and selected still points. In this sense, the alternative cinema of the *fotoromanzo* presents us with an alternative distribution of cinema's originally distributed form: one in which readers/viewers themselves are assigned the crucial role of the projector, the very part that 'activates' cinema by providing the movement – *of* the film and, consequently, *in* the film – so distinctive of it.[8]

From a certain viewpoint – such as, in part, the one adopted by *The White Sheik* and *Loving Lie* – this redistribution makes the *fotoromanzo* a 'poor', elementary if not primitive, incarnation of cinema. Yet this also makes the *fotoromanzo* a very rich and complex form – a form, in fact, that may even tell us more about cinema than cinema itself can. The *fotoromanzo*'s alternative, and alternatively organised, cinema – where, moreover, movement is repositioned outside of its 'matter' and, partly, in the mind of the viewer – highlights that cinema is both matter and idea: both concrete apparatus and immaterial concept, or even ideal (see Levi 2010: 53, 67). But this is not to say that the *fotoromanzo* helps us to see that cinema's historical apparatus is just one among many possible, contingent materialisations of the idea of cinema. Rather the contrary: what the *fotoromanzo* contributes to reveal, as my detailed discussion of how cinema (in)forms the genre hopefully brought into focus, is the way in which cinema's historical apparatus is crucial to the idea of cinema – if not, indeed, to cinema *as* idea. For, as Levi suggests,

[I]f the Idea, or the dream, of cinema, may, indeed, be said to have preceded and motivated the invention of the film medium, it seems equally necessary to recognize... that this Idea acquired sufficient conceptual precision – that it gained its own, albeit immaterial, specificity – *only after the cinematographic apparatus had already been invented.* (Levi 2010: 56; Nardelli 2009: 259; *cf.* Walley 2003: 23)

In this respect, the importance of the alternative cinema of the photo-novel lies precisely in the fact that it brings into relief not only the non-coincidence between cinema's concretisation in its traditional filmic apparatus and cinema's conceptual dimension but also the necessary interdependence between these two poles: it crystallises how the idea of cinema exceeds the very technology on which its conceptual definition nevertheless crucially depends.

<p style="text-align:center">* * *</p>

Just as photo-novels and their publications began to decline in popularity in the course of the 1960s and 1970s – partly as a consequence of television's competition –the form became attractive to a number of writers, film-makers and artists. Alain Robbe-Grillet and Samuel Beckett overtly re-appropriated the cine-novel when they also tried their hand at cinema, publishing illustrated book versions of *Last Year at Marienbad* (*L'Année dernière à Marienbad* 1961), *The Immortal One* (*L'Immortelle* 1963) and *Film* (1965) that exceed the conventional format of a simple script (Beckett 1969; Robbe-Grillet 1962 [1961]; Robbe-Grillet 1971 [1963];); while Jean-Luc Godard published book versions of many of his films, some of which, such as that of *Breathless* (*À bout de souffle* 1960), adopted quite closely the comic-strip layout of post-war cine-novels (Godard 1974). Less overtly, yet perhaps more interestingly, the photo-novel can also be seen to inform a number of more radically experimental books produced by artists (some of them also film-makers), such as Ed Ruscha, John Baldessari, Gilbert and George, Sol LeWitt, Michael Snow and Hollis Frampton, during the same period. In fact, it is here that the 'cinema by other means' of the photo-novel – and, in particular, the way in which the genre's composite of photography and the book assigns movement to the reader/viewer – comes to be critically developed and self-consciously articulated.

The selective, succinct sequentiality of the photo-stories in books such as John Baldessari's *Four Events and Reactions* (1975) and *Brutus Killed Caesar* (1976), for instance, invites us to dwell on the mental movement the reader/viewer is called on to provide. Synthetically presenting mini-stories (four separate 'events' such as touching a cactus in one book and several versions of how Brutus killed Caesar in the other), via respectively only two and three images, both books draw attention to the imagined movement between and within images necessary to 'montage' the separate images. For it is through this imagined movement – by 'filling in' the movement of the action which

the visual sparseness of these stories only implies or suggests – that spatial sequencing is translated into a temporal one and made to work as a narrative. And, indeed, by 1978, Baldessari himself pointed out that he had come to realise that 'the serial photographic things [he] was doing' (and many of these 'photographic things' were photo-books), 'were pretty much like films' (Baldessari 1978: 11, quoted in Tucker and Pincus-Witten 1981: 16). By contrast to *Four Events* and *Brutus Killed Caesar*, Ed Ruscha's *Crackers* (1969) draws out imagined movement but emphasises the physical movement of turning and looking at the pages, as a very short, tongue-in-cheek, story by Mason Williams – 'How to Derive the Maximum Enjoyment from Crackers' (1967) – is turned into a photostory which also functions as a kind of flipbook, with photographs presented *as* (full-size) pages to be turned in fairly rapid succession. An even more articulate example of the reader's part as 'projector' is offered by Michael Snow's brilliantly complex *Cover to Cover* (1975), in which – by, as in *Crackers*, proceeding through photographs sequenced as pages – the reader follows Snow himself as he eventually arrives to the opening of a show of his work, where he picks up a copy of the very book the reader has been leafing through. In addition to using the composite of photography and the book to evoke cinematic devices or effects, such as cuts, rendered through blank or black pages, or shot/reverse-shot sequences, articulated via verso and recto, the book decidedly plays up the reader's input of physical movement. Here, in fact, in order to keep with the photographs' sequencing – to engage with, and follow, their narrative – the reader needs not only to turn the pages but also, at a point, to turn the book itself around by 180 degrees (and, consequently, to continue to turn the pages in what seems to be a backward direction).

Though all too briefly evoked here, these examples provide an intriguingly 'open' conclusion to the 'leafing through cinema' this essay has considered. For, here, the photo-novel is re-appropriated as a doubly reflexive form: a form whose overt exploration of photography and/on the bound page is at once self-reflexive and a reflection of, if not indeed *on*, cinema's pervasiveness and transcendence of the technological apparatus through which it was first concretised.

Bibliography

Alovisio, S. (ed.) (2007), *Cineromanzi: La Collezione del Museo Nazionale del Cinema*, Turin: Museo Nazionale del Cinema.

Anelli, M.T., et al. (2007), *Fotoromanzo: fascino e pregiudizio. Storia, documenti e immagini di un grande fenomeno popolare*, Milan: Savelli.

Beckett, S. (1969), *Film: Complete Scenario, Illustrations, Production Shots*, New York: Grove Press.

Bolter, J.D. and R. Grusin (1999), *Remediation: Understanding New Media*, Cambridge: MIT Press.

Burgin, V. (1980), 'Photography, Fantasy, Fiction', *Screen*, 21:1, pp. 43–80.

Campany, D. (2008), *Photography and Cinema*, London: Reaktion.

Carrión, U. (1985), 'The New Art of Making Books' (1975), in J. Lyons (ed.), *Artists Books: A Critical Anthology and Sourcebook,* Rochester: Visual Studies Workshop Press, pp. 31–43.

De Berti, R. (2000), *Dallo Schermo alla Carta: Romanzi, fotoromanzi, rotocalchi cinematografici: il film e I suoi paratesti*, Milan: Vita e pensiero.

Drucker, J. (2004), *The Century of Artists' Books* (1994), New York: Granary Books.

Edey M. (ed.) (1978), *Great Photographic Essays from Life*, Boston: Little, Brown

Evans, W. (1938), *American Photographs*, New York: Museum of Modern Art.

Forgacs, D. and S. Gundle (2007), *Mass Culture and Italian Society from Fascism to the Cold War*, Bloomington: Indiana University Press.

Foster, H., R. Krauss, Y. Bois and B. Buchloh (2007), *Art Since 1900: Modernism, Antimodernism, Postmodernism*, London: Thames and Hudson.

Godard, J. (1974), *À bout de souffle*, Paris: Balland.

Gundle, S. (2000), *Between Hollywood and Moscow: The Italian Communists and the Challenge to Mass Culture, 1943–1991*, Durham: Duke University Press.

Honnef, K. (2002), 'The Book Is the Medium of Photography', in A. Thurmann-Jajes and M. Hellmold (eds), *Ars Photographica: Fotografie und Künstlerbücher*, Bremen: Neues Museum Weserburg, pp. 47–51.

Levi, P. (2010), 'Cinema by Other Means', *October*, 131, pp. 51–68.

Maynard, P. (1997), *The Engine of Visualization: Thinking Through Photography*, Ithaca: Cornell University Press.

Moholy-Nagy, L. (1947), *Vision in Motion*, Chicago: Theobald.

—— (1967), *Painting, Photography, Film*, London: Lund Humphries.

Nardelli, M. (2009), 'Moving Pictures: Cinema and Its Obsolescence in Contemporary Art', *Journal of Visual Culture*, 8:3, pp. 243–64.

Newhall, B. (1937), *Photography: A Short Critical History*, New York: Museum of Modern Art.

North, M. (2005), *Camera Works: Photography and the Twentieth-Century Word*, Oxford: Oxford University Press.

Robbe-Grillet, A. (1961), *Last Year at Marienbad: A Cine-Novel*, R. Howard (trans.), London: John Calder, 1962.

—— (1963), *The Immortal One*, A.M. Sheridan Smith (trans.), London: Calder and Boyars, 1971.

Scott, C. (1999), *The Spoken Image: Photography and Language*, London: Reaktion.

Sontag, S. (1977), *On Photography*, New York: Farrar, Straus and Giroux.

Stimson, B. (2006), *The Pivot of the World*: *Photography and Its Nation*, Cambridge: MIT.

Tolmer, A. (1931), *Mise en Page: The Theory and Practice of Lay-Out*, London: The Studio, n. pag.

Tucker, M. and R. Pincus-Witten (1981), *John Baldessari*, New York and Dayton, Ohio: The New Museum and Wright State University.

Twyman, M. (1970), *Printing 1770–1970: An Illustrated History of Its Developments and Uses in England*, London: Eyre and Spottiswoode.

Walley, J. (2003), 'The Material of Film and the Idea of Cinema: Contrasting Practices in Sixties and Seventies Avant-Garde Film', *October*, 103, pp. 15–30.

While every reasonable effort has been made to contact the copyright holders of the images appearing in this article, the author would be grateful for any information concerning their copyright.

Notes

1. Levi's discussion builds on Bolter and Grusin's (1999) often-cited concept of 'remediation' but concentrates on the ways in which a newer medium (such as cinema) may be represented through an older one (such as, in his examples, sculpture and painting loosely labelled), rather than, as Bolter and Grusin principally – though not exclusively – do, on the ways in which an older medium (such as cinema) may be contained within a newer one (such as television) (Levi 2010: 65).
2. In the aforementioned article, Levi at a point also describes his notion of 'cinema by other means' as a 'process' of 're-materialization' of cinema into materials other than cinema's original constituents (Levi 2010: 56).
3. Moholy-Nagy's sentence reads as follows: 'There is no more surprising, yet, in its naturalness and organic sequence, simpler form than the photographic series. This is the logical culmination of photography'.
4. Talbot himself conjectured about such methods and adumbrated what came to be developed as the photographic halftone process in the 1880s (Twyman 1970: 31).
5. In fact, Weimar Germany was one of the first countries in which the mass-consumption illustrated press flourished in the late 1920s and early 1930s (see, for example, Foster, Krauss, Bois and Buchloh 2007. 240 44).
6. http://www.nightzero.com/index.html (accessed 19 January 2011).
7. Though *fotoromanzi* were largely based on original stories, adaptations of classic novels were not uncommon.
8. Of course, the movement '*in* the film' is closely intertwined with visual perception and the act of viewing.

Part III

Paintings, Artists and Film

Chapter 8

Michael and *Gertrud*: Art and the Artist in the Films of Carl Theodor Dreyer

David Heinemann

In his two films about artists, *Michael* (1924) and *Gertrud* (1964), important but problematic works that frame his best-known and most highly regarded films – *The Passion of Joan of Arc* (1927), *Vampyr* (1932), *Day of Wrath* (1943), *Ordet* (1954) – Carl Theodor Dreyer explores the theme of romantic love in the artistic milieu. Art and artistic creation and performance lie at the heart of these films, and Dreyer's *mise-en-scène* contains numerous paintings and *objets d'art*. These objects play a decorative role, but also a narrative one: they presage and mirror events; they express or catalyse characters and relationships. While characters relate actively to these works of art, interpreting and communicating through them, the stylistic strategies employed in the films frequently aestheticise the characters, conspicuously transforming them into works of art in their own right. Through composition, staging and performance – Dreyer's tableau style, close-ups of disembodied faces, statue-like poses – characters are compared, and compare themselves, to figures in art. At once automaton and agent, the characters inhabit an uncertain realm between object and subject, predetermination and free will. From the conflict between these opposing orientations, often manifested through the forced marriage of narrative development and pictorial stasis, Dreyer comments on the role of art in life and the dislocations of the human soul as it confronts the intolerable in the world.

In *Cinema 2: The Time-Image*, Deleuze explains that the experience of the 'intolerable' occurs when we realise that we have lost our connection to the world and are trapped in 'the permanent state of a daily banality' (1989: 164). This state might be caused by a prescriptive economic and ideological framework that does not appear to admit of change. Rodowick describes Deleuze's notion of our contemporary daily situation as 'characterized by repetition as the return of the same, primarily in the standardized production of commodities and the proliferation of information … mechanical, stereotyped, and habitual repetition' (1997: 203). Deleuze finds revolutionary potential in a particular kind of cinema which provides ways to help us to think afresh, to imagine new realities. Certain modernist films feature protagonists who are in some sense 'seers', aware of a spiritual malaise and able dimly to envisage the possibility of change in the world, even if this change cannot yet be thought, much less articulated. The form of these films challenges the viewer with a new image of the world, a 'time-image' that comprises 'irrational' connections between shots, disjunctive or vacuous spaces, false continuity and the sense of a direct image of time: time in its duration; time, 'the unalterable form filled by change' (Deleuze 1989: 17). Deleuze cites some of Dreyer's protagonists as examples

of the 'seer' character, or 'mummy' as he also calls them, who 'sees better and further than he can react, that is, think' and tries to find a way out of the spiritual entrapment:

> To believe, not in a different world, but in a link between man and the world, in love or life, to believe in this as in the impossible, the unthinkable, which none the less cannot but be thought: 'something possible, otherwise I will suffocate'. (1989: 164)

This is the situation in which the protagonists of *Michael* and *Gertrud* find themselves. Their attempts to find a way out, as well as the often radical formal qualities of these films, provide a sustained exploration of the role of art in life.

Both *Michael* and *Gertrud* are tragedies, although not in the classical sense. Indeed, for these films Dreyer chose to adapt works by authors with a 'modern' conception of tragedy, as he makes clear in an interview in which he discusses the play *Gertrud*:

> I had chosen the work of Hjalmar Söderberg because his conception of tragedy is more modern, he was overshadowed far too long by the other giants, Ibsen and Strindberg. Why did I say he was 'more modern'? Well, instead of suicide and other grand gestures in the tradition of pathetic tragedy, Söderberg preferred the bitter tragedy of having to go on living even though ideals and happiness have been destroyed. (Quoted in Nash 1977: 67)

Michael too features a protagonist attempting to come to terms with the destruction of his happiness and his ideals. Although some critics consider the film to be an anomaly in Dreyer's oeuvre, the story is broadly similar to that of *Gertrud*.[1] Both films have a comparable three-part narrative structure. The story begins with the protagonist in love with someone whom they believe to be their ideal lover. This lover then betrays their trust and disparages their love, resulting in the protagonist's disillusionment and misery. In the final act the protagonist appears to come to terms with the loss, transfiguring it into an apotheosis of character. These are tragedies about the 'banality' of the everyday (in Deleuze's sense), featuring tragic heroes who suffer not from a fatal flaw but from the incommensurability of life and love with their idealised notions of them. Dramatically the films are made difficult by the absence of catharsis; although the characters visibly suffer, Dreyer mobilises narrative and stylistic strategies which inhibit viewer identification. Key to these is the role played by art within the diegesis.

The films suggest that art, artistic creation or performance can act as conduits for feelings of spiritual and sexual love. In *Michael* the celebrated middle-aged painter Claude Zoret, known as the Master, first meets the aspiring artist Michael when Michael presents to him a sheaf of sketches. Zoret claims the work is worthless ('Come back once you have learned how to really see!') but engages Michael as a model. Michael becomes his muse and, it is implied, his lover. He also becomes something of an adopted son to the childless, unmarried Zoret. Zoret paints his most highly regarded and successful

works with Michael as his model, most notably *The Victor*. In the flashback to their first meeting, it appears that Zoret notices Michael's beauty only after his rejection of the young man. He calls him back: 'I feel like painting you. Do you want to pose for me?' What prompts Zoret to act as he does? Perhaps when he sees Michael's potential as a model – that is, the basis for a work of art – he begins to fall in love with him. Or is it rather the reverse: smitten by his boyish charm, Zoret envisages making him into a work of art? The film makes clear that in the world of *Michael* artistic practice and the appreciation of art are a training for seeing, for achieving clarity of vision, aligned with understanding, and dependent on loving. In his relationship with Michael, the Master proves that he knows 'how to really see'.

Art can stimulate feelings of love and also provide a medium for characters to communicate this love. The Countess Zamikow, with whom Michael will betray the affections of Zoret, first properly notices Michael only after she has seen Zoret's paintings in which he features as a naked mythical hero. The onset of Zamikow's and Michael's mutual infatuation is marked by alternating close-up, single shots of the characters gazing radiantly at each other as they stand before Zoret's masterwork, *The Victor*. Rather than seeing Michael in the painting, Zamikow sees the painting in Michael: 'So that is you!' she says to him, smitten by his beauty which the painting has just revealed to her. Demonstrating the power of art to influence our perception of (pro-filmic) reality, Dreyer deploys in this sequence reflexive stylistic techniques as if to mirror for the film's viewers the experience of the characters they observe. In Michael's glamorous close-up, a shot sustained beyond its narrative function, the actor appears to look straight into the camera, directly engaging the viewer in an appreciation of this portrait of youthful beauty but also breaking the fourth wall. Intercutting these close-ups with extreme long shots highlights their artifice (this is not continuity editing), as does Zamikow's white feather headdress which, in creating an exaggerated halo effect in her close-ups, bares the device of the glamour shot itself. Even Michael's boyish prank, turning the portable spotlight used to illuminate Zoret's paintings on Zamikow herself, as if *she* were a work of art, a sculpture perhaps, encourages a reflexive reading of this scene. We are thus witness to multiple acts of creation of ideal beauty within and through art, both in the diegesis and extradiegetically.

Later, Michael's love for the Countess Zamikow allows him to see her truly and to finish the painting on behalf of the Master, who is incapable of completing her eyes. Stylistically the moment is one of the most striking in the film. The single close-ups of the two characters are composed on axis with the actors looking directly into the camera, Zamikow's face masked from just below her eyes (Figure 1), and a dolly toward Michael's face (one of the few dolly shots in the film) marking the intensity and importance of the moment but also the artifice of its representation. Indeed the incipient lovers are together engaged in artifice: the completion of a work of art. In the world of the film, the success of Michael's intervention (Zoret exclaims, 'Yes! Now it's her eyes!') testifies to the strength of their psychic and emotional connection.

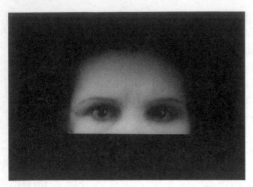

Figure 1. Representing the artifice of representation: the Countess Zamikov poses for her portrait in *Michael*. Rights: Friedrich-Wilhelm-Murnau-Stiftung. Distributor: Transit Film GmbH.

In *Gertrud* too love is channelled, if not engendered, by art. Gertrud, herself a famous poet and former opera singer now married to a lawyer, falls in love with the pianist and composer Erland Jansson when she sees him perform at a concert of his work. She later declares her feelings to him by singing a love sonnet accompanied by him on the piano. This moment is represented primarily by a long, arcing dolly shot in which the camera moves to a closer view of the two characters performing, then returns on the same trajectory to its original position. In its conception this recalls the dolly shot of Michael while he completes the painting of Zamikow (despite the fact that in *Michael* the movement toward and away is divided in the edit by a shot of Zamikow). In both cases Dreyer's camera marks the moment of shared artistic creation, whether painting or lieder, setting it apart stylistically from the shots around it through its complexity and unorthodox symmetry. As in *Michael*, so in *Gertrud* the lovers' emotional bond is established and expressed through an aesthetic act within the narrative, itself overtly aestheticised through the film-making strategies employed. Paradoxically, the distinctive camera work used to represent the characters' strength of feeling mutes the dramatic impact of the scenes by rendering them aesthetic objects to be appreciated by the viewer for their formal beauty.

But why, we may ask, does art inspire such strong feelings between characters? Two contradictory answers present themselves. On the one hand, art in these films (even if it may seem kitsch to viewers and may have been to Dreyer himself)[2] embodies quixotic notions about the ideal, the eternal, the ever-present. Such sentiments fit well with characters' romantic conception of love and are reflected in the style of art: academic painting and Hellenistic sculpture depicting mythical figures, romantic music, nocturnes and lieder. The Countess says to Michael on his first visit to his lodgings where *The Victor*, a recent gift from Zoret, hangs in a prominent position in the background, 'I long

to believe there is something like an eternity.' On the other hand, the commodification of art and its value as an index of social and financial worth is never far from our awareness, nor that of the characters. Zoret's paintings are bought and sold throughout *Michael*.[3] Indeed, the conflict between the lovers is metonymically represented in Michael's selling and Zoret's buying back for him his most famous and valuable painting *The Victor*. If Zoret imagined he was capturing Michael's heart forever by immortalising him in art, then Michael's gesture is a reminder of the economic relationship that parallels their romantic relationship. Zoret treats Michael paternalistically, as an inferior, yet the film insists that without Michael as his muse Zoret would not have achieved such artistic and financial success. The Duke of Monthieu says to Michael, 'You owe him a lot, Michael. But the Master owes you a lot too.' The Countess, currently in financial straits, requests a portrait by Zoret precisely because of its cultural value, which she hopes will increase her own value. Zoret agrees to paint her because he may believe he has found another muse. Artists require money to practice their art, and art makes money. In *Gertrud*, Erland throws over Gertrud for the woman whom, he claims, is helping him in his career.

Inspired by, creating and owning art, the protagonists come to believe that their lovers should have similar ideal qualities, but also that, as with art, they should be able to possess them. Gertrud and Erland appear to agree on this point. In splitting up with Gertrud, Erland says to her, 'I dream of an ideal woman, but you are not that woman. She must be chaste and obey me and be my property. You are too proud. … It's your soul which is proud.' Gertrud says to her former lover Gabriel, 'It was your work that separated us. And honour, fame, money, everything that shone.' In leaving her husband, she declares, 'A woman loves her husband above all else, but work comes first for him. … The man I am to be with must be mine entirely.' Although the nature of the desired possession may differ, ultimately the films suggest that the economic structure of capitalism and the emotional realities of romantic love are incompatible. Only once Zoret has bequeathed everything to the prodigal Michael does he express a sudden realisation which also forms the epigraph of the film: 'Now I can die in peace, for I have seen a great love.'[4] Divesting himself of his possessions, including the paintings through which he captured and attempted to control Michael, appears to awaken him to a new awareness. Perhaps he has ceased to regard Michael as his model, his work of art, his property.

Reinforcing the conceptual link between art objects and lovers, the *mise-en-scène* of the films serves to compare the two. Not only is Michael pictorially and narratively likened to the paintings of him but other characters are also associated with sculptures and paintings featuring different models and subjects. Paradoxically, the work of art can become the embodiment of the person. In the subplot of *Michael*, the Duke of Monthieu and Alice Adelsskjold embark on an adulterous affair despite the ever-presence of Alice's solicitous husband. At Zoret's dinner party the lovers communicate their mutual passion wordlessly through a sculpture, the naked torso of a woman, which becomes a simulacrum of Alice (Figure 2). The Duke caresses the sculpture as though it were Alice herself, while Alice nearly swoons in response.

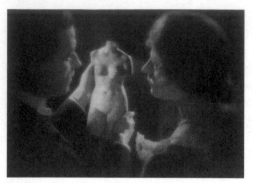

Figure 2. Communicating through art: the Duke of Monthieu and Alice embark on an adulterous affair in *Michael*. Rights: Friedrich-Wilhelm-Murnau-Stiftung. Distributor: Transit Film GmbH.

In *Gertrud* the linking of art object and character serves a less material but more metaphorical and obviously reflexive function. During her first tryst with Erland in the park, a statue of Aphrodite plays a key role in the *mise-en-scène*. From a medium two-shot of the lovers, the camera dollies back in a subtle arc-and-pan motion to reveal the statue of Aphrodite. The only apparent reason for the camera movement is to accommodate the statue in the frame; indeed, the dolly works contrary to the mounting tension of the scene, taking us further from the actors. Balancing the composition in the left middle ground, the statue forms a vital part of the scene, transforming the two-shot into a three-shot, which is then held for over a minute (Figure 3). Unlike in the examples from *Michael*, the characters do not appear to notice the sculpture; it is only there for the film's audience to reflect on and clearly invites a comparison with Gertrud at the very moment when she is deciding to consummate her relationship with Erland. At the end of the scene the camera, dollying with the pair as they leave the park, holds on the statue letting the characters clear the frame and reminding the viewer of its presence and signifying function: it personifies and universalises Gertrud's love and sexuality; it bestows on her time-bound action, represented by film as movement, something of the stillness and timelessness of the plastic arts.

As in these scenes, throughout *Michael* and *Gertrud* art is everywhere present in the *mise-en-scène*, forming the bond and backdrop of the protagonists' relationships and also commenting on their situations. It has often been remarked in Dreyer criticism that the works of art, as well as other elements in the film including character dialogue, tend to interpret events for the viewer, leaving the viewer cognitively adrift in the face of what may seem to be an interpretive vacuum. This is particularly evident in *Gertrud*. Compounded by the slow pace, the monotonous and rhythmic delivery of lines, and

Figure 3. Characters mirrored by works of art: Gertrud is compared to Aphrodite in *Gertrud*. Copyright Palladium A/S.

the long takes, the film generates an 'emptiness' which David Bordwell describes as 'excessive' in that the style 'reduces meaning but prolongs perception. ... This prolonging of perception creates a drainage of meaning. Either the narrative is saying nothing or it is saying nothing *new*' (1981: 186–87, emphasis in original). Addressing the use that Dreyer makes of art within the *mise-en-scène* James Schamus, in his recent monograph on *Gertrud*, describes the film as 'rhetorically mirror[ing] itself, as its characters also pause to read the enframed narratives that make up their story' (2008: 43). A good example of this – Schamus' primary example – occurs during the banquet sequence of *Gertrud* which draws on narrative information supplied earlier, in the park scene discussed above.

During their encounter in the park Gertrud tells Erland of a dream she had the previous night in which she ran naked through the streets pursued by hounds, awaking when they caught her. The next night, Gertrud meets her old friend Axel at the banquet and sits with him in the lounge. Just as Axel finishes describing his recent work on dreams and psychic phenomena, Gertrud notices the tapestry hanging on the wall behind them. Once again the camera reframes to feature the work of art, dollying back from the characters (Figure 4). The tapestry depicts the essence of Gertrud's dream. Like the statue of Aphrodite, it mirrors narrative information, figuratively suggesting what the protagonist is currently experiencing or about to undergo. The scene in the lounge occurs moments before Gertrud discovers that Erland has made their affair public, bragging to his friends at a party about his conquest, and that he is not the person she thought him to be. Although she does not yet realise it herself, her interpretation of the dream as she expresses it to Erland – that the *two* of them are 'quite alone in the world' – is incorrect. In fact, as the tapestry and her description of the dream both make clear, *she* is quite alone in the world. Erland is one of the hounds.

Figure 4. Art mirrors narrative events: a tapestry representing Gertrud's dream? *Gertrud*. Copyright Palladium A/S.

For viewers, and often also for the characters, the works of art foreshadow events, provide a commentary on the characters' moment-to-moment actions and act as tokens of the past, triggers for memory. All three of these functions, operating on the characters' past, present and future, create a strong sense of predetermination. It is as though the characters' fates are mapped out and recorded by the art that surrounds them. Indeed, determinism is a diegetic issue in both films and a topic of conversation. Prior to Gertrud's noticing the tapestry, Axel mentions that he is writing a book on free will. Gertrud replies, 'My father was a mournful fatalist. He taught us that everything in life was predestined. … "Destiny controls everything".' She, however, believes in free will: 'I prefer to choose my husbands myself.' Yet, as we have seen, the *mise-en-scène* appears to contradict her. Indeed, Gertrud herself occasionally speaks deterministically about making choices. Before consummating her relationship with Erland she says to him, 'When I saw you at the concert I had to love you. … Yes, it's my sorrow to have to love you as I do.' To Gabriel's mourning the loss of Gertrud, Gertrud replies in a tragic vein, 'No, one must choose. And one always realises that one has lost the only thing worthwhile.' Similarly in *Michael* a strong sense of tragic inevitability is generated in the opening sequence when Zoret, presenting his dinner guests with a *memento mori*, an image of a skull on a trivet, initiates a discussion about death. What emerges is a prefiguring of the entire plot. With death on his mind, Zoret concludes the conversation by announcing that he has decided to paint the moment when Caesar is murdered by his adopted son Brutus. When Michael asks Zoret who the model will be for Brutus, Zoret simply fixes him with a portentous stare. When Michael does eventually betray him, the Master takes to his bed and dies.

It is as if the characters are being doubled, shadowed by fictional figures that mythologise, but also seem to determine, their actions. At times, however, this mirroring is so foregrounded as to be overdetermined. In *Michael* Zoret, devastated by his loss of his muse, transfigures his suffering into art. He paints a canvas of a Job-like figure entitled *The Vanquished* enframing an obvious narrative in relation to his painting of Michael, *The Victor*. At a ceremony in honour of him and his latest painting, the film's style underscores the connection between Zoret and the figure in the painting. In a two-shot featuring the painter and his representation in the painting, the camera racks focus from Zoret to the painting behind him. Accompanying this shift of focus the light on Zoret is gradually flagged off, throwing him into dark shadow (Figure 5). Lighting effects unmotivated by the diegesis occur throughout Dreyer's oeuvre but here arguably add a disconcerting level of artifice in the service of conveying what the viewer has already long since divined: that the Job figure is a representation of Zoret. Zoret may have painted the figure with the intention of likening himself to Job, but by framing the Master in his own frame the film emphasises determinism over self-determination. However, given the level of stylistic excess we may be inclined to wonder whether the interpretive function is primary.

As noted above, Dreyer's stylistic excess produces a strong distancing effect. In *Michael*, 90-degree cuts on action, mismatched eyelines and enormous changes of shot size, from extreme long shot to medium close-up, repeatedly within the same scene, keep us aware of the artifice of the spectacle before us. Close-ups of faces leap out of the darkness and also out of the context carefully established in the preceding long shot. Thus, on the one hand, the films' style reinforces the air of artifice already engendered by the numerous

Figure 5. Zoret enframed by his own self-portrait in *Michael*. Rights: Friedrich-Wilhelm-Murnau-Stiftung. Distributor: Transit Film GmbH.

works of art in the *mise-en-scène*. On the other hand, it undermines the capacity of this art to support the narrative in establishing an air of tragedy. This may explain why the tragedies fail to come off as some viewers might expect – or hope! Instead of identifying with the characters in their suffering, we are continually reminded that they remain fixtures in a work of art. But if this is the conclusion to which our interpretive endeavour leads us, we find that the films have got there first: within the diegesis the characters have already been made, and made themselves, into works of art.

If *Michael* and *Gertrud* remain unsatisfying films dramatically, it may be that Dreyer is aiming to direct our attention elsewhere, away from strictly narrative or stylistic elements, or even the reciprocal relationship of these elements, and toward the friction created between them. Often pictorial and (in *Gertrud*) aural elements seem to pull away from the narrative, creating a fissure, a tear in the fabric of the work that makes one aware of the image and sound running alongside but separate from the story. This stylistic strategy highlights, at the expense of the action, the diegetic space, the fall of light and shadow, the separation of a particular moment from the moments on either side. It is as though the action stills and the moving pictures stop to become a painting or a *tableau vivant* in Brigitte Peucker's sense of the term:

> Tableau vivant moments in film set up a tension between the two- and three-dimensional, between stasis and movement, between the 'death' of the human body in painting and its 'life' in cinema. Further, because tableau vivant exists at the nodal point that joins painting, sculpture, and theatre, its evocation in film is a moment of intensified intermediality. (Peucker 2007: 26)

This intermediality creates a sense of layering, collage or palimpsest that emphasises the hybrid nature of the film medium and the objecthood of the people and things represented which the filmic image 'can only metaphorically suggest' (Peucker 2007: 26). As opposed to 'proto-cinematic paintings' such as those of the Northern European realist tradition as identified by Anne Hollander in *Moving Pictures* (1989: 29) which aspire to a state of imminence, revelation, ambiguity and fluidity, as though they were almost already moving pictures, it seems as though Dreyer aspired to imbue moving pictures with pictorial qualities which are the obverse of the proto-cinematic but can be found in the same painting tradition: a sense of suspension and attentive detachment. Elements of cinematic form such as lighting, framing, acting, camera movement and pacing thus combine with the diegetic works of art to produce *tableau vivant* moments which suspend the characters between subjecthood and objecthood, life and death, cinema and painting.

Dreyer had a lifelong interest in painting and cited in interviews the influence on his work of James Abbott McNeill Whistler and the Danish painter Vilhelm Hammershøi.[5] In his book-length study, *The Films of Carl-Theodor Dreyer*, David Bordwell notes the influence of these and other painters on the visual style of various films by Dreyer and

discusses the significant and abiding impact of Hammershøi (1981: 42, 172). Dreyer's predilection for the tableau style, for a focus on domestic interiors that in their design and framing tend to subordinate the characters to line and shape, as well as for a style of soft, oblique lighting that reminds us at times of Vermeer and the Northern European chamber art tradition, led him to de-dramatise his stories through an insistent focus on settings. The characters and their dramas are often subordinated to space and to the art contained within it, and the films can therefore seem to form a single picture, rather than a series of moving images. This effect is intensified by the *kammerspiel* aesthetic of these films in which the action is confined almost entirely to interiors. The sense of a continuous space existing beyond the frame or beyond the walls of the rooms in which the scenes play out is problematised by Dreyer's omission of exterior establishing shots and the transitional shots that most filmmakers use to link one interior space to another. Cutting directly from an interior scene in one location to an interior scene in another leads to a sense of disorientation, as these different spaces are made to appear isolated, disconnected – almost as if they were indeed separate paintings, with the connective movement that cinema conventionally provides suspended.

In the final moments of *Gertrud* the characters are first subordinated to, then eliminated from, the space that surrounds them, leaving in the final frame – the last shot of Dreyer's career – a chair, a door, an empty space (Figures 6 and 7). We feel the narrative, which has always struggled to emerge from under the weight of the spaces in which it plays out, slowly wind down, as if from the force of entropy, leaving in its place emptiness, stasis. The similarity of many of Dreyer's settings and compositions to those of the paintings of Hammershøi is striking. These final shots, in their simplicity, their spareness, their focus on doors and rooms, recall in particular the painting *Interior* (also called *The Four Rooms*) painted in 1914, one of the last Hammershøi completed (Figure 8). A description of the style of Hammershøi's paintings is illuminating in relation to Dreyer's films. In a review of the Royal Academy's 2008 exhibition of Hammershøi's work, British painter and writer Julian Bell wrote,

> Art suspends. But that is condition worth submitting to. … I note one of his favourite manoeuvres. To make as if to smother an underpainting that's bright and warm with chilling, heavy overlays, above all of grey; but to hold back the brush so that the life keeps peeping through. (Bell 2008)

This provides an apt metaphorical description of Dreyer's stylistic project, his 'excess' smothering the characters and distancing the viewer, yet still tantalising with the spark of passionate lives.

With their overt artifice, their disjunctiveness, their portraits of characters captured at times in a state of suspended animation, characters who suffer and who cannot be helped nor fully empathised with, *Michael* and *Gertrud* present problematic viewing. We may feel, along with the protagonists themselves, a sense of suffocation – the denial

Figure 6. The narrative winds down: Gertrud and Axel are subordinated to the space in *Gertrud*. Copyright Palladium A/S.

Figure 7. The final shot of *Gertrud*: a focus on setting. Copyright Palladium A/S.

Figure 8. A 'proto-cinematic' painting? The still image, pregnant with narrative possibilities. Wilhelm Hammershøi's *Interior* (1914). Reproduction courtesy of Ordrupgaard, Copenhagen. Photographed by Pernille Klemp.

of catharsis. The protagonists, however, like Deleuze's seers, 'cut off from an over-rigid, over-burdensome, or over-superficial external world' (Deleuze 1989: 171), nevertheless find the strength to affirm their faith in this world. Despite the weight of determining social and economic forces, and the tragic realisation that, as Gertrud puts it, 'love is suffering, love is unhappiness' and that one must always lose 'the only thing worthwhile',[6] both make a choice that 'no longer concerns a particular term, but the mode of existence of the one who chooses' (Deleuze 1989: 171). This creative act is to put their faith in love and in life. On his deathbed Zoret exonerates Michael; Gertrud carries on a long-term platonic relationship with Axel and declares near the end of her life, 'love is all'. Artists and idealists, they not only function as characters in a drama, but they also personify the transformative power of art.

Bibliography

Bell, J. (2008), 'So True, So Intimate', available at www.guardian.co.uk/books/2008/jun/28/ saturdayreviewsfeatres.guardianreview2. Accessed 28 June 2008.

Bordwell, D. (1981), *The Films of Carl-Theodor Dreyer*, Berkeley: University of California Press.

Deleuze, G. (1989), *Cinema 2: The Time-Image*, H. Tomlinson and R. Galeta (trans.), London: Athlone.

Drum, J. and D.D. Drum (2000), *My Only Great Passion: The Life and Films of Carl Th. Dreyer*, London: Scarecrow.

Hollander, A. (1989), *Moving Pictures*, New York: Knopf.

Nash, M. (1977), *Dreyer*, London: BFI.

Peucker, B. (2007), *The Material Image: Art and the Real in Film*, Stanford, CA: Stanford University Press.

Rodowick, D.N. (1997), *Gilles Deleuze's Time Machine*, Durham, NC: Duke University Press.

Schamus, J. (2008), *Carl Theodor Dreyer's* Gertrud: *The Moving Word*, Seattle: University of Washington Press.

Notes

1. Drum and Drum have a very low opinion of *Michael*, finding it 'bereft of the nobility and idealism that characterize virtually all of Dreyer's serious films. ... It is difficult to know why Dreyer chose to film *Mikaël* in the first place, since it is so unlike him' (2000: 105, 107). Dreyer, however, who was proud of the film, finds similarities between *Michael* and *Gertrud*, and also between their authors: 'The author of the novel [*Mikaël*], Herman Bang, belonged to the same period as Hjalmar Söderberg, the author of *Gertrud*, and it was even said of Söderberg that he imitated Bang, although it was Bang who imitated Söderberg. Well, it turns out that they knew each other and were even very friendly' (quoted in Nash 1977: 49).

2. Commenting on the décor in *Michael*, Dreyer remarks that the film's atmosphere reflects the 'rich taste' of the period, 'which was in bad taste but which, obviously was considered excellent at that time' (quoted in Nash 1977: 49).

3. One of cinema's renowned cameramen, Karl Freund, who photographed most of *Michael*, plays a bit part as the art dealer LeBlanc; casting the director of photography as a purveyor of images, a choice made by Dreyer himself, appears to be yet another extradiegetic comment on the story.

4. Which love Zoret refers to remains ambiguous. It could be the love of Zamikow and Michael, or Zoret's own love for Michael.

5. Among these interviews is one recorded in New York in 1965 and included in Eureka's Masters of Cinema series DVD release (2004) of *Michael*.

6. In these films, 'the only thing worthwhile' is love. Both protagonists remark on how lonely they are. Gertrud admits to Gabriel, 'My life has been so appallingly lonely and empty.' Zoret confides in the journalist Switt, 'No one knows how lonely I am.'

Chapter 9

Resonances of Nineteenth-Century Realism in Steve McQueen's
Hunger

Toni Ross

After an established career in experimental film and video, Steve McQueen's first feature film, *Hunger*, was released in 2008 and has since garnered much critical acclaim.[1] Co-written by McQueen and Irish playwright Enda Walsh, *Hunger* draws on events that occurred in the Maze prison of Northern Ireland in 1981. Specifically, the film covers the months leading up to a hunger strike campaign by Irish Republican prisoners in that year, through to the death by self-starvation of Provisional IRA member Bobby Sands.

In interviews McQueen has mentioned a number of art historical references he drew inspiration from in the making of his film. These include *The Disasters of War* (1810–20) series of etchings by Goya and court portraits of Velázquez (Bunbury 2008: 18). The latter discernibly inflect the comportment and framing of human figures in the film, where characters are occasionally placed against flat, monochromatic grounds devoid of incidental detail. This pictorial contrivance recalls the elimination of background features from the portraits Velázquez produced for the Spanish court in the 1620s. The prints Goya created in response to Spain's invasion by Napoleonic France in the first decade of the nineteenth century also come to mind in McQueen's recreation of the brutal, unofficial war between Irish Republicans and prison officers in the Maze. McQueen like Goya opts for a realist rejection of heroic depictions of war, instead confronting the beholder with the cruelties and deprivations suffered by all involved. Some scenes of physical clashes between prisoners and guards in *Hunger* are especially reminiscent of *The Disasters of War* series. The grotesque arches and contortions of prisoner's naked bodies under assault from uniformed men recall Goya's graphic scenes of battlefield atrocities where captives from both sides of the Franco-Spanish conflict were tortured and mutilated.

Despite these specific evocations of Spanish pictorial art, the following analysis will not focus on *Hunger*'s art historical references as revealed by McQueen. Instead it will be proposed that the film reprises certain formal operations and themes of nineteenth-century realist art. My particular concern is to examine two features of realism, both pictorial and literary. The first addresses a perception of realism as a democratic aesthetic, an idea that gained currency in French art criticism and elsewhere in Europe from the 1830s onwards (Hemingway 2007: 107). A second, related component of my argument links the intensification in *Hunger* of film's visually descriptive powers and a heightening of sensory experience to pre-cinematic forms of realism. A subset of this endeavour will trace affinities between McQueen's film and a small selection of realist works, both drawing and painting, by German artist Adolph Menzel (1815–1905).

My comments regarding affinities between *Hunger* and examples of Menzel's art are indebted to a recent study by art historian Michael Fried entitled *Menzel's Realism: Art and Embodiment in Nineteenth-Century Berlin*. I specifically highlight the distinction Fried makes between a *haptic* or *embodied* mode of pictorial realism adopted by Menzel and an optical realism he associates with photo-based media (Fried 2002: 252). For Fried, the haptic dimensions of Menzel's art address viewers as multi-sensory, embodied beings, whereas optical realism privileges vision above the other senses and encourages a mode of spectatorship based on distance and mastery. I wish to argue, however, that McQueen employs the photographic and sonic resources of cinema in ways that recall the haptic inclination of Menzel's art as well as other features of nineteenth-century realism. This argument seeks to supplement commentaries on the film that have noted McQueen's consistent activation of visceral sensory effects with enhanced historical insight.

The realism I impute to *Hunger* bears little relationship to popular definitions of realist art as faithfully mirroring external reality or, in naturalist mode, as privileging objective observation (Earnshaw 2010: 15–16). Rather, the account of realism elaborated here not only benefits from Fried's account of Menzel's pictorial realism but also from philosopher Jacques Rancière's writings on the philosophical and artistic origins of modern aesthetics. Rancière reminds us that nineteenth-century realism introduced thematic preoccupations and formal techniques that impinge on literary and visual art to this day. These features of realism include a destabilisation of the boundary between established poetic forms or subject matter and mundane events of prosaic life, and a shifting of the primacy of dramatic action (propelled by characters) over descriptive functions in both literature and visual art (Rancière 2004: 37–38).

In some respects, Rancière's account of what realism bequeathed to modern art reprises existing art historical and literary studies, which view realist art as paralleling political upheavals of the nineteenth century that challenged the hierarchical social formations of the European *ancien regimes*. Understood in these terms, realism engaged with prosaic themes, lower class characters and everyday experiences previously invisible or marginalised in the upper echelons of European art. For Rancière, however, the politics of artistic realism is less to do with the political or class sympathies of artists than with the emergence of a new paradigm of aesthetics that changed established ways of making, conceiving and responding to works of art. Expanding on the aforementioned characteristics of realism, Rancière refers to 'the primacy of a proximate mode of focalization' that disturbs the flow of dramatic action and the making visible of a tactile sensory world seemingly independent of human will or consciousness (Rancière 2004: 24). The following analysis of *Hunger* traces how these preoccupations and devices operate alongside the film's narration of a contentious episode of recent Irish and British history. It will be argued that McQueen treats the visual and sonic description of prosaic sensory phenomena with as much seriousness as narrating the words and actions of film characters. In other words, a tension between narration and description is maintained throughout the film.

Historical events and their cinematic translation in *Hunger*

Her Majesty's Prison Maze, also known locally as Long Kesh or the H-Blocks, was a high-security institution built by the British government to incarcerate participants in the conflict known as the 'Troubles'. This term describes civil unrest, sectarian and colonial conflict in Northern Ireland from the late 1960s to the end of the twentieth century. Although the Maze closed in 2000 it was fully operational in 1981 when Republican prisoners embarked on a hunger strike campaign in pursuit of prisoner-of-war status. The British government had withdrawn so-called special category status in 1976, thereby overturning a previously recognised legal distinction between paramilitary prisoners and ordinary criminals.

Twenty-seven-year-old Bobby Sands, who had been Officer Commanding of IRA prisoners when a hunger strike was called off without resolution in the previous year, led off the hunger strikes of 1981. Even though the Republican leadership outside the prison was opposed to a second hunger strike, Sands commenced his fast on 1st March 1981. While Sands slowly wasted away in prison he was elected a member of the British parliament for Fermanagh and South Tyrone, an event that drew attention to the prisoners' campaign in news media around the world. But despite the international publicity and public demonstrations provoked by the hunger strikes, the British government, headed by Margaret Thatcher, refused to yield to the prisoners' demands for political status. Sands died on 5 May 1981 after 66 days of refusing food. He was the first of ten Republican prisoners to die during the following seven months. Only after the Republican leadership called off the hunger strike on 3 November 1981 did the British government accede to many of the prisoners' demands, without ever reinstating special category status.

Much of the aforementioned contextual information is absent from *Hunger*, except for the occasional use of terse textual inserts. For example, the film's concluding intertitle provides little more than a body count. It informs us that Sands died after 66 days, nine other prisoners followed him and that sixteen prison officers were killed during the period of the prison protests. While some have criticised this paucity of background detail, the elision of historical explanation arguably enhances *Hunger's* emotional and mnemonic power. By this I mean that McQueen's adoption of a highly unusual approach to the cinematic re-enactment of historical events perhaps stays with audiences longer and more intensely than worthy but stylistically conventional film narratives about the Irish Troubles.

Hunger unfolds in three acts with the first two focussed on the brutalising conditions in the Maze leading up to Sands' decision to go on hunger strike. These sequences graphically re-enact the 'blanket' and 'no-wash' campaigns of Republican prisoners. Protesting the withdrawal of political status the prisoners refused to wear prison uniforms, wash or slop out their cells. A number of scenes show prisoners clothed only in blankets, smearing their excrement on cell walls, sharing space with decomposing food and maggots, and channelling urine into the cellblock corridors of the prison.

Also dramatised in the first two acts are the experiences of prison officers, in particular the fictitious character Raymond Lohan (Stuart Graham). Introductory scenes follow Lohan's daily routine as his wife serves him breakfast and he checks for explosive devices under his car before driving to work. Close-ups of Lohan's tense face and lacerated knuckles fill the screen in the early moments of the film. But the cause of these injuries only emerges later, when the prison guard is revealed to be an enthusiastic enforcer of the Maze regime. Some of the most disturbing passages of the film show Lohan and other prison officers assaulting Republican prisoners as they are subjected to internal body searches or forcibly washed and barbered. Yet Lohan also becomes a victim of violence. Towards the end of the second act, during a visit to his mother in a nursing home, the prison guard receives a bullet to the back of the head courtesy of a Republican assassin.

The second act of *Hunger* concludes with an intense and much admired 22-minute dialogue between Sands (Michael Fassbender) and fictional Nationalist priest Dominic Moran (Liam Cunningham). Most of this episode is shot as a single (seventeen-minute) take with a static camera focussed on the shadowed profiles of Sands and Moran, wreathed in swirling cigarette smoke, as they heatedly debate the political and moral validity of the hunger strike. The final third of the film traces in gruesome detail the physical deterioration and ultimate death of Sands.

Apart from the central dialogue between Sands and Moran, McQueen eschews the expository approach typically adopted in films about Ireland's colonial history and its aftermath. Recent examples of this method include Terry George's *Some Mother's Son* (1996), Ken Loach's *The Wind that Shakes the Barley* (2006) and the dialogue-heavy *Five Minutes of Heaven*, released in 2009. Unlike these films, dialogue and historical exegesis are dramatically reduced in *Hunger*, while attention is lavished on the visual and sonic texture of the film. McQueen has stressed that he wanted to immerse cinema audiences in the pathos of the Maze experience, instead of objectively chronicling the historical facts of the situation. His self-professed objective was to 'show what it was like to see, feel, hear, smell and touch in the Maze at this time' (Mac Giolla Léith 2008: 131).

The interplay of sensory description and narrative action

In a perceptive analysis of the cinematic means McQueen uses to achieve this ambition, Caoimhín Mac Giolla Léith describes the viewing experience of *Hunger* as aggressively visceral and imposing in its sensory effects (Mac Giolla Léith 2008: 127). Vision and sound conspire to intensify the sensorial impact of scenes of brutal violence and the suffering of male bodies under extreme physical duress.[2] A much-noted example occurs in the second act where riot police have entered the prison to regain control over Republican prisoners after they have smashed up their cells. These scenes are filled with the intimidating sound of truncheons rhythmically beaten against riot shields or loudly impacting on the bodies of prisoners whose cries and shouts are part of the chaotic sonic

cacophony. At the same time, the close proximity camerawork situates spectators in the midst of flailing limbs, descending batons and violated bodies. A notable reduction of visual distance between spectators and events unfolding on screen occurs repeatedly in *Hunger*. Its effect is to block the viewer's quest for spatial orientation, to dissolve the spatial distance necessary to identify with particular film characters or to immediately comprehend or symbolise what meets our eyes. In her study of the activation of haptic effects in various examples of avant-garde cinema and video, Laura U. Marks speaks of how the film-maker may abandon optical clarity in order to 'engulf the viewer in a flow of tactile impressions' (Marks 2002: 1). McQueen makes substantial use of this device, ensuring greater receptivity on the viewer's part to sensory effects of vision and sound felt in or on the body before being processed as components of the narrative. A related point has been made by the film-maker about the normal priority given to dialogue in feature films. In an interview for *Cineaste* McQueen observes, 'In most movies, as soon as things start, dialog emerges, and I wanted a movie where more or less the first forty minutes is in silence, so the viewers' other senses come to the fore' (Crowdus 2009: 24).

Much media commentary at the time of *Hunger*'s release predictably concentrated on scenes of violent conflict or the actions of characters, such as Sands, the prison guard Lohan and Republican cellmates Davey Gillen (Brian Milligan) and Gerry Campbell (Liam McMahon), whose abject prison experience features in the first act of the film. But as Gary Crowdus has noted, McQueen also includes many 'impressionistic details' that, I want to suggest, may be investigated from the perspective of realism (Crowdus 2009: 23). An instance of the amplification of visual (and sonic) details occurs at the beginning of the final act, directly following the dialogue between Sands and the priest.

At the end of this riveting verbal joust Sands has clearly resolved to go ahead with the hunger strike, and Dominic Moran seems just as certain he will never see him alive again. The next scene introduces a sharp decline in tension, an oscillation between emotional intensity and its alleviation that recurs throughout the film. This shift also marks a departure from the eloquent words and high drama of the face-off between Sands and Moran, during which the avowed atheist Sands suggests that his role as an uncompromising political revolutionary fulfils society's need for a Christ figure 'to give life a pulse'. The following sequence, however, offers a very different vision of the pulse of life, one decanted of grandiloquent human ambitions. A lap dissolve opens onto a perspective witnessed a number of times previously where a static, centrally placed camera frames the receding, tunnel-like space of a prison corridor with rows of cell doors on each side. Disguised by protective clothing, a prison employee walks towards the camera, throwing liquid disinfectant into pools of urine scattered along the passage. He returns to the far end of the corridor and wielding an industrial broom methodically sweeps the cocktail of human fluids and disinfectant under cell doors and down the corridor towards us. The only sound we hear is the amplified swish of the broom as it meets liquid and concrete, which gets louder as the sweeper moves towards us (Figure 1). During these moments, all of our attention is channelled towards the flows of liquid,

Figure 1. 'Battle of the liquids' sequence, *Hunger*, 2008.

the mechanical movements of the anonymous sweeper, and the syncopated sound of this activity. Such close observation and temporal distension of uneventful rituals of life in the Maze intermittently interrupt those passages of *Hunger* where the actions of characters take centre stage. The discussion, still to come, of nineteenth-century realism allies this feature to a widely accepted view of realism as giving aesthetic validity to lowly or commonplace subjects and experiences.

The next stage of what McQueen has named 'the battle of the liquids' sequence cuts to a series of abstract, spatially constrained images. In extreme proximity to its object of scrutiny, a tracking camera traverses the liquid residue of the cleaning ritual just witnessed.[3] Reflected on the surface of fluid forms are both identifiable and enigmatic sources of light (Figure 2). Here combat between human protagonists is reduced to an elemental world of bodily and chemical fluids distinguished by their mutability and malleability. As previously mentioned, by positioning the camera in close proximity to events or objects filmed McQueen sacrifices optical clarity and depth of vision in order to immerse the viewer in visual and sonic sensations. Yet, in the concluding moments of this sequence, the extreme close-ups of patterns of drying liquid are overlaid with the archly modulated, emotionally distant and unmistakable voice of Margaret Thatcher. McQueen here excerpts a brief section from one of Thatcher's parliamentary speeches where she coolly denigrates the hunger strikers for manipulating the 'most basic' human emotion of pity in order to 'sow the seeds of hatred and conflict'. These moments set up

Figure 2. 'Battle of the liquids' sequence, *Hunger*, 2008.

a stark contrast between the ocular ambiguity of chiaroscuro illumination, the camera's close observance of the surface of abstract forms of evaporating liquid and the emotional (and optical) distance from events expressed by Margaret Thatcher's words, which coldly discount any feeling of compassion evinced by the hunger striker's actions.

As the previous analysis suggests, while parts of *Hunger* are filled with the actions, and less often the speech of human agents, there are many occasions, where vision and sound enhance the material palpability of trivial phenomena, interrupting the propulsion of the narrative. Crowdus mentions 'long stretches of boredom', 'maggot infested cells' and 'the gentle ministrations of a hospital attendant during Sands's prolonged death watch' (Crowdus 2009: 23). A further selection of such moments would include a close-up in the early scenes of the film where a shower of toast crumbs cascades into the lap of prison officer Ray Lohan as he eats breakfast. There is also the camera's assiduous concentration on the movements of Republican prisoner Davey Gillen's fingers as he traces the punctured mesh of his cell window and intently scrutinises a fly crawling along his fingers.

This use of close-ups to accentuate the material presence of inanimate objects or the sensory impact of mundane activities brings to mind the words of Hungarian film theorist Béla Balázs who wrote in the 1950s that the cinematic close-up reveals 'the hidden life of little things' (Balázs 1952: 54). For Balázs, who echoes Walter Benjamin here, photographic close-ups expand and deepen our sensitivity to material dimensions

of the world normally passed over by human eyes. Yet, despite Balázs's referencing of cinema's technical means, aesthetic validation of the anonymous poetry of commonplace things occurs in realist literature and painting before the arrival of cinema.

The politics of nineteenth-century realism

In his writings on the emergence and characteristics of aesthetic modernity Jacques Rancière acknowledges the progressive secularisation of western art as discerned by Hegel, early in the nineteenth century: 'the more art becomes secular, the more it makes itself at home in the finite things of the world, is satisfied with them, and grants them complete validity' (Hegel 1988: 594). Extending such claims, Rancière views French realism as transforming 'classical' artistic norms that contoured neo-classical painting and literary production under the aegis of *les belles-lettres*. Drawing on Erich Auerbach's history of changing conceptions of *mimesis* from Antiquity to modernity, he argues that the 'classical' aesthetic paradigm adhered to an idea of *mimesis* posited centuries earlier in Aristotle's *Poetics* (Auerbach 1953). Rather than tasking art with faithfully resembling phenomenal reality, *mimesis* for Aristotle meant the *fictional* representation of actions, with actions being logical sequences of words or deeds normally undertaken by human agents, and governed by the ends at which they aim (Rancière 2005: 14). I hardly need add that similar criteria typically sustain the narratives of mainstream cinema.

Rancière has stressed that for painting to attain fine art status within a 'classical' system of the arts, it needed to conform to an Aristotelian conception of poetics: the telling of stories concentrated on the actions of human agents (Rancière 2007: 75). The visually descriptive capacities of painting were therefore subordinated to the directives of mythological, religious or historical narratives about those 'who dedicated themselves to the pursuit of great designs or ends and faced the chances and misfortunes inherent to such a pursuit' (Rancière 2008: 237). These words seem applicable to sympathetic historical or fictional accounts of Bobby Sands's quasi-religious martyrdom for the cause of Irish independence. Moreover, the nobility of Sands' self-sacrifice continues to be commemorated by word and ceremony in Irish Republican politics. At the same time, McQueen has stated that one of the reasons he wanted to make a film about the hunger strike was because it 'was one of the biggest political events in Britain in recent history. But it's already forgotten over here, swept aside' (O'Hagan 2008). This concern to make visible 'realities' repressed or overlooked in public sphere representations recalls the democratic spirit of nineteenth-century realism, which sought to bring 'into literary or painterly view common worlds of experience that had previously been aesthetically unseen, disregarded, or out of bounds' (Bowlby 2007: xiii).

Although McQueen affirms that he wanted to make visible an historical episode too quickly forgotten in Britain, critical responses to *Hunger* have also noted that he avoids romanticising Sands as hero, victim or martyr (Crowdus 2009: 22). Yet, despite this

tempering of simplistic moral typecasting, the film undoubtedly confects an absorbing and empathy-inducing narrative of the suffering Sands endured, sacrificing his corporeal being as a form of political protest. In this respect, *Hunger* conforms to the classical formula of *mimesis* previously described. Alternatively, the film's realism comes to the fore when dramatic action is punctuated by closely observed details that enlarge the descriptive and sensory power of image and sound. In a number of contexts, Rancière has examined the political significance of this aspect of realism.

Rancière views realism, along with Romanticism, as inaugurating tendencies of aesthetic modernity. They form part of an artistic episteme that he names the 'aesthetic regime of art', which being 'born at the time of the French Revolution' was allied to democratic demands for social and political equality (Rancière 2009: 36). In this account, the aesthetic regime, as an offshoot of broader transformations of social life, reconfigures how art had previously constituted the field of perceptual experience. Specifically, modern art dismantled the artistic and implicit social hierarchies of established representational systems. In the case of realism, this involved a refusal to privilege artistic depiction of noble actions over prosaic subjects or situations. As Rancière puts it,

> The border between the two territories had been drawn long ago by a short statement voiced by Aristotle: poetry is 'more philosophical' than history because it deals with combinations of actions, while history deals with 'life', where things just happen without necessity, one after the other. (Rancière 2008: 237)

As previously suggested, McQueen deliberately avoids elevating the deeds of characters or the causal links of the story above a proximate attentiveness to trivial, ephemeral or commonplace events of the Maze experience. *Hunger* also significantly breaks down conventional generic distinctions between fictional representation and factual events of history. For Rancière, such dismantling of hierarchical divisions between narrative and descriptive functions, between poetic fiction and prosaic life has featured in realist art from its early phases.

When analysing realism, Rancière frequently references Gustav Flaubert's novel *Madame Bovary* (1856). He speaks of the egalitarianism of Flaubert's choice of subject matter for this famous realist text, where '[t]he adultery committed by a farmer's wife is as interesting as the heroic actions of great men' (Rancière 2004: 55). But more importantly for my account of *Hunger*, Rancière draws attention to Flaubert's use of words to meticulously describe microscopic sensory phenomena. These passages, devoted to an elemental, material level of sensory experience, achieve a status equal to various turns of the plot, such as moments when characters fall in love. For example, Rancière isolates the moment when Charles Bovary is first attracted to Emma, who will later become his wife. Here Flaubert writes, 'The draught beneath the door blew a little dust over the flagstones, and he watched it creep along' (Rancière 2008: 242).

A similar imagistic attentiveness to micro-phenomena punctuates the narrative of *Hunger*. The 'battle of the liquids' sequence and other moments of descriptive detailing have been mentioned. But these are far from the only occasions when descriptive intensification overtakes narrative action. Another striking passage of descriptive fecundity occurs during a sequence in *Act Two* that references the 'no-wash protest' of republican prisoners. For three years prior to the hunger strikes of 1980 and 1981 prisoners responded to restrictions on toilet visits and physical violence from prison staff by spreading excrement on the walls of their cells. As a result, the prison administration instituted industrial cleaning of the cells every two weeks or so. Again without supplying background information, *Hunger* includes scenes of this cleaning ritual. Figures covered from head to foot in protective garb are shown applying hydraulic hoses to the dried excreta. The culminating shot of this sequence closes in on an incongruously artistic spiral of faeces daubed on a cell wall, which is progressively erased by highly compressed sprays of water (Figure 3). The gestural application and dense pigment-like qualities of the excrement bring to mind the tactile surface corrugations of abstract expressionist painting. But the most significant sensory impressions of these moments are the liquidation of particles of excremental matter, the

Figure 3. Cleaning excrement from cell walls of the Maze prison, *Hunger*, 2008.

clouds of water spray that white out one half of the screen and the overwhelming sound of water flowing through hydraulic hoses.

A comparison might be made between such moments in *Hunger* and Rancière's argument that Flaubert's description of a vitalistic world of micro-sensation creates a tension within *Madame Bovary* between Aristotelian poetics and a different kind of aesthetic sensibility. He contends that Flaubert presents characters 'who are still trapped in the old poetics with its combinations of actions, its characters envisioning great ends, its feelings related to the qualities of persons, its noble passions opposed to everyday experience' (Rancière 2008: 243). At the same time, the novelist makes visible a different way of experiencing the world, one whose principle, expressed by a thick descriptive elaboration of mundane sensory phenomena, is that 'life has no purpose. It is an eternal flood of atoms that keeps doing and undoing in new configurations' (Rancière 2008: 243).

The previous gloss of Rancière's account of *Madame Bovary* focuses on Flaubert's articulation of prosaic life as a materialist, sensory stratum of experience in tension with the rational designs of narrative meaning or the strivings of human agents. This detailed presentation of sensory phenomena, unsubordinated to narrative meaning, recalls Immanuel Kant's theorisation of the reception of natural beauty in the absence of pre-given concepts and as incarnating purposive wholes without utilitarian or moral purpose. As Alison Ross explains, the politics of literature expressed by Flaubert's realism activates for Rancière a 'questioning of established ways of organizing in advance the perception of the visible world' (Ross 2010: 141).

The extreme empiricism of Flaubert's efforts to reach beyond the logical linkages of narrative action towards the immediacy of sensory experience finds echoes in nineteenth-century realist painting, which also enhanced the role of visual description and the materiality of commonplace things. Images by German artist Adolph Menzel exemplify these tendencies. While Menzel worked with a wide range of subjects and genres during a career that spanned the nineteenth century, many of his pictures express an undiscriminating visual attentiveness to everyday sights and experiences. Works by Menzel I have selected for discussion share a number of features with McQueen's method in *Hunger*. Specifically, both artists intensify visual description of unremarkable objects or phenomena, which are assigned a level of sensuous immediacy that dominates the space of picture or screen. In each case, we are invited into a world of visual details and surface appearances that might normally escape notice.

Menzel's *Fur Coat on a Sofa (The Artist's Pelisse)* (*c.* 1859, oil on paper, board backing) (Figure 4) fits the generic category of domestic still life. Here the folds of Menzel's own textile and fur pelisse, and the silky and downy texture of these materials are closely observed and carefully documented. Or, more accurately, Menzel creates a visual dynamic between the abstracted solidity of the pink couch, the lumpy black interior of the coat and the close detailing of hairs that make up the pelt. Notably, the application of paint to notate the fur accents the textural qualities of this material. Michael Fried has observed that a sense of corporeal vitality or 'bodily feeling' pervades the garment despite

Figure 4. Adolph von Menzel, *Fur Coat on a Sofa (The Artist's Pelisse)*, ca. 1859, oil on paper, board backing, 38.6 x 44.5 cm. Photo: Bayerische Staatsgemäldesammlungern – Neue Pinakothek, Munich.

the absence of the coat's owner (Fried 2002: 46). The suggestion of sentience injected into this inanimate object arises, in part, from the pelisse's emulation of the posture of a human body sprawled on a sofa. But the spatial relation Menzel constructs between image and viewer also deserves comment. If judged according to criteria of perspective vision, or filmic depth of field, the relationships of scale between the coat and the sofa on which it sits would be considered unrealistic. The way in which the pelisse fills the

frontal plane of the image dwarfs its surroundings of wall, floor and sofa. Allied with a sense of sentience that inhabits the coat, the spatial dynamics of the painting suggest that the pelisse might at any moment slide or flop forward into the viewer's space. This illusion accentuates a tactile rather than optically distanced relationship between image and spectator, which also regularly features in *Hunger*.

A number of other works by Menzel contract spatial distance between viewer and image, while giving aesthetic validity to lowly subject matter. One example from his many sketchbooks, which document people and sights he witnessed in the environs of Berlin,

Figure 5. Adolph von Menzel, *Marks on a Urinal Wall*, 1900, pencil,
© Kupferstichkabinett, Berlin, Sketchbook 73, pp. 3-4 (inventory no. 00092614).

is particularly apposite to *Hunger*. The late pencil drawing of *Marks on a Urinal Wall* (1900) (Figure 5) indicates the extent to which Menzel turned his eyes and his art towards the most degraded or incidental phenomena of everyday life. This loosely worked, black-and-white sketch of irregular patterns left by traces of urine on the wall of a public *pissoir* parallels McQueen's use of close-ups to maximise the tactile surface qualities of micro-phenomena. Menzel's sketch also precedes by seventeen years Marcel Duchamp's famous induction of a urinal, with its scatological connotations, into the annals of modern art.

As Fried suggests, many of Menzel's images adopt an artistic perspective in close proximity to the things depicted, along with the sense that they have emerged from a process of intensive looking that attends carefully, even lovingly, to every surface detail of ordinary objects portrayed. This close-up treatment, in turn, invites the viewer to approach the pictures closely, to be drawn into the scene, as if we might reach out and touch the things represented. Menzel's works show that a proximate perspective and descriptive attentiveness towards ordinary things preoccupied realist painting before the advent of the cinematic close-up and its purportedly unique access to 'the hidden life of little things'.

In his study of Menzel, Fried draws on phenomenology to argue that the audience address manufactured by the artist conveys a heightened sense of bodily, multi-sensory involvement with the objects and scenes depicted (Fried 2002: 257). Significantly, he contrasts the *tactile* and *embodied* realism of Menzel's art with an optical realism commonly associated with photo-based media. Fried equates photographic looking with impersonal detachment where artist and viewer are disconnected, via mechanical mediation, from empathetic identification with the image produced and the world of the thing represented (Fried 2002: 252). Alternatively, Menzel's embodied vision situates the artist, and by proxy the viewer, corporeally and imaginarily inside the world represented by the picture. This distinction depends on Fried's claim that photography elevates vision above the other bodily senses and that 'the photographic surface is mechanical, inexpressive, above all uninflected by the operator's "touch"' (Fried 2002: 249).

Fried speculates that Menzel's injection of a sense of vitality and carnal palpability into everyday objects or experiences creates a different subject–object relationship to that identified in Karl Marx's analyses of capitalism and commodity culture. As is well known, Marx wrote of subjects constituted by the instrumental and acquisitive values of capitalism as engaging with the material dimensions of life according to the prerogatives of ownership and mastery (Fried 2002: 255). Thus, experience as contoured by the perceptual order of capitalism estranges modern subjects from the material conditions of existence on which society and humanity depend. The various manifestations of realist art previously discussed, from Rancière's reading of *Madame Bovary* to Fried's account of the haptic orientation of Menzel's art, might be viewed as responses to a perceived dulling of human responsiveness to sensuous experience in its various modalities. Yet Fried implies that pictorial art such as that produced by Menzel has a greater capacity than photo-based media to address viewers as embodied, rather than simply ocular subjects

of vision. Alternatively, my discussion of the photographic and sonic means McQueen employs in *Hunger* to heighten haptic sensation has stressed continuities between realist ideas and practices across the arts.

Conclusion

As the previous analysis of *Hunger* suggests, McQueen exhibits a willingness, honed by artistic training and a singular sensibility, to treat the description of prosaic sensory phenomena with as much seriousness as narrative action. But this is not a case of mobilising cinematic means to factually verify or explain historical events. McQueen notably refuses to treat the 'reality' of the hunger strike campaign of 1981 and Sands's death as a series of historical facts to be cognitively assimilated but too quickly forgotten by audiences. *Hunger*, as many have attested, withholds exposition that would flesh out many visual and sonic events represented on screen. Rather, the 'real' is produced as a constellation of sensory effects manufactured by the film-maker that intensify visceral dimensions of the film-viewing experience. Spectators of *Hunger* are addressed as subjects immersed in oscillating waves of sensory feeling as much as translators of narrative meaning. But a question remains regarding the political significance of this distended, intrusive staging of sensory illusion.

One answer to this question lies in the counterpoint set up in the concluding moments of the 'battle of the liquids' sequence. Here, McQueen contrasts the camera's intimate proximity to a shifting and unstable surface of liquid and light with the political rigidity and emotional distance expressed by Margaret Thatcher's dismissal of the pathos of the hunger strikers' situation. Without signalling overt partisanship on the rights or wrongs of those involved in the hunger strike, McQueen patently seeks with his film's surfeit of sensory effects to appeal to the audiences' susceptibility to feeling, touch or even suffering, if only in response to the film's *recreation* of both dramatic and banal rituals of life in the Maze. It is precisely this aesthetic capacity to feel pleasure or pain, let alone empathy for the suffering of others, that McQueen exposes as lacking from the conceptual neutrality and moral certitude of Thatcher's language. McQueen's ambition to make a film able to impinge carnally on spectators, rather than as wholly conceptually processed sensation, overturns any privileging of cognitive mastery or narrative coherence over embodied feeling.

Over ten years ago art critic Okwui Enwezor remarked that McQueen's moving image works propose at least two ways of seeing: 'one through the conventional optical mode of simply watching the image, and the other by "physically" (haptically) seeing film through the whole body, as illusionistic sensations' (Enwezor 1999: 44). This claim overlaps with Fried's thought of two different modalities of spectatorship in his account of Menzel's art. The first kind of seeing, implicitly identified by Enwezor with dominant patterns of cinematic reception, designates a distant, uninvolved perspective of conceptual mastery

over the material world and corporeal sensation. The second invokes a viewer implicated in, affected by and responsive to sensory data, whether in art or everyday life, typically subordinated to communicative utility or the egoistic theatre of human actions.

Enwezor, not incorrectly, situates the 'haptic vision' of McQueen's art within a lineage of avant-garde experiments in cinema and photography, from Soviet factography to Michael Snow's structuralist film experiments of the early 1960s (Enwezor 1999: 38). However, I have suggested that the importation of a haptic quality into art's vision of the world in *all* of its dimensions – significant or incidental, noble or prosaic – continues earlier developments in realist literature and pictorial art. At the same time, McQueen, employing all of the resources of film, adds to this equation the imposing pathos of sound in its phenomenal aspect.

Steve McQueen has created a film that addresses spectators as though the descriptive and phenomenal immediacy of their experience of the film is continuous with 'life' in the Maze prison in 1981. This makes *Hunger* and its subject matter memorable: both emotionally involving and confronting in a way rarely achieved by films on the 'Troubles' cleaved to expository narrative or documentary form. But perhaps McQueen's most impressive achievement has been to activate connections *and* tensions between different modalities of representation. For all of its appeal to the immediacy of sensory experience, *Hunger* sustains a narrative fiction of human actions and words, no matter how fractured or reduced. By fashioning exchanges between the binding force of narrative action and disaggregated moments of sensory disturbance, by refusing to segregate sensory or historical 'facts' from narrative fiction, McQueen has fashioned a vision of the past that resonates powerfully in the present.

Acknowledgements

Research for this essay has been assisted by the Australian Government through the Australia Council for the Arts, its arts funding and advisory body and by the Visual Arts and Craft Strategy, an initiative of the Australian State and Territory Governments. I would like to thank Steven Allen for his extremely helpful editorial comments on an earlier draft of this chapter.

Bibliography

Auerbach, E. (1953), *Mimesis: The Representation of Reality in Western Literature*, W. Trask (trans.), Princeton, NJ: Princeton University Press.

Balázs, B. (1952), *Theory of Film*, Edith Bone (trans.), London: Dennis Dobson.

Bowlby, R. (2007), 'Forward', in M. Beaumont (ed.), *Adventures in Realism,* Oxford: Blackwell Publishing, pp. xi–xviii.

Bunbury, S. (2008), 'Warrior Martyrs', *The Sydney Morning Herald,* pp. 18–19.

Crowdus, G. (2009), 'The Human Body as Political Weapon: An Interview with Steve McQueen', *Cineaste*, 34:2, pp. 22–25.

Earnshaw, S. (2010), *Beginning Realism*, Manchester: Manchester University Press.

Enwezor, O. (1999), 'Haptic Visions: The Films of Steve McQueen', *Steve McQueen*, London: ICA, pp. 37–50.

Fried, M. (2002), *Menzel's Realism: Art and Embodiment in Nineteenth-Century Berlin*, New Haven and London: Yale University Press.

Hegel, G.W.F. (1988), *Aesthetics: Lectures on Fine Art*, vol. 1, T.M. Knox (trans.), Oxford: Oxford University Press.

Hemingway, A. (2007), 'The Realist Aesthetic in Painting: "Serious and Committed, Ironic and Brutal, Sincere and Full of Poetry"', in M. Beaumont (ed.), *Adventures in Realism,* Oxford: Blackwell Publishing, pp. 103–24.

Mac Giolla Léith, C. (2008), 'Flesh Becomes Words', *Frieze*, 117, pp. 125–31.

Marks, L.U. (2002), *Touch: Sensuous Theory and Multisensory Media*, Minneapolis/London: University of Minnesota Press.

O'Hagan, S. (2008), 'McQueen and Country', *The Observer*. Available at www.guardian.co.uk/film/2008/oct/12/2. Accessed 1 October 2011.

Rancière, J. (2004), *The Politics of Aesthetics*, G. Rockhill (trans.), London and New York: Continuum.

—— (2005), 'From Politics to Aesthetics', *Paragraph*, 28:1, pp. 13–25.

—— (2007), *The Future of the Image*: London, Verso.

—— (2008), 'Why Emma Bovary Had to Be Killed', *Critical Inquiry*, 34, pp. 233–48.

—— (2009), 'Contemporary Art and the Politics of Aesthetics', in B. Hinderliter et al. (eds), *Communities of Sense: Rethinking Aesthetics in Practice,* Durham and London: Duke University Press, pp. 31–50.

Ross, A. (2010), 'Expressivity, Literarity, Mute Speech', in J.P. Deranty (ed.), *Jacques Rancière: Key Concepts,* Durham: Acumen Publishing Ltd, pp. 133–68.

Notes

1. *Hunger* was awarded the *Camera d'Or* and the Critics' Prize at the Cannes Film Festival of 2008, the inaugural Sydney Film Festival Prize of 2008, the 2008 Diesel Discovery Award at the Toronto International Film Festival and best film prize at the *London Evening Standard* Film Awards of 2009.
2. McQueen's vision of life in the Maze presents a closed world of masculine experiences and exchanges, variously coloured by aggression, cruelty, comradeship, paternal care, bravado and rivalry. Women such as Lohan's dutiful wife, Sands's grieving mother or the nameless girlfriends and wives who visit Republican prisoners occupy the fringes of the action, imagery and what little dialogue exists.
3. McQueen refers to the 'battle of the liquids' sequence in an interview with Jason Solomons, included on the commercial DVD of *Hunger* (Pathé and Twentieth Century Fox 2009).

Chapter 10

'You a Graffiti Artist?': The Representation of Artists and the Visual Arts in the Film-Making of Martin Scorsese

Leighton Grist

The directorial *oeuvre* of Martin Scorsese presents numerous figures – fictional, fictionalised and actual – that can be considered, one way or another, as artists. It is a list that includes, among others, a writer, a jazz saxophonist, a world-champion boxer turned nightclub entertainer, a television chat-show host, a wannabe chat-show host, a classical-era Hollywood film-maker and a clutch of rock and blues musicians and singers.[1] Many of these figures have been regarded as instantiating, with varying degrees of displacement, self-affirmation and/or self-critique, embodiments of Scorsese himself: an interpretative stance that, encouraged in part by Scorsese being a self-proclaimed 'personal' film-maker,[2] is more broadly indicative of a recourse to the biographical that continues to inform much author-centred criticism. Focused initially on a discussion of the 'Life Lessons' segment of the episode film *New York Stories* (Scorsese, Francis Coppola and Woody Allen 1989), and its representation of its protagonist, abstract expressionist painter Lionel Dobie (Nick Nolte), this chapter, while acknowledging the suggestiveness of Dobie's representation with respect to Scorsese, will seek to move beyond the often unhelpful reductiveness of biographical criticism to examine the larger reflexive connotations of the representation of artists and of visual art within Scorsese's film-making – stylistically, epistemologically and institutionally. In developing its argument the chapter will in addition make reference briefly to *The King of Comedy* (Scorsese 1983) and *After Hours* (Scorsese 1985) and somewhat more extensively to *The Age of Innocence* (Scorsese 1993) and *Kundun* (Scorsese 1997). The critical perspective of the chapter is unabashedly auteurist, but also resolutely materialist.

'Life Lessons'

Running 43 minutes, 'Life Lessons', which was scripted by Richard Price, is based – in some respects closely – on Fyodor Dostoevsky's 1867 novel *The Gambler*, as well as on the diary of Dostoevsky's one-time lover Polina Suslova and Suslova's short story, 'The Stranger and Her Lover', which repeats portions of her diary almost verbatim.[3] The segment begins with Dobie having a show opening in three weeks but being unable to paint. Collecting Paulette (Rosanna Arquette) – the latest in what is suggested to be a line of assistants-cum-lovers for whom Dobie supplies room, board, a salary and 'life lessons that are priceless' – at an airport terminal, Dobie is told by her that she has been away with a lover, performance artist Gregory Stark (Steve Buscemi), and that although their affair is over she intends

to leave Dobie and return home. Dobie persuades Paulette to stay with him on a non-sexual basis and soon begins to paint, albeit while tormented by his continuing desire for Paulette. 'Life Lessons' correspondingly relates artistic creativity, with due, self-conscious psychoanalytic implication, to repressed and displaced sexuality.[4] Moreover, not only is this underscored through the structuring of incident, but it is leavened with an adduction of a fetishistic disavowal of castration, which is mediated and condensed through the segment's reflexively anachronistic employment of the iris – as note, for example, the irised close-ups, from Dobie's point of view, of Paulette's foot and ankle.

However, while this in addition contributes to the segment's expressionist transmission of Dobie's subjective perspective, the same is correlated with a more distanced, objective and critical perspective on character and action. Indeed, as a character Dobie inclines towards a clichéd representation of an abstract expressionist painter. Burly, shaggily bearded, frequently paint spattered and inhabiting a spacious loft in New York's SoHo district, Dobie is a cigarette-smoking, hard-drinking, seemingly intemperate figure who evinces a dislike of and disregard for social niceties. The model is tacitly Jackson Pollock – or at least the Pollock of popular imagination.[5] Much of what Dobie is represented as saying and doing in turn implies – and solicits – sardonic censure. Witness his occasional self-aggrandising assertions or the suggestion of his pathetic and even self-abasing desire and need for Paulette, which sees him early on entering, farcically, her bedroom on the flimsiest of pretexts and later, on Paulette returning from a party with a younger artist, Reuben Toro (Jesse Borrego), standing, shirtless, gazing up at the 'vaginal', window-like opening of her bedroom that is, for Dobie, a recurrent point of fascination: a moment that, as accompanied by the grandiloquently empathetic strains of the aria 'Nessun Dorma' from Giacomo Puccini's opera *Turandot*, borders on the bathetic.[6] Moreover, when Dobie physically assaults Stark in a bar, in what Susan Felleman describes as 'righteous, chivalrous indignation, supposedly in defense of Paulette' (2006: 124), the shots of Dobie's dealer, Phillip (Patrick O'Neal), holding his hand to his face suggest that such behaviour is all too familiar.

In the segment's opening scene Phillip similarly complains that Dobie has gone through the same thing 'every show' for the past 'twenty years'. The suggestion is that Dobie, at some level of consciousness, is using his frustration to fuel his art; markedly, when Paulette states that she does not love Dobie, he responds, 'So what?' In turn, during their conclusive argument, Dobie virtually admits instrumentality – 'I indulge in love, I indulge in making my stuff, and they feed off each other' – before adding, unconvincingly, that 'this is selfish' and asking Paulette, with transparent insincerity and increasing exasperation, whether he should 'stop painting' and 'just be a nice person' for her. Nevertheless, when Paulette finally leaves, Dobie launches into a self-rationalisation that is in equal parts risible and robust, 'You think I just use people … You don't know how involved I get, or how far down I go.' Moreover, as 'Life Lessons' both offers a distanced apprehension of and expressionistically compels a certain complicity with Dobie, so the character is apparently both critiqued and vindicated.

Further to this, Dobie is granted the voicing of an artistic credo. When Paulette demands that Dobie tell her whether she has any talent, and adds that sometimes she feels that she should 'just quit', he asserts, 'you make art because you have to, because you've got no choice. It's not about talent. It's about no choice but to do it. … You give it up you weren't a real artist to begin with.' In addition, Dobie's art and, by extension, his credo obtain stylistic endorsement, with the scenes of, in particular, Dobie painting providing an acute implication of compulsive personal and artistic investment.

As much is not least demonstrated by the scene in which Dobie, watched by Paulette, paints to the accompaniment of Bob Dylan and The Band's 1974 live version of 'Like a Rolling Stone' (Figure 1). Occurring closely upon Dobie's speaking his artistic credo, the scene presents an intensive, largely jump-cut montage of predominantly close and variously angled shots that, augmented by the use of tracking and tilting, and aligned empathetically with the sneering energy of the accompanying music, matches and conveys, expressionistically, Dobie's fervent yet concentrated activity.[7] In this, the scene is, besides, indicative of the reflective stylisation that marks the scenes of Dobie painting throughout. Consider, for instance, the repeated, parallel closer tracks then jump-cut montage of close-ups as Dobie paints to the accompaniment of Cream's 'Politician'; the long-held, front-on medium shot of Dobie as he ardently paints to the accompaniment of Ray Charles's 'The Right Time'; or the triple superimposition of Dobie as he paints to the accompaniment of Procol Harum's 'Conquistador'. The scenes serve to validate Dobie's art and Dobie as an artist; they likewise validate Scorsese's film-making and Scorsese as a film-maker. Regarded intertextually, in terms of Scorsese's authorship, the scenes, in their related but diverse stylisation and strong expressionist connotation, invite comparison with those of Jake La Motta's (Robert De Niro) boxing matches in *Raging Bull* (Scorsese 1980). More generally distinctive of Scorsese's film-making is the recourse to characteristically foregrounded, *nouvelle vague*-derivative editing and the particularly integrated and, again, foregrounded employment of music, this whether, as in the case of 'Like a Rolling Stone' or 'Conquistador', it works empathetically or, as with respect to 'Politician' or 'The Right Time', anempathetically.[8] The resultant music–image relationship evokes in turn the influence of British film-maker Michael Powell's conception of the 'composed film', regarding which, to cite Powell, 'music, emotion and acting made a complete whole, of which the music was the master' (1986: 584).[9]

Accepting such, the track-ins to specific images within Dobie's painting on individual lines of the well-known refrain of 'Like a Rolling Stone' have an obviousness that borders on the pretentious and/or the laughable. They are, however, arguably salvaged by the reciprocal intensity of the song and of the montage of which they are a part. Similarly, not only can the bathetic resonance of the shot of Dobie standing beneath the opening to Paulette's bedroom be seen to be mitigated by the segment's manifest linkage of the sexual and the creative, but the same is more immediately underscored by it cutting, as 'Nessun Dorma' continues, still empathetically, to a track along the painting on which he had been working, to – that is – evidence of achieved artistic accomplishment. This

Figure 1. 'Life Lessons': Lionel Dobie (Nick Nolte) paints to the accompaniment of 'Like a Rolling Stone'.

further returns us to the segment's dual perspective concerning Dobie, and betrays its ultimate weighting, as the representation of his manifest and mortifying failings is effectively subsumed by the exculpating affirmation of his talents and their result – a trajectory confirmed with 'Life Lessons' ending with the successful opening of his show.

The segment's mutual validation of Dobie and Scorsese's art and artistry is, moreover, complemented by a number of suggestive parallels that are apparent between character and director. The use of 1960s and 1970s rock and pop music and Italian opera, which the repeated shots of Dobie's tape deck assign as 'his' music, reflects the like music employed across Scorsese's work, but especially within the admittedly biographical *Mean Streets* (Scorsese 1973). The segment's relation of unsuccessful heterosexual coupling and artistic creation has similar reverberations. When making 'Life Lessons' Scorsese was in his fourth marriage, to producer Barbara De Fina, which was rumoured to be in difficulties;[10] Dobie as well states that he has been married 'four times'.[11] Both Dobie's assertion that New York is 'the only city' and his artistic credo fit nicely with Scorsese's star image as not just a 'personal' but a New York film-maker somewhat at odds, in his committed aesthetic rectitude, with the Hollywood institution: even Scorsese's early student short *What's a Nice Girl Like You Doing in a Place Like This?* (1963), as it courts biographical interpretation, represents a writer, Harry (Zeph Michaelis), who becomes first obsessed with a photograph and then literally trapped within a painting.[12] In 'Life Lessons' Scorsese's personal investment can similarly be regarded as being implicated in

the segment's combination of affirmation and critique, and of their apparent weighting, this yet as the critical and farcically pathetic components of Dobie's representation suggest a certain, unshrinking self-censure. Nevertheless, to contend that 'Life Lessons' is simply, as Felleman avers, 'a thinly veiled autobiographical confession' (2006: 125) is too easily to dismiss matters. Within Scorsese's film-making the personal and the biographical are better conceived as being generative rather than conclusive, motive rather than point, as factors that inform the films' not infrequently intense and unflinching engagement with what they represent.

Such reflects upon and is underscored by the larger epistemological ramifications of 'Life Lessons', concerning which the segment bears out Felleman's critically more fertile contention that when a film represents '"art" as a theme or engages an artwork as motif' it is 'more or less openly and more or less knowingly entering into a contemplation of its own nature and at some level positing its own unwritten theory of cinema as art' (2006: 2). Scorsese's film-making is in, amongst other elements, its reflexivity, its expressionist intimation of the subjective and its persistent thematic concern with social and psychosexual alienation, unequivocally modernist. So is Dobie's abstract expressionism, a mode that, betokening the relative autonomy of the aesthetic, reflects abstractly on the real and, similarly to Scorsese's film-making, externalises the interior, articulates depth not surface. By contrast, the art of Dobie's rival Stark – in its superficial, affectless recounting of the quotidian and its reciprocal collapsing of aesthetic distance – exemplifies the postmodernism to which performance art is often referred. It is also implied, when compared to Dobie's art, to be wanting. When Dobie is shown painting to 'Like a Rolling Stone', a series of cutaways to Paulette as she watches suggest that she is becoming increasingly – and, fittingly, sexually – enraptured by his art and artistic mastery. When Stark performs, there are cutaways to Dobie watching stony faced. In part attributable narratively to Dobie's sexual jealousy, his reaction besides suggests aesthetic-cum-epistemological evaluation, which the segment seemingly upholds. Hence Dobie's early description, and qualitative dismissal, of Stark as 'the comedian', which his represented performance somewhat confirms, or, again, the stylistic validation, diegetically and reflexively, of the scenes of Dobie painting: complementing which, not only does the selected, accompanying rock music carry distinct modernist implications, but as Ray Charles's music draws on the blues, so it is derivative of a form that itself partakes of the same.[13] Analogous aesthetic evaluation is implicit when, the morning after the party, Dobie asks Toro, evoking another postmodernist phenomenon, and in a phrase that recalls Travis Bickle's (De Niro) threatening self-regard in *Taxi Driver* (Scorsese 1976), 'You a graffiti artist, Toro?' Furthermore, on Toro weakly responding, 'Well, I wouldn't say that', he is jolted by the sudden, loud sound of 'Nessun Dorma', and the subsequent shot of Dobie painting proceeds to show him standing, smiling, as though he has bested Toro through his art.

The privileging of modernism over postmodernism within 'Life Lessons' is in addition affirmed in terms of character representation. That of Toro rather confirms Dobie's

claim at the party that Toro is there 'to score and split', while that of Stark likewise substantiates – in not just his performance but his offhand treatment of Paulette – Dobie's contention that Stark is a 'self-absorbed, no-talent son of a bitch'. Also, whereas Stark's performance speaks of incidental masculine violence, of fighting and possibly killing a man who stands on his foot and of smacking another person, Dobie at the bar, with further aesthetic and epistemological resonance, and whatever his actions' other connotations, actualises it.

Modernism, postmodernism and the Hollywood institution

A similarly weighted opposition of the modernist and the postmodernist is, moreover, apparent in other films directed by Scorsese. *The King of Comedy*, as it structurally replays *Taxi Driver* but replaces the split, alienated figure of Travis with the fragmented, schizophrenic figure of Rupert Pupkin (De Niro), articulates the modernism–postmodernism dualism implicitly in terms of a conflict between the prime modern medium of cinema and the prime postmodern medium of television. The usurpation of the modernist by the postmodernist is correspondingly enacted by the replacement of established comedian and chat-show host Jerry Langford (Jerry Lewis) by the aspirant comedian and chat-show host Pupkin. In turn, Langford – who is kidnapped by Pupkin and who, as played by Lewis, is described by Beverle Houston as constituting 'a man of cinema who is subject of, but not subject to, television' (1984: 79) – sees the end of Pupkin's television debut as broadcast on multiple television screens in a shop window: an image that visually implies the paradigmatic postmodernist artefacts that are Andy Warhol's numerous multiple-image artworks (Figure 2). Within *After Hours*, which, like 'Life Lessons', is set within New York's SoHo district, a central motif is a sculptural, *papier-mâché* rendition of Edvard Munch's painting *The Scream*, an object that the film's protagonist Paul Hackett (Griffin Dunne) variously works on, appears fascinated by, assumes as a burden and, as he himself is covered in *papier-mâché*, effectively becomes. However, as the sculpture implies a postmodernist pastiche of a canonical modernist piece, so it evokes a loss of affect, a diminution of resonance.[14] Instead of the undifferentiated, irreducible angst conveyed by Munch's original, the sculpture references – within a narrative that is structured so as to suggest a male anxiety-dream – a more defined, contemporaneous, psychic and cultural disquiet, indexes the 'crisis' of masculinity that has become a much-proposed aspect of postmodernity.[15] With the sculpture being the 'first thing' that the burglar Neil (Cheech Marin) claims that he had 'ever bought', it as well works to hint at the way in which art was, during the 1980s, conditioned by its increasing commodification.

This brings us conveniently to the necessary, if necessarily abbreviated, contextualisation of the discussed film texts' epistemological reference historically and institutionally. As an aesthetic and cultural phenomenon, postmodernism is, for Fredric Jameson,

Figure 2. *The King of Comedy*: Jerry Langford (Jerry Lewis) apprehends Rupert Pupkin's (Robert De Niro) multiply imaged television debut.

indivisible from the emergence of 'late or multinational' capitalism, within which he proposes that there has been apparent 'a prodigious expansion of capital into hitherto uncommodified areas' (1984: 78). Concordantly, as Hollywood, following the majors' corporate rationalisation during the 1970s, became, in concert with the hegemonic spread of deregulatory, free-market policies, during the 1980s a multinational, global force, so the blockbuster film-making central to its economic recovery transmuted into the high-concept film: to wit, an expressly postmodernist mode that – founded on replication, recombination and pastiche – combines a superficial stress on stylishness with typed characters and weak, reduced narratives that serve as a framework for the presentation of a series of quasi-discrete, often spectacular set pieces.[16] The period correlatively saw the institutional marginalisation of the auteur-centred modernism of the art cinema-influenced New Hollywood Cinema that enjoyed a comparative flourishing within and on the fringes of the Hollywood mainstream between the late 1960s and mid-1970s, out of which Scorsese's film-making issued and that his film-making can be seen to epitomise. The discussed texts' epistemological emphases accordingly imply an attempt at endorsing an embattled modernist practice, this in the face of its seeming institutional obsolescence. *The King of Comedy* was an ignominious box-office failure, costing US$20 million and returning just US$1.2 million domestically; the low-budget (US$4.5 million) *After Hours* was produced independently; while *New York Stories*, despite comprising segments from three acknowledged auteurs, took only US$10.7 million domestically on a budget of US$15 million.

The Age of Innocence and *Kundun*

The Age of Innocence and *Kundun* were produced when Scorsese would seem to have enjoyed a firmer institutional position. Following the critical and, especially, commercial success of *GoodFellas* (Scorsese 1990),[17] *The Age of Innocence* was made when Scorsese had a six-year production deal with Universal, and *Kundun* was the first fruit of a similar four-year deal with Disney. The specificities of the films' production nevertheless insinuate the residual vicissitudes confronting a modernist auteur within late twentieth-century Hollywood. Universal baulked at finding the US$34 million to produce *The Age of Innocence* – which, as an adaptation of Edith Wharton's identically titled novel, was perhaps not the kind of 'personal' project that they wanted from Scorsese – and the film was financed and distributed by Columbia. Disney hedged their risk on *Kundun* – a US$28 million biopic of the fourteenth Dalai Lama, shot with a non-professional cast, on location mainly in Morocco – by obtaining co-financing from French major UGC. In terms of their representation of art, and of one would-be artist, *The Age of Innocence* and *Kundun* are, however, manifestly contrasting, latently complementary and both elaborate and cast light back on the preceding representation of visual art and of artists within Scorsese's *oeuvre*.

Pam Cook describes *The Age of Innocence* as being 'literally an art movie' in which 'characters are judged according to their taste and the audience is tested on how many paintings and *objects d'art* it can identify' (1994: 46). Certainly, as the numerous replicas of paintings shown in the film contribute to what is, regarding Scorsese's film-making, its further, typical anthropological purpose by reflecting 'what paintings' that people 'had in their houses at that time' (Christie and Thompson 2003: 189), so they invite critical reflection on the film's characters and, with corresponding authorial typicality, their implied cultural determination.[18] In turn, Newland Archer (Daniel Day-Lewis), the film's protagonist, can be considered as being represented as an artist *manqué*, being a character who declares that he cares for art 'Immensely' and that, when 'in Paris or London', he 'never' misses 'an exhibition'. However, Newland can also be seen as being represented, more critically, as a figure who uses art as a variously indulgent and self-serving compensation – or even alibi – for his cultural conformity, and specifically his failure to act on his socially transgressive desire for his wife's cousin, Ellen Olenska (Michelle Pfeiffer). Hence the scene at Newport in which Newland sees Ellen from afar, for the first time since his wedding a year and a half previously, as she stands, at sunset, dressed in white, on a pier, looking out to sea, the Lime Rock lighthouse to her left, towards which a sailboat advances (Figure 3). The film's narrator (Joanne Woodward) observes that Newland gives himself 'a single chance', that Ellen 'must turn before the sailboat crosses the Lime Rock light. Then he would go to her'. Ellen does not turn, and Newland does not approach her. Consistent with the painterly qualities of numerous shots in *The Age of Innocence*, the images of Ellen and her surroundings are, as much noted, in their combination of diffused golden glow and shimmering reflected sunlight,

reminiscent of an Impressionist artwork, an effect complemented with respect to technical configuration by their uniting shot footage with matte painting (the lighthouse) and composited elements (the setting sun, the boat).[19] In short, the incident, which is preceded by the narrator comparing the reappearance of Ellen within Newland's life to the discovery of 'caverns in Tuscany', with their 'old images staring from the walls', implicitly links the aesthetic with Newland's refusal of decision.

In *Kundun*, cinema is tacitly, and once more reflexively, aligned with a Tibetan sand painting, what constitutes, in the words of Andrew O'Hehir, 'a colourful and elaborate mandala' (1998: 42). Both cinema and sand mandalas are founded on materially delicate means, and both are ephemeral in their representations, with mandalas being ritually destroyed on their completion. Furthermore, as sand mandalas carry transcendent implications, so too, it is suggested, does cinema. The film's closing section, which comprises an extended, largely associational montage sequence, not only represents the construction and destruction of the mandala but also combines the objective with the subjective and fuses spatially and temporally what the Dalai Lama (Tenzin Thuthob Tsarong) earlier reads are 'the three states of existence' – 'the past, the present and the future'. He in addition reads the words, which proceed to describe the 'three states' as being 'purified' by 'the clear light', with a torch whose bright light implies that of a film

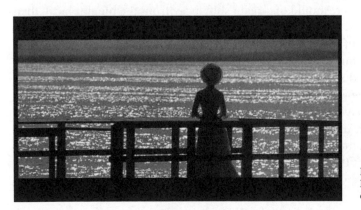

Figure 3. *The Age of Innocence*: Ellen Olenska (Michelle Pfeiffer) on the pier at Newport.

projector. Situated thus as transcendentally illuminating, cinema and related visual technology and representations are also, in contrast to Newland's aesthetic investment in *The Age of Innocence*, associated with social and historical engagement. Apart from the Dalai Lama's spectacles, witness, for example, the telescope through which he views and comes to understand the Tibet outside his palaces, and the copies of *Picture Post*, the newsreel of the Hiroshima atomic bomb and its aftermath and the print of *Henry V* (Laurence Olivier 1944) through which he views and seeks to get to grips with the world outside Tibet. Moreover, the early trick film *La Poule aux oeufs d'or* (Gaston Velle 1905), which the Dalai Lama is as well shown watching, functions implicitly to confirm cinema's seemingly inborn spatial and temporal transcendence.

Furthermore, while *Kundun* thus possibly highlights that which is debatably suggested across Scorsese's film-making, that if Scorsese has a God, then that God is cinema, the film's reflection on the medium as it yet represents, and invites reflection on what it represents, places it as continuing, epistemologically, the modernist reference of that film-making. As much is, similarly, inherent to the upfront stylisation of *The Age of Innocence*. In turn, not only does the Impressionist connotations of the scene at Newport provide a more specific modernist allusion, but Ellen – who is represented as embodying, for Newland, a potential, 'modern' liberation – is associated, diegetically and textually, with the paintings of the proto-Impressionist Italian Macchiaioli School.[20] The film's critical representation of Newland is, besides, maintained to the film's coda when – older, widowed and lacking any obstacle to him pursuing a relationship with Ellen – he passes up the opportunity once more to see her, finding solace instead, as he sits in the square before her Paris apartment, in a vision of Ellen as she stood on the pier at Newport, with the difference that this time she turns around. Suffused with the failure of heterosexual coupling, *The Age of Innocence* encourages afresh biographical reference to the much-married Scorsese. Amy Taubin, however, points up the reflexivity of Newland's vision of Ellen – which both approximates a flashback and, in its painterly attributes, foregrounds, like the earlier 'Impressionist' images, its filmic construction – by observing that Newland 'is lost in the movie inside his head, and that that movie is precisely the one we've been watching' (1993: 6). Moreover, should one again shift away from the biographical, then as in 'Life Lessons' repressed sexuality is implied to obtain displaced artistic expression, so the like can be argued of Newland's vision of Ellen, not least as it invokes almost literally the parallel that Sigmund Freud draws between creative work and daydreaming.[21] Reciprocally, if for Newland art serves as a compensation and/or alibi for his inability to pursue his desire, to engage with the world, then *The Age of Innocence* can, squaring the biographical and the reflexive, and with larger connotations for Scorsese's film-making as a whole, be considered, in its own achieved artistic accomplishment, its integrated combination of stylistic virtuosity and layered thematic resonance, to present a glorious, self-justifying apotheosis of the same.

Coda: *Akira Kurosawa's Dreams*

In *Akira Kurosawa's Dreams* (Akira Kurosawa 1990), Scorsese appears in a cameo role, playing painter Vincent van Gogh. As van Gogh, however, Scorsese remains recognisably himself. With his hair and beard dyed red, and wearing a straw hat and, invoking van Gogh's infamously severed ear, a bandage around his face, Scorsese not only is barely disguised but speaks his lines – which voice a near desperate imperative artistically to capture encompassing nature – with familiar, New York-accented rapidity. Scorsese had met Kurosawa in 1980, during Scorsese's campaign regarding the fading of colour film stock, and Kurosawa cast him as van Gogh wanting 'the same kind of enthusiasm and intensity' (Christie and Thompson 2003: 163) that Scorsese had then shown.[22] Representing Scorsese as van Gogh might, accordingly, be considered less as an attempt to embody the painter as a historical individual than as an exemplar of the passionate and committed artist. Such would appear to return us, within a somewhat different context, to the personal and the biographical as being generative rather than conclusive, motive rather than point. In turn, like Scorsese's film-making, van Gogh's painting is expressionist. It is also, concordantly, modernist.

Bibliography

Chion, M. (1994), *Audio-Vision: Sound on Screen* (1990), C. Gorbman (ed. and trans.), New York: Columbia University Press.

Christie, I. and D. Thompson (eds) (2003), *Scorsese on Scorsese*, rev. edn, London: Faber and Faber.

Cook, P. (1994), '*The Age of Innocence*', *Sight and Sound*, n. s. 4:2, pp. 45–46.

Creed, B. (1987), 'From Here to Modernity: Feminism and Postmodernism', *Screen*, 28:2, pp. 47–67.

Felleman, S. (2006), *Art in the Cinematic Imagination*, Austin: University of Texas Press.

Freud, S. (1990), 'Creative Writers and Day-Dreaming' (1908), I. F. Grant-Duff (trans.), in A. Dickson (ed.), *Art and Literature*, Harmondsworth: Penguin, pp. 129–41.

Friedman, L.S. (1997), *The Cinema of Martin Scorsese*, Oxford: Roundhouse.

Grist, L. (2000), *The Films of Martin Scorsese, 1963–77: Authorship and Context*, Basingstoke: Macmillan.

—— (2007), '"The Blues Is the Truth": The Blues, Modernity, and the British Blues Boom', in N.A. Wynn (ed.), *Cross the Water Blues: African American Music in Europe*, Jackson: University Press of Mississippi, pp. 202–17.

Hodenfield, C. (1989), '"You've Got to Love Something Enough to Kill It": Martin Scorsese – The Art of Noncompromise', *American Film*, 14:5, pp. 46–51.

Houston, B. (1984), '*King of Comedy*: A Crisis of Substitution', *Framework*, 24, pp. 74–92.

Jameson, F. (1984), 'Postmodernism, or the Cultural Logic of Late Capitalism', *New Left Review*, 146, pp. 53–92.

Keyser, L. (1992), *Martin Scorsese*, New York: Twayne.

Nicholls, M. (2004), *Scorsese's Men: Melancholia and the Mob*, Melbourne: Pluto Press Australia.

O'Hehir, A. (1998), '*Kundun*', *Sight and Sound*, n. s. 8:4, pp. 41–42.

Pizzello, S. (1993), 'Cinematic Invention Heralds *The Age of Innocence*', *American Cinematographer*, 74:10, pp. 34–44.

Powell. M. (1986), *A Life in Movies: An Autobiography*, London: Heinemann.

Scorsese, M. (1985), 'Foreword', in I. Christie, *Arrows of Desire: The Films of Michael Powell and Emeric Pressburger*, London: Waterstone, pp. 10–13.

Stern, L. (1995), *The Scorsese Connection*, London: BFI.

Taubin, A. (1993), 'Dread and Desire', *Sight and Sound*, n. s. 3:12, pp. 6–9.

Thompson, R. (1976), 'Screenwriter: *Taxi Driver*'s Paul Schrader', *Film Comment*, 12:2, pp. 6–19.

Wyatt, J. (1994), *High Concept: Movies and Marketing in Hollywood*, Austin: University of Texas Press.

Notes

1. To unpack this list, the figures adduced are Harry (Zeph Michaelis) in *What's a Nice Girl Like You Doing in a Place Like This?* (Scorsese 1963), Jimmy Doyle (Robert De Niro) in *New York, New York* (Scorsese 1977), Jake La Motta (De Niro) in *Raging Bull* (Scorsese 1980), Jerry Langford (Jerry Lewis) and Rupert Pupkin (De Niro) in *The King of Comedy* (Scorsese 1983), Howard Hughes (Leonardo DiCaprio) in *The Aviator* (Scorsese 2004), while of the rock and blues musicians and singers one might cite The Band (*The Last Waltz*, Scorsese 1978), Corey Harris and Ali Farka Toure (*Feel Like Going Home*, Scorsese 2003), Bob Dylan (*No Direction Home: Bob Dylan*, Scorsese 2005) and The Rolling Stones (*Shine a Light*, Scorsese 2008).

2. Chris Hodenfield, for example, quotes Scorsese as saying, 'If it's not personal … I can't be there in the morning' (1989: 46). Similar sentiments have recurred in interviews with and pieces written by Scorsese throughout his career.

3. Scorsese had wanted to film an adaptation of *The Gambler* since the late 1960s. In 1973 Scorsese got Paul Schrader to write a script outline, but its development was subsumed by Schrader's scripting of *Obsession* (Brian De Palma 1976) and Scorsese's making of the Schrader-scripted *Taxi Driver* (1976), a project that has been acknowledged by Schrader as being influenced by Dostoevsky's 1864 novel *Notes from the Underground*; see Thompson (1976: 10). That noted, Scorsese has declared that 'elements of' *The Gambler* had previously found 'their way into' other films that he had directed: 'In *Raging Bull*. A little bit in *Taxi* [*Driver*] … And in *New York, New York*, a lot' (Hodenfield 1989: 50).

4. See, in particular, Freud (1990).

5. See, likewise, Felleman (2006: 151).

6. Michel Chion describes what he terms '*empathetic music*' as music that expresses 'its participation in the feeling of the scene, by taking on the scene's rhythm, tone, and phrasing' (1994: 8).

7. The canvas that the scene shows Dobie working on is a reproduction of a painting titled *The Bridge to Nowhere* by New York artist Chuck Connelly. The close-ups of Dobie's hand as he paints are, moreover, of Connelly's hand while wearing Dobie/Nolte's shirt.

8. Chion declares music '*anempathetic*' when it exhibits 'conspicuous indifference to the situation, by progressing in a steady, undaunted, and ineluctable manner', albeit it thus 'has the effect not of freezing emotion but rather of intensifying it' (1994: 8).

9. The varied influence of Powell's work on that of Scorsese has long been recognised and acknowledged; see, for example, Scorsese (1985).

10. See Keyser (1992: 188).

11. The implied disjunction between successful heterosexual coupling and achieved artistic and other individual expression is, in addition, an opposition that recurs throughout Scorsese's film-making, as consider, differently, *Alice Doesn't Live Here Anymore* (Scorsese 1974), *Taxi Driver, New York, New York, Raging Bull, The King of Comedy, After Hours, The Last Temptation of Christ* (Scorsese 1988) and *The Aviator*.

12. For a discussion of the film that expands on this, see Grist (2000: 14–15, 21–22).

13. For such an argument with respect to the blues, see Grist (2007).

14. Regarding pastiche as a defining characteristic of postmodernism, Fredric Jameson describes it thus, 'Pastiche is, like parody, the imitation of a peculiar mask, speech in a dead language: but it is a neutral practice of such mimicry, without any of parody's ulterior motives, amputated of the satiric impulse' (1984: 65).

15. For an influential discussion of some of the issues informing this 'crisis', see Creed (1987).
16. For a detailed account of the formal composition of high-concept film-making, see Wyatt (1994: 1–64). Further to *The King of Comedy*, moreover, 'high concept' as a term and an idea first originated in the 1970s within television.
17. Having cost US$26 million, *GoodFellas* returned US$46.8 million at the domestic box office.
18. Scorsese initially chose 'about 150' paintings to reproduce for the film but had to 'cut down the numbers' because 'it was going to cost too much' (Christie and Thompson 2003: 189).
19. For more on the formation of the images, see Pizzello (1993: 41). Among those who have compared the images to Impressionist painting are Cook (1994: 46), Friedman (1997: 183) and Nicholls (2004: 35).
20. Paintings of the Macchiaioli School are shown as being present, and studied by Newland, in Ellen's New York house. That one represents a white-clad, faceless woman holding a parasol besides resonates with the images of Ellen at Newport both in terms of Ellen's white attire and as its facelessness implies the enigma that Ellen maybe always remains for Newland. The painting in addition connects with the later close-up of Ellen's likeness as she is painted, reading, holding a parasol that, shot from Newland's point of view, precedes and implicitly frames his looking for Ellen herself on Boston Common.
21. See, again, Freud (1990).
22. For an outlining of Scorsese's campaign concerning colour film, see Stern (1995: 154–55).

Part IV

Evocative Frames

Chapter 11

Framing Loneliness in Painting and Film

David Morrison

P
ainting and film share sufficient similarities as examples of visual art to make the influence of one medium felt on the other and vice versa, and both media employ existing visual conventions in order to produce both meaning and feeling in the work. This chapter will explore the ways in which film and painting employ similar strategies to convey the specific emotion of loneliness through the use of particular aesthetic tropes and devices, and will propose a sense of interaction between the two art forms in terms of affective construction. The tropes examined stem from an extended research project examining the feeling of loneliness in film and have been identified through a process of viewing a diverse range of films as well as examining a number of paintings touching on the theme. Indeed, the overlap between the two artistic fields provides the inspiration for the ideas to follow, as a number of recurring tropes and devices have been identified, which tend to retain a sense of lonely feeling even when employed in differing ways and in different mediums. The strategies for evoking loneliness range from general qualities, such as blankness, stillness and emptiness, to more specific lonely tropes: the downward gaze, the act of eating and drinking alone, the isolation of characters within the frame or the gaze from the window. Many of these elements can be found in films as diverse as Billy Wilder's *The Apartment* (1960, United States), and Aki Kaurismäki's *Lights in the Dusk* (2006, Finland/Germany/Italy/Sweden), in both Hollywood film and the art cinema as well as in the paintings of a variety of artists, most noticeably those of the North American artist Edward Hopper (1882–1967), who forms the focus here.

Hopper is a pertinent artist to concentrate on, partly because he employed so many of the elements noted above but also because, as Gail Levin (1980: 9) notes, he 'was directly concerned with emotional content in his art'. Although Hopper insisted that '[t]he loneliness thing is overdone' (Levin 1980: 10), the mood of his work frequently appears linked to a feeling of undesired isolation and thus provides a useful template for a visual approach to loneliness. In addition to his thematic relevance, Hopper was also an artist influenced by film, as well as one who provided influences for film, and as such provides a useful example for an examination of the shared aesthetics between two media. Numerous critics invoke the cinema when discussing Hopper, and it is not unusual to find comparisons phrased within filmic terms, so that for David Anfam (2004: 39), for instance, the settings for the films of Michelangelo Antonioni are 'an acute rendition of Hopper's *mise-en-scène* in another medium'. The sense of deliberate framing in Hopper adds to the idea of filmic composition, and this is often heightened by the use of windows and the sense, as Lloyd Goodrich puts it, 'sometimes conveyed of a remote observer, as

if a wall had been removed' (Goodrich 1976: 70). Hopper's paintings can make us feel as spectators or voyeurs of loneliness and, as we will see, many films conveying this emotion also present a similar sense of remote observation through a determined lingering upon images of loneliness witnessed.

Much has been written about Hopper and the cinema (see, for example, Fischer 2000: 334–56 or Crewdson 2004: 42–47), and for this reason many of the directors often associated with the artist, such as Todd Haynes, Wim Wenders, Paul Schrader, Alfred Hitchcock and so on, will not be discussed here. Rather, the aim is to concentrate specifically on how Hopper portrays loneliness in his paintings, to examine how film frequently uses similar methods in working towards a comparable goal, and through this comparison to demonstrate a sense of continuity between both art forms in the use of lonely aesthetics. For this reason the main films selected for analysis have been chosen primarily as diverse depictions of loneliness, stemming from differing cultures and film-making traditions, rather than for any immediate links to Hopper's work, although his paintings may indeed have influenced the films cited.

Before proceeding further, however, the question of the universality of any aesthetics of emotion, as opposed to factors of cultural and historical specificity, must be addressed. The tropes of loneliness can be found, to some degree, in both paintings and films that hail from different traditions, cultures and time periods, raising some difficulties that require additional justification. Although cultural difference will always be inescapable in any work of art, it is nevertheless appropriate to compare culturally diverse films and paintings when considering the subject of emotion, since there are fundamental aspects of emotional feeling that are more universal in nature than often supposed. Torben Grodal's *Embodied Visions: Evolution, Emotion, Culture, and Film* challenges, with a 'bioculturalist' approach, many of the prevailing theories in film studies, and his ideas have proved influential for this analysis (see particularly Grodal 2009: 3–55). Grodal's work demonstrates how human biology, in addition to human culture, helps determine the ways in which films are both made and experienced, and provides some explanations for why particular themes or emotions engage viewers from different countries and in different time periods. Essentially, films find optimal ways of activating emotional dispositions, and the way in which this is done often carries a similar approach between films, in part because certain devices work better on our innate dispositions than others, as well as the additional factor that films obviously influence other films. The 'fine-tuning' of the narratives and devices may then, however, also reflect cultural specifics (Grodal 2009: 54).

Grodal's arguments are complex and not easily summarised in a short essay. It might help, however, to loosely employ his idea of the manufacture of cultural products as being similar to the production of tools. Grodal notes that if a tool works and fulfils a need, then it will often spread to places other than where it was invented. Stories too have travelled the world, 'and the same goes for simple functional ways of depicting humans, animals, and other agents' (Grodal 2009: 32). Whilst the tropes are more complicated

in construction than many of the basic story elements that Grodal deals with, there is nonetheless the possibility raised that aesthetic devices, as cultural artefacts, are also similar to tools in that they perform certain useful functions in an efficient manner. The tropes of loneliness can be seen as devices that work as effective solutions for the portrayal of a particular emotional state. They are recognisable ways of conveying loneliness across different cultures, partly because of the factors of influence, as noted above, but also possibly because of the way in which they interact with innate dispositions in human beings and how we experience the world (see Grodal 2009: 12–13). The degree to which this is the case is bound to vary depending on the tropes and how they are used, and cultural factors will also always play a part. As a final note, it is useful to remember that film-makers will often manipulate a film's formal features in order to provoke a desired emotional response, and as Noël Carroll (2008: 158–59) points out this means that films can be 'emotively pre-focused', so that they are satisfying the necessary criteria for the emotion to be felt, often across wide-ranging audiences.

While many of the above ideas stem from writing on film specifically, it is not too difficult to see that in painting too certain aesthetic strategies are employed to convey particular feelings. A commonly recurring trope of loneliness in both painting and film is a scene of a figure eating or drinking alone. This image can be so effective at conveying loneliness, primarily because of the historical and cultural associations of eating and drinking as something that has typically been seen as a group activity, whether with family or in a community (although it may also stem from an innate instinct to feed and care for family), and also because restaurants and bars are seen as places of social interaction (see, for instance, Lukanuski 1998: 112–20). This fundamental sociability of restaurants, cafes and bars means that for anyone eating out on their own and feeling lonely, it can easily intensify these feelings.

In Finnish director Aki Kaurismäki's *Lights in the Dusk*, the lonely character of Koistinen, a virtually friendless ex-security guard just released from jail at this point in the film, sits alone at a table with coffee cup, gazing out of a window (Figure 1). The scene shares some similarities with Hopper's *Automat* (1927) (Figure 2), in which a woman sits staring down at her coffee, with both scenarios containing a few key features that produce an air of loneliness. First, there is the fact that the characters are drinking alone and that no one else can be seen, no waiters or other customers, for instance. The melancholy gaze (a common feature of Hopper's work – see Margaret Iversen 2004: 52–65) of both characters also suggests their loneliness, as one stares downwards while the other stares out of a window, and finally there is also an emptiness about both compositions. In *Automat*, the empty chair and the large black space of the night outside suggest an interior emptiness in the seated woman. The diagonal lines, formed by the reflection of the lights, lead off into space, exacerbating the sense of a void behind. In the scene from *Lights in the Dusk*, the emptiness is stressed by a solitary rose on the table (a symbol of the romance conspicuously absent from Koistinen's life), the expanse of tablecloth and the dark band behind Koistinen's head. There is also no food to be seen, no nourishment

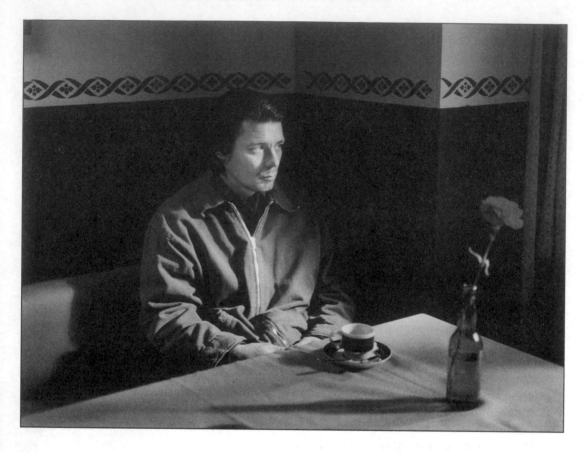

Figure 1. Koistinen (Janne Hyytiäinen) sits alone in *Lights in the Dusk*.
Photograph by Marja-Leena Hukkanen; copyright belongs to Sputnik Oy.

for the soul or body (and the film also features other scenes where Koistinen sits in empty cafeterias or stands in a corner of a restaurant drinking alone).

In Jun Ichikawa's *Tony Takitani* (2004, Japan), a story of a lonely boy who grows into a lonely man, the viewer is presented with a scene of an adolescent-aged Tony, effectively living alone, eating by himself in medium close-up and situated low down in the frame, facing the viewer. He is surrounded only by a black background dotted with a few spots of light, somewhat reminiscent of the dark void of *Automat*'s backdrop. The camera lingers for roughly twenty seconds on this image, and the young Tony directly tells us, in a rare address to camera, that 'I never thought I was especially lonely', but the surrounding

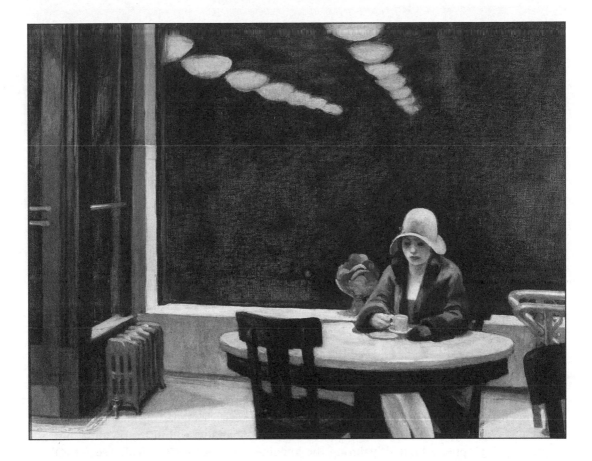

Figure 2. Edward Hopper (American, 1882 – 1967), *Automat*, 1927, Oil on canvas; 36 x 28 1/8 in. (91.4 x 71.4 cm.). Des Moines Art Center Permanent Collections; Purchased with funds from the Edmundson Art Foundation, Inc., 1958.2.

empty space, and the fact that he is eating alone, tells a different story. On the film's official website Ichikawa (2005) has cited Hopper in describing the blank spaces of the film, and there is certainly a similarity in a number of the compositions.

This type of solitary eating or drinking image, however, also occurs in the paintings of a number of artists, not just Hopper, as well as in numerous films about loneliness. Ivo Kranzfelder (2002: 146) notes that in Impressionist paintings, restaurants were often employed to suggest an individual's isolation, citing Edgar Degas' *The Absinth Drinker* (1875–76) or Edouard Manet's *Plum Brandy* (*c.* 1877) as examples. Kenneth

Bendiner (2004: 155–56) uses the example of Edvard Munch's *Self-portrait with Wine Bottle* (1906) to make a stronger argument, proposing that 'there are few more potent ways of expressing loneliness and existential angst than isolating a diner or drinker in a restaurant milieu'. Examples in film range from world cinema such as Tsai Ming-liang's *What Time Is It There?* (2001, Taiwan/France), in which a lonely Taiwanese girl sits homesick in Paris cafes and restaurants, and a widow sets an empty place at home for a husband who can no longer share her meals, through to melancholic Hollywood comedies such as *Sideways* (Alexander Payne 2004, United States). Here, Miles eats in long shot in an empty restaurant after his friend abandons him for a date, and he later drowns his sorrows alone in McDonalds, having smuggled a prize bottle of wine in to drink from a Styrofoam cup.

Nighthawks (1942), one of Hopper's most famous paintings, also presents an image of a man drinking on his own, in the form of the figure sat at the counter with his back to us, although his beverage is not alcoholic and there are also others present in the room. Any notion that the others might alleviate a feeling of loneliness, however, would be unfounded. For instance, the middle-aged, unhappy-looking couple sat at one end of the counter demonstrate little sign of interaction but instead stare ahead, lost in thought, appearing bored in one another's company. In fact people rarely look at each other in Hopper's paintings, and again this lack of interaction is something we often see in films dealing with loneliness. As an example, in *Lights in the Dusk*, Koistinen and his date sit on a sofa, staring ahead as they make occasional comment to one another, but by the end of the scene, with barely any eye contact made, Koistinen finds himself dumped.

Vivien Green Fryd (2003: 81) discusses the motif of the estranged couple in Hopper's work in terms of 'the modern marriage in crisis', suggesting that paintings such as *Nighthawks* 'may reflect Hopper's sense of loneliness within his own life and marriage'. Hopper admitted 'painting the loneliness of a large city' (Kuh 1962: 134) in *Nighthawks*, but there are other elements to note besides the distant couple and the solitary drinker that help to construct this feeling in the painting. Once more there is also a sense of emptiness to the image. The characters in the diner are small and diminished, surrounded by immense, unpopulated space, which is exaggerated by the large rectangles and diagonal lines in the composition. The row of empty stools leading up to the solitary man seems to exacerbate the figure's lack of companionship, suggesting the possibility of company but at the same time denying him this hope. This general quality of emptiness is common in Hopper and, as Wieland Schmied (2005: 15) notes, seems to grow throughout his career, so that '[a]s Hopper's interiors grew emptier, the feeling of loneliness and abandonment they evoked deepened'. Yet, in addition to all the above elements of character situation and *mise-en-scène*, as it were, there is also the positioning of the spectator, as we appear to be looking through the window, watching them, although they are unaware of us.

In 'Two or Three Things I Know About Edward Hopper', Peter Wollen (2004: 70) touches on a theme common in Hopper criticism, which is the feeling of voyeurism,

suggesting that we are often placed in the position of the uninvited Peeping Tom. Whilst Wollen does not discuss loneliness specifically, the idea of the viewer being put in the position of a spectator or a witness is useful, with the very deliberate nature of the framing emphasising the viewer's act of looking. Yet why should the fact that we are viewing characters through a window help to suggest loneliness? It is perhaps because the viewer effectively intrudes on the private thoughts and emotions of the characters behind the glass, acting almost as a voyeur of those in melancholic isolation, glimpsing lonely moments that would not normally be glimpsed.

For a filmic equivalent think of the scene in Alfred Hitchcock's *Rear Window* (1954, United States) in which Miss Lonelyhearts, framed in long shot by the rectangular expanse of her apartment windows, toasts an imaginary guest at her conspicuously unoccupied table, before finally breaking down in tears. It is worth remembering here though that we are effectively seeing through the eyes of her neighbour across the way, apartment-bound photographer Jeff, as the cuts back to his reactions make clear. There is not then quite the same sense of private voyeurism in this scene as there would be were we seeing the image without reference to any character's point of view. The Hopper-esque equivalent would be simply our viewing of the image of Miss Lonelyhearts alone, spied behind the glass in an unguarded private moment, head bowed in sadness.

Wollen (2004: 70) ponders a step further than merely the idea of witnessing in relationship to Hopper's work and asks, 'Supposing we were in that room ourselves, what difference would it make?' This is a useful question with regard to loneliness, since if we, as the viewer, could enter the space, we might relieve the sense of loneliness, yet the self-conscious framing device of the window makes it clear that the character is separated from the world outside and from us as the viewer. The threshold of the window acts as both a translucent connection to the character, but it also acts as a reminder of the character's fundamental partition from the world beyond.

Film frequently employs framing in a similar manner to Hopper's paintings to produce a feeling of observation in the spectator. In *Lights in the Dusk* the camera lingers on a rectangle of light created by a hot dog van's window, framing the image of a lonely woman, Aila, staring into space (Figure 3) (for context, Aila has just been visited by Koistinen, the secret object of her affections, and told that he has been out on a date). The long-shot composition here has some loose similarities with Hopper's *Nighthawks*, although if anything the surrounding darkness in *Lights in the Dusk* provides a greater contrast between inside and outside the window. Interestingly, in lingering on this shot, the film appears to employ a sense of pictorial stasis, as if deliberately leaving time to contemplate the image, and thus illustrates one of the main differences between film and painting, in terms of film's temporal aspect. In the scene described from *Rear Window* the temporal element of film acts mainly to provide narrative information and context, as we watch Miss Lonelyhearts's actions in the apartment and view Jeff's reaction to this, but in the scene from *Lights in the Dusk* time is more primarily employed to place emphasis on a particular image, to allow reflection on what is seen and felt.

Figure 3. Aila (Maria Heiskanen) in *Lights in the Dusk*;
copyright belongs to Sputnik Oy.

After Koistinen leaves the hot dog van, there is a close-up image of Aila's barely moving face, with only a slight intake of breath hinting at the emotion inside. The image then cuts to the aforementioned long shot of Aila standing and looking melancholy before the brightly lit window, complete with neon sign overhead. The shot remains with almost no movement for four seconds, before the neon sign is then extinguished, then another five seconds pass and the light inside the van also switches off. There then follows four seconds of darkness before a new shot begins. Here the film uses the static sense of timing partly for deadpan comic results (it is a Kaurismäki film after all), but partly also to allow us to linger on the image, to have time to feel something of the loneliness there, as a spectacle of understated emotion is privileged. The temporal nature of the shot also acts to compound the lonely effect by finally plunging the woman into sudden darkness, by literally turning out the lights.

The sense of duration and stillness that may contribute to a mood of loneliness will be discussed further later, but to return to examine the motif of the window, it is worth noting that the film examples given above, as well as Hopper's *Nighthawks*, position the viewer as looking through the glass to see the character within. Images of lonely people are not always seen from this perspective, however. Hopper's paintings are also full of people (usually women) staring out of windows but viewed from inside rather than outside their rooms. In Hopper's *Eleven A.M.* (1926), *Morning in a City* (1944), *Morning Sun* (1952) and *A Woman in the Sun* (1961), women either sit or stand staring out of windows towards the sunlight shining in, while in *Hotel Window* (1956) the elderly lady stares only out at darkness. This gazing out of windows is an action usually performed alone, and the figures regularly appear to be in a contemplative, often melancholic, state. The Hopper images are pensive, and their equivalents in film represent a pause within the action, whereby an individual becomes lost in thought or feeling. An example of this pensive window gaze can be seen in a character such as Charlotte in Sofia Coppola's *Lost in Translation* (2003, United States/Japan), curled up in her underwear by her hotel window, staring out at the city below. Frequently there is a sense of longing about these scenes, a 'longing for places beyond the window', as Gail Levin (1980: 49) puts it, and there is also what she suggests is a 'sense of waiting'.

These feelings of longing and waiting bear some relationship to the work of Romantic artists such as Caspar David Friedrich, whose *Woman at a Window* (1822) presents a longing more associated with religious ideas, with a window onto a realm beyond the earthly (see, for instance, Iversen 2004: 60; Kranzfelder 2002: 182). There is, however, also a sense of loneliness in these Romantic paintings that contains echoes of an existentialist dilemma, a consideration of isolation in the universe, and this is especially true of Friedrich's more landscape-based paintings, such as *Monk by the Sea* (1808–10), which also uses a number of lonely tropes, such as the diminished human being contrasted against a vast, empty and hostile environment. Some critics have found elements of the spiritual in Hopper too, but more often his work is read in terms of individual isolation or at least a sense of social alienation. The longing here could be interpreted as sexual longing or simply a longing to connect with people in the world outside, to have someone with whom to share the view from the window as it were, a companion in the lonely city.

Vivien Green Fryd provides a more gendered reading of Hopper's employment of the woman at the window. Fryd (2003: 95–96) suggests that the artist's use of the window in his paintings imprisons the subject within the bounds of domesticity. This gendered sense of entrapment gives a further reason for the impression of loneliness, as opposed to simply a desired sense of solitude, in paintings such as *Morning Sun, Eleven A.M.*, and *Morning in a City*. The characters are cut off behind the glass, their sexuality constrained, and thus these are not images of a solitary, peaceful reflection but rather melancholic images of figures who feel their aloneness as something of a prison. This notion of domestic entrapment brings to mind filmic images such as those of middle-aged widow Carrie in Douglas Sirk's *All That Heaven Allows* (1955, United States). Here the loneliness is

made more explicit, however. In one shot, after Carrie decorates a Christmas tree alone, the window's prison-like bars frame Carrie's face as she gazes out on the snow. In an earlier scene, after we watch Carrie close the window from an exterior shot, the camera tilts downwards and we see her daughter below the window, kissing passionately with a boyfriend. Back inside, Carrie draws the net curtains, and the camera focuses on the golden leaves of the tree cutting that her gardener, Ron Kirby, gave to her. At this point in the film it is clear that Carrie is essentially denied, yet longs for, the passion that her daughter experiences. She is trapped by 1950s social mores, while romance and life goes on in the world beyond her confinement.

A further set of window images to be found in Hopper's work finds his figures ignoring, rather than staring at, the outside world. Instead of gazing out, they simply look downwards (and inwards). In *Summer in the City* (1949) and *Excursion into Philosophy* (1959), a woman and a man, respectively, sit on the edge of a bed, signalling no interaction with either their partners or the connection to the outside world in the form of the window. In *Hotel Room* (1931), a woman sits on a bed and looks at a book; yet even here, in the midst of reading, she appears lonely and not simply in a state of contemplative solitude. Part of the reason for the feeling of loneliness in these three images is the downward gaze, suggesting a melancholic sadness, and indeed Margaret Iversen (2004: 54) reads *Excursion into Philosophy* as a specific 'attempt at a modern allegory of Melancholia'. Images containing a similar idea can be found in numerous films, and the downward gaze is a common signal of dejection and isolation. In *Tony Takitani*, Tony is often to be found sat staring downwards, whether at his desk, sat in his dead wife's dressing room or killing time on a park bench. In *Lights in the Dusk* too, Koistinen's gaze is often lowered, and we are presented with a scenario similar to the above paintings as Koistinen sits on the edge of his jail cell bed, ignoring the window as connection to the world (the window is not actually seen in this jail cell image from *Lights in the Dusk*, but the cold winter light cast on the wall is). Koistinen's face lacks any sign of animation or interaction. He appears lost in thought, staring into space; yet the slumped shoulders, the sapped blankness of expression and the turning of his eyes to gaze at the floor all suggest his thoughts are not of peaceful solitude but rather a lonely unhappiness. While the empty blank spaces of Koistinen's cell also contribute to the mood of loneliness here, it is Koistinen himself, complete with downward gaze, who visibly embodies it.

The camera lingers on this image of Koistinen for about ten seconds, longer than would be required to give us the requisite narrative information, and the sense of stasis is aided by the impassiveness of Koistinen's face. The duration accorded to the shot has little to do with story progression but everything to do with feeling and tone. The slow pace could, of course, partly be attributed to Kaurismäki's directorial style or partly to cultural factors, with some critics (see, for instance, Soila 2003: 12) suggesting that many of the stylistic features of Kaurismäki's films play up to national stereotypes of Finns as lonely, taciturn people. Nevertheless, the sense of stasis in the shot and the patient holding on images of loneliness is something that also occurs in many films of differing

nationalities as well, such as in *What Time Is It There?* or *Tony Takitani*, for instance. Images of eating and drinking alone, staring out of windows or sitting downcast are often held longer than would be necessary for the advancement of storyline. The images are often more about mood, emotion and tone, and the delayed scene allows feeling to develop in a similar manner to the way in which it might in pondering the still image of a painting. Much painting strives to convey movement, of course, but Hopper's images are unusually static, and can seem like stills from a film, 'a scene that is frozen in time or a fragment removed from a spatiotemporal narrative', as Fryd (2003: 112) suggests. In this respect they provide useful examples for film-makers intent on deliberately holding on images of isolation within a film, their compositions and situations lending themselves to being lingered upon.

Many films dealing with loneliness contain a sense of 'dead time' or a lack of narrative momentum. Through the sense of resulting stasis feeling is allowed to emerge, with spectacle and affect privileged over plot and story. In 'Between Setting and Landscape in the Cinema', Martin Lefebvre suggests that the strategy of 'dead time' can help to produce the equivalent of pictorial landscapes in film, that it presents 'a way of rendering space, a way of taking it out of the film's continuity and narrative development, in order to distinguish it and to make it autonomous in the eyes of the spectator' (Lefebvre 2006: 40). In this way we are forced to contemplate images in their own right, and not simply for their development of plot, and so scenes such as the woman staring from the hot dog van, or Koistinen sat in his jail cell, take on an importance that lies beyond story, in a more emotional realm of mood, feeling and tone.

There is often a sensation akin to waiting in these scenes, a physical sensation of time passing which involves our awareness of time. The characters in these films, or indeed the unmoving figures in painting, can appear to be enduring their state of loneliness, waiting in time until that state might be cured. Many films dealing with loneliness portray everyday activities (eating, drinking, daydreaming), and in these mundane circumstances they often appear to be killing time, almost stoically accepting their lonely state. This state of killing time is present in the day-to-day existences of many of the characters in the films of Tsai Ming-liang, and it is there in the frequently mundane and solitary activities of Koistinen in *Lights in the Dusk* or Tony in *Tony Takitani*. Hopper's paintings too, however, are noted for portraying the everyday, and Ivo Kranzfelder (2002: 48) links the artist to the Impressionists and a European heritage, as Hopper captures the 'usually unnoticed sense impressions and emotional reactions of living individuals'. In *Disclosure of the Everyday: Undramatic Achievement in Narrative Film*, Andrew Klevan (2000: 208) touches on something similar when he suggests that films which do not engage in 'energetic scenarios' but rather instead concentrate on the undramatic everyday allow 'the viewer to consider, and feel, emotions which are nuanced'. Everyday activities do not intrinsically convey loneliness in painting and film, but the sense of time dragging by, or of frozen moments, helps to bring out this subtle, quiet emotion when the relevant context is present.

Not all films containing loneliness operate in this manner, however, and it would be true to say that this propensity for 'dead time' can be found more in art cinema than in Hollywood cinema, for instance. This may be because, as Steve Neale (2002: 103–04) and David Bordwell (1979: 57) have noted, art films tend to concentrate on character and interior drama over and above action and plot, with an emphasis on visual style. This lack of narrative drive, and the stress on interiorisation then, makes films that lean towards the art cinema end of the spectrum more likely to employ 'dead time' to suggest internal feeling and emotion. It could also be argued that films stressing visual style will also be more likely to display some of the other lonely tropes discussed so far. Nevertheless, even in a Hollywood comedy, while it may not be quite so immediately apparent, one may still find interesting instances of images being lingered over and evidence of the tropes being employed.

Billy Wilder's *The Apartment* (1960, United States) is a romantic comedy, and yet it creates a feeling of loneliness around two central characters, Mr Baxter and Fran Kubelick. At various moments in the film there are examples of certain of the tropes already mentioned, such as eating and drinking alone (Baxter eats a TV dinner by himself, and later he comments to Fran that dinner for two is a 'wonderful thing'), a melancholy and resigned downward gaze (Fran in particular stares blankly downwards as Sheldrake makes his excuses on Christmas Eve), the window gaze (somewhat reversed here, with Baxter forlornly staring up at his own window, waiting on the street while a couple uses his apartment), a sense of emptiness (Baxter sits among rows and rows of empty desks in the office) and so on. However, I would like to focus on one particular scene, in which Baxter sits alone in the park, having been ousted from his apartment so that others may enjoy their amorous activities.

The scene begins with an image of a park at night. A continuous line of benches runs diagonally from bottom left to around middle right of the frame, vanishing into the distance. Into this scene walks Baxter in long shot. He sits down looking tired, folds his arms to keep warm, gazes down and appears to collapse into sleep. The camera moves in slightly on Baxter as he sits down but remains in long shot, keeping him surrounded by the empty spaces of the nighttime park. The street lamp to the left of frame provides merely a cold gleaming, illuminating only the bench stretching into the distance, a reminder of absent bodies as Baxter sits alone. The falling leaves and theme music add to the sense of melancholy, but the emptiness and overall composition of the scene is reminiscent of a Hopper painting, a connection that Richard Armstrong (2000: 105) also makes. In fact this particular scene bears a strong resemblance to a specific Hopper etching entitled *A Night in the Park* (1921). Both images employ similar strategies of long-shot framing, with a diagonal line of empty benches and the cold light of a street lamp. In lingering on the image of Baxter the film creates for a moment an image to be contemplated, despite some movement within the 27-second shot, and it uses the sense of extended time to enable us to feel something of Baxter's lonesome situation.

There are, however, many differences between the two images, reflective of the differences between the mediums of film and painting. The aforementioned camera movement in the scene from *The Apartment* encourages empathy for Baxter with a slight track-in moving us closer to his figure. He is seen in a closer proximity than Hopper's anonymous figure, and though both images suggest loneliness, Hopper's etching remains more mysterious and enigmatic, while we are left in no doubt about how we should feel for Baxter (this is due in part to the falling leaves and emotive saxophone music that accompany the shot, adding to the sentiment of the scene, with sound being an important element for the manipulation of emotion). Painting and film may share analogous aesthetics, but there will always be differences according to the specific properties of the medium. One might argue, for example, that the way in which the trees have been etched in *A Night in the Park* adds to the slightly menacing presence here, a feeling that is not present in the scene from *The Apartment*. Yet, as we have seen, it can be valuable and enlightening to ponder the similarities, as well as the differences between these art forms, in terms of their approach to conveying emotional content.

This essay then has presented a brief overview of how painting and film often employ similar strategies in conjuring a sense of loneliness. The comparison of Hopper's work with relevant film-makers suggests an aesthetics of feeling that can be shared by both mediums, and this aesthetics of feeling is seen to operate across a broad field, appearing in works from different cultural backgrounds and historical periods. As Torben Grodal's work helps to indicate, this may be due in part to influences crossing borders, but also to innate dispositions in human beings, and how human biology influences the way in which we interpret our world and works of art. As a brief illustration of how this might apply to a trope such as the downward gaze, as an example, there is evidence to suggest the existence of universal facial expressions for a number of basic emotions (Ekman and Friessen in Grodal 2009: 12; see also Ekman in Plantinga 1999: 242). This presents, therefore, a possible reason why the downward gaze might so often be used to convey loneliness and melancholy. That is not to say that cultural factors do not apply, for the nuances of facial expressions may still then be overridden to some extent by cultural variation, and it is perfectly valid to relate the use of silence and blank expression in Kaurismäki's films, for example, to elements of Finnish culture, as many critics do. Nonetheless, the tropes of loneliness occur in a wide array of paintings and films, and so one must consider other factors, such as influence and human biology, as well as factors of human culture in order to consider why these tropes are so frequently employed. It could be useful to research which aspects of the works relate most strongly to these various factors, and indeed this might provide an avenue of future exploration.

The fact that the tropes of loneliness identified arise in both painting and film, and across a broad spectrum of artistic expression, has important implications, since if a taxonomy of tropes for other emotions could also be identified in a similar manner, then it should be possible to build a much greater understanding of how emotion is constructed in the visual arts, to more tangibly pin down what can be an elusive and

shifting field. Whilst the focus here has been on the specific emotion of loneliness, there is the possibility for discovering an aesthetics of feeling that touches on a wider range of emotion and feeling, since a different emotion could be substituted and the same methodology applied. As it stands, however, more work needs to be done on examining how the two art forms of film and painting interact with one another in terms of aesthetics and on quite why the tropes identified operate so effectively as strategies for conveying loneliness. In spite of its negative connotations, loneliness is a fundamental part of being human, and its use and construction in two of our most important art forms is certainly worthy of further attention and study.

Bibliography

Anfam, D. (2004), 'Rothko's Hopper: A Strange Wholeness', in S. Wagstaff (ed.), *Edward Hopper*, London: Tate, pp. 34–49.

Armstrong, R. (2000), *Billy Wilder, American Film Realist*, Jefferson, NC, and London: McFarland & Company.

Bendiner, K. (2004), *Food in Painting: From the Renaissance to the Present*, London: Reaktion Books Ltd.

Bordwell, D. (1979), 'The Art Cinema as a Mode of Film Practice', *Film Criticism*, 4:1, pp. 56–64.

Carroll, N. (2008), *The Philosophy of Motion Pictures*, Oxford: Blackwell Publishing.

Crewdson, G. (2004), 'Aesthetics of Alienation', *Tate Etc*, 1:1, pp. 42–47.

Fischer, L. (2000), 'The Savage Eye: Edward Hopper and the Cinema', in T. Ludington (ed.), *A Modern Mosaic: Art and Modernism in the United States*, Chapel Hill, NC: University of North Carolina Press, pp. 334–56.

Fryd, V.G. (2003), *Art and the Crisis of Marriage: Edward Hopper and Georgia O'Keeffe*, Chicago and London: University of Chicago Press.

Goodrich, L. (1976), *Edward Hopper*, New York: Harry N. Abrams.

Grodal, T. (2009), *Embodied Visions: Evolution, Emotion, Culture, and Film*, New York: Oxford University Press.

Ichikawa, J. (2005), 'Director's Memo', available at http://www.tonytakitani.com/e/introduction/index.html. Accessed 5 December 2010.

Iversen, M. (2004), 'Hopper's Melancholic Gaze', in S. Wagstaff (ed.), *Edward Hopper*, London: Tate, pp. 52–65.

Klevan, A. (2000), *Disclosure of the Everyday: Undramatic Achievement in Narrative Film*, Trowbridge, Wilts: Flicks Books.

Kranzfelder, I. (2002), *Edward Hopper, 1882–1967: Vision of Reality*, Köln: Taschen.

Kuh, K. (1962), *The Artist's Voice: Talks with Seventeen Artists*, New York: Harper & Row.

Lefebvre, M. (2006), 'Between Setting and Landscape in the Cinema', in M. Lefebvre (ed.), *Landscape and Film*, New York: Routledge, pp. 19 59.

Levin, G. (1980), *Edward Hopper: The Art and the Artist*, New York: W.W. Norton & Company.

Lukanuski, M. (1998), 'A Place at the Counter: The Onus of Oneness', in Ron Scapp and Brian Seitz (eds), *Eating Culture*, Albany: State University of New York Press, pp. 112–20.

Neale, S. (2002), 'Art Cinema as Institution', in C. Fowler (ed.), *The European Cinema Reader*, London: Routledge, pp. 103–20.

Plantinga, C. (1999), 'The Scene of Empathy and the Human Face on Film', in C. Plantinga and G.M. Smith (eds), *Passionate Views: Film, Cognition, and Emotion*, Baltimore: John Hopkins University Press, pp. 239–55.

Schmied, W. (2005), *Edward Hopper: Portraits of America*, Munich: Prestel.

Soila, T. (2003), 'The Landscape of Memories in the Films of the Kaurismäki Bros.', *Film International*, 3, pp. 4–15.

Wollen, P. (2004), 'Two or Three Things I Know about Edward Hopper', in S. Wagstaff (ed.), *Edward Hopper*, London: Tate, pp. 68–79.

Chapter 12

Grievability and Precariousness in Alain Resnais's *Hiroshima, mon amour*, Ari Folman's *Waltz with Bashir* and Alexander Sokurov's *Alexandra*

Dennis Rothermel

The face of anguish in Alain Resnais' *Hiroshima, mon amour* (1959)

A French actress converses with her lover, a Japanese architect, at night in a cafe in Hiroshima. They sit opposite each other at a table by a window. The River Ota flows gently by just outside. She tells how she had fallen in love with a German soldier stationed in her town. The people in her town killed him the day the nation was liberated, and she was shamed publicly. The day the atom bomb falls on Hiroshima, she leaves.

As she tells about the day she found him dying, she leans back in her chair, so that the upper portion of her body is out of direct light. Her back stiffens. The one side of her face is dimly lit. On the other side a faint flickering glimmer of light reflected from the River Ota animates her face. Her countenance and her voice are at first carefully controlled as she explains how she saw him lying in the street, how she knelt by him, how it took so long for him to die, how she stayed with his body all that day and night, and how she felt as cold as he was once he was dead. Against her resolve to tell this story in its factual detail, her voice becomes increasingly strained. Finally, as she explains how she had lain on top of him and could not tell when he died, and could not tell the difference between his body and hers either before or after, and how this had been her first love, she leans forward into the full light, revealing unfathomably severe anguish. Her lover reaches across the table and slaps her face twice quickly, bringing her back into the present moment. She regains her composure, wilfully unfazed by his rude treatment. She smiles wanly. But the inerasable residue of the anguish from that day fifteen years before is only lightly suppressed in the calm expression that she is able to recover.

Judith Butler's exposition of grievability and precariousness in frames of war

In her recent book, *Frames of War*, Judith Butler explicates 'frames of recognition … of personhood' as underlying a nation's acquiescence to war and its tacit acceptance of both social and military violence inflicted on its behalf. These frames of recognition delimit who is and who is not worthy of affinity (Butler 2009: 5–13). Where those frames enforce domination, persons are construed as threats and objects of scorn. Where those frames are exclusionary, some people will not register as within the scope

of recognition. An individual who is not *apprehended* as a person is not yet available for recognition as an equivalent Other. An individual who falls outside the historically defined realm of social reality would not yet be *intelligible* as subject to recognition as an equivalent Other.

The frame of war that a nation adopts distinguishes between lives worth living and lives worth destroying (Butler 2009: 22). Lives worth sacrificing will be among the former and for the sake of the former. Honourable and hence grievable sacrifice will not be comprehended as extended to those whose lives the frame of war renders worth destroying (Butler 2009: 31). As they form and as they shift, these frames of war can serve to ennoble or perchance to denounce a nation's war effort. The nation's internal debates about a war will devolve to how frames of recognition of personhood are in conflict.

Grievability that is suddenly extended to the previously excluded Other initiates apprehension of the Other as subject to the precariousness that defines life and thus as deserving recognition. Such shifts show how these frames are mutable. The snapshots taken by ordinary soldiers at the Abu Ghraib prison in 2005 as they indulge inflicting gratuitous torture and humiliation on enemy captives undermine the ideological framing of that war as extending a national vision of civil democracy (Butler 2009: 40). But it is the apologetic analysis of the vulnerability of human nature to harbour sadism when placed into service as prison guards that shows the implicit conceptual flimsiness of the frame of war. In this way, framing always entails conning its subjects into accepting contrary evidence as positive, and thus there is an inherent logical potential of the frame not simply to permit but to instigate the impetus to break out of it (Butler 2009: 11).

Butler's broader point is that all matters of life and death – including those underlying national debates on abortion, physician-assisted suicide, immigration and health care – are framed by discriminatory recognition of personhood (Butler 2009: 7). In the context of national acquiescence to war, the decisive factors in the definition of a frame are those that enable or suppress 'grievability across populations' and 'recognition of precariousness as the shared condition of human life' (Butler 2009: 13, 24). The transparent comprehension of these two factors of grievability and precariousness thus pose the strongest internal conceptual fault lines in a frame that defines personhood exclusively.

Precariousness is 'the condition of life being conditioned' by danger, by deprivation and by death. The power of an image – still or moving – thus can intrude to challenge a nation's frame of war (Butler 2009: 23). One can detect the suffering, pain and anguish that corroborate the presence of a soul, a person, a conscience all like one's own. The greatest terrain for the confrontation of frames of recognition of personhood thus lies in the shared imagery of a nation's culture.

Grievability and precariousness in *Hiroshima, mon amour*

The detached narrative the two lovers share in the non-diegetic voice-over in the film's introductory section of documentary photographs and footage intercut with fragmentary views of them embracing in bed poses the conflict between what she believes she can understand about Hiroshima and what he responds flatly that she cannot.

She has come to Hiroshima to act a role in a film. In that removal from her own country and immersion in a pretend frame, she cannot avoid conflating the two lovers fifteen years apart. Her present transitory excursus retraces her transgression against the frame of her countrymen in France during the war, for whom no German was innocent, no German was beyond their enmity and no German soldier could be spared death – especially one who has seduced one of their own. She became the scapegoat for their powerlessness to vanquish the enemy they despised. Her suffering public humiliation masked the deeper grief of her loss of her lover. Thus the same event has different meaning from either side of the frame of recognition of her personhood. The nation's exultation is the moment of her deepest sorrow.

The moment of recapitulation of her grief to her Japanese lover brings her back to the framelessness of that first love affair. Her first telling of her story about Nevers covers the events by innuendo, omits the love affair, its doom and aftermath. She is able to relate that much while still smiling, as if these were events that no longer carry her emotional investment. The next recapitulation begins to fill in those omitted details – except for the event of her lying with her dying lover. This time the story is fragmentary and disoriented. She explains that the soft light of the Loire makes it beautiful – that same soft light from the River Ota that basks the side of her face in the second recapitulation of the story. Working backwards and forwards from fragments of the story before and after the day when she laid with him as he died, she circles in on the one solid core event that is burned into her memory. From the vantage point of that regained framelessness, she can envision neither life nor death, nor happiness – in spite of the ardent entreaties of her Japanese lover. The time remaining for her with him dissipates into a series of desperate appeals, now all the more appropriate to the anonymity they had maintained with each other from the outset.

They finally address each other in the detached tones of the flatly declamatory, non-diegetic voice-over that we had heard in the first segment of the film, once again separated by those frames of being French and being Japanese and with the same dissociated tones and pauses. She declares that his name is Hiroshima, pronouncing the name slowly, syllable by syllable, as if committing it to memory for the first time. He replies that hers is Nevers.

Resnais's film places the story of the two lovers in the context of Hiroshima, with but spare and oblique connections between the story of the two lovers and the destruction of the city and the massive slaughter of its people. Match cuts precisely connect the River Ota in Hiroshima with the River Loire in Nevers, travelling-camera views of streets in

Hiroshima and Nevers, detail shots of his hand with her dying German lover's hand and her hand with the deformed hand of a young female survivor of the bombing. It is that moment of profound anguish, for which a lifetime will not suffice to erode away, that postulates the measure to the contrast. As anguished as was her time kneeling next to her dying lover, as anguished as that memory remains, as anguished as becomes the moments she now lives through with her Japanese lover as they endure the protracted contemplation of their impending inevitable separation, so is the anguish of the loss of those from the bombing, unfathomably magnified by contrast – 200,000 lives lost in nine seconds, lives that are just as much full of loving, passion, discovery, transformation and also anguish. As intense as is the anguish of the woman and the man in this oblique, ontologically distant refraction of the event that took place at this locale, so much infinitely more is that other loss – as if theirs were a mere spot indelibly seared by the burning sun in the sky from a distance of millions of miles. We understand how beyond imagination is the sun's heat from inspecting that seared spot. The intensity of this small refracted anguish thus provides a measure not of that greater anguish but of how unfathomable it is to contemplate.

Understanding her as a victim, and moreover, as standing in place of the 200,000 souls whose lives were vaporised in seconds, is a move that Resnais encourages us to accept as the pathway out of frames of war. It is when she can be understood as a victim that simultaneously Germans, Japanese, French and Americans are no longer demonised. Where that has yet to transpire, the frame of war that separates persons deserving recognition from those who are not remains. Reversing what one may first perceive, it is the love story that becomes the backdrop for the story of Hiroshima. There is no singular moment of their falling in love in Hiroshima and no moment of sad departure – only a protracted reverberation of consignment to the trauma.

Grievability and precariousness in Ari Folman's *Waltz with Bashir* (2008)

A pack of 26 dogs gallops along a city street. They growl and snarl viciously. The dogs stampede headlong through everything in their path, without breaking stride. They knock over cafe tables and chairs. People cower in their advance, clutching each another in terror, not knowing whether they will be attacked, and realising that they would have no means of escape or defence if they were. What had a moment before been ordinary and safe has suddenly become vulnerable and estranged. The menacing dogs' muzzles protruding in close-up views extend that fear to the viewer. The image of the vicious dogs interjects the sudden recognition of our own precariousness into the contented appreciation of mundane diversions that we share with the people on the street.

Folman starts the film with this forceful visual metaphor of the random horrific violence of war – how victims can be singled out without warning, without justification, or just as easily spared. It is also the recurrent dream of a soldier. Boaz Rein-Buskila

was a soldier in the Israeli Army's incursion into Lebanon in 1982. He had the assigned role of shooting dogs in a village before his squad would enter, lest the barking would warn their adversaries of their approach. He was given that task because everyone in the squad knew that he was incapable of shooting people. Twenty years later he begins to have a recurrent nightmare of those 26 dogs seeking him out. The dogs stop below his apartment window – staring up at him, growling and barking – his own particular reminder of the terror of his experiences in that war. That that was his assigned task, that it substituted for his irrepressible humanity in not being capable of harm against another human soul, all counts for nothing against the persistent remorse for having inflicted harm on innocent animals, which was nevertheless instrumentally intertwined with how his fellow soldiers did kill people. That penetrating sorrow, which he would have had no excuse in expressing to his fellow soldiers, rivets his attention to the precariousness of a dog's life, a soldier's life, any grievable life.

Boaz tells this story to the film-maker – Ari Folman – one rainy night in a bar in Tel Aviv. Folman, both the subject and the author of the film, wondered how much of his own experiences as a soldier in that war are suppressed beyond his ability to recollect. Folman staged interviews with individuals who shared those experiences with him, along with conversations with a psychologist, a news reporter who had witnessed seminal events and Zahava Solomon, an author of research on the impact of combat on soldiers (Solomon 1993, 1994). The interview sessions were recorded in a video sound stage, with the intent to depict the conversations in animation – animation that derives from drawings of the participants placed in external locations, along with animation of the events that they describe from memory. The film thus comprises a nearly incongruous case of an animated documentary. That the animation derives from drawings and not photographic images is immediately evident on viewing – the drawn effects are perceptually distinct from rotoscoping. The visages of the participants seem natural but also artificially imaged, noticeably with stiff, stop-motion, jolting movements and fragmented, placid expressions.

The acousmatics of the film's casual interview dialogue, which is associated with a representative but not indexical image, sustains a separation of the subjects from our view. We hear presumably unrehearsed voices behind an animated façade that represents their conversation but without any suggestion of veridical representation. That the visual representations turn out to be altered deliberately is not in the least surprising, nor deceptive. These voices lie *behind* the masking animation yet represent actual participants, not fictional characters, in contrast to animated feature films. That they are heard but not seen, however, contrasts with interview documentary film. Though synchronised but separated from the visual aspects of the diegesis, these voices diverge from the ascribable traits that the theory of the *acousmêtre* would suggest (Chion 1998: 25, 27, 42, 63). The speakers are not omniscient – on the contrary, they are avowedly unreliable in their recitation of their memories. They are not all-seeing – on the contrary they are as limited in what they see, what they saw and what they can remember seeing

as they are limited in their power to have changed any of that. They are not omnipotent – on the contrary they are powerless in the experiences in war that they recall from 25 years before and powerless at this later time either to escape those memories or to be able to retrieve them faithfully. They are not disembodied, but their bodies are distinct from the visual representations we see. It is not the case that they are voices without a place – but their place is not the place pictured for us to see directly. Their presence to us is not intimately close, on this side of the diegesis, but removed, on the other side of the diegesis, yet more directly intellectually present than is the visual diegesis. They are sealed within this palpable closeness that is at the same time an impenetrable separateness.

Folman's objective in the project is to corroborate one incident that he recalls vividly and to try to discover incidents that he may have suppressed. His understandable trepidation, that he might discover something about what he did or saw, about him, that would be profoundly troubling, becomes the driving premise of the narrative, which is also his impetus in making the film.

One of his fellow soldiers whom he interviews, Carmi Cna'an, recalls how when his squad lands ashore in Lebanon, they all begin shooting – at nothing and for no reason but spontaneous group fear. But then their attention fixes on a car moving into range. The soldiers turn their fire impulsively to the car, riddling it with hundreds of bullets. Afterwards they discover a family inside, all dead. Carmi explains that Ari was there – but he does not remember being there. Without explaining this, Carmi's story reveals how solidly soldiers suppress the recognition of the personhood of those who happen into the scope of their lethal actions. Not even for a moment can they stop to grieve or to regret – however much they would in any other circumstance. Ari's memory has blotted out this horrific event. What they did senselessly obliterated grievable life. That it was palpably unconscionable suffices psychologically for the event to be suppressed from his memory.

Folman fixes on his own flashback memory after the meeting with Boaz. The scene is surreally coloured in orange and black. Soldiers, including himself, bathe in the sea near the shoreline in Beirut. They are naked except for their weapons. Hearing commotion ashore, they emerge from the water, dress and pass through a crowd of women coming towards them. No one is able to confirm this incident that Folman remembers so vividly. Discovering its meaning entails finding connection between the fragments of real events contained in that remembered scene with events that he must have been able to witness but which he cannot consciously abide.

The scene that Ari remembers vividly at the Beirut beach, though, is not confirmed. He comes to realise that that memory constitutes a transformed remnant of what he did witness. As the Israeli army paved the way for the Phalangists to enter the Palestinian camps, the oblique sounds of the ensuing massacre came slowly to sink in to the soldiers observing from the perimeter. The massacre continued for three days. The soldiers take so long to realise what is going on because they could not conceive of it happening – there is no framework to put these details into. Finally when it is over, Ari is among the soldiers who first see the carnage. Coming towards them and past them are the wailing

women – the one remnant in that vivid but false memory of what he had suppressed. The last 50 seconds of the film shows documentary footage of women as they emerge from the camps where they have been allowed to return where they see the corpses of the men and children of their families. The women stream by, weeping, wailing from the depths of their souls, gesturing beseechingly, angrily, helplessly to anyone who would be there, to anyone who could be responsible. It is an event that could not be depicted other than how it was captured. Folman's choice to compose the film in animation was predicated on the conclusion with these images placed in juxtaposition.

The remembrances that *Waltz with Bashir* relates demonstrate how the frames of war that soldiers in harm's way inherit nevertheless are extremely fragile, however strongly military training conditions them to be impervious. Those frames make trigger-happiness their first instinctual survival tactic. Those frames will make it difficult to recognise that a massacre unfolds in front of them, difficult to confront how their own reactions will have killed innocents, and unbearable to retain memories of the loss of their buddies. Their own precariousness is packed away into the acceptance of their duty as encompassing dying.

We sense the realism of the soldiers' testimonies, while not connecting with these individuals personally, which would arise with photographic representation. The soldiers are thus not this soldier, this other soldier, but all of them a soldier – particular soldiers representative of soldiers who experienced that war. The dialectical abstraction that retains while superseding the indexical source is the heart of Folman's choice in constructing this seemingly contradictory invented form, the animated documentary. But just in the same way, the war depicted in scant, episodic and partially untruthful remembrances is not this war but *a* war – representative of the experiences that soldiers can have in war. The indexical is thus isolated on the experiences and not on just these soldiers. The women's wailing amplifies this universal pertinence – theirs is the demonstration of the absolute grievability of personal loss – loss of a husband, a brother, a son, a father, an uncle, a cousin. Theirs is the concrete horror in which all the mass of all possible horror is concentrated, not in the least symbolic, substitute or representative but purely concrete; it anchors the horror so indelibly that a soldier is no longer a soldier who witnesses it, since to be a soldier means to suffer horror obdurately.

How Folman's *Waltz with Bashir* challenges frames of war becomes particularly evident in critical reception of the film that insists on placing the film within the continuing context of military and political strife in the region. That context sustains frames of war, even in retrospect to events 25 years past. The focus on the memories of just a few soldiers about their experiences in the war and the overt avoidance of any attempt to fill in the broader context of that war pinpoint just those memories as the subject of the film – connecting thus with how soldiers endure war experiences during and long after.

For the sake of how the film focuses on the experience of soldiers and thus to deliver an anti-war message, it does not matter which soldiers are the focus, nor what military contingent in the conflict, nor which conflict. It is not always the assignment of guilt that is the most important point in comprehending moral calamity. The haste to accede to

the vantage point of the one who judges leaves behind access to recognition (Butler 2005: 44–49). By retreating from the details of a context that would encourage judgement of either the soldiers central to the story or the Israel Defense Forces, or Israel, or any aspect of the political context of the war, Folman has ventured into narrative documentary that provides experiences to comprehend without the need to subject these experiences to finalising judgement.

Grievability and precariousness in Alexander Sokurov's *Alexandra* (2007)

A grandmother visits her grandson, who is an army officer stationed at a remote outpost in a foreign country controlled by insurgents. Ostensibly he is among the Russian soldiers in Chechnya but not identified as such and importantly so. His delight in seeing her unexpectedly and her caring concern for his well-being create a frame of familial reference incongruous with the realm of military violence that engages him in the stark landscape. His soldiers treat her with careful deference and cheery politesse, harkening to a civil life at a polar extreme to their daily forays out into the country to confront the lethal menace of their adversaries.

She is intent to observe all the aspects of her grandson's existence in the clustered tents of the outpost. He shows her the equipment they use. He helps her up into an armoured personnel carrier. Inside she is overcome by the cramped, suffocatingly odiferous space that contains a dozen men when in use. This brief taste of the least relevant deleterious aspects of being a soldier yet stands in stark transgression against normal human conditions. Even as she sees nothing in her grandson that suggests his change from the decent, caring and civil young man she knows and loves, she worries without respite that what she knows about soldiers – that they return home never the same from the horrors they witness and perpetrate – will affect him as well. Her grandson shows her how to hold and shoot a gun. She peers along the barrel at an imagined target and ponders – this is what he does, this is how he does it, this is how he sights a human and shoots. She talks to him of strong people as those who can endure having inflicted death upon strangers – and yet to be able to return to the civil people they were previously. He listens knowingly but without granting hope that these simple words can give him that strength. She speaks in a voice one level above a whisper, resigned but dauntless in her simple quest. He unbraids her hair and talks about washing his socks and underwear, but he refuses to talk about getting married. The connections to civil life are thus hardly more than perfunctory. He re-braids her hair while she mutters inaudibly *sotto voce*. He strokes her hair endearingly. Thus the tenderness of life in a family hinges on fragmentary reminiscences; gestures torment by reminding without reviving that life.

The men accommodate Alexandra's presence tenderly, but she is out of place at every moment and so is demonstrated the alienation of civil life in the actual context of soldiers at war. 'No grimacing,' she warns, 'I'm the one who should be grimacing.' The perspective

from civility is cause for revulsion, more so than the perspective of those who have become defined by what will be revolting to civility. Alexandra wanders through the camp, looking at what the men do, how they endure the tedium, how they do not speak of the dangers they encounter, nor the destruction they administer. She peers through the tent window at them sitting around the mess-hall table, shirtless, with close-cropped hair, for the moment devoid of everything that marks them as soldiers except for the tacit acceptance of the boredom. Alexandra can see the soldiers' deprivation in every simple detail, in their soft-spoken angelic speech, in the feet of a soldier as he sleeps, in the desultory, obligatory fun they take in horseplay, how they carry out the routine of cleaning their weapons. They speak emptily of a fatherland, yet they are at a loss to name what that means. Her weighty sedentariness gathers in all the languid reticence of the soldiers. They understand her purpose without needing to hear it said; they say nothing of the purpose that has placed them there, in the desolate land, huddled in the dusty tents of their canvas enclave. Even the moment of putting on a coat and scarf, as she would were she at home, re-emphasises the disparity between a world in which to live, to cope and to hope to thrive and one in which it is all one can hope for to endure and to survive.

Internally and externally the terrain is unembellished, accidental and painted in inhospitable patchworks of incomplete images. Not even the natural terrain looks either natural or inhabitable. Daylight and evening are differentiated by levels of beige and brown. Soldiers barter everything – which is their privilege but also a distracting pointless enterprise. People abide living in buildings half destroyed by bombings, as if it were natural. The world and its living conditions are provisional – always ready for destruction or abandonment. Life has become statically nomadic. Domestic and military cargo rest side by side in the boxcar that transports Alexandra back out of the boundless border world. The elements of ongoing living and ongoing killing are coexistent. She turns away from it, overwhelmed and forlorn.

Sokurov's treatment is effortless; yet every single moment builds on the juxtaposition of frames of war and peace, which do not cut between grandson and grandmother but across both of them. It is only by that incongruous juxtaposition that either is in a position to confront that incongruity. The gritty indexicality of the flattened-contrast, near-monochromatic spectrum of reality of this world adumbrates its constrained spectrum of fates within shared stark precariousness. When she leaves, she stands in the opening of the train boxcar that has served as transport to and from the camp. Framed surreally this way, our view from behind her is of an aesthetically flattened realm passing by her. It is a realm beyond comprehension, without narrative order or social organisation, showing the traces of destruction and desperate coping rather than intentional construction. Her grandson, she knows, is lost to that realm. If he returns, she knows he will bring it with him.

The distant mirror that refracts but a fragment of the horrifying inferno in this case is carried close to where the soldiers are, but in the moments when they lean far away from it, towards emulating life at home. Their cognisance of their precariousness is measured

by the tension in that need to lean away. Alexandra's quiet observance cannot span the gap. The ontological distance is all the more infinite for having the mirror placed intimately close.

Memory and the ontologically distant intensifying refraction

In his commentary on Resnais's *Hiroshima, mon amour*, Gilles Deleuze explains how the film diverges from expected narrative structures. First, Resnais undercuts a point of reference in space and time for the comprehension of the narrative. The opening segments of the film – in which the woman and man comment on the documentary evidence of the bombing of Hiroshima – is out of time in connection with the rest of the story. It could be placed before, during or after the interactions between them that the film depicts. The mood of their discourse is impossible to connect between the two segments. There is no orientation in time, either among the film's segments or between the events of the present and the events fifteen years prior. Moment by moment, orientation to a continuous temporal and spatial frame is undercut. Deleuze calls Resnais's cinema thus one that is composed in sheets of time. These elements of the film that frustrate our absorption into a sympathetic alignment with the perceived lived time and the emotions of the central characters nevertheless sustain our ability to comprehend the meaning of their experiences. The fragmentation into sheets of time allows for the oblique perspective on what Butler calls the frames of war, frames that define the recognition of personhood in terms of oppositional identity.

Second, the narrative collapses into memory – it is thus not possible to distinguish flashback from the present in the diegesis, nor is it possible to distinguish events that happened from how they are remembered. Finally, space and movement recede as the organising axes of the diegesis (Deleuze 1989: 116, 122, 125). The fragmentary images of the lovers together, too small in angle of view to register any more than the slow caressing embrace of two bodies together, define an intimacy that cannot be placed within a time frame of lovemaking. The voice-over dialogue accompanies a succession of still documentary images, short fragments of documentary film of the bombing and the treatment of victims, and documentary and pseudo-documentary footage of the production of the film about public demonstrations against atomic weapons. This collection of images does not tell a story. It is against this exposition of images *not* set into an unfolding frame of time and space that the lovers' conversation at the cafe stands as the sole moment of temporal narrative. It is the woman's anguish that rivets these timeless elements of the film together.

Similarly, Folman's construction of a documentary account based on interviews interleaved with visual re-enactments and organised as an autobiographical expedition also sustains a reflective standpoint that allows our penetrating comprehension of the experiences of soldiers yet while placing that on a plane for contemplation of its

meaning and not emotive catharsis. The animation of the interviews separates the narrators' accounts from the visual diegesis, rendering the visual depiction a fabrication and the narration distanced. The soldiers' enduring struggles with their experiences supplant the primacy of the story of the war as the organising structure of the film. The juxtaposition of archive footage of the impact of horror anchors those experiences, not to return to the time and place of the original events, but as the piercing image of what experience of war remains once the incidental details no longer have defining context. The concluding 50 seconds of the film has its power only as placed on that reflective plane for contemplation.

Similarly, Sokurov presents the life of a soldier from the fragments of that life's moments of repose, when the daily confrontations with violence are suspended. But Sokurov also grants us how this is comprehended without illusion from the standpoint of the person most lovingly endowed with care for the soldier's being able eventually to live a life contentedly. Sokurov situates this transparent ambiguity by having the soldier's realm flattened into a monochromatic spectrum of shades of brown dust, viewed dispassionately from the reflective frame of a slowly passing boxcar, where Alexandra stands on arrival and departure. The film's meaning is sustained by those moments when we can observe, along with Alexandra, details of the soldiers' life that reveal faint but indelible traces of what is not shown or depicted – where and how they shoot and kill, and are shot at and killed. The temporal arrangement of those details is ambiguous and unimportant. What the woman shares without needing to say so is the grandson's memory of his life with her at home. Their exchanges reverberate in those unspoken remembrances. The locale of the war is not named, and the relationship of the camp to the surrounding terrain is not revealed. The details that the woman's presence allows us to perceive unfold without the organising connection of movement. It is her look, her unspoken anguish and her turning away from this terrain of undifferentiated forces of living and dying that serve as the organising elements of the film.

Sitting across the table from where his lover reveals how searingly that moment of undiluted pure grief orients her being forever, the man becomes dizzy at this proximity to pure grief and lashes out at her, to force her to return to his gaze, to his presence, to where that searing orientation retreats from her visage. Later he is contrite for having hit her, for believing that he could force her to forget, for forgetting what he had told her, that overwhelming horror is not possible to know and also impossible to forget. The young soldier who saw the women emerge from having witnessed the slaughter in the camps, who heard their wailing and for that moment could not be a soldier, becomes something other than he was. Even as he represses it immediately, he is already what he has become, if only to discover that years later when he searches for the memory of that moment. The man who unbraids and braids his grandmother's hair enjoys in that casual gesture what cannot belong to being a soldier. For the moment he becomes the man who would return to what his life was before being a soldier, but as having become other than being a soldier. These mirroring refractions of horror registered minutely or

mutely but implicitly amplified by the dimension of distance from their source all flicker in the moment of confrontation between a man and a woman. The woman is the one who has experienced the horror, who sees and has seen the horror, who knows what the horror is. The man is the one who resists the knowledge, but even in that overt resistance, he knows that he is already becoming a person who will eventually no longer resist that knowledge. '[A]ll becomings begin with and pass through becoming-woman,' Deleuze and Guattari explain. 'It is the key to all the other becomings. … To hide, to camouflage oneself, is a warrior function … ; the warrior arises in the infinity of a line of flight' (Deleuze and Guattari 1987: 277). That infinity is exactly the same dimension as that of the small, local mirroring of the distant horror.

It is the cinematic construction of reflection that is crucial in finding the meaning of these experiences of horror and loss. In *Hiroshima, mon amour*, the mirroring takes the form of a woman's anguish over the indelible loss that shattered her life, a loss that arose in an instant, without warning and without justification. In *Waltz with Bashir*, the mirroring arises in witnessing the traumatic first moments of revelation of loss of family, without warning and without justification. In *Alexandra*, the mirroring takes the form of a grandmother's comprehending gaze on the unmistakable traces of the transformation of innocence into souls hardened to accept horror, to accept the loss of grievability and to become inured to precariousness. Thus the violence can be brought back home to be seen for what it is, without bringing with it the frame of war that would obfuscate its meaning. The poetry or images that can force open the fissures in the frame of war that a nation's people sustain can arrive unexpectedly – found, captured or discovered in the midst of the war's events (Butler 2009: 11). Alternatively, images of this stature can be the careful construction of the art of cinema, which will be no less forthright in creating the potently meaningful image whether in fiction or documentary film, whether in regard to a named conflict or not, and whether that conflict be skirmish or holocaust.

Bibliography

Butler, J. (2005), *Giving an Account of Oneself*, New York: Fordham University Press.

—— (2009), *Frames of War: When Is Life Grievable?*, London: Verso.

Chion, M. (1998), *The Voice in Cinema*, C. Goldman (trans.), New York: Columbia University Press.

Deleuze, G. (1989), *Cinema 2: The Time Image*, H. Tomlinson and R. Galata (trans.), Minneapolis: University of Minnesota Press.

Deleuze, G. and F. Guattari (1987), *A Thousand Plateaus: Capitalism and Schizophrenia*, B. Massumi (trans.), Minneapolis: University of Minnesota Press.

Solomon, Z. (1993), *Combat Stress Reaction: The Enduring Toll of War*, New York: Plenum.

Solomon, Z. (1994), *Coping with War-Induced Stress: The Gulf War and the Israel Response*, New York: Plenum.

Chapter 13

'un cinéma impur': Framing Film in the Early Film Industry

Judith Buchanan

In discussing its place among, and approach to, the other arts, André Bazin effectively identified cinema as a medium founded upon an ontological paradox. Cinema emerges from Bazin's 'Pour un cinéma impur' ('In Defense of Mixed Cinema') as a cultural form whose specific strength seems all but predicated on its lack of specificity – on, that is, its medium impurity. A cinema that is 'independent, specific, autonomous' is not the only model to which the cinephile should be 'favourably predisposed', suggests Bazin (1967a: 70). Rather, the fact that 'the cinema draws unto itself the formidable resources of elaborated subjects amassed around it by neighbouring arts' should be a cause not of censure but admiration (Bazin 1967a: 75). Cinema's particularity lies in its capacity to possess other art forms not only by imbibing their materials but also by mimicking their mechanisms. Thus it is with respect to both subject and communicative processes that Bazin posits his defence of 'un cinéma impur', a cinema unashamedly appropriative in its cultural reach.

Clarifying this same duality of potential relationship between cinema and the precursor arts, Robert Stam has subsequently celebrated cinema as a medium that 'can literally *include* painting, poetry and music or … metaphorically *evoke* them by imitating their procedures' (Stam 1992: 131, my emphasis). How early cinema expressed its glorious impurity specifically in relation to fine art *both* by direct inclusion *and* by imitative evocation of its procedures is the subject of this chapter. In it I discuss how early cinema:

i. made concerted efforts to court the look and feel of painting in its mode of exhibition;
ii. claimed artists, studios and paintings as part of its own pool of favoured subjects; and
iii. quoted specific and identifiable paintings within its own works.

Framing film

In the early cinema period (1895–1913),[1] there were, inevitably, plenty of downmarket exhibition venues whose approach to the materials of exhibition was, of necessity, principally determined by cost. In the first decade of the film industry in Britain, for example, many venues serving intermittently as moving picture exhibition halls would simply string up a sheet for a screen and hope that the cloth stayed more or less in place

throughout the projection. First-hand accounts of early cinema-going remember how such sheet-screens were often insufficiently weighted at the bottom to prevent screen quiver, and so picture ripple, when anything moved in the vicinity (Morgan 1974: 123), and reports of the sheet actually coming down during the projection suggest that this too was a not uncommon occurrence (McKernan 2007: 8).

Fixed-site projection venues, by contrast, did typically fix and frame their screens in more formal and commercially permanent ways. And while some opted for a plain, utilitarian style of frame for their screen, in keeping with the modest tone of the premises more generally, there were venues at the other end of the social scale that proudly made a design feature of their screen and used it to proclaim the cultural aspirations of the specific venue, the particular film company and the industry more generally. An 1896 poster for Edison's pioneering Vitascope (Figure 1), for example, shows the cinema screen encased within an ornate, gilt-edged frame, directly imitative of a grandly framed painting. Adopting the visual codes of gallery exhibition in this way testified in part to the cultural aspirations of the early film industry. And, correspondingly, it trailed an implicit invitation to its picture patrons to conceive of themselves as, in effect, gallery-goers, connoisseurs of cultural works of distinction who could sit and view a framed picture that simply now had the added virtue of animation. Almost irrespective of the subjects exhibited within those privileging gilt frames, the symbolic architecture of cultural elevation and artistic worth is telling about how the industry wished to conceive of itself.

Figure 1. 'Edison's Greatest Marvel The Vitascope', 1896. Colour lithograph, 30" x 40". Courtesy of the Prints and Photographs Division of the Library of Congress, Washington DC.

Figure 2. 'At the Cinema'. Postcard c.1912 (author's collection).

Decorative cinema screen frames appear on many images of cinema-going from the period, including on advertisements for particular exhibitors' 'high-class moving pictures' (Mathews 2005: 147) and on a range of satirical postcards with cinematic subjects. The exhibition architecture configured on a card from *c.* 1912, for example, includes a smart frame hanging on the wall, flanked by potted plants with a draped curtain privileging the space of the exhibition yet further (Figure 2). Indeed, so infused is the image with the visual codes of the gallery, and so incidentally evocative of the presentation conventions of the stage, that the inscribed caption 'At the Cinema' is actively helpful in disambiguating the intended location of the depicted action in this case.

Cinema's aspirational self-alignment with the art establishment was sufficiently a given in these pioneering years for *Punch* to enjoy speculating what might happen if the art establishment were to reciprocate the emulative approach. In May 1899 it published a cartoon inviting the Royal Academy to compromise its dull allegiance to originals and instead install a mutoscope of art cards that might then facilitate a swifter, private tour of its exhibits 'for the use of visitors in a hurry' (Figure 3.1). And seven years later *Punch* extended the tongue-in-cheek speculation by publishing a further 'suggestion' to the Royal Academy: this later cartoon showed the experience of viewing works of art on a wheel (which had been offered by the mutoscope) expanded to render it now a collective and public one (Figure 3.2). Gallery-goers had, in effect, been converted into moving

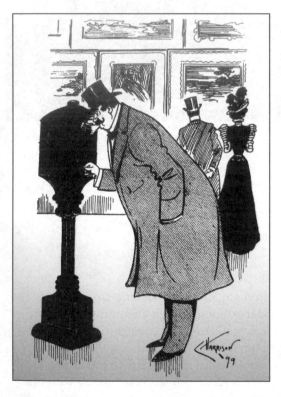

Figure 3.1. 'A Mutoscope of the Pictures, for the use of visitors in a hurry. The Royal Academy "done" in five minutes.' *Punch* (10 May 1899), p.255.

Figure 3.2. 'The Age of the Wheel. A Suggestion for the Royal Academy.' *Punch* (16 May 1906), p.359.

picture patrons who could sit and admire the contents of the gallery as these appeared before them in rolling succession. While ostensibly hinting that the traffic in ideas about exhibition conventions between the moving picture industry and the art establishment during the period could be symbiotic, the satire was really condescendingly predicated on an awareness of the impossibility of such a stooping or cultural compromise in the community of gallery-goers. If anything, *Punch*'s superficial pretence to dismantle the hierarchies of this particular intermedial engagement succeeds most obviously in reinforcing them. The Royal Academy could be teased about how it might best reciprocate the compliment of emulation paid to it by the moving picture industry, but in truth it knew both that modishness was not its goal and that it needed no newfangled technologies of display to lend it credibility.

By contrast, early cinema did need the cultural legitimacy that surrounding its presentations with an artistic picture frame could suggest. And drawing on a strategically self-legitimising architecture of exhibition in this way was a move inherited directly from the nineteenth-century stage. The tendency to regard plays as pictorial subjects through the stylised use of *tableaux vivants* had been taken to its natural conclusion in London in 1880, when Squire Bancroft had famously encased the Haymarket Theatre's proscenium in a two-foot wide gilt picture frame, thus making explicit the residual function of the proscenium as an architecture of enclosure and symbolic separation, and of a stage performance as an aesthetic composition on which one could gaze appreciatively (Southern 1951).[2]

Nor were *tableaux vivants* and pictorial subjects exclusively the province of the *legitimate* stage. Throughout the 1890s, for example, there was a roaring trade in 'living pictures' on many of the prominent vaudeville and music hall stages in both European and American East Coast venues (Nead 2007: 69–82). Such acts involved the restaging of well-known paintings and statuary as appropriately attired performers assumed held poses within an oversized picture frame against appropriate scenic backdrops. Audiences were expected to identify the allusion and appreciate the pictures as a pleasing-on-the-eye and persuasively accurate rehearsal of artworks from a known repertoire. The commercially successful living picture show of 1894 and 1895, mounted at Koster and Bial's Music Hall on 34th Street in New York City, for example, was reviewed in the *New York Daily Tribune* in May 1894 in the following terms:

> The assurance of the pictures was enough to crowd the house. As the successive pictures were displayed the upper part of the house became more than pleased; it was excited. The tableaus [sic] were disclosed in a large gilt frame. Black curtains were draped in front of it, and were drawn aside at the proper time by pages. The pictures were for the most part excellently posed and lighted and were shown with much artistic effect. The most of them were reproductions of paintings and a few were original arrangements. ('A New Set of Living Pictures' 1894: 7, C6)

It was, we discover, those in 'the upper part of the house' who were particularly appreciative (most of the private boxes at Koster and Bial's being placed at circle and gallery level). Offering up visual citations of European works of arts for the appreciation of the cultural cognoscenti (especially works which brazenly featured the persuasive semblance of female nakedness cleverly wrapped in a legitimating aura of artistic distinction) was playing for exactly such hierarchical distinctions to be drawn between upper and lower, the classy and the cheap seats, between those who have the satisfaction of catching the allusion and those for whom it offers an appealing *frisson* while triggering no accompanying spark of recognition. These living pictures traded on a little pre-banked cultural knowledge in order to give up the lightly veiled secret of the provenance of their original. And part of the transaction such a presentation makes with its audience is specifically to license a little discreet smugness as one acknowledges one's place in the community of the culturally literate, a community for whom the visual citational code is fully legible. Indeed, *The New York Times*' reviewer for Koster and Bial's refreshed programme of living pictures in Summer 1894 took pleasure in parading his own superior cultural credentials in response to the succession of visual quotations on offer. While warmly commending the show as a whole, he declared the least stimulating of the pictures performed to be 'Diana's Hunting Party': this one picture, he wrote with barely suppressed artistic smugness, 'would have been more enjoyable had one not seen the original so often' (Pastor 1894).

Having mounted the popular living picture shows in the 1894 and 1895 seasons, on 23 April 1896, Koster and Bial's Music Hall in New York then became the venue for the pioneering exhibition of Edison's Vitascope moving pictures. And the two shows may have shared more than just a theatrical venue. Since the 'large gilt frame' that the *New York Daily Tribune* had reported the venue prominently showcasing for its framed living picture presentations during 1894 and 1895 was succeeded by a twenty-foot gilt frame (Ramsaye 1964: 232) used to anchor, display and artistically privilege the screen for Edison's moving pictures at the same theatre in April 1896 (Figure 1), it seems likely that these two large gilt frames were in fact one and the same. Theatres are, of course, well practised in recycling their properties in different contexts as the staging needs require. When the innovative Vitascope screening was proposed, the generously sized gilt frame already in the theatre's store of stock stage furniture from its previous two seasons might well, therefore, have suggested itself as a suitable property for the display of the Edison show also. And if so, the passing of a direct material legacy from one self-consciously 'artistic' presentation to another at Koster and Bial's provides a neat symbol of other points of continuity between living pictures and the new projected moving pictures also. The lucrative fad for living *tableaux* in the 1890s, after all, constituted part of the cultural backdrop and tapestry of influences for the subjects of early moving pictures.

Artists and studios in early films

Before cinema arrived to claim his attention, the artistically trained Georges Méliès painted a self-portrait in oils (Figure 4).[3] In it he imagines his own head bursting through an easel-propped canvas that had been awaiting inscription. Indeed, given the Latin tag which accompanies the portrait – *ad omnia Leonardo da Vinci* ('(This much/such treatment) to all things, Leonardo da Vinci') – the disruptively intrusive head is perhaps addressing Leonardo on a *pars pro toto* basis as a totemic representative of the entire art establishment, or perhaps ventriloquising Leonardo's own voice as itself a challenge to all that had gone before. Lynda Nead reads the painting as 'testif[ying] to Méliès's lifelong commitment both to art and to film' (Nead 2007: 102). The painting's alleged ability to testify directly to Méliès' commitment to the cinema would require a later date of composition than seems to be the case. And rather than testifying to his 'commitment... to art', the image strikes me as illustrating his form-breaching desire to cock a fearless snook at artistic convention - and, hubristically, to do so through the agency (and perhaps even in the appropriated voice) of the artist who had himself been considered so dramatically innovative and visionary in his own moment, Leonardo da Vinci. The iconoclastic vandalism of the imagined act is striking in its verve and disrespectful energy. In his depiction of his own head newly erupting into centre frame from behind his own easel, however, Méliès may have hoped to transcend the image of a *pure* saboteur and court, in addition, the flavour of something questing and as yet unfulfilled. Is it to ascribe an artificial teleology to a prior moment to suggest that in this earlier self-portrait Méliès configured himself as a man who, through the deposition of an old art form, had now emerged the other side of the ripped canvas in search of a new platform for self-expression, a new communicative medium? As if with atavistic loyalty, he depicts himself still gripping his paintbrushes as his tools of self-expression. In the new world in which he has destroyed his canvas, however, these have become merely the displaced, anachronistic tokens of a past life. Moreover, rather than looking triumphant at where he now finds himself, he looks almost sad – like a man who knew that the still forms of artistic representation could no longer satisfy him and needed symbolic debunking, but unsure where to go next. And where *should* he go next? With the insight that the subsequent history and Méliès' own biography bring, the answer is clear.

Once cinema arrived and so decisively claimed Méliès' groundbreaking creative energies, he was then able to re-engage with the potential meanings and uses of a painterly canvas in a tonally transformed key. In his 1899 short film *Le Portrait Mystérieux/The Mysterious Portrait*, the film-maker is seen magically conjuring and then entertainingly interacting with a self-consciously jocular animated portrait of himself (Figure 5). The film is joyous in its chirpy energy and skittish atmospheric charge and, as such, can be invited to speak back feelingly to the earlier, and sadder, self-portrait that seems to crave resolution: this is where that iconoclastic artist for whom still portraiture was not enough could take his creative energies the other side of that ripped canvas – to the new representative possibilities of the cinematograph. Here there was, as his animated 'mysterious' cinematic

Figure 4. Méliès self-portrait. Date unknown. Oil on canvas, 63.5 x 52cm.
Courtesy of the Lawrence Steigrad Fine Arts, New York.

self-portrait demonstrates, innovative, experimental fun to be had with the meanings of an artist, a subject and a canvas and of the potential relationships between them.

While many early film-makers, including Méliès, in Europe and the United States produced 'artist' films, it was the American Mutoscope and Biograph Company (AMBC) who effectively turned such films into a genre: the film of the enchanted painting. In addition to the twelve or more films based directly on living pictures (Musser 2005: 8), they additionally released a further slew of films based on the engaging but disruptive will of paintings to self-animate. Many of these indulged a specifically cinematic Pygmalion fantasy – viz., that by some mysterious animating force, a female artistic subject comes

Figure 5. Georges Méliès, *Le Portrait Mystérieux* (1899).

to life, Galatea- or Hermione-like, to participate for good or ill, or both, in the world of the desiring male artist or onlooker. The dramatic engine of each of these short films is, typically, an anarchically zany energy of a broadly comic character. The subtext, however, tends to be less breezy, exploring as it often does the unstitching of the artist's attempts to assert any control over the outworking of his own fantasy. The AMBC's short films *The Artist's Dream* (1899), *The Artist's Dilemma* (1901) and *The Easy Chair* (1904) will serve as central examples for these purposes. All three are one-shot shorts of approximately two minutes projection time with a narratively cyclical structure. Chronologically organised, they collectively recount, by sample illustration, the development of the enchanted painting genre.

In *The Artist's Dream* an artist sleeps in his studio, next to two large, recently completed canvases, each containing a life-sized portrait of a beautiful woman. Mephisto appears and animates the women of the paintings who duly assert their new vitality by stepping out of their containing frames (Figure 6.1). Mephisto wakes the artist to appreciate what is apparently the realisation of his fantasy of creation and desire. The artist then lives out his Pygmalion billing by attempting to hug each of his artistic creations in turn (Figure 6.2) but is rewarded, through stop-motion trickery, by finding himself embracing thin air (Figure 6.3). Two harridans now replace the two beautiful women and harass the artist. Mephisto reappears to make these women vanish and to reinstate those of the painter's artistic fantasy – though now restored to their frames as two-dimensional paintings. Mephisto, his job of demonic meddling and eventual restitution accomplished, jumps nimbly out of the frame. The painter views his paintings, restored now to stasis and singular identities, reaches for the bottle, takes a generous swig and collapses back onto his sleeping position on the chair, from where his tormenting 'dream' has apparently emerged.

The puckish animus who can intuit and realise an artist's desire to meet and love the subject of his own painting is a common feature across many of these films. And in each case he employs his magic to turn the animated subject into a frustrating tease as it engages in the world of the artist. In *The Artist's Dilemma* (1901), the demon takes the form of a clown who comes tumbling out of a grandfather clock in the artist's studio with the playful promise of fun. It is not Mephisto but this apparently ludic figure who in this film animates the painterly subject and so becomes the agent of the entertaining but, once again, unsparing subversion of the artist's fantasy.

At the beginning of *The Artist's Dilemma*, the generic artist (whose continuity with his predecessor film artists is confirmed by the fact that he is played by the same (unknown) actor as in *The Artist's Dream*) again sits dreaming on a stool in his studio, his dream apparently summoning a beautiful woman from the magical portal of his grandfather clock. The artist rubs his eyes at the muse-like beauty of the woman, before escorting her to a model's podium, arranging her in a pose and taking up his position at his easel to capture her form. Now the tumbling figure of a Pierrot in clown make-up and pantaloons emerges from the magical gateway of the clock. He offers to paint the model for the artist.

Figure 6.1. Mephisto 'animates' and 'releases' the subjects of two paintings from their frames. *The Artist's Dream* (AMBC, 1899).

Figure 6.2. Pygmalion- like, the artist attempts to make love to one of his animated female subjects. *The Artist's Dream* (1899).

Figure 6.3. The artist is mocked by his own subject: when he attempts to embrace her, she vanishes. *The Artist's Dream* (1899).

The artist agrees and hands over his palette to the clown. The clown unceremoniously discards such delicate tools of artistry in favour of a workman's bucket and comically large decorator's brush. To the artist's amazement, the clown's crude brush strokes magically produce a beautiful image of the model on the canvas (Figure 7.1). When the enchanted painting is complete, the clown offers his hand to the woman in the painting, who, by a simple stop-motion effect, becomes real, takes the offered hand and steps out of her own frame onto the studio floor (Figure 7.2). In response, the model from the podium comes down to meet her own enchanted artistic image and the 'twin' women dance a jolly jig, appropriately in unison. With matching, well-aimed high kicks they then floor both clown and artist before merging magically both with each other and with the clown into the figure of a single woman. The artist, on his feet once more, now declares his love to this composite woman (Figure 7.3). However, when he tries to embrace her, she magically converts into the clown who knocks the artist down for the second time in the film. The clown then disappears via an acrobatic leap, leaving the artist to consider the now vacated spaces of his studio, return to his stool and settle back down into the sleep that has produced the energetic and baffling action of his dream and the film's spectacle.

In both *The Artist's Dream* and *The Artist's Dilemma*, the artist's studio becomes a site on which a comic struggle between artistic desire and control is played out. And, repeatedly, the puckish or mephistic intruding intermediary undermines all artistic control and turns the apparent realisation of the artist's fantasy into a source of humiliating torment: the work of art that is bettered by a clown brandishing a painter and decorator's brush; the Galatea-like women brought to life who disappear or self-convert into harridans or clowns when hugged; the women who floor their creator-suitors with their high kicks. Given the indignities the artist has to suffer at the hands of his own artistic creations in these films, it is little wonder that it comes almost as a relief for him when, at the end of each film, the animated are de-animated once again and the subjects persuaded to reel themselves back in to single identities and pictorial stasis or even to cede completely to innocent, blank canvases.

That a dream of the still image being licensed to *move* should have been a staple of the cinematic repertoire in the 1890s and early 1900s should not surprise, allegorising, as it conspicuously does, the mysterious animating force of the cinematic process that itself converts still images into moving ones. The regularly replayed 'dream' of an image coming to life captures both the heady excitement and the potential alarm that the cinematic release from pictorial stasis could generate. Still canvases and painterly subjects that remained predictably still in the extra-cinematic world had, from one perspective, become yesterday's thing, and the artists who produced them, yesterday's men: and as such, both became amenable to satirical treatment in the cinema. Not only, therefore, did cinema's very projection mechanisms enact, in its own terms, the film industry's triumph over the still image and the still image makers, but as if to trumpet the advantage, the industry's software (the subjects of its films) made fully explicit what was already implicit in the hardware. Film-makers' comically madcap animated portraits of artists

Figure 7.1. The clown creates a magical painting of the female model. *The Artist's Dilemma* (AMBC, 1901).

Figure 7.2. The painted woman comes to life and steps out of her own frame. *The Artist's Dilemma* (1901).

Figure 7.3. The repeatedly outwitted artist attempts to make love to the animated subject of the enchanted painting. *The Artist's Dilemma* (1901).

being systematically bamboozled and humiliated by their own flirtatious dream to work with animated images both made gentle fun of traditional artists, who in these films lack the canniness to handle the moving images they apparently crave, and simultaneously celebrated the film-makers' own superior adeptness in this respect through the entertaining panache with which they cinematically narrate the comic contest.

It was also, of course, precisely the supplanting of still images with moving ones that the very early film shows had often explicitly showcased in their opening moments. These typically began with a projected still image on the screen that then erupted into life once the projectionist started cranking. As Maxim Gorky famously reported in July 1896 in response to his first exposure to the touring Lumière show:

When the lights go out in the room in which Lumière's invention is shown, there suddenly appears on the screen a large grey picture, *A Street in Paris* – shadows of a bad engraving. As you gaze at it, you see carriages, buildings and people in various poses, all frozen into immobility … [Y]ou anticipate nothing new in this all too familiar scene, for you have seen pictures of Paris streets more than once. But suddenly a strange flicker passes through the screen and the picture stirs to life. Carriages coming from somewhere in the perspective of the picture are moving straight at you, into the darkness in which you sit; somewhere from afar people appear and loom larger as they come closer to you … All this moves, teems with life and, upon approaching the edge of the screen, vanishes somewhere beyond it.[4] (Gorky 1996: 5)

The wonder of Gorky's 'But suddenly' moment finds an equivalent in many reports of early film shows. In the United States in the late 1890s, for example, two showmen, Albert E. Smith and J. Stuart Blackton,[5] chose similarly to emphasise the wonder of moving images by projecting the first frame of their most popular film initially as a frozen image. As Smith subsequently recalled, Blackton would work the audience's anticipation at these early shows in the following sensationalised terms:

Ladies and Gentlemen, you are now gazing upon a photograph of the famous Black Diamond Express. In just a moment, a *cataclysmic* moment, my friends, a moment without equal in the history of our times, you will see this train take life in a marvelous and most astounding manner. It will rush toward you belching smoke and fire from its monstrous iron throat. (Smith 1952: 39)

The significance of the 'cataclysmic' moment in which movement breaks from stillness formed the basis of their show. The medium's gasp-worthy properties might even be thought of as residing symbolically in that one magical instant, the moment that referenced the still image and then outstripped it so decisively by creating a new world of animation.

By 1904, the magical conversion of works of art into real versions of themselves within films had already become cinematically conventionalised. As a consequence of the subject's prevalence and familiarity, film-makers realised that the mere display of a framed image within a film was now sufficient to generate the *expectation* that that image would, before the end of the film, be invited to escape the two-dimensional limitations of its own frame borders. This being the case, the established generic convention was already ripe for subversion. It is unsurprising, therefore, that the existence of a secure generic template encouraged some film-makers specifically to reference the cliché in order then playfully to thwart the conventional denouement.

The AMBC's *The Easy Chair* (1904) did just that. In this film, a potential buyer arrives at an artist's studio where a large canvas of an easy chair is prominently displayed. Although the audience knows definitively this is a painting, its realistic style and display at floor level render it a persuasive simulacrum of a three-dimensional piece of furniture in the room. After some comic business of irresolution about where to sit, the buyer – unaware that any of the chairs visibly available in the room might be merely a painting – finally decides to seat himself on the painted chair. An acquaintance with the conventions and internal trajectories of the enchanted painting film generate the expectation that the chair will now magically self-convert into a sittable upon version of itself, able to support his weight. However, in this film, unlike its predecessors from the same stable, this painting obstinately, and genre defyingly, refuses to shift dimensions. As the art buyer lowers himself down upon the seeming chair, therefore, he does not become the beneficiary of a stop-motion miracle of substitution, a real chair for a painted one, as the generic conventions should clearly dictate at this point. Instead, the painting remains a painting and so the buyer rips the canvas, disappearing backwards through the destroyed picture to land unceremoniously in a heap on the floor.

Having repeatedly rehearsed the cinematic enactment of the processes by which the simulacrum takes on, if only temporarily, the properties of the real, it was therefore now possible to let the two-dimensional still representation forgo the established temptation to transmute and allow it to remain just that, in defiance of audience expectations. In *The Easy Chair*, spectators have to acknowledge that the joke is as much on them for their trust in the predictable workings of generic convention as it is on the hapless buyer for his credulity about the material world.

Artistic quotations in early films

Looking back on the early days of cinema from the perspective of the 1930s, Erwin Panofsky noted how 'instead of imitating a theatrical performance already endowed with a certain amount of motion, the earliest films added movement to works of art originally stationary' (Panofsky 1997: 95). The 'instead' of Panofsky's assertion ascribes to early cinema a consistency of allegiance to works of art and neglect of theatrical approaches. Needless

to say, this is misleading: early cinema certainly *did* often imitate theatrical performances in subject matter, set dressing and performance style. Nevertheless, Panofsky's insertion of works of art as a relevant referent within a history of the earliest films usefully corrects an imbalance in how that history has sometimes been written. For if not consistently, then certainly frequently, early films would perform their own aspirational self-alignment with fine art by 'quoting' a specific painting into which they would then breathe a pulse. Archibald Willards's famous 1891 Yankee Doodle painting is deliberately quoted in Billy Bitzer's 1905 one-minute film for the AMBC entitled *Spirit of '76* (Mathews 2005: 154). And the practice of directly importing a painting into a film in this way continued to hold a fascination for years subsequently. Millais's 1852 painting *Ophelia*, for example, is directly cited in the *Hamlet* film released by Italian production company Rodolfi-Film in 1917. Though different in almost every other way, these two films nevertheless adopt a broadly comparable citational strategy in the use they make of the famous paintings they absorb into their own cinematic structures. Despite the momentary departure from Willards's painting when one of the drummers accidentally drops a drum stick in *Spirit of '76* and despite the gently lapping water that plays over the drowned body of Ophelia in the Italian *Hamlet*, both film scenes are, in conception, unambitious, non-investigative acts of homage to the source painting rather than attempting anything more energetic or interrogative in their intertextual engagements with it.

A cinematised adoption of a painting need not, however, be employed with such acquiescent passivity. As it transmutes a moment of artistic equilibrium and suspended action into sequentially organised narrative, cinema can, in the process, make a significant interpretive intervention on the subject. And in other films, painterly quotations have served a more abrasive or interventionist purpose beyond the merely pleasure inducing, recognition sparking and culturally reassuring. The assassination scene in the 1908 one-reel *Julius Caesar* from American film production company Vitagraph is a case in point (Figure 8.1).[6] As was usual for its moment, it is a one-shot scene, theatrically blocked and recorded on a studio stage from a static, frontally placed camera. Less immediately obvious to audiences now is that in both the detail of the scene's design and the specifics of its choreography, Vitagraph had directly copied the set, statuary and deployment of characters from the French neo-classicist Jean-Léon Gérôme's iconic painting *The Death of Caesar* (1867) (Figure 8.2). In the early twentieth century, this was a popular painting with a significant profile: it had been variously on exhibition in New York and was in circulation in reproduced form. It is unsurprising, therefore, that the painterly quotation within the film should have been identified and explicitly commented upon in review at the time (Bush 1908: 447).

The assassination of Caesar inevitably presents particular challenges to those wanting to present it in dumb show, particularly as played at a pace (necessitated in part by the compressed one-reel format) liable to compromise any pretence to high seriousness. Such a scene always runs the risk of tipping over into an exhibition of the rushed, the overblown and the risible. As if alive to this possibility and eager to

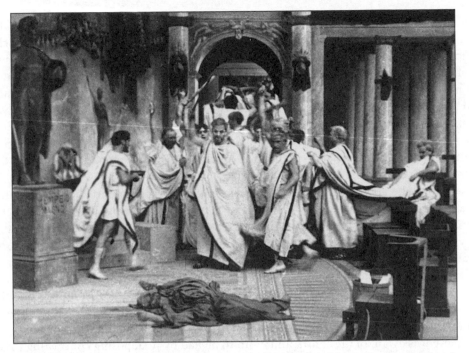

Figure 8.1. Capitol scene from *Julius Caesar* (Vitagraph, 1908). Courtesy of the paper print collection of the Motion Picture, Broadcasting and Recorded Sound Division of the Library of Congress.

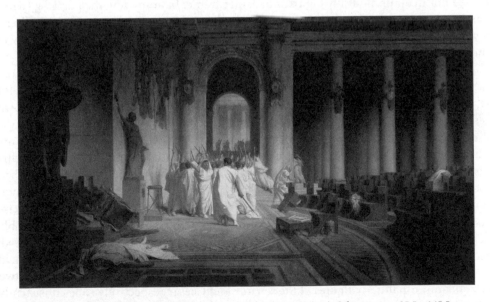

Figure 8.2. Jean-Léon Gérôme, 'The Death of Caesar', French (1859-1867). Oil on canvas. 85.5 x 145.5 cm. Courtesy of the Walters Art Museum, Baltimore.

indemnify their release against ridicule, however, Vitagraph embedded within the action a self-consciousness of the potential comedy of the moment. For while epoch-defining events are taking place at the centre of the frame, there is, at the right edge of the frame, one elderly senator who sleeps on his bench throughout. As supplications are made to Caesar, the senator sleeps. As Caesar is stabbed, staggers from side to side and dies conveniently in centre frame, he sleeps. As the conspirators rouse themselves to proclaim liberation in the streets, he sleeps still. As Antony breaks through the crowd and is then left alone with the body to appeal dramatically to the gods and, arm thrust in the air, assert his allegiance to his dead ruler, the senator snoozes happily on the benches now deserted by his colleagues.

And the joke about a dramatic obliviousness to historical import that the sleeping senator's presence constitutes in this context is one whose spring, like almost all else in the scene, lies in the Gérôme painting. However, whereas Gérôme's sleeping senator provides a mildly witty peripheral detail,[7] in the film he becomes funny in ways beyond what was possible in his previous instantiation. The enhanced comedy in the film depends on the senator's immobility now dramatically juxtaposed with the frenetic and ongoing levels of animation by which he is surrounded, emphasising both the incongruity and the comic persistence of that stillness. Vitagraph's gleeful appropriation of this peripheral figure from Gérôme and decision to leave him in place throughout the action suggests the company was aware of the contrapuntal fun to be had by juxtaposing contrasting tones of action within a single shot, thereby licensing the nodding senator at the periphery of the image gently to ironise the potential gravitas of the history-making action being played out in an unmodishly high key in centre frame. In animating the painting (while barely animating the senator), Vitagraph transformed a single incongruous peripheral detail from the painting into a skittishly sustained point of puncture for the dignity of the scene as a whole.

Absorbing Gérôme into the film's narrative and aesthetic structures, however, did more than point up the scene's potential humour. Tracking Caesar through the scene, for example, reveals another effect of the painting as explicitly conjured backdrop and known referent for the film. While, therefore, the sleeping senator arrives from Gérôme onto the film's senatorial benches as if unwoken by his recent transference of artistic medium, Caesar, by contrast, starts the scene active, mobile and alive – and, as such, implicitly resistant to the lifeless body and pile of crumpled robes on the floor that Gérôme had ascribed to his painterly self. As the outworking of the known history carries the character towards his fate, however, the film's Caesar is simultaneously drawn towards the precise configuration of the fallen Caesar in which his artistic self had already been memorably delineated. By the end of the scene, the film's Caesar has, in effect, been de-cinematised, reclaimed for the eloquent stasis of death in the very form and positioning in which Gérôme had memorialised him (Figures 8.1 and 8.2). Meanwhile, around these two key still, quasi-painterly figures of the senator and Caesar respectively (one consistently still, the other finally so), the film takes sustained pleasure in its injection of vitality,

temporality and, we might even say, paint-surpassing cinematicity in the passionately animated behaviour of those participative in, and witness to, the assassination.[8]

In *Julius Caesar*, therefore, Vitagraph did not simply bring a work of art 'within the range of everyday seeing' to render it now 'an open book to the masses', as Bazin would later advocate cinema might usefully do with and for a painting (Bazin 1967b: 167, 168). Rather, the film's use of its quoted work of art transcended the merely citational and disseminative and instead riffed on the comic potential of animating the cited work, dramatised the potency of the aesthetic pull towards known, still, iconic forms, and enjoyed its own irrepressible dynamism in its intimately admiring encounter, and contest, with Gérôme.

Drawing on a pool of artistic reference, and inviting an audience to identify both the allusion and what has been done with it, collaborated with a host of other influences to reinforce the cultural tensions – in particular about target market – to which many early films already and innately played host. Films that drew on 'high-culture' sources were, that is, frequently both burdened and enriched by competing agenda as they found themselves caught between an aspiration to take the industry upmarket by appealing to the cognoscenti and a commercial imperative to create crowd-pleasers. An embedded painterly quotation contributed to some of these visible internal tensions about dominant mode of address and target market. Given the conflicted nature of the debate, it is perhaps apt that the inclusion of this particular well-known work of art in this particular film had the nicely paradoxical effect of simultaneously lending cultural gravitas *and* impish subversion to the scene. The mixed, even contradictory, operations of the artistic quotation in this film in fact neatly epitomise the ways in which many films of the period sought to position themselves as a point of easy mediation for the two-way traffic between 'high' art and mass culture.

<p style="text-align:center">* * *</p>

Tom Gunning's influential argument that pioneering cinema created 'an aesthetic of astonishment' as part of a 'cinema of attractions' has now passed into the received wisdom about what early cinema *was* (Gunning 1989). In the process, Gunning's paradigm has, in the way of things, sometimes been reduced to a cruder and misleading summary of itself in which a stupefied audience for early cinema is posited, watching in awed astonishment as the wondrous moving images unspool before their eyes. Many of the generously allusive signals within the films themselves pointing knowingly beyond their own borders provide an antidote to that critically reductive tendency by reminding us that the 'astonishment' that early cinema provoked was not one that paralysed or deactivated participative discernment or associative thinking, or that equated in any way to stupefaction. From the first, in fact, the moving picture industry offered a product part of whose pleasure was to be found specifically in active and judicious comparison – comparison with the extra-cinematic world of lived experience and, crucially, comparison

with other, known cultural works and styles of artistic address. And the resulting intertextual and intermedial encounters to which early cinema played host testified to the laudable impurity of a medium whose generous cultural reach allowed it both to collaborate imaginatively and compete playfully with fine art in ways that contributed richly to the aesthetic character, dramatic engine and cultural aspirations of the emerging film industry.

Bibliography

Bazin, A. (1967), 'In Defense of Mixed Cinema', *What Is Cinema?* Vol. 1, in H. Gray (trans.), Berkeley: University of California Press, pp. 53–75.

—— (1967) 'Painting and Cinema', *What Is Cinema?* Vol. 1, in H. Gray (trans.), Berkeley: University of California Press, pp. 164–69.

Bush, W.S. (1908), 'Julius Caesar', *Moving Picture World*, 3.23, p. 447.

Gorky, M. (1996), 'In the Kingdom of Shadows' (1896), in C. Harding and S. Popple (eds), *In the Kingdom of Shadows: A Companion to Early Cinema*, London/Madison and Teaneck: Cygnus Arts/Fairleigh Dickinson University Press, pp. 5–6.

Gunning, T. (1989), 'An Aesthetic of Astonishment: Early Film and the (In)credulous Spectator', *Art and Text*, 34, pp. 31–45.

—— (2004), 'The Intertextuality of Early Cinema: A Prologue to *Fantômas*', in R. Stam and A. Raengo (eds), *A Companion to Literature and Film,* Oxford: Blackwell, pp. 127–43.

'Jean-Leon Gérôme Dead; French Painter and Sculptor Found Lifeless in Bed', *The New York Times* (11 January 1904), p. 7.

Mathews, N.M. (2005), 'Art and Film: Interactions', in N.M. Mathews with C. Musser (eds), *Moving Pictures: American Art and Early Film, 1880–1910.* Manchester, VT: Hudson Hills Press, pp. 145–58.

McKernan, L. (2007), '"Only the Screen was Silent …": Memories of Children's Cinema-Going in London before the First World War', *Film Studies*, 10, pp. 1–20.

Morgan, V. (1974), *Yesterday's Sunshine: Reminiscences of an Edwardian Childhood*, Folkestone: Bailey Brothers and Swinfen.

Musser, C. (2005), 'A Cornucopia of Images', in Nancy Mowll Mathews with Charles Musser (eds), *Moving Pictures: American Art and Early Film, 1880–1910*, Manchester, VT: Hudson Hills Press, pp. 5–37.

Nead, L. (2007), *The Haunted Gallery: Painting, Photography, Film c. 1900*, New Haven and London: Yale University Press.

'A New Set of Living Pictures: Some Fine Groupings Displayed at Koster & Bial's', *New York Daily Tribune* (11 May 1894), p. 7, C6.

Panofsky, E. (1997), 'Style and Medium in the Motion Pictures' (1934), in I. Lavin (ed.), *Three Essays on Style*, Cambridge, MA: MIT Press, pp. 91–128.

Pastor, T. (1894), 'New "Living Pictures" at Koster and Bial's', *The New York Times*. Available at *NYT*'s online archive: http://query.nytimes.com/mem/archivefree/pd f?res=FA0F12FA3C5415738DDDA80A94D0405B8485F0D3. Accessed December 2010.

Ramsaye, T. (1964), *A Million and One Nights: A History of the Motion Picture Through 1926* (1926), New York: Simon and Schuster; Essandess paperback reprint, p. 232.

Smith, A.E. (1952), *Two Reels and a Crank: From Nickelodeon to Picture Palace*, Garden City, New York: Doubleday and Co.

Southern, R. (1951), 'The Picture-Frame Proscenium of 1880', *Theatre Notebook*, 5:3.

Stam, R. (1992), *Reflexivity in Film and Literature: From Don Quixote to Jean-Luc Godard*, New York: Columbia University Press.

Notes

1. There is no stable consensus among film historians about how precisely to parcel up the industry's early developmental phases. Nevertheless, the years 1895–1913 predating the arrival of the feature film (a single story film of four or more reels) are generally referred to as the 'early cinema' period. Typically, this is configured as incorporating the 'pioneering years' (1895–*c.* 1906) and the 'transitional era' (*c.* 1907–13). On the problems inherent in identifying definitive film historical periods, see Gunning (2004).
2. Southern also challenges Bancroft's claim to originality in fully framing the proscenium arch.
3. The painting is undated, but the material history of the painting and Méliès' full head of hair seem to place it in the 1880s. It was previously thought to be not by Méliès but by Dutch painter

Gesina Mesgad and was sold as such at auction in 1997. The Rijksbureau voor Kuntshistoriche Documentatie (Netherlands Institute for Art History) has since confirmed that Mesdag is not the artist. I am grateful to Lawrence Steigrad, of the Lawrence Steigrad Fine Art Gallery in New York, for a very helpful correspondence about the painting's provenance.

4. Maxim Gorky saw the pioneering Lumière programme at the Nizhny-Novgorod Annual Fair on 30 June or 1 July 1896. His review, 'The Kingdom of Shadows', was published in Russian in the local newspaper *Nizhegorodski listok*, 4 July 1896.

5. Smith and Blackton went on to become co-founders of the globally successful film production company Vitagraph.

6. The entire action of the play was condensed into approximately thirteen minutes projection time. The surviving BFI National Archive 35mm viewing copy (with German intertitles) is 836 ft in length, which equates to approximately nine minutes projection time.

7. Gérôme had a taste for depicting individuals abstracted from the emotional import of a scene: another Gérôme painting, 'Door of the Mosque El Asseneyn', shows a sentinel unemotionally smoking a pipe beside a row of severed heads (see 'Jean-Leon Gérôme Dead' 1904: 7).

8. Animating a Gérôme seems in keeping with the painter's own interests in the nature of still and moving art works, evidenced in his own three paintings of Pygmalion and Galatea.

Contributors

Steven Allen is Senior Lecturer in Film and Media Studies at the University of Winchester, where he is programme director for the MA in Cultural Studies. His research interests include Anglophone cinema, with particular focus on representations of landscapes, cultural memory and the body, and he also writes on animation. He has published work on the seaside in British cinema, the role of cultural memory and violence in *The Passion of the Christ*, sound in Tex Avery's MGM cartoons, and anime fandom in the UK. He is currently completing a monograph entitled *Cinema, Pain and Pleasure: Consent and the Controlled Body* (Palgrave, 2012).

Judith Buchanan is Professor of Film and Literature in the Department of English and Related Literature and Director of the Humanities Research Centre at the University of York. She works on silent cinema, adaptation, narrative transmission in film and literature and Shakespeare and the Bible on film. She is the author of *Shakespeare on Silent Film: An Excellent Discourse* (CUP, 2009) and of *Shakespeare on Film* (Longman-Pearson, 2005). She is currently editing a book for Palgrave Macmillan entitled *The Writer on Film: Screening Literary Authorship* while working on the apocryphal figure of Judith in film, art and literature and the operations and meaning of the body in silent cinema.

Ian Christie is a film historian, curator and broadcaster, currently Professor of Film and Media History at Birkbeck, University of London. He is also a Fellow of the British Academy and serves as vice-president of Europa Cinemas. His most recent book, *The Art of Film: John Box and Production Design* (Wallflower, 2009), examined the role of production design through the career of one practitioner. A concern with the visual runs through other books on Powell and Pressburger, Scorsese, Gilliam and Russian cinema, as well as the many exhibitions he has curated. www.ianchristie.org.

Leighton Grist is Senior Lecturer in Media and Film Studies at the University of Winchester, where he is programme director for the MA in Film Studies. The writer of numerous articles published in edited collections and in journals, his output has included work on classical and post-classical Hollywood, on genre, and on matters pertaining to film theory, psychoanalysis, and gender. He is in addition the author of *The Films of*

Martin Scorsese, 1963-77: Authorship and Context (2000), and is presently completing a follow-up volume.

Ian Hague is a PhD student and associate lecturer in the History department at the University of Chichester. His research focuses on how comics communicate information to the reader using all five senses (sight, hearing, touch, smell and taste). Ian is also the director of Comics Forum, the annual academic conference on comics that takes place every November as part of Leeds' sequential art festival, Thought Bubble. He did his BA in English at the University of Hull, and his MA in Cultural Studies at the University of Leeds. His research interests include materiality, technology, and theoretical approaches to comics.

David Heinemann is a Lecturer in Film at Middlesex University. He also teaches on the *MA in Filmmaking* programme at Goldsmiths College. With a particular interest in modernist cinema, his previous publications on the films of Eric Rohmer include a chapter in the collection of essays, *Rohmer et les autres* (2007).

Laura Hubner is Senior Lecturer in Film and Media Studies at the University of Winchester, where she is programme director for BA (Hons) Film Studies. She has published journal articles and book chapters on Scandinavian and European cinema, gender, the body and filmic representations of fairytale/gothic horror. She is author of *The Films of Ingmar Bergman: Illusions of Light and Darkness* (Palgrave Macmillan, 2007) and editor of *Valuing Films: Shifting Perceptions of Worth* (Palgrave Macmillan, 2011).

Tina Kendall is Senior Lecturer in Film Studies at Anglia Ruskin University. Her research interests include theories of spectatorship, affect, and unpleasure, especially as these relate to contemporary European cinema. She is co-editor of *The New Extremism in Cinema: From France to Europe* (Edinburgh University Press, 2011), and is currently preparing a monograph on the cinema of Bruno Dumont. She has also published on questions of stillness, intermediality, disgust, and the new materialism in film.

David Morrison completed his PhD, 'A Study of Loneliness in Film', at King's College, London. He has taught on a variety of Film Studies modules at King's and at Oxford Brookes University.

Matilde Nardelli is currently a British Academy Postdoctoral Fellow at University College London. Her research looks at the interrelation between cinema and the other visual arts and media, and she is preparing a book on experimental film and cinema in the gallery since the 1960s. She has published articles on Michelangelo Antonioni, film and photography, and cinema's obsolescence in contemporary art.

Dorota Ostrowska teaches film and modern media at the Department of History of Art and Screen Media, Birkbeck, University of London. She is the author of *Reading the French New Wave: Critics, Writers and Art Cinema in France* (Wallflower Press, 2008) and co-editor (with Graham Roberts) of a volume of essays entitled *European Cinemas in the TV Age* (Edinburgh University Press, 2007).

Toni Ross works in the School of Art History and Art Education, College of Fine Arts, University of New South Wales. Her recent publications include 'From Classical to Postclassical Beauty: Institutional Critique and Aesthetic Enigma in Louise Lawler's Photography,' *Communities of Sense: Rethinking Aesthetics and Politics*, edited by Beth Hinderliter et al. (Durham and London, 2009); 'Image, montage,' *Jacques Rancière: Key Concepts*, edited by Jean-Philippe Deranty (Durham, GB, 2010). She is currently working on a book to be published by I.B. Tauris entitled, *Rancière Reframed: Interpreting Key Thinkers for the Arts.*

Dennis Rothermel is Professor of Philosophy at California State University, Chico. His research lies in the intersection of Continental philosophy and cinema studies. His recent publications include an essay on *The Piano, Crouching Tiger, Hidden Dragon, The Pianist*, and *Hero* in the *Quarterly Review of Film and Video*; 'Slow Food, Slow Film,' also in the *QRFV*; and book chapters on Joel and Ethan Coen's *No Country for Old Men*, Clint Eastwood's *Mystic River*, John Ford's *My Darling Clementine*, Bertrand Tavernier's *In the Electric Mist*, 'Julie Taymor's Musicality,' and 'Anti-War War Films.' He has also co-edited a volume of essays, *Remembrance and Reconciliation* (Rodopi, 2011), authored by members of the Concerned Philosophers for Peace. He is working on two monographs, one on Westerns and one on Gilles Deleuze's two-volume essay on cinema, and also on an anthology co-edited with Silke Panse, *A Critique of Judgment in Film and Television.*

Index